Lecture Notes in Computer Science 8230

Commenced Publication in 1973
Founding and Former Series Editors:
Gerhard Goos, Juris Hartmanis, and Jan van Leeuwen

Hartmut Koenitz Tonguc Ibrahim Sezen
Gabriele Ferri Mads Haahr Digdem Sezen
Güven Çatak (Eds.)

Interactive Storytelling

6th International Conference, ICIDS 2013
Istanbul, Turkey, November 6-9, 2013
Proceedings

Springer

Volume Editors

Hartmut Koenitz
University of Georgia, Athens, GA, USA
E-mail: hkoenitz@uga.edu

Tonguc Ibrahim Sezen
Istanbul Bilgi University, Eyub-Istanbul, Turkey
E-mail: tonguc.sezen@bilgi.edu.tr

Gabriele Ferri
Indiana University, Bloomington, IN, USA
E-mail: gabferri@indiana.edu

Mads Haahr
Trinity College, Dublin, Ireland
E-mail: mads.haahr@cs.tcd.ie

Digdem Sezen
Istanbul University, Beyazit-Istanbul, Turkey
E-mail: dsezen@istanbul.edu.tr

Güven Çatak
Bahçeşehir University, Karaköy-Istanbul, Turkey
E-mail: guven.catak@bahcesehir.edu.tr

ISSN 0302-9743 e-ISSN 1611-3349
ISBN 978-3-319-02755-5 e-ISBN 978-3-319-02756-2
DOI 10.1007/978-3-319-02756-2
Springer Cham Heidelberg New York Dordrecht London

Library of Congress Control Number: 2013950388

CR Subject Classification (1998): J.5, K.8.0, H.5, H.3.4-5, H.3.7, I.2.1,
I.2.11, H.4.0, K.3.1

LNCS Sublibrary: SL 3 – Information Systems and Application
incl. Internet/Web and HCI

Typesetting: Camera-ready by author, data conversion by Scientific Publishing Services, Chennai, India

Printed on acid-free paper

Springer is part of Springer Science+Business Media (www.springer.com)

Preface

Interactive digital storytelling is not only an exciting and challenging field, but also a vibrant interdisciplinary research area. The main conference in this field is ICIDS, the International Conference for Interactive Digital Storytelling. This volume contains the papers presented at the sixth ICIDS held November 6–9, 2013, in Istanbul, Turkey. While formally only in its sixth year, ICIDS traces its origins back more than a decade, with roots in several European conferences.

ICIDS brings together scholars and practitioners from areas such as computer science, communication and digital media studies, game studies and literary studies. Few conferences encompass such a diverse community and, while this comes with its own set of challenges, it is also an immense strength that ideas and thinking can flow freely between such varied disciplines and result in a lively interdisciplinary dialogue.

The diversity in the research community is captured in the logo for this year's conference: a bridge, whose elements signify the different academic and practical perspectives from art to computation. This is a fitting representation not only for our multidisciplinary field but also for a conference in Istanbul, a city that bridges two worlds — Europe and Asia — both figuratively and literally in the form of the bridges over the Bosphorus. We continue the idea of symbolic bridging in the conference motto "Connecting Narrative Worlds," which expresses our goal for this edition of ICIDS.

With this year's conference, we especially aimed to promote understanding and to provide a platform for discussion between game designers, researchers in artificial intelligence, transmedia producers, digital artists, narratologists, and digital game scholars from all around the world. With this goal in mind, we pioneered several additions to the conference, chiefly amongst them a separate call for interactive narrative art works and demos, which is designed to strengthen the connection between deep thinking and cutting-edge practice. We also introduced a short workshop format to provide more room for the discussion of innovative topics.

The keynote speakers appearing at ICIDS 2013 similarly reflect the diversity in disciplines and perspectives. We invited renowned artist and interactive pioneer Toni Dove, the interactive storytelling expert Ernest Adams, and the independent game developer Dan Pinchbeck.

Since the early 1990s, Toni Dove has expanded traditional narratives through the use of interactive components and immersive devices to explore multiple points of view. Her 1993 piece "Archaeology of a Mother Tongue" constitutes one of the first attempts to bridge the gap between a complex narrative and a virtual-reality environment, combining performance with immersive computer-based experiences. She continued this artistic exploration in the following years until "Lucid Possession," a work premiered in early 2013.

Ernest Adams is a game design consultant, writer, and lecturer. He is the author of *Fundamentals of Game Design and Game Mechanics: Advanced Game Design* (with Joris Dormans) and was lead game designer at Bullfrog/EA. At the Game Developers Conference 2006, he presented a talk titled "A New Vision for Interactive Stories," which contributed to shape the debate on games and narrative in the following years.

Dan Pinchbeck is Reader at the University of Portsmouth, where he pursues his research on the significance of the relationships between gameplay, story-telling, and player psychology. He is also creative director of The Chinese Room, the game design studio responsible for the critically acclaimed "Dear Esther" in-teractive narrative game, which won the Best World/Story award at IndieCade in 2009.

Papers from 25 countries as far apart as Australia and Kuwait were submitted to ICIDS 2013, showing that the interest in our field is not only sustained but also universal. Out of those 51 submissions, 14 long papers were selected (for a 27.4% acceptance rate).

As in previous years, the papers submitted were of extremely high quality and of remarkable variety in their theoretical approaches. While we are very pleased with such high-quality work being submitted, deciding the best contributions to accept was a difficult task. We extend our gratitude to the members of the ICIDS Program Committee, who thoroughly reviewed the submissions and upheld the high standards of the conference once more.

Finally, we can only begin to express how grateful we are to this year's host institution, Bahçeşehir University Faculty of Communication, especially the Department of Communication Design, and Bahçeşehir University Game Lab (BUG). They bestowed an outstanding level of support and outright generosity on the conference.

The researchers who attend ICIDS come from different worlds not only by virtue of their different disciplines; they also position themselves at different points on the theoretical-practical spectrum and now also come from nearly every part of the globe. With such a rich and complex community, the ability and willingness to keep building bridges and make connections is of crucial importance. As organizers of ICIDS 2013, we wish to celebrate the diverse perspectives of scholars and practitioners in our community, but also highlight how important it is for the community to stay engaged in its global dialogue — across disciplines, across theory/practice, and across geography and cultures. We need to keep building bridges and keep using them. Welcome to the proceedings of ICIDS 2013, Connecting Narrative Worlds.

November 2013

Hartmut Koenitz
Tonguc Ibrahim Sezen
Gabriele Ferri
Mads Haahr
Digdem Sezen
Güven Çatak

Organization

Program Committee

Fatos Adiloglu	Bahcesehir University, Turkey
Ruth Aylett	Heriot-Watt University, UK
Wolfgang Broll	TU Illmenau, Germany
Brunhild Bushoff	Sagasnet Munich, Germany
Marc Cavazza	University of Teesside, UK
Yun-Gyung Cheong	IT University of Copenhagen, Denmark
Feride Cicekoglu	Istanbul Bilgi University, Turkey
Dario Compagno	Université de Paris 8, France
Patrick Coppock	Università di Modena e Reggio Emilia, Italy
Chris Crawford	Storytron, USA
Mirjam Eladhari	University of Malta, Malta
Riccardo Fassone	Università di Torino, Italy
Gabriele Ferri	Indiana University, USA
Michael Frantzis	Goldsmiths College, UK
Pablo Gervás	Universidad Complutense de Madrid, Spain
Andrew Gordon	ICT/USC, USA
Stephan Günzel	Berliner Technische Kunsthochschule, Germany
Mads Haahr	Trinity College Dublin, Ireland
Ian Horswill	Northwestern University, USA
Ido Iurgel	Rhine-Waal University of Applied Sciences, Germany
Klaus Jantke	Fraunhofer IDMT, Germany
Noam Knoller	University of Amsterdam, The Netherlands
Hartmut Koenitz	University of Georgia, USA
Petri Lankoski	Södertórn University, Sweden
Sandy Louchart	Heriot-Watt University, UK
Inderjeet Mani	Yahoo! Labs, USA
Kevin McGee	National University of Singapore, Singapore
Alex Mitchell	National University of Singapore, Singapore
Bradford Mott	North Carolina State University, USA
Janet Murray	Georgia Institute of Technology, USA
Frank Nack	University of Amsterdam, The Netherlands
Mark Nelson	IT University of Copenhagen, Denmark
Valentina Nisi	University of Madeira, Portugal
Ian Oakley	UNIST, Republic of Korea

Table of Contents

Analyses, Evaluation, and User Experience Reports

Artificial Intelligence and Story Generation

New Narrative Forms

Workshops

Modeling Foreshadowing in Narrative Comprehension for Sentimental Readers

Byung-Chull Bae, Yun-Gyung Cheong, and Daniel Vella

Center for Computer Games Research
IT University of Copenhagen
Rued Langgaards Vej 7, 2300 Copenhagen S, Denmark
{byuc,yugc,dvel}@itu.dk

Abstract. Foreshadowing is a narrative technique of manipulating the reader's inferences about the story progression. This paper reviews research on foreshadowing and reader comprehension in narratology and cognitive science. We use the term *sentimental reader* to refer to sophisticated readers who make active efforts in their reading experiences, and then we list various examples of foreshadowing found in novels, films, and games, discussing their impact on the sentimental reader's reasoning process. We further present an example of interactive fiction associated with the use of foreshadowing and conclude with future work.

Keywords: Foreshadowing, Narrative Comprehension, Reader Model.

1 Introduction

For decades narrative theorists have characterized the concept of foreshadowing from different perspectives. Narratologist Gerard Genette explains, on the basis of the story-discourse distinction, how story events can be differently re-ordered at the discourse level [1]. In his work, *telling in advance* (or *temporal prolepsis*) refers to situations where some future events are told ahead of time at the discourse level. This can be accomplished in two ways. The first, called *advance notice*, is direct and explicit, playing the aesthetic role of building anticipation for what is to come. This concept is similar to that of *flashforward* in film media, which shows some future events prior to the events leading up to them. The other type, called *advance mention*, describes indirect and implicit references whose importance may or may not be revealed later in the story. The notion of advance mention is close to that of foreshadowing in film [2], in that it works, for the most part, retrospectively. Genette also addresses the fact that the author can employ advance mentions in two ways - either falsely or genuinely, in order to fool the readers who believe that they can detect this narrative *seed*. Genuine advance mentions orient the reader in the right direction in relation to upcoming story developments; however, false advance mentions (or snares, to use Barthes's terms [3]) plant a wrong impression that leads the reader astray from the main story plot, thereby misleading the reader. As such, the mixed use of both types of foreshadowing in a story may challenge active readers who try to find and decipher hidden clues in the story.

H. Koenitz et al. (Eds.): ICIDS 2013, LNCS 8230, pp. 1–12, 2013.
© Springer International Publishing Switzerland 2013

Chatman [4] interprets foreshadowing as the seeding of an anticipatory satellite from which a kernel event can be inferred, where kernels refer to major plot events that serve as branching points directing a main path in the story plot, and satellites are minor plot events entailing no branching plot (or choice). Using this satellite-kernel relationship, foreshadowing can be characterized in two ways: a satellite event foreshadowing a later kernel event and a satellite event foreshadowing another, later satellite event. Chatman also claims that foreshadowing can evoke suspense. In suspense-entailing foreshadowing, the reader is given more knowledge about uncertain future events than the story characters, generating a disparity of knowledge between the reader and the characters. This knowledge disparity can lead to the creation of suspense for the reader at the discourse level, while generating surprise for the characters at the story level.

Some computational models of narrative generation have explored foreshadowing. A case-based reasoning system Minstrel [5] makes decisions about what to foreshadow and when to foreshadow (i.e., the story point where foreshadowing content will be located), based on the characterization of uncommonness and similarity of actions and states. Although their approach to selecting uncommon events was admittedly naïve, Minstrel made an attempt to increase story coherence and unity of a story. Montfort's Curveship [6] is an interactive fiction system with various formal narrative capabilities, including temporal re-ordering of events and focalization [1][7]. While Curveship does not support the function of foreshadowing directly, it can narrate some future events proleptically (based on the notion of Genette's prolepsis [1]) provided that a point of insertion and a rule for selecting future events are given. Curveship works on the basis of the temporal relations of events, not the causal information of them. The work of Bae and Young [8] presents a narrative generation system using the concept of Chekhov's Gun-style foreshadowing, where an important item or character is initially shown with hidden information. To best of our knowledge, no attempts have been made to analyze the reader's narrative comprehension with a specific focus on foreshadowing in a computational way.

To summarize, although foreshadowing is an effective narrative device influencing the reader's active comprehension of the story, little effort has been made in terms of investigating its operation. The goal of this research is to set the initial foundation for a *sentimental* reader's mental model while reading a story that contains foreshadowing in it. Sentimental readers (or critical readers) [9][10] refer to the readers whose reading process is modified by an awareness of aesthetic narrative techniques, and who are therefore able to grasp underlying story elements that are only partially shown. The remaining sections of this paper are organized as follows. In the next chapter we provides more detailed explanation about the two classes of the reader model. Various examples of foreshadowing found in classical media (including novels and films) and games are presented in chapter 3. Chapter 4 addresses a sentimental reader model and a possible example of the use of foreshadowing in interactive fiction. Chapter 5 concludes with discussion and future work.

2 Two Classes of Model Reader

A same story can be comprehended differently depending on the individual reader's cognitive and affective capabilities ddd cultural background of the reader. The text can be either underread (i.e., things present in the text are overlooked) or overread (i.e., things absent in the text are erroneously inferred), due to the gaps in the story [11]. While it is likely that individual reader has his or her own unique experience in reading, there have been attempts to classify readers into a number of classes. Umberto Eco theorized a distinction between the *naive* and the *critical* reader [9: p. 55]. The naive reader reads a text on purely semantic level, grasping only its literal and referential meaning without any perspective on how (or why) this meaning is constructed by the text. The critical reader, on the other hand, reads not only the semantic meaning of the text, but also gains an awareness of the formal and aesthetic techniques by which that meaning is conveyed. Eco argues that a text can be structured in such a way that it anticipates two model readers, a naive and a critical one, and that, as such, it can be read on two levels. A mystery story, for instance, might be read by a naive reader who enjoys being unwittingly carried along by the devices used by the writer to create suspense, fear, and surprise. A critical reader might read the same story and gain an appreciation, not only for the content of the story, but for the formal techniques and narrative strategies that the writer uses to create the story's effect.

In a similar vein, novelist Orhan Pamuk draws on a distinction made by the philosopher Friedrich Schiller, suggesting that literature can exist – both in its production and in its consumption – in two different modes: the *naive* and the *sentimental* [10]. Similarly to Eco, Pamuk describes the naive reader as a reader who understands text as an unproblematic representation of external reality, while the sentimental reader understands the mediated nature of the text's representation. The sentimental reader, therefore, is sensitive to interpreting not only what is said but also how it is said. Both theories of Eco and Pamuk reveal the extent to which the reader is an active participant in the activation of the text's signification.

The reader's process of reading narrative has been also investigated in cognitive science and psychology. Cognitive scientists Gerrig and Bernardo [12] view the reader as a problem solver who constantly tries to find the solutions available to the protagonist to achieve a given mission or to survive. Their theory claims that the reader feels more suspense as the potential solutions available to the protagonist are eliminated [12][13]. As a mental representation of a story constructed by the reader, Zwaan [14] suggests an event-indexing model consisting of space, time, goals (and causation), and characters (and objects). Based on these dimensions, the reader builds *a situation model* as if she herself is in the situation depicted in the narrative text. This generic model has been employed as a reader model to keep track of the reader's inferences in narrative comprehension [15][16]. Trabasso et al. investigate the causal relationship among story events as the key to understanding story recall [17], where the greater the number of direct causal connections a story event has, the more readily it is recalled; the more readily an event is recalled, the more significant it is considered.

3 The Use of Foreshadowing in Media

3.1 Foreshadowing in Novels and Films

In Stephen King's novel 11/22/63, the protagonist Jake recounts, commenting early in the story, "I wish I had been emotionally blocked, after all. Because everything that followed - every terrible thing - flowed from those tears." This kind of *advance mention* prepares the reader for anticipating fearful and tragic events that are about to happen as the story unfolds. This also helps the reader maintain a sense of curiosity and desire to finish reading the story (even through sections where it might be comparatively dull). In *The Alchemist* by Paulo Coelho, the shepherd boy Santiago consults a fortune-teller about his recurrent dream. In the dream a child leads him to the Egyptian Pyramids to show where treasures are located, but he wakes up before knowing the exact location. This dream drives him to embark on a long journey, at the end of the story, to Egypt where the scene in the dream is actually realized.

In the film *Life of Pi* (directed by Ang Lee, adapted from the novel authored by Yann Martel), the young boy Pi meets a priest in a chapel while drinking holy water. The priest gives him a glass of water, saying, "You must be thirsty." The audience also learns that the tiger Richard Parker was initially named *Thirsty*. As the story progresses, Pi recounts his 227-day journey on the sea, struggling with the tiger while they share a small lifeboat. At the end of the story, however, when Pi provides a fabricated story to the Japanese officials who are investigating the shipwreck, a sentimental reader may comprehend that the story told so far was an allegory of an underlying story in which Pi himself was the tiger - a revelation foreshadowed by the earlier link between Pi and the tiger.

Genuine and false foreshadowing can be mixed together - that is, foreshadowing can be partially genuine and partially false. For instance, in Martin Scorsese's film *Hugo* (2011; adapted from the novel *The Invention of Hugo Cabret* written by Brian Selznick), the sentimental reader can recognize at least two different types of foreshadowing. One is the main character Hugo Cabret's talent to unlock a door. Hugo first demonstrates this skill when opening a theater door to watch a movie with a girl named Isabelle. Later, at the climax of the film, Hugo uses this skill to escape from a cage. This is an example of genuine foreshadowing, using the plot device known as *Chekhov's gun*, where a seemingly unimportant object or person introduced earlier in the story turns out to play a significant role in the plot. Another case of foreshadowing in the film is Hugo's dream about a train crash. In the dream, Hugo is on a train track and picks up a key that is necessary to operate the automaton. Suddenly a train approaches down the train track and presumably hits Hugo. Later in the film, a similar situation occurs. This time Hugo is on the train track to pick up the automaton itself, not the key. The train approaches as it did in his dream, but someone saves Hugo right before the train hits him. This can be considered as genuine foreshadowing since the actual situation plays out almost identically to its foreshadowing manifested as a dream. It is also false foreshadowing in that some important details and events are opposite to the reader's expectations. When the train approaches in the latter scene, moreover, the audience can feel suspense due to its foreshadowing in Hugo's dream.

In the film *In Bruges* (directed by Martin McDonagh, released in 2008), a hired assassin, Ray accidentally kills an innocent little boy while on a mission to assassinate a priest. Ray and his partner Ken are ordered by their boss Harry to keep a low profile in Bruges, Belgium. Soon, Ken is given the task of killing Ray as punishment for the boy's death. When Ken refuses to do this, Harry makes a verbal commitment that he would commit suicide on the spot if he were to kill a child by mistake. And then, at the climactic scene of the film, when a similar situation appears to happen to Harry, the (naive) audience understands Harry's decision to kill himself. Furthermore, it is highly likely that the sentimental audience would have predicted Harry's suicide before the incident, and, indeed, may have expected the situation far earlier, when Harry's verbal commitment was made. Here, foreshadowing serves as predictor of a character's future incident or destiny for sentimental viewers, and as persuasive device for naive viewers later in the story [18].

In the Korean movie *Helpless* (directed by Young-Joo Byun, released in 2012), a seemingly mundane dialogue between two supporting characters plays out as a critical clue to the prime suspect's whereabouts later in the film. A regular moviegoer may find this scene abnormal because the short conversation, which appears to be unrelated to the ongoing story, is shot in great detail. When it turns out that one of the characters in the scene becomes the target of the future crime, the audience can establish a strong causal relation to the conversation shown in the beginning.

3.2 Foreshadowing in Games

Given that digital games are perhaps best considered a hybrid form - entertainment software that "contains many forms of media content" [19] - it is hardly surprising that foreshadowing can become an element in the game designer's vocabulary. Moreover, due to the capacity of games to deploy the medial characteristics, formal properties and cultural codes of media such as literature and cinema, it is inevitable that the techniques of foreshadowing that are brought into play will, to a considerable extent, mirror those found in earlier media. For example, in Journey1, a game that structures itself as a spiritual quest, a hieroglyph seen in an early video cut-scene foreshadows the death of the player-character at the end of the quest.

The potential for a new dimension of foreshadowing, however, might reveal itself once the specific formal properties that differentiate narrative in games from that in other media are brought into the equation. First of all, it is only possible to speak of foreshadowing in respect to the category of digital games that Juul defined as progression games – games that are structured around a "predetermined sequence that the player has to perform to complete the game" [20: p.158]. Since foreshadowing as a narrative structure requires the presence of at least two events – the foreshadowing event and the foreshadowed event, with the former preceding the latter in presentation – only a game which is to some degree structured around a linearly-organized progression of events can ensure the presentation of both events in the correct sequence to the player. Even within games of progression, one of the recognized challenges of

[1] Thatgamecompany, 2012. `http://thatgamecompany.com/games/journey/`

applying the notion of narrative to games is that, unlike in other narrative media, it is problematic to conceive of a game narrative as the representation of a fixed sequence of events: it is perhaps more accurate to think of games as spaces of possibility out of which the player can actuate a unique sequence of events. In light of this, Calleja coins the term *alterbiography* to refer to "the story generated by the individual player as she takes action in the game" [21: p. 115].

Narrative in games, then, is best understood as an alterbiography, a sequence of events or actions actuated by the player (albeit most likely determined to a great extent by a pattern set in place by the designer). In this context, the foreshadowing of a narrative event that requires the player to perform a specific action or set of actions can serve as a powerful tool by which the player may be guided towards the relevant ludic action for furthering the game state, and, by extension, actuating the foreshadowed event. A particularly succinct and explicit example of this form of ludic foreshadowing can be found in the Flash-based game *You Have To Burn The Rope* [2], which consists of a tunnel leading into a single chamber in which the player-character has to defeat a boss character. A brief exploration of the chamber leads to the discovery of a path leading to a high platform, where the player can see a chandelier hanging over the boss character, and a series of flaming torches that can be picked up and carried. In this case, the solution to the puzzle has been doubly - and explicitly - foreshadowed; first, in the name of the game itself, and second, in a series of instructions that are laid out on-screen as the player-character is traversing the tunnel that leads to the boss chamber. The first two messages – "There's a boss at the end of this tunnel" and "You can't hurt him with your weapons" lay out the situation that is awaiting the player in the next scene; the third – "To kill him, you have to burn the rope above" – reveals the action that the player has to perform in order to resolve the scene. In effect, then, both the upcoming task and the solution to the task are explicitly foreshadowed, and the task of the player is simply that of performing the foreshadowed event.

You Have To Burn The Rope plays its foreshadowing to comedic ends, overstating the point to such an extent that there is no longer any puzzle to solve at all, with the game having intentionally given itself away. *Portal 2* (Valve, 2011) might provide us with a more nuanced example of this form of ludic foreshadowing. The core mechanic of the game lies in using the player-character's portal gun to create portals on available surfaces, thereby solving spatial puzzles through the linking of two separate points in space. The player, however, is not able to create a portal on any given surface in the game. Only certain surfaces – usually marked by differences in texture – are 'portalable'. Later sections of the game introduce a new element – conversion gel – that can be spread onto a non-portalable surface to make it portalable. In the game's final scene, the player finds herself confronting Wheatley, a rogue artificial intelligence construct, in an encounter that reflects the conventions of the climactic digital game 'boss encounter'. The only evident portalable surface is a panel right below Wheatley's robotic body, but, without a second usable surface on which a

[2] Ken Bashiri, 2008. http://www.kongregate.com/games/Mazapan/you-have-to-burn-the-rope

complementary portal can be created, there seems to be no evident action available to the player to extricate herself from the situation. At this point, an explosion opens a hole in the ceiling, through which the moon is visible in the night sky. Since the entirety of the game to this point has taken place in a vast series of underground chambers that the player-character is trying to escape from, this reveal of the night sky carries considerable dramatic weight. Its significance is underlined in Wheatley's threat to the player-character: "Take one last look at your precious moon. Because it can't help you now!"

The observant player, however, will be drawn to recall a number of references to the moon throughout the course of the game. Some of these are implicit: a landscape painting in the first room of the game changes, on a second viewing, to reveal an oversized moon hanging over the scene, and a number of concealed, 'secret' chambers throughout the course of the game contain graffiti relating to the moon, such as diagrams of the lunar cycle. More explicitly, in one of the many audio recordings that the player hears throughout the game, Cave Johnson, the founder of the company responsible for the facility in which the game takes place, describes the invention and development of the aforementioned conversion gel, revealing a material connection between it and the moon: moon rock, it seems, is the raw material out of which the gel is produced. The effect of these multiple points of foreshadowing, when it comes to the final confrontation, is twofold. First, recalling these earlier references to the moon signals to the player that the moon's appearance in this scene is important. Second, the connection between the moon and conversion gel invites the player to reach the conclusion that the moon, as an entity within the gameworld, might possess the same mechanical property as the conversion gel. It might, in other words, also be a portalable surface, and, as such, it might provide exactly what the player needs to solve the given puzzle. In this way, the foreshadowing of the scene provides the player with the information she requires to perform the correct ludic action: by launching a portal onto the moon that connects with the portal beneath Wheatley, the boss character is sucked into space, and the situation is resolved.

3.3 Discussion

Foreshadowing is a narrative device by which the author intends to influence the reader's temporal or chronological reasoning about the story in some ways. The functions of foreshadowing are diverse. It serves to maintain the reader's curiosity throughout the story in *11/22/63*, to increase the postdictability (i.e., making sense of the story as a whole in retrospect [22] in *Hugo* and *The Alchemist*, and to strengthen retrospective coherence in *Helpless* and *In Bruges*. The use of foreshadowing in games is problematic, for the foreshadowed events can vary depending on the player's action. A prevalent function of foreshadowing in games (*You Have To Burn The Rope* and *Portal 2*) is to provide the player with *narrative affordances*, a term used in [23] to describe "artifacts (specifically, story events) which prompt mental structures that allow players to envision intuitive outcomes to the current story." Our work focuses on the type of foreshadowing used to build retrospective coherence in novels and films, and to serve as narrative affordances in games.

4 Sentimental Reader's Narrative Comprehension on Foreshadowing

4.1 Foreshadowing and Possible Worlds Theory

When consuming stories, sentimental readers can detect foreshadowing events when a particular scene (usually a satellite event) stands out. For instance, a cinematic long-shot fixated on an object hints at the potential usage of this object in the upcoming story. A dialogue between minor characters can be noticeable when its content (which is seemingly not related to the current story progression) is clearly heard. While these kinds of discourse-level foreshadowing techniques are an interesting topic, this research focuses on the detection of foreshadowing at the story level. More specifically, we are interested in the analysis of causal connection in story as a key to detecting foreshadowing events.

The reader model of narrative comprehension in our work also draws on Possible Worlds theory [24][25]. The theory was initially originated from semantic logic [26] and has been adopted to explain the reader's mental activities while reading texts [24][25]. The concept of possible worlds refers to any world that can be accessible via modal operations such as inference, imagination, desire, dreaming, hallucination, foretelling, promising, obligation, or storytelling within stories [27]. Possible worlds can be constructed by the author, the characters in the story, and the reader. In Possible Worlds theory, the story world clearly described in the text is called Textual Actual World (TAW). Due to gaps in the story the reader tends to build multiple story worlds in her mind as long as these stories are not contradicting the TAW. Drawn from this theory, the reader model in our research is deemed to maintain multiple possible stories unless the story progression reveals the opposite situations.

Figure 1 illustrates the sentimental reader's reasoning process regarding the detection of foreshadowed events, based on the film *In Brouges*. The box containing events represents a story, wherein the story begins from the leftmost cell. The reader model, given the initial and the goal state of the story, builds partial stories as the story unfolds. When a foreshadowing event (in the example, Harry's promise of suicide) is presented, naive readers would simply consider this as a part of the story. The sentimental readers, however, can understand this as a hint of future events (step 1: Detection) and immediately construct a partial plan containing the additional goal state (i.e., Harry's death) and some predicted steps leading up to it (step 2: Build partial PWs). We believe that multiple possible worlds can be built, some of which are eliminated as the story unfolds. When the reader reaches a point at which critical information is revealed, as in step 3: Activation (i.e., midget's death by Harry's shooting), the reader can infer some future events leading towards the foreshadowed ending (step 4: Build complete PWs). In the movie, Harry, who promised to commit suicide on the spot if he kills an innocent child, mistakes the dead midget in children's wear for an actual child: believing himself to have killed a child, he keeps his earlier promise by killing himself.

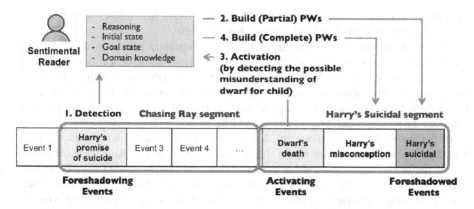

Fig. 1. Foreshadowing and Foreshadowed events in story progression. An example of the film *In Brouges* was used for illustration. Although a single possible world (PW) is illustrated in this figure, multiple possible worlds can be formed depending on the reader's reasoning capabilities.

The reader model shall have the functionality of tracing what the reader will infer when a foreshadowed situation occurs, given foreshadowing. Depending on his or her reasoning capability and preference, each reader may infer differently for the same foreshadowing. This happens because the reader does not have access to the author's complete story world (or fabula) [28][29][30], and some important information can be omitted intentionally by the author for a particular effect (e.g., surprise and suspense).

4.2 A Design of Foreshadowing in Interactive Fiction

As mentioned in previous sections, foreshadowing, by providing the reader with narrative affordances [23], can serve as a seed for building different possible worlds. Interactive fiction, where different endings and plots are possibly selected by the reader, is an interesting domain in this vein because the story designer can use foreshadowing to guide the player to experience specific emotions – such as suspense, surprise, curiosity, empathy, emotional identity, etc., which are crucial to understanding the reader's emotional experiences while reading a story [31].

We are currently designing an experimental study with a text-based interactive fiction in order to test how foreshadowing can influence the reader's choice of story progression, and eventually to test how this experience can contribute to the reader's overall enjoyment of her reading experience. As a story material, we adopted a modern Korean short fiction, *A Lucky Day*, written by Hyun Jin-geon in 1924, which is about what Kim, a very poor rickshaw driver, experiences in a day. On a rainy morning, when Kim is going out to work, his sick wife asks him not to leave her alone. But Kim doesn't hesitate to leave because he desperately needs money to buy daily food for his family. On that day Kim makes enough money to buy a beef-and-rice soup for his sick wife, which she wanted to eat so much from several days ago, a big bowl of rice soup for his three-year old son, and even a few drinks for himself. At that moment, a passenger calls for him and wants to go long-distance with paying ridiculously much money. Kim hesitates due to his sick wife lying at home but agrees to go, thinking to himself that this is not an everyday luck. On his way back home he stops by a pub and gets drunk, trying,

but in vain, to forget the bad feelings about his wife. Finally Kim arrives at home with a beef-and-rice soup in his hand and finds out his dead wife.

As the original novel is written using the omniscient third person perspective with the focalization of Kim, the reader can see the situations through Kim's perspective. Foreshadowing in the novel is often manifested by the advance mention [1] of the omniscient narrator about the coming tragedy – for example, "As he approaches his home, Kim feels relaxed in a strange way. This relax does not come from the relief but from the desire of delaying to know every detail of coming misfortune."

In the interactive version we are designing different endings with various plots, which will be explored by the reader through Kim's perspective. Kim's wife, depending on the reader's choice, is either dead or alive, and foreshadowing is given in two ways – either genuine or false – depending on the reader's choice and the predefined ending. A simple example of interactive design of the story is given in Figure 2, where the reader can choose her own path. If the reader decides to come home earlier before going to the South Gate, she may have a chance to save the life of Kim's wife. The foreshadowing, either genuine or false, can be given to provide the reader with the emotion of suspense or surprise. We are also designing various realization of foreshadowing. For example, associated with the death of Kim's wife, Kim has a day-dream of his wife's death while taking a short break; one of his passengers talks to Kim about his dead mother when he was young; Kim sees two dead birds in the street – one is big and the other is small. As for the foreshadowing associated with positive ending (i.e., Kim's wife is alive), the opposite situations would be possible.

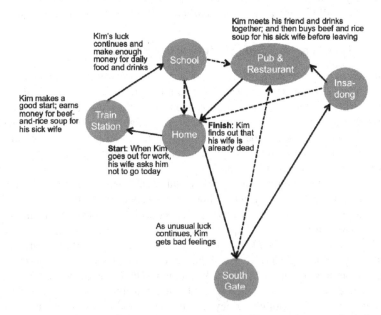

Fig. 2. A design of interactive fiction based on a South Korean short novel, *A Lucky Day* (1924), where the circles represent the main locations in the story; the solid line refers to the main character Kim's temporal and spatial movement in the original story; the dashed line refers to possible branching or detour in the interactive fiction version.

5 Conclusion and Future Plans

In this paper we have explored various cases of foreshadowing in narrative and games, proposing a use of reader model that represents the class of sentimental readers (as defined in [9][10]) under the assumption that these readers are able to detect the use of foreshadowing in narrative. Our research draws upon narrative and cognitive science theories, as well as insights obtained from examples of foreshadowing found in novels, films, and games.

The present work describes the initial steps taken towards the understanding of foreshadowing in narrative both from the reader's and the story designer's point of view. Based on various usages of foreshadowing and relevant narrative theories, we are designing an experimental study to evaluate how different types of foreshadowing can influence the (sentimental) reader's expectation and choice of the story progression in interactive fiction. We expect that our studies will be beneficial to the design of the drama manager and the reader model in interactive storytelling.

We also have a future plan to include discourse-level foreshadowing, using background music and/or lighting in order to manipulate the intensity of foreshadowing (i.e., how explicit or implicit the given foreshadowing is), as well as the use of foreshadowing in differently focalized story (e.g., exploration of the interactive fiction of *A Lucky Day* through the eyes of dead Kim's wife).

Acknowledgements. This work has been supported in part by the EU FP7 ICT project SIREN (project no: 258453).

References

1. Genette, G.: Narrative Discourse: An Essay in Method. Cornell University Press, Ithaca (1983)
2. Bordwell, D.: Narration in the Fiction Film. University of Wisconsin Press, Madison (1985)
3. Barthes, R.: S/Z. Collins Publishers, Toronto (1974)
4. Chatman, S.: Story and Discourse: Narrative Structure in Fiction and Film. Cornell University Press (1978)
5. Turner, S.: The Creative Process: A Computer Model of Storytelling and Creativity. Lawrence Erlbaum Associates, Hillsdale (1994)
6. Montfort, N.: Ordering Events in Interactive Fiction Narratives. In: Proceedings of the AAAI Fall Symposium on Intelligent Narrative Technologies (2007)
7. Bae, B., Cheong, Y.: Automated Story Generation with Multiple Internal Focalization. In: Proc. IEEE Computational Intelligence in Games (2011)
8. Bae, B.-C., Young, R.M.: A use of flashback and foreshadowing for surprise arousal in narrative using a plan-based approach. In: Spierling, U., Szilas, N. (eds.) ICIDS 2008. LNCS, vol. 5334, pp. 156–167. Springer, Heidelberg (2008)
9. Eco, U.: The Limits of Interpretation. Indiana University Press, Bloomington (1990)
10. Pamuk, O.: The Naive and the Sentimental Novelist. Vintage International (2011)

11. Abbott H.P.: Interpreting narrative. The Cambridge Introduction to Narrative, 2nd edn., ch. 7. Cambridge University Press (2008)
12. Gerrig, R.J., Bernardo, A.B.I.: Readers as problem-solvers in the experience of suspense. Poetics 22(6), 459–472 (1994)
13. Cheong, Y.: A Computational Model of Narrative Generation for Suspense. Ph.D. Dissertation, Department of Computer Science, North Carolina State University (2007)
14. Zwaan, R.A.: The Construction of Situation Models in Narrative Comprehension: An Event-Indexing Model. Psychological Science 6(5), 292–297 (1995)
15. Niehaus, J., Young, R.M.: A Computational Model of Inferencing in Narrative. In: AAAI Spring Symposium on Intelligent Narrative Technologies II, pp. 83–90 (2009)
16. Cardona-Rivera, R.E., Cassell, B.A., Ware, S.G., Young, R.M.: Indexter: A computational model of the event-indexing situation model for characterizing narratives. In: The Workshop on Computational Models of Narrative at the Language Resources and Evaluation Conference, pp. 32–41 (2012)
17. Trabasso, T., Sperry, L.: Causal Relatedness and Importance of Story Events. Journal of Memory and Language 24, 595–611 (1985)
18. Higdon, M.J.: Something Judicious This Way Comes... The Use of Foreshadowing as a Persuasive Device in Judicial Narrative. University of Richmond Law Review (May 2010)
19. Aarseth, E.: A Narrative Theory of Games. In: Proceedings of the International Conference on the Foundations of Digital Games (2012)
20. Juul, J.: Half-Real. MIT Press, Cambridge (2005)
21. Calleja, G.: In-Game: From Immersion to Incorporation. MIT Press, Cambridge (2011)
22. Kintsch, W.: Learning from Text, Levels of Comprehension, or: Why Anyone Would Read a Story Anyway. Poetics 9, 87–98 (1980)
23. Young, R.M., Rivera-Cardona, R.: Approaching a Player Model of Game Story Comprehension Through Affordance in Interactive Narrative. In: The Fourth Workshop on Intelligent Narrative Technologies, AIIDE (2011)
24. Ryan, M.-L.: Possible Worlds, Artificial Intelligence, and Narrative Theory. Indiana University Press, Bloomington (1991)
25. Eco, U.: The Role of the Reader: Explorations in the Semiotics of Texts. Indiana University Press, Bloomington (1984)
26. Kripke, S.: Semantical Considerations on Modal Logic. Acta Philosophica Fennica 16, 83–94 (1963)
27. Herman, D.: Routeledge Encyclopedia of Narrative Theory. Routeledge, London (2005); Herman, D., Jahn, M., Ryan, M.-L(eds.)
28. Rimmon-Kenan, S.: Narrative Fiction. Routledge, London (2002)
29. Prince, G.: Dictionary of Narratology, Revised Ed. University of Nebraska Press (2003)
30. Toolan, M.: Narrative: A critical linguistic introduction, 2nd edn. Routledge, NY (2001)
31. Oatley, K.: A Taxonomy of the Emotions of Literary Response and a Theory of Idenification in Fictional Narrative. Poetics 23, 53–74 (1994)

Narrative Intelligibility and Closure in Interactive Systems

Luis Emilio Bruni and Sarune Baceviciute

Department of Architecture, Design and Media Technology,
Aalborg University, Copenhagen
{leb,sba}@create.aau.dk

Abstract. In this article we define various aspects, or parameters, of interactive narrative systems and present them as a framework that can help authors, creators and designers to conceive, analyze, or prioritize the narrative goals of a given system. We start by defining the Author-Audience distance (AAD), which in turn can be seen as a function of *Narrative Intelligibility*. AAD can also be influenced by the intended or unintended level of abstractedness or didascalicity (i.e. figurativeness) of a given narrative. We define narrative intelligibility in complementarity with the related notion of *Narrative Closure*. We also make a distinction between the goals of the system and the goals of the narrative that it mediates, and consider the proposed parameters at two interrelated levels of analysis: the system level and the embedded narrative level, as the normative values and goals of these two levels should not be taken for granted.

Keywords: Narrative Intelligibility, Narrative Closure, Interactive Narrative, Interactive Storytelling, Emergent Narratives, System Goals, Author-Audience distance, Narrative Paradox, Abstract Narratives, Didascalic Narratives, Interactivity, non-linear narratives, Edutainment.

1 Introduction

All representational media in general, and immersive-interactive media in particular, are endowed with some degree of narrativity, which suggests that every system embraces a specific goal and thus an intrinsic communication cycle between a system (and its designer) and its users. In this article, we therefore assume that experiences are not solely dependent on user's involvement (in whatever way we wish to characterize it) [1], but are also related to the success of narrative communication between a user and a system, which determines the degree to which the goals of that system have been accomplished. We see thereby a close relation between 1) the various aspects of narrative communication, 2) interaction between user and system, and 3) the achievement of the goals of the system.

[1] Extensive efforts to conceptualize and quantify subjective experiences encountered by users in media have consequently led to a wide array of often inconsistent or contradicting propositions for defining the psychological involvement of the user. Some of the most accepted frameworks define these experiential phenomena in terms of *immersion* [1, 2], *presence* [3-5], *engagement* [6, 7] or *flow* [8].

H. Koenitz et al. (Eds.): ICIDS 2013, LNCS 8230, pp. 13–24, 2013.
© Springer International Publishing Switzerland 2013

In spite of antecedents of interactivity in literature and written media, it is only with digital technology that new possibilities for altering the linear reception of a given narrative have become possible [9], i.e.: the process of meaning construction within interactive systems. With the advent of new media and its possibilities for interactivity in the generation and reception of narrative structures, the issue of "the narrative paradox" arises, in which the relationship between authorship and interactivity is seen as being inversely proportional i.e.: the problem of having a free-roaming interactive world and an author-controlled narrative at the same time [10-15].

However, in the fields of interactive narratives and storytelling there may be a risk of reifying the notion of the "narrative paradox" as if it was a problem that exists as an absolute, and consequently becomes susceptible of some general solution. Therefore we may be misled to "solve" the paradox with a unique and general formula. The paradox arises in all its implications with the "empowering" possibilities of digital media and presupposes an ideal of "emancipating" the audience from the "tyranny" of the author [9]. This emancipation deserves a closer look of its aims in order to avoid the risk of converting the emergent field of interactive narratives into an autotelic endeavor that ends up promoting the design of systems with no explicitly defined goals in which we would be engaged in producing a narrative for the sake of itself.

Rather, the narrative paradox is context-dependent and in some circumstances it ceases to be a paradox and it may even become a desideratum (as we will see). First we need to explore the alleged freedom of the recipient subject to condition, alter, produce or intervene in a given narrative work. The degree of freedom (or "emancipation") will be intrinsically related to the purpose, objectives and *raison d'etre* of the proposed work. There will always be an author, designer or creator of the system, unless by *reduction ad absurdum* what we as audience are given is an expressive tool to fully develop our ideas, in which case we become the authors (like for example programs like Nevigo's articy:draft or Autodesk Maya). If the result is not shared with a target recipient it could then be said that we become authors and audience in a sort of introspective communication. A similar situation may arise in the frame of "emergent narratives" [16-19] if the system has no defined objectives, where instead of individual introspection the result may be more in the form of a dialogue (e.g. The Sims). Besides these cases, the different degrees of freedom will be constrained by the system's objectives. These aims can in turn be accordingly defined in the range of applications in which interactive narrative systems are being proposed.

In order to investigate these issues, this article addresses and defines various aspects or "parameters" of interactive narrative systems and presents them as a framework that can help authors, creators and designers to conceive, analyze, and prioritize the narrative goals of a given system.

2 Author-Audience Distance (AAD)

The first parameter that we find pertinent to investigate in the present framework is what could be called Author-Audience Distance (AAD), which is a function of "narrative intelligibility" (to which we will return later).

The notion of message transmission between sender and receiver has been studied and conceptualized from many different disciplines and points of view (e.g. semiotics, communication science, information theory, literary studies, psychology, etc.) [20-25]. Based on these kinds of models, Eco [26] has also considered the semantic-pragmatic relations implicit in authorial organization of the narrative and its interpretation by the receivers. In order to understand the concept of intentionality in narrative communication between an interactive system and a user, it is relevant to deal with the problem of AAD by referring to the rich semiotic tradition which has framed the issue in terms of interpretation, coding and decoding processes. As it has been repeatedly pointed out by semioticians, coding and decoding in information theory remains at a syntactic level and lacks any semantic value, which is the level where interpretation begins. Furthermore narratives are not transmitted exclusively by means of symbolic messages but they present also high degrees of iconicity, independent of the language, medium or modality of representation, be that natural language or multimodal representations in interactive immersive media. This fact introduces further limitations on the assumption of transmission efficiency (or fidelity) implicit in communication theory. In other words, it is well accepted that in any narrative communication act there is an interpretation gap between senders and receivers that can be represented as the distance between sender and receiver, addresser and addressee, or author and audience, depending on the communicational context.

In his seminal paper, Eco [26] introduces the concept of "aberrant decoding" in order to explain how messages can be interpreted differently from what was intended by their sender. Such interpretation gap, if not intended by the sender (in our context the author), is due to sender and receiver not sharing properly the coding system, which makes the receiver diverge in his interpretation from the "preferred decoding" intended by the sender. We refer here to this interpretation gap as the AAD which thereby illustrates the continuum that goes from complete aberrant decoding to perfect reception of the preferred decoding, depending on how defective is the sharing of the coding an decoding system between author and audience.

This notion can be further extended to immersive-interactive media, suggesting that AAD might have even more complex dynamics due to the fact that besides the potential interpretation gap of linear communication, interactivity introduces the possibility of the audience's intents to be explicitly realized. However, it is possible to assert that while the authorial intents tend to be forgotten in highly interactive systems that privilege the realization of the users' intents, the author's intentions still play a predominant role in such contexts and instead could be manifested as rules or boundaries within which the user can interact. This in fact means that in spite of the AAD, and the potential divergence between intents, every system still poses a specific goal, which then ultimately depends mostly on the author/designer and the nature of the system (e.g. entertainment, education, persuasion, communication, etc.).

In cases of non-interactive narrative communication, audiences tacitly assume that the author will comply to the cooperative principle [27-29] when communicating the story, and that the author and the audience share the expectation that elements introduce into the story will ultimately demonstrate their relevance [27]. In other words, audiences of linear narratives will have a tendency to seek to get the "preferred

decoding" intended by the author, what Brunner calls "the story as it is" [25]. On the other hand, in interactive scenarios the cooperative principle between the user and the system (i.e. the author/designer) now depends also on interaction and the choices that are made by the user. In this case, the cooperative principle is manifested in terms of cueing the user's further actions, providing feedback and affordances, and it still plays an important role because the audience's trust will now depend on maintaining an effective distribution of control between the system and its users. Otherwise the users will feel loss of agency, meaning that their intentions and expectations in relation to the system will not be fulfilled [29].

As productive interactivity[2] allows the user to directly manipulate the narrative pathways provided by the system, it thereby also offers a bigger potential for the user to implement his/her intentions in the narrative communication process. This means that the author's intentions become harder to be guaranteed, or at least face a greater challenge in terms of successful transmission of the narrative's substance to the user, potentially increasing the AAD. Nevertheless, even though the authorial figure becomes allegedly weaker in highly interactive scenarios, the author's intents still play a significant role when defining the system's boundaries, the degrees of freedom granted to the user, and the rules by which the user is allowed to utilize that freedom in a given context.

Therefore, the fate of the narrative paradox and the productivity and optimality of user experience in a given immersive interactive system should be assessed not only regarding the user's psychological involvement in the meaning generation process but also by evaluating the distance between author and audience always in strict relation to the explicit goals setup for the system.

3 Abstract vs. Didascalic Narratives

Another parameter that is interesting to consider in relation to AAD is how abstract or descriptive a narrative work is. This can be approached by analyzing the level of abstraction inherent to various manifestations of narrative content. We propose here to look at these differences by defining a continuum that goes from *abstract narrative* on one extreme to what we call *didascalic narrative* on the other.

Here, abstract refers to all forms of content having only intrinsic form with little or no attempt at pictorial, figurative or explicit representation [30], but however with potential to elicit some degree of narrativity. On the other hand, didascalic, a word borrowed from Greek to imply a very didactic, explicit, obvious, self-explanatory message (and from the Italian *didascalia*), refers to content with high intrinsic pictorial, descriptive, explicit, concrete, figurative or narrative representational power. In any immersive-interactive media, an author may have an intended narrative in mind with the option of presenting its substance in a more or less abstract or didascalic

[2] Ryan [9] defines two types of interactivity to characterize user's involvement: selective interactivity, as for example, a random or a purposeful selection among alternatives, and productive interactivity, where the participation and involvement of the users' actions are fruitfully allowing them to transform the textual or virtual worlds.

form (to some extent correlating also to how symbolic or iconic the given representation may be). In spite of the intention of communicating the substance of a narrative, the author may also have the intention to leave open space for different layers of interpretation, where it is up to the receiver to "fill in the gaps". Such intentions and the author's ability to implement them will determine where a particular narrative will be located in this continuum (see fig. nr. 1).

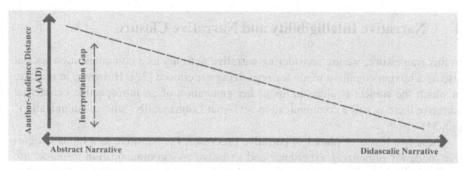

Fig. 1. Author-Audience Distance as a function of the Abstract-Didascalic continuum

To use Brunner's words, a narrative representation with high levels of abstractness may lead to confused, incomplete and cloudy interpretations. According to him *"we are more aware of our interpretive efforts when faced with textual or referential ambiguities."* [25]. On the other hand, highly didascalic narratives create the illusion that there is little interpretation effort and that "the story is as it is": *"Great storytellers have the artifices of narrative reality construction so well mastered that their telling preempts momentarily the possibility of any but a single interpretation—however bizarre it may be."* [25]. In such a didascalic narrative, the skillful exploitation of the available representational devices and resources predispose the audience to one and only one interpretation creating a sort of "narrative necessity". According to Bruner [25], another factor that can make a story seem self-evident and not in need of interpretation (i.e. highly didascalic) is "narrative banalization", that is, the work is so conventional and within a well-known canon that it will lead to a very straightforward and almost automatic interpretative routine.

While some media are capable of offering more explicit narrative representations [31], other media, by their own nature, may tend to host more abstract manifestations. However, we believe that the content itself, independently of the media, can have abstract or didascalic manifestations. Thereby the level of narrative abstraction of the content would more likely depend on the content itself and on the interpreter's decoding capacity, rather than on the independent properties of the media.

Lastly, another important issue arises from the discussion of narrative content in terms of the abstract and didascalic continuum, namely whether or not the level of abstraction affects the level of narrativity of a given content. For example, a narrative may have several levels of interpretation embedded and intended by the author, some of which may not be accessible to interpreters that do not possess the de-coding key for those layers. The work could then appear very explicit to some subjects whereas it

could remain very abstract for others. Therefore, the AAD determined by the level of abstraction of the given narrative will also be dependent on how much the author and the audience share the decoding or interpretation key. In other words, the level of abstraction may serve as an inaccessible language for the "non-initiated" or as a "secret" language for the knowers of the "code". This means that the level of abstraction, in this sense, may be a relative and dynamic one.

4 Narrative Intelligibility and Narrative Closure

In this framework, we are considering narrative not only as a communication act but also as a human cognitive mode for organizing experience [32]. However, in the case in which the subject is alone in his or her generation of an introspective or internal narrative there is still a communication act, what Lotman calls "auto-communication" [33, 34].

These two levels or planes of narrative processes, i.e. narrative as a human cognitive mode for organizing experience and narrative as a communication resource, are obviously intrinsically related, both evolutionarily and ontogenetically. However, it is useful to make the analytical distinction since either mode can be operative in different narrative contexts as for example when we are forming in our mind the history of our identity, or when we are being transported into a fictional or virtual world provided by an author in what becomes then an act of narrative communication.

These two different "functions" of narratives give place to two different but interrelated processes of meaning generation, interpretation and reception in a narrative communication act between an author and a target audience. On the one hand there is the process in which the audience receives or generates meaning in a way that is close to what is intended, desired or expected by the author. On the other hand there is the process where the audience may construct its own meaning out of what is being mediated, independent on whether that meaning corresponds or gets close to what is intended by the author. The former process we propose to be referred to as *narrative intelligibility* and the latter one as *narrative closure*.

In the case of narrative intelligibility, meaning generation can thereby be addressed in terms of the user's understanding of the mediated narrative in relation to the intended meaning ascribed by the author, i.e. the fidelity of the transmission, or how close the AAD is. In other words, in relation to narrative intelligibility this distance then depends on the alignment between the author's intended meaning and the one comprehended by the user. So, on the one extreme we have a complete coincidence between the author's intended meaning and the one received by the user, and on the other total incomprehension. AAD can therefore be seen as a function of intelligibility, which in turn may be influenced by the degree of abstractness and didascalicity of the given narrative.

In the scenarios concerning narrative closure [38, 39], on the other hand, there may be more or less divergence between the meaning intended by the author and the one generated by the user. This consequently suggests that a considerable AAD may be present in spite of the fact that through the cognitive-interpretative process of the

receiving subject some form of meaning might be constructed. We can thereby assert that narrative intelligibility presupposes closure, but narrative closure may be reached without an intelligible intended message. In this sense, the kind of closure resulting from a narrative generation in a subject's mind entails that something is being understood, even though is not something that was intended to be understood in the communication act. This would be the case for example in interactive narrative projects that go in the direction of emerging narratives.

The relations between meaning construction and AAD also vary according to whether we are confronted with a linear or an interactive system, as well as according to the goals of such system, which may place the experience of intelligibility either at the narrative or at the system level. Since linear narratives are more or less based on a complete authoritative control of the experience, they guarantee, or at least support, high degrees of intelligibility, with the possibility for the author to move along the abstract-didascalic continuum in order to introduce some degree of freedom of interpretation. In this latter case, the audience would still be experiencing some sort of narrative closure in spite of the diminishing narrative intelligibility.

Narrative Intelligibility	Narrative Closure
The understanding of the substance of a narrative very closely in the way it was intended by its author or creator. The level of intelligibility defines the author-audience distance.	The experience of coherence and completeness of understanding after having experienced a narrative, even though the narrative's substance is not understood very closely to the way it was intended by the author or creator.
A successful narrative communication would ideally entail both narrative intelligibility and closure. However this ideal may vary according to the intentions of the author-designer.	
Narrative Intelligibility without Narrative Closure	Narrative Closure without Narrative Intelligibility
This can theoretically happen in a case in which the author intended to transmit a specific narrative substance but his narrative construction lacks coherence and completeness, and this is faithfully transmitted to the receiving subject who then experiences the original lack of closure.	The recepient can experience a sense of coherence and completeness without necessarily understanding the narrative as intended by the author (or sender), or when the author does not intend to communicate a particular narrative substance but is interested in producing the experience of narrative closure (as in the case of emerging narratives).

Box 1. The Relation between Narrative Intelligibility and Narrative Closure

Interactive narrative systems may, on the other hand, intentionally or not, difficult or hinder an automatic interpretative routine for understanding "the story as it is" – should that be the intention of the author or designer. If narrative intelligibility is not the goal of the system, then the alignment between the author and the audience should be considered at the level of fulfillment of the goal of the system. Normally, but not necessarily, this would translate into, instead of experiencing narrative intelligibility, experiencing some form of narrative closure, where *"the author and audience share the expectation that elements introduced into the story will ultimately demonstrate their relevance"* [27]. Hence, if the author and the audience are not sharing the same interpretation (narrative intelligibility), achieving narrative closure– i.e.: that the given elements can be connected into some relevant or coherent scheme – is a minimal requisite (see box nr. 1).

5 Goals of the System

As previously stated, every message transmitted through a communication channel encompasses a specific meaningful content and a particular intent defined by the initiator of communication – in this case, the author, who structures his/her work to affect the reader in a particular way [20-22, 26, 27, 35-37]. It thereby becomes evident that every narrative, and hence content in any digital interactive-immersive system implicitly has a specific intention to be apprehended by the user. However, the "faithful" or trustworthy reception of the mediated narrative may not be the same as the goal of the system. If the goal of the system is in focus and the narrative (emergent or not) is just a tool or an accessory for the goal, then the authorship resides more in the goal than in the narrative. In other words, the goal of the system supersedes the narrative. On the other hand, if the normative value or the quality of the narrative, and its trustworthy transmission, is the central element of a system (i.e. it coincides with its goal) then the authorship resides in the narrative itself and the system is just a medium for its transmission. If instead, both, the goal of the system and the narrative are completely disregarded (i.e. total freedom for the user) then by *reduction ad absurdum* we are just furnishing the audience with an expressive tool to become authors.

In certain circumstances the author/designer[3] of an interactive narrative application may intend to allow maximum freedom of interpretation into unforeseeable new narratives. However, this is not the case for interactive narrative scenarios that are concerned with effective communication with specific normative or goal-oriented content. This is evident for example in the case of "edutainment", where the challenge is to maximize the interacting subject's freedom, high levels of engagement, fun, joy, playability, and the possibility of an individualized experience while maintaining a threshold of narrative closure *and* intelligibility of the main theme intended by the author of the application. How much an author or a designer of a system wants the mediated narrative to be transmitted with high fidelity and intelligibility, making it highly didascalic so as to shorten the author-audience distance, or how much he intends to maintain a high level of abstractness leaving freedom for open interpretations, or yet, how much he intends a combination of didascalicity and freedom of interpretation (only possible in interactive systems), will depend on the (normative) goals of the system. Based on this, we propose that narrative intelligibility and closure – as a cognitive process that characterizes the complex immersive and engaging experiences of users – cannot be assessed or considered without integrating the intentions and goals of the system in the assessment process.

[3] It is relevant to qualify the terms "author" and "authoring" as used in this context. Customarily, in the field of digital interactive applications, the roles of designer and author are implicitly conflated. Authoring therefore implies mainly the general tasks of a designer, without necessarily paying particular attention to the thesis or the substance of the content being mediated. Whereas this may be the case in purely entertainment applications, it may sometimes not be the case in the context of applications (such as edutainment or serious games) that deal with didactic or normative content. In these cases, the authoring part of the equation is more concerned with assuming responsibility for the content and it may be more or less distinct from the actual design.

Thereof, if one wants to use digital, interactive, and narrative-based technology for communicational, pedagogical, educational, didactic, therapeutic or artistic purposes, for instance, there must be a more or less explicit or implicit normative goal in the whole endeavor. On the other hand, some developments in interactive narrative, storytelling, and drama have focused on the generation of engagement by attempting to empower the interacting subject in the composition of the narrative, emphasizing more the experience of narrative closure than that of intelligibility of a particular thesis.

In this discussion it becomes important to note the distinction between experiencing the system and experiencing the narrative that it mediates. The author or the designer thereby has to define closure and intelligibility at two levels – the level of the system and the level of the embedded narrative. At the system level, the audience experiences intelligibility as meaningful interaction, which results as expected by the author/designer, in relation to the goals of the system. In this case, *this* intelligibility determines the AAD at the system level. Closure at the system level is also experienced as meaningful interaction, but it may result independently of the author/designer and the alleged goals of the system. At the embedded narrative level, high sense of intelligibility likewise entails a short AAD, but in this case the user experiences a good understanding of the narrative as intended by the author, and if the narrative is well integrated to the system's goals the user will also get the experience of intelligibility at the system level. Whereas, closure at the narrative level entails a good sense of having experienced a narrative, which, however, does not necessarily coincide with the author's preferred or intended interpretation.

From the design point of view, the desire level of narrative intelligibility and/or closure will thereby be intrinsically related to the goals of the system. Sometimes intelligibility and/or closure are not necessarily a normative value in themselves. In such cases intelligibility and/or closure may be achieved (and desired) at the system level instead of at the narrative level. Based on these considerations, we can postulate three cases for relating the goals of the system and the goals of the narrative. 1) In the first case, the goal of the system is the mediation of the narrative itself, or is very closely related or embodied in the narrative. Here, the goals of the system and the goals of the narrative conflate into each other, i.e.: the goal of the system becomes achieving some sort of narrative intelligibility and/or closure. Examples of this can be found in interactive storytelling, emergent narrative systems, artistic or literary implementations. 2) In the second case, the embedded narrative is just one more resource within the system in order to achieve its goals. Here, the role of the narrative, and the intelligibility and/or closure that result from it, is subsidiary to other goals of the system. If the goal of the system foresees or needs an open interpretation of the mediated narrative (i.e. with large AAD), and the narrative is therefore very abstract, the user can get his overall sense of intelligibility and/or closure by attaining the goals of the system, even if the level of narrative closure and/or intelligibility was very low. This can be encountered in interactive narrative applications in such fields as edutainment, persuasion, therapy or entertainment. 3) The last case considers that the embedded narrative may be one desirable resource within the system but is nonessential in order to achieve the system's goals. Here, the role of the narrative, and the

resulting narrative intelligibility and/or closure is an accessory to the system. This case can be seen in some FPS games and systems where a narrative is, for example, presented in a form of cinematic cuts that are not central to the goals of the system.

In figure 2 we have summarized how the parameters that we have been defining here can be considered and related to each other at these two levels of analysis (the interactive system and the mediated or embedded narrative) giving place to three different cases or types of applications.

Fig. 2. Two Levels of Analysis for Goals, AAD, Intelligibility and Closure

For example, a work like 'Dear Esther' could be considered as case number one where the narrative is the goal. Here, in spite of the low level of narrative intelligibility a high level of narrative closure may be possible. This being the goal of the work, the system becomes intelligible in spite of the lack of fidelity in the transmission of a particular narrative. Similar analysis can be made with other projects such as 'Heavy Rain', 'The Sims', 'World of Warcraft', 'First Person Victim [14]', 'My World' [19], etc.

6 Conclusions

Two of the salient and very well-discussed issues in interactive and non-linear narratives, the "narrative paradox" and the "combinatorial explosion", pose interesting design challenges when mediating particular contents that need to be conveyed in an intelligible manner in cases which entail and presuppose the communication of didactic or normative content, while simultaneously maintaining freedom in navigational interactivity.

The central tenet of this article is that, if from the designer or author point of view the minimizing of author/audience distance represents a success criterion for developing such interactive narrative applications, this distance can be understood in different ways depending on the explicit or intended goal of the system. The requirement of narrative intelligibility, i.e. that the audience's understanding or interpretation of the work closely matches that of the author- which normally would be the determinant

factor to evaluate author/audience distance – in interactive systems may not necessarily be a requirement for achieving the goals intended by the system, which become in this way the main criteria for evaluating the author/audience distance.

The present framework is intended to serve as a departing point for authors and designers given the task of embedding particular normative content in an interactive application. This includes applications in edutainment, communication, therapy, cybermedicine, digital interactive technology for sustainability, persuasive technology, artistic expression, or in general authors who have a particular stake in the "message" being mediated. It should also help in making sharper the distinction between design choices and authoring intensions in applications that have a manifested agenda and where authoring involves assuming responsibility for the content.

References

1. Jennett, C., Cox, A.L., Cairns, P., Dhoparee, S., Epps, A., Tijs, T., Walton, A.: Measuring and defining the experience of immersion in games. International Journal of Human-Computer Studies 66(9), 641–661 (2008)
2. Brown, E., Cairns, P.: A grounded investigation of game immersion. In: Proceedings of the CHI 2004 Extended Abstracts on Human Factors in Computing Systems. ACM (2004)
3. Slater, M., Usoh, M., Steed, A.: Depth of presence in virtual environments. Presence-Teleoperators and Virtual Environments 3(2), 130–144 (1994)
4. Witmer, B.G., Singer, M.J.: Measuring presence in virtual environments: A presence questionnaire. Presence 7(3), 225–240 (1998)
5. Lombard, M., Ditton, T.: At the heart of it all: The concept of presence. Journal of Computer-Mediated Communication 3(2) (1997)
6. O'Brien, H.L., Toms, E.G.: What is user engagement? A conceptual framework for defining user engagement with technology. J. Am. Soc. Inf. Sci. Technol. 59(6), 938–955 (2008)
7. McMahan, A.: Immersion, engagement and presence. In: The Video Game Theory Reader, pp. 67–86 (2003)
8. Csikszentmihalyi, M.: Flow: The psychology of optimal performance (1990)
9. Ryan, M.: Narrative as virtual reality. Johns Hopkins University Press, Baltimore (2001)
10. Adams, E.: Three problems for interactive storytellers. Designer's Notebook Column, Gamasutra (1999)
11. Riedl, M.O., Stern, A.: Believable agents and intelligent story adaptation for interactive storytelling. In: Göbel, S., Malkewitz, R., Iurgel, I. (eds.) TIDSE 2006. LNCS, vol. 4326, pp. 1–12. Springer, Heidelberg (2006)
12. Juul, J.: A clash between game and narrative. Danish literature (1999)
13. Louchart, S., Aylett, R.: Solving the narrative paradox in VEs – lessons from RPGs. In: Rist, T., Aylett, R.S., Ballin, D., Rickel, J. (eds.) IVA 2003. LNCS (LNAI), vol. 2792, pp. 244–248. Springer, Heidelberg (2003)
14. Schoenau-Fog, H., Bruni, L.E., Khalil, F.F., Faizi, J.: Authoring for Engagement in Plot-Based Interactive Dramatic Experiences for Learning. In: Pan, Z., Cheok, A.D., Müller, W., Iurgel, I., Petta, P., Urban, B. (eds.) Transactions on Edutainment X. LNCS, vol. 7775, pp. 1–19. Springer, Heidelberg (2013)

15. Plowman, L., Luckin, R., Laurillard, D., Stratfold, M., Taylor, J.: Designing multimedia for learning: Narrative guidance and narrative construction. In: Proceedings of the SIGCHI Conference on Human Factors in Computing Systems. ACM (1999)
16. Louchart, S., Swartjes, I., Kriegel, M., Aylett, R.: Purposeful authoring for emergent narrative. In: Spierling, U., Szilas, N. (eds.) ICIDS 2008. LNCS, vol. 5334, pp. 273–284. Springer, Heidelberg (2008)
17. Aylett, R.: Narrative in virtual environments-towards emergent narrative. In: Proceedings of the AAAI Fall Symposium on Narrative Intelligence (1999)
18. Louchart, S., Aylett, R., Kriegel, M., Dias, J., Figueiredo, R., Paiva, A.: Authoring emergent narrative-based games. Journal of Game Development 3(1), 19–37 (2008)
19. Baceviciute, S., Albæk, K.R.R., Arsovski, A., Bruni, L.E.: Digital interactive narrative tools for facilitating communication with children during counseling: A case for audiology. In: Oyarzun, D., Peinado, F., Young, R.M., Elizalde, A., Méndez, G. (eds.) ICIDS 2012. LNCS, vol. 7648, pp. 48–59. Springer, Heidelberg (2012)
20. Greimas, A.J., Perron, P., Collins, F.: Description and Narrativity: "The Piece of String". New Literary History 20(3), 615–626 (1989)
21. Barthes, R., Duisit, L.: An introduction to the structural analysis of narrative. New Literary History 6(2), 237–272 (1975)
22. Perron, P.: Semiotics. In: John Hopkins Guide to Literary Theory & Criticism, 2nd edn. John Hopkins University Press (2005)
23. Shannon, C.E., Weaver, W.: A Mathematical Model of Communication. University of Illinois Press, Urbana (1949)
24. Lasswell, H.D.: The structure and function of communication in society. The Communication of Ideas 37 (1948)
25. Bruner, J.: The narrative construction of reality. Critical Inquiry 18(1), 1–21 (1991)
26. Eco, U.: The Role of the Reader, London (1981)
27. Young, R.M., Cardona-Rivera, R.E.: Approaching a Player Model of Game Story Comprehension through Affordance in Interactive Narrative. In: Proceedings of the 4th Workshop on Intelligent Narrative Technologies (2011)
28. Grice, H.P.: Meaning. The Philosophical Review 66(3), 377–388 (1957)
29. Young, R.M.: The cooperative contract in interactive entertainment. In: Socially Intelligent Agents, pp. 229–234. Springer (2002)
30. Merriam-Webster: "abstract". Retrieved on from: Merriam-Webster Dictionary (2013), http://www.merriam-webster.com/dictionary/abstract
31. Ryan, M.: Avatars of story. University of Minnesota Press (2006)
32. Bruner, J.S.: Acts of meaning. Harvard University Press (1990)
33. Lotman, J.: Two models of communication. In: Soviet Semiotics: An Anthology, pp. 99–101 (1977)
34. Lotman, J.: Universe of the Mind. A Semiotic Theory of Culture. I.B. Tauris & Co. (1990)
35. Jakobson, R.: Closing statement: Linguistics and poetics. In: Sebeok, T.A. (ed.) Style in Language, pp. 350–377 (1960)
36. Chandler, D.: Semiotics for beginners (2005) (retrieved November 6, 2007)
37. Anderson, L.: The new critical idiom: Autobiography (2001)
38. Carroll, N.: Narrative closure. Philosophical Studies 135(1), 1–15 (2007)
39. Smith, B.H.: Poetic closure: A study of how poems end. University of Chicago Press (2007)

On Games and Links: Extending the Vocabulary of Agency and Immersion in Interactive Narratives

Stacey Mason

Digital Arts + New Media Department,
University of California, Santa Cruz, CA, USA 95064
stcmason@ucsc.edu

Abstract. The opposition between narrative agency—the ability for readers and players to make meaningful choices—and narrative immersion has been an ongoing conflict in the world of interactive storytelling. Some forms, such as games, have been argued to be more successful at balancing the tension between interactivity and immersion than forms like hypertext fiction [16]. Using these two forms as illustration, this paper will argue for the need for more nuanced understandings of "agency" and "immersion" by introducing definitions of diegetic and extra-diegetic agency alongside definitions of narrative and mechanical immersion. Extending the vocabulary of agency and immersion highlights some key differences in how games and hypertexts have been understood.

1 Introduction

While early researchers of interactive literature presumed that meaningful choices and immersive stories combine within interactive systems to create deeper, more engaging narratives [13], a wave of critics in the late 1990s and early 2000s argue that choices may instead distract the reader [9], drawing her consciousness out of the immersive narrative experience by forcing the self-reflexivity inherent in choice-making [16]. If we are reading a hypertext, and we pause to consider a choice among links on a screen, we are no longer fully immersed in the fictional world.

Marie-Laure Ryan explores immersion and agency within interactive environments in her 2001 book *Narrative as Virtual Reality* [16], but after a thorough exploration of their effects on the narrative experience, Ryan concludes that narrative immersion requires recentering the rules of one's world and a participation in a storyworld. She concludes her analysis of hypertext and interactivity by arguing that "the proper appreciation of the multidimensionality of hypertext is incompatible with recentering and imaginative membership in a fictional reality." [16] In a later chapter on how agency and interactivity might coexist, Ryan suggests that 3D games, being a more narratively immersive environment might offer a hybridization that can reconcile the tension between agency and immersion.

Choices are commonplace in games, unlike hypertext, these choices are usually not criticized as distracting, despite holding the same potential for the player to focus on

H. Koenitz et al. (Eds.): ICIDS 2013, LNCS 8230, pp. 25–34, 2013.

meta-game choices—thus pulling her out of the immersive game experience. What, then, is the difference between the choices presented in games and those in hypertext?

In this paper, I will argue that the difference lies in the kinds of choices presented to the reader and their effect on the immersive experience. To understand these ideas, we will need a more specific vocabulary, and I hope to differentiate between *diegetic choices* and *extra-diegetic choices* to better understand how they affect the reader/player's consciousness[1] differently as it is projected into an immersive experience. In understanding these experiences, I will also differentiate between *narrative immersion* and *mechanical immersion*. I also hope to understand how this self-projection might shape the kinds of narratives we see in the future.

2 Immersion: Mechanical and Narrative

To understand the relationship between choices and the reader's immersive experience, we much first understand how agency and immersion are interrelated. The correlation between the two are long-documented. In her 1997 book *Hamlet on the Holodeck: The Future of Narrative in Cyberspace*, Janet Murray introduces the interdependence between three aspects of interactive narrative: immersion, agency, and transformation[2] noting,"the more realized the immersive environment, the more active we want to be within it" [13]. Murray views immersion as "the sensation of being surrounded by a completely other reality [...] that takes over all of our attention, our whole perceptual apparatus" [13], describing the experience that John Gardner calls the "perfluent dream" [5] when it is applied to reading, and Nakamura and Csíkszentmihályi describe as flow in the context of performing activities [14]. While it might be easy to dismiss the two as obviously distinct—and I would argue that they are—they are often conflated in the literature, especially in the context of games. A more thorough comparison between these two phenomena reveals important similarities and differences.

Nakamura and Csíkszentmihályi define flow as "the state in which people are so involved in an activity that nothing else seems to matter; the experience itself is so enjoyable that people will do it even at great cost, for the sheer sake of doing it" [14]. They classify the following six factors as encompassing an experience of flow:

1. Intense and focused concentration on the present moment
2. Merging of action and awareness
3. A loss of reflective self-consciousness
4. A sense of personal control or agency over the situation or activity

[1] Though Aarseth considers the distinction between the reader and the player to be essential [1], interactive narrative often presents considerably complicated and overlapped situations. For the purposes of this paper and the sake of clarity, I will use "reader" as the generic term to designate the person interacting with a narrative environment (even in arguably game-like circumstances) and "texts" as the generic word for all included interactive experiences.

[2] As Mateas points out in his "A Preliminary Poetics," [12] Murray's "transformation" is highly problematic in that it can relate to several types of transformation within both the text and the reader. For this reason, and to maintain the scope of the paper, I will focus most heavily on immersion and agency, with transformation informing my approach, but not motivating it.

5. A distortion of temporal experience, one's subjective time experience is altered
6. Experience of the activity as intrinsically rewarding, also referred to as "autotelic experience" [14]

Immersion, then, need not necessarily involve narrative. Repetitive work might be immersive, as might a film, solving a crossword, or a conversation with a friend. In the context of interactive texts, I would argue for a distinction between mechanical immersion, corresponding to "flow" in which the player is immersed within the text or game's mechanics and the constraints of its systems, and narrative immersion corresponding to Gardner's perfluent dream (and Murray and Ryan's "immersion") which describes the transporting of one's consciousness to a story and events. Of course, there is naturally much overlap between the two, just as there is much overlap between reading a game from ludological and narratological perspectives. For the purposes of this essay, we will be most interested in narrative immersion, but I find the distinction of the two cases a useful addition to the discussion.

3 Diegetic and Extra-diegetic Agency

Agency within a narrative system is deeply interdependent with immersion. Murray defines agency as "the satisfying power to take meaningful action and see the results of our decisions and choices" yet qualifies that decisions only constitute agency if the choices are meaningful and produce intended results [13]. The problematic distinction of what constitutes "meaningful" choices and how much latitude is given with "intended results" will be further examined in this essay.

Much of the discourse has been focused on a narrow view of interactivity, one that relies on diegetic agency while ignoring other forms of interactivity. Aarseth describes ergodic literature and agency by delineating between a reader and a player:

> A reader, however strongly engaged in the unfolding of a narrative, is powerless. Like a spectator at a soccer game, he may speculate, conjecture, extrapolate, even shout abuse, but he is not a player [...] He cannot have the player's pleasure of influence: "Let's see what happens when I do this." The reader's pleasure is the pleasure of the voyeur. Safe, but impotent.
> The cybertext reader, on the other hand, is not safe, and therefore, it can be argued, she is not a reader [...] The effort and energy demanded by the cybertext of its reader raise the stakes of interpretation to those of intervention [...] The tensions at work in a cybertext, while not incompatible with those of narrative desire, are also something more: a struggle not merely for interpretative insight but also for narrative control. [1, orig. emph]

Aarseth's distinction between active player and the passive reader becomes more difficult in the case of hypertext literature. Clearly under Aarseth's own definition of "ergodic literature" as that which requires "nontrivial effort" to peruse [1], hypertext is an active experience, since it often requires significant effort to traverse the text and create meaning among lexia [10]. The decisions, however, are done at a remove, as a reader of the text rather than a player within it.

In narratological terms, theorists have been focused on agency as changing fabula, or in narratologist Seymour Chatman's more helpful terminology *story*—the events that happen or action of the narrative—with less emphasis on changing sjuzet, Chatman's *discourse*—or the ordered retelling of those events [3]. Consider, for example, the difference between a Choose Your Own Adventure (CYOA) book and navigating the lexia of a hypertext novel. We might differentiate the experience of the two readers. The CYOA novel affords the reader agency: she may turn to page 7 to attack the dragon or turn to page 45 to run. Her choice directly affects the outcome of the story, and turning to the appropriate page will afford the intended result (likewise if she follows links instead of turning pages). She is clearly exerting agency by affecting the story. The hypertext reader, however, does not necessarily embody a character within the story. The case for this constituting agency, however, becomes stronger when one considers that many of the Eastgate stories contained guard fields or other conditional structures that prevented certain lexia from being accessed until others had been accessed. Choices had real consequences. Furthermore, the order of the story certainly affected the reader's interpretation of story events, since she was usually focused on trying to construct a cohesive narrative from the parts she had seen [16]. Not visiting certain lexia might change the entire implications of the piece as in Joyce's *afternoon, a story* [7] and *Twelve Blue* [8].

Reordering a story without changing the events presents an interesting problem for agency: we are making meaningful decisions, and perhaps our decisions are producing our intended results, but are not affecting the story events, only our understanding of those events, or the discourse. As Ryan explains, "If we assume that hypertext projects a single *fabula*, rather than a radically new story in each reading session, this means that reading is cumulative," that is, as the reader traverses (and re-traverses) different lexia, she is trying to construct a whole, cohesive narrative rather than taking each lexia as independent [16]. For this reason, I think a distinction between the types of choices a reader might make is useful. For our purposes, diegetic choices are those that a player makes as a character or presence within a story world that affect story, while extra-diegetic choices are those that a reader makes as a removed observer that affect discourse. This distinction is the key to understanding the reader's relationship to the protagonist of an interactive narrative.

Historically, agency and immersion have been treated with varying levels of interdependence. Nakamura and Csíkszentmihályi treat agency as a precursor to immersion. Where Murray and Ryan begin their explorations with immersion, implying that it is a precondition to agency, Espen Aarseth begins with agency as a precondition to ergodic literature [1]—a reasonable argument, since without agency there is no "interactivity." Michael Mateas, in his "A Preliminary Poetics," integrates Murray's categories with Brenda Laurel's ideas on an Aristotelean model for interactive drama, arguing for the "primacy of agency" and concluding, "Agency is a necessary condition for immersion" in interactive drama. [12]

Here we find a chicken and egg problem facing agency and immersion: is agency a prerequisite for immersion or vice versa? The experience of narrative in novels and films suggests that agency is not a necessary condition for immersion, yet flow theory and interactive forms suggest otherwise. The problems that we face, then, include

understanding the relationship of agency to both mechanical and narrative immersion, understanding the distinction in levels of agency between the observer and the inractor, and understanding how diegetic and extra-diegetic choices factor into our experience of projection into a narrative.

4 The Complicated Relationship between Immersion and Agency

Armed with a better vocabulary for understanding the problems facing the relationship between agency and immersion, let us explore these difficulties. The difference between mechanical immersion and narrative immersion is analogous to the difference between flow and the perfluent dream. Narrative immersion does not require agency. A person in a movie theater is a passive receiver of the story; she is performing trivial effort in receiving the story. She does not exercise agency over the narrative, and she has nothing close to diegetic agency. On the other end of the spectrum, a worker stamping labels onto cans may experience mechanical immersion without being engaged in any type of story, but is the worker experiencing agency?

Nakamura and Csíkszentmihályi detail the requirements for entering the flow state, including the sense "that one can control one's actions" [14]. They elaborate to suggest that the need for control is actually a need for "a sense that one can in principle deal with the situation because one knows how to respond to whatever happens next" [14]. Mechanical immersion thus requires not only that a person knows how to respond to a challenge, but that she is aware of that knowledge.

> When in flow, the individual operates at full capacity and finds this intrinsically rewarding. The flow interviews made clear that this is a state of dynamic equilibrium. Entering flow depends on establishing a balance between perceived action capacities and perceived action opportunities. The balance is intrinsically fragile. If challenges begin to exceed skills, one becomes vigilant and then anxious; if skills begin to exceed challenges, one relaxes and then becomes bored. [14, emph added]

The applications to interactive texts, particularly games, is obvious. Mechanical immersion requires that we are comfortable and familiar enough with the constraints, challenges, and opportunities within a system to "master" it. Achieving agency within interactive systems requires not only that we have control over certain aspects of the system, but that we understand the control we have, we know our limitations, and we are fluent with the our means of influencing the virtual space.[3]

[3] We take the idea of fluency for granted with older media. Aarseth considers reading a book or watching a film to require "trivial effort," [1] but that is only because we have become fluent enough with typography, punctuation, and page turning for novels—and cuts, close-ups, and montage in film—that parsing the meaning of these conventions is now considered trivial. Greg Ulmer postulates that as media converge, so too will our *electracy,* or literacy for understanding transmedia forms [19]. Only 20 years ago, we were still negotiating the semantics of links. [10].

Murray comments on "interactivity" by noting that "the pleasure of agency in electronic environments is often confused with the ability to move a joystick or click on a mouse. But activity alone is not agency" [13], offering that agency is dependent on "meaningful choices," which might raise the question of whether extra-diegetic choices even count as agency at all. Agency is dependent on choices that have a real effect, choices that are dependent on the agent and her decision. Agency by definition is not interested in the artifice of choice. The idea of "meaningful choice," however is not specific enough when dealing with interactive narrative. Do we mean choices that meaningfully affect the story events, or are those that only affect the discourse also meaningful? Murray and Aarseth both include hypertext narratives in the scope of "interactive narratives," yet the choices presented by the classic postmodern hypertexts do not present anything like diegetic choices. Interactive texts offer agency and control, but they need not necessarily offer diegetic control. If interactive texts by definition are ergodic and require nontrivial effort to read, and movement within and through a story requires (or affords) the reader decisions, we must allow that they are affording agency, even if those choices are only affecting the discourse and not the story.

Consider Michael Joyce's classic hypertext *Twelve Blue*. In this work, as was typical of early hypertexts, Joyce presents a narrative through several short, interlinked passages or lexia. The reader cannot change the story events, all of her choices are extra-diegetic, and her decisions determine only the order in which the passages are presented. No matter which path the reader takes, she will always come to one particular lexia entitled "Everything can be read," but each time she reads it, the meaning she interprets will change based on what she has read before it. Thus the order in which the work is read is extremely important, certainly a "meaningful choice" even though it does not affect the story events.

It is important to emphasize that while distinguishing diegetic from extra-diegetic choices, and mechanical from narrative immersion, the two do not necessarily correspond in all cases where one type of agency is a path to one type of immersion. A hypertext work like *Twelve Blue* might elicit narrative immersion through extra-diegetic agency, or the absent-minded clicking of links without even reading the lexia might lead to mechanical immersion. These two rubrics—types of immersion and types of choices—exist as related, but distinct, rubrics. It is interesting, however, to examine their effects on our interaction within a story.

5 Affect and Space

Narrative immersion is interested in our projection of consciousness into the story world, but how we exist within that world is dependent on the types of choices we are given. Some texts afford us only extra-diegetic choices, allowing us to project our consciousness into the story world as an observer only. The allowance of diegetic choices, on the other hand, lets us exist inside the story world as a character or avatar. Even texts that do not represent the reader as such—*The Sims* [17] and other God games, for example—allow the reader a presence in the virtual realm, and makes

readers directly responsible for the outcome of the story.[4] To understand the how agency affects our projection of consciousness into narrative, we must first examine space within narratives.

According to Seymour Chatman, our concept of story is framed in the idea of space. Story exists in "story space," [3] the barrier to which is the text. When reading a book, we project our consciousness into the world, the space, of the characters. We feel as though we are "present" for the events. A film, for example futher defines this space. The characters exist within the space on the other side of the screen. Story space encompasses the perceived space the characters inhabit (note: this is not the space the actors inhabit while shooting the scene), including the space outside the immediate frame of the shot. [3]. Narrative immersion then, occurs when we start to consider ourselves as present in that space.

In digital media, the idea of space is closely related to agency. In *New Philosophy for New Media*, Mark Hansen explores the idea of "digital any-space-whatever" (ASW) as distinct from the "empirical space" in which we—as real people—exist [6]. Departing from Deleuze's examinations of ASW in cinema, Hansen describes a process of framing that the body undergoes in an effort to situate itself in virtual space that corresponds very closely to the same situating of consciousness that Ryan describes when a reader enters a fictional world and adjusts to the "rules" of that world [16]. In digital space, this process relies heavily on *affect* [6], Hansen's term for the situation of one's self in virtual space through similar proprioceptive cues to our real world spatial understanding: movement, vision, feedback "feel", etc..Affect, then, becomes central to the our connection with an avatar character, whether that avatar is visible as in *Super Mario Bros.* [18], or invisible as in *The Sims* [17].

Murray argues that if we click a button and something other than our intended result happens, agency is not exerted [13] and immersion is disrupted, thus raising the question of how long down the chain of story events our preconception of the "intended result" is justified. If pressing a button swings a sword, we can expect that to be the case each time we press that button. If, however, we press a button to swing a sword in hopes of killing a dragon, and instead cause the dragon to turn into a swan, have we exercised agency? If the swan does something unexpected, that action can surely be removed from our original pressing of the button and its intended result, but how far does the idea of "intended result" carry? It is ridiculous to assert that true agency means no unexpected event can ever occur, and I would argue that agency involves a great deal of uncertainty: we do not necessarily know the consequences of our decisions when we make them. What Murray describes when she describes interface interaction is not agency, but affect. Affect is a necessary path to agency; we must be able to interact with the system in a way that yields expected results, and we must be fluent with our means of affect to experience immersion. Yet in my distinctions between diegetic immersion, extra-diegetic immersion, and affect, I would like to stress that these forms are not mutually exclusive, rather they express different

[4] This is not to say that the reader is authoring the story or to diminish the author's role or power. The author, as the devisor of the system with which the reader interacts is ultimately in control of any situation within the narrative since she provided the framework [13] [1].

categories by which we might discuss a piece and how it elicits the reader's sense of control.

The difference between affect and diegetic agency is rooted in Murray's idea of "meaningful choices." Diegetic agency allows us to make changes to the narrative. Affect, on the other hand, allows us to move through the space, swing a sword, or jump over an obstacle. The two are interrelated, but not synonymous. In Big Blue Box's 2004 game *Fable* [4], the player controls a character in an action-RPG style fantasy. She may press buttons to swing a sword, cast spells, and so on. Performing each of these actions individually, I would argue, constitutes affect. The player may perform "good" or "evil" tasks, saving a man versus killing him for example, and her character and game experience will change according to that decision. I would argue that this type of choice is diegetic agency. Sometimes the two might coincide: a player might swing a sword to kill a man, thus exercising both affect and diegetic agency at the same time. Two players who have similar experiences of the game will have inevitably swung their swords at different times, but if their diegetic choices align, they will consider themselves to have had a similar gameplay experience.

The correlation between affect and diegetic space seems straightforward, but how does affect factor in to our experience of digital narratives in which we do not embody an avatar, but rather observe the events as in *Twelve Blue*? Here our affect lies in the click of links and navigation through a text. The distinction between affect and extra-diegetic agency lies in the reader's intent. Clicking links or performing other navigational tasks might be considered affect while the decision to choose a particular link over another might be an extra-diegetic decision. Again, the reader might exercise both affect and agency at the same time.

Interestingly, the space in which affect occurs differs from *Fable* to *Twelve Blue*. In *Fable*, affect occurs within the story space, whereas in *Twelve Blue*, the affect occurs outside of the story space but within the discourse space. The level at which we exercise affect is thus closely related to our level of embodiment within a digital text, which is in turn tied to how closely we identify with the characters whose fates we control.

6 The Avatar and Responsibility

I have so far discussed how the process by which we project our consciousness into a story, but what are the implications for these different models? If the reader identifies with an avatar character in a story world, she takes on a certain level of responsibility for the outcome of events in a different way than when she is merely an observer. The idea of embodiment within the text has created new models for how that text might affect a reader, experiences which games take for granted but literature has yet to fully explore.

The discrepancy in responsibility of outcomes is notable in the treatment of the death of allies between games and literature: where games foster a sense of responsibility and guilt for the death of an ally, literature provokes empathy rather than remorse. In many games, the death of an ally comes tinged with a sense that you should

have prevented that death. You, the player, have exercised your agency and caused your ally to die. Because the avatar/protagonist's psyche is a void to only be filled by the player's agency, it is the player, not the character, who causes that death. Valve's brilliant *Portal* [15] treats this guilt with dark comedy, as GlaDos, the game's antagonist, admonishes the player for "killing" her "companion cube" (a small cube you acquire to help you solve puzzles, and which you are then forced to destroy) faster than any other test subject on record, highlighting the player's decision to carry out the cube's death to advance the game. The player feels a sense of responsibility because the decision ultimately came from her, and her agency played an active role, as opposed to watching the event occur and being powerless to stop it. In Michael Joyce's hypertext *afternoon, a story*, on the other hand, the protagonist, Peter, admits "I want to say I may have seen my son die this morning." We are privy to much of Peter's psyche and we empathize with him deeply, but ultimately we do not feel Peter's guilt. The links we clicked on to reveal that passage were only expressions of extra-diegetic agency.

Games are already taking advantage of the player's diegetic control to foster powerful emotions and make political statements. In Infinity Ward's *Call of Duty: Modern Warfare 2* [2], the avatar character is an undercover operative infiltrating a terrorist organization. He accompanies the terrorist group as they bomb an airport and murder civilians. Within the constraints of the game, the player must kill these civilians lest she be discovered by the terrorists, however the player may struggle with shooting realistic representations of civilians and children as they scream and beg to be released. The game deliberately capitalizes on the player's diegetic agency, the fact that she is choosing to murder innocent people, and evokes guilt and doubt—the same feelings the fictional avatar would have. Combined with anti-war quotes during loading scenes, and outcomes within the game that undermine the conventional first-person shooter tropes that glorify war, the game uses the player's sense of responsibility to impart its message about the futility and moral uncertainty of war. Where a novel might convey these themes by provoking a sense of empathy with a protagonist's frustrations, a game can make the player feel those frustrations directly [11]. The sense of responsibility is dependent on the presence of diegetic agency.

7 Conclusion

Understanding how we, as readers, relate to interactive digital texts informs how authors write stories for digital media. It is my hope that by defining more specific terms for the types of choices in interactive narrative, and by examining their relationship to different types of immersion, we might gain a better understanding of the way we relate to interactive texts. The distinction between virtual worlds and literature is a fascinating and increasingly blurred distinction, and I hope that an improved vocabulary will be helpful in describing similarities and differences in these media.

Understanding the distinctions between the types of choices we make in interactive texts, and their impact on the reader, we might gain an understanding for the kinds of narratives we might see in the future or use this insight to model more robust narrative systems. Such knowledge is also critical for understanding the strengths and

limitations of these media and for beginning conversations on how other literary devices—point of view, episodic narrative, etc.—affect our relationships to characters in interactive forms differently than in previous media.

Acknowledgments. I would like to extend a special thanks to Noah Wardrip-Fruin for reading an early draft of this essay and providing invaluable insight, as well as Michael Mateas, Aaron Reed, John Murray, Peter Mawhorter, and John Mawhorter for offering helpful feedback and dialogue that led to the formulation of these ideas.

References

1. Aarseth, E.: Cybertext: Perspective on Ergodic Literature. Johns Hopkins University Press (1997)
2. Call of Duty: Modern Warfare 2. Infinity Ward. Xbox 360 (2010)
3. Chatman, S.: Story and Discourse: Narrative Structure in Fiction and Film. Cornell University Press (1978)
4. Fable. Big Blue Box. Video Game. Xbox (2010)
5. Gardner, J.: The Art of Fiction: Notes on Craft for Young Writers. Random House Digital, Inc. (1991)
6. Hansen, M.B.N.: The Affective Topology of New Media Art. In: New Philosophy for New Media, pp. 197–232. MIT Press (2004)
7. Joyce, M.: Afternoon, a story. Eastgate Systems, Inc., Watertown (1989)
8. Joyce, M.: Twelve Blue. Eastgate Systems, Inc., Watertown (1996)
9. La Farge, P.: Why the Book's Future Never Happened. Salon (2012)
10. Landow, G.P.: Hypertext 3.0: Critical Theory and New Media in an Era of Globalization. Johns Hopkins University Press (2006)
11. Mason, S.: The Player's Role: Understanding Agency in Digital Game Narratives. In: Hargood, C., Millard, D.E. (eds.) Narrative and Hypertext 2011 Proceedings: A Workshop at ACM Hypertext 2011, pp. 21–24. University of Southampton Press, Eindhoven (2012)
12. Mateas, M.: A Preliminary Poetics. Electronic Book Review. Web (2005)
13. Murray, J.: Hamlet on the Holodeck. The Free Press, New York (1997)
14. Nakamura, J., Csíkszentmihályi, M.: Flow Theory and Research. In: Snyder, C.R., Lopez, S.J. (eds.) Oxford Handbook of Positive Psychology, 2nd edn., pp. 195–203. Oxford University Press (2002)
15. Portal. Valve. Video Game. Xbox 360 (2007)
16. Ryan, M.: Narrative as Virtual Reality. Johns Hopkins University Press (2001)
17. The Sims, Maxis. Video Game. PC (2000)
18. Super Mario Bros. Nintendo. Video Game. Nintendo Entertainment System (1986)
19. Ulmer, G.: Internet Invention: From Literacy to Electracy. Pearson Longman, White Plains (2002)

The Visual Construction
of Narrative Space in Video Games

Altuğ Işığan

Izmir University, Faculty of Fine Arts, Department of Film and Television,
Izmir, Turkey
Isigan.altug@gmail.com

Abstract. The video game *Perspective* (Borgen et al./DigiPen, 2012) poses a challenge onto current classifications of game spaces in the field of game studies, and onto established conventions of dimensionality in the game industry. Based on the challenge posed by this game, this paper explores whether spatial properties of game worlds are intrinsic to them and simply reflected via their representations, or whether their spatial properties are essentially arbitrary and must be produced and held up via spatial discourse. In the light of its findings, the paper questions whether it makes still sense to maintain a categorical distinction between 2D and 3D games.

Keywords: Visual Construction, Narrative Space, Game Spatiality, 2D Games, 3D Games.

1 Introduction

The recently published game *Perspective* [1] poses an important challenge onto established modes and notions of spatiality in the game industry and in game studies. One reason for this is that the game reveals to us the arbitrary nature of the meanings that spatial signifiers convey. The game thereby testifies the discourse-dependent nature of narrative space in video games. In the light of *Perspective*, it becomes impossible to continue to see established conventions of dimensionality and navigation in the game industry as intrinsic and easily classified aspects of game spaces. An analysis of *Perspective* would require a shift in focus from the currently available classifications of "given" spatial modalities [2, 3, 4, 5] in video games to the deeper investigation of the visual construction of their navigable spaces and the combinations of various depth clues that are utilized in the process of their construction.

The problem we face in all these aspects is to learn to see game spaces as constructs whose properties must be *produced and held up* via discourse, and not as concrete places whose properties are intrinsic and merely reflected via their representations. In order to deal with this problem, this paper provides a review that touches issues from dimensionality to navigation and from image to text. The paper then provides a summary of its findings.

H. Koenitz et al. (Eds.): ICIDS 2013, LNCS 8230, pp. 35–44, 2013.

2 Properties of Video Games: Intrinsic or Constructed?

2.1 A Fresh Perspective on Game Spatiality

Perspective (Figure 1) seems to challenge classifications that put games as either two or tridimensional worlds. The players of this game control the camera so as to alter its relative position to the moving object in the game world, that is, their avatar. This allows players to modify the x, y and z values of the navigable axes in the game and enables their avatar to go around otherwise insurmountable obstacles. For example a seemingly tridimensional and insurmountable obstacle becomes a two-dimensional plane that the avatar can easily jump on and walk over if the player achieves the required spatial order by adjusting the camera position so as to make the tridimensional obstacle to appear flat. Furthermore, through zoom-in's and zoom-out's, the player can also alter the relative size of the avatar in relation to its environment and the image frame. This provides yet another way for the player to move the avatar around otherwise insurmountable obstacles. Through such intensive camera-work, the player can overcome a variety of spatial puzzles and reach the exits of numerous game levels.

Fig. 1. Screenshot of the video game Perspective

Typical game spatiality models that consider dimension and values of axes of game worlds as intrinsic, would have their problems to explain how all this is possible (probably resorting to terms like "hybrid", which are descriptive, but not explanatory), for they have the tendency to take spatial properties as facts rather than as achievements of visual discourse. These models work fine with most games that follow established visual conventions, but as soon as these conventions are violated, they start to lose their explanatory power. This is because they deal with the illusory and essentially arbitrary game spaces produced by spatial discourse as if these were concrete places.

The game *Perspective* allows us to raise a number of interesting questions, all of which will be answered below:

- Is there such a thing as a 2-D game world?
- Is there a better way to assess the problem of dimensionality in text?
- Are the x, y, and x values intrinsic to the axes that we name after these?

2.2 Is There Such a Thing as a 2-D Game World?

In order to answer this question, it is crucial to distinguish between the *projection plane* made available through, or used as, a medium (the screen, the canvas, a sheet of paper etc) and the *image* itself, whose *illusory space* is made of a compositional order of graphic elements whose arrangement may create the illusion of the presence of a potentially endless number of related *depth planes*.

At least two graphic elements are required to articulate a visual discourse on spatiality. Their relationship produces the illusory presence of two image planes – *figure* and *ground* – and a sense of distance – *depth* – between them. In other words, this is also the minimum number of *spatial signifiers* that is needed to make the appearance of the z-axis possible. A sense of depth is not intrinsic to the space presented in the image, but an illusion born out of the *structural relationship of a chain of at least two spatial signifiers* that are used to create such sense of depth: spatial properties such as the z-axis are therefore always constructed and not simply reflected.

The spatial signifiers that are utilized in a spatial discourse are aligned along specific reading lines whose articulation may go into various directions. They therefore possess the potential to yield different meanings depending on the preferred reading line. The following optical illusion (Figure 2) illustrates this point:

Fig. 2. Optical Illusion: A vase or two faces?

In the figure above, we see three graphic elements, a white shape and two symmetrical black shapes. The way in which we articulate these three visual signifiers

along the reading line (in this case a reading line that suggests an articulation along the z-axis, from figure to ground) will result in two different meanings, either a white vase against a black background, or two black faces against a white background. This reveals how meaning is never intrinsic to the graphic element itself, but a result of the structural relationship between the signifiers that it is composed of and the reading line we follow as we assemble the chain of signifiers. In other words, the signifier |white shape|[1] does not automatically send us to the meaning *vase*. What it means depends on its position within the compositional order, that is, its mutual relationship with other signifiers, the direction of the reading line that the reader follows, and the signified (either "vase" or "background") that it becomes associated with in the process. For example if we read the black shapes as the figures, the visual composition we perceive changes and the signifier |white shape| seems to become associated with the signified "background". Hence, the ultimate meaning that is produced and read is a matter of holding up a certain reading line so as to maintain a productive articulation of signifiers that hold up the meaning one believes to read.

2.3 The Case of Text as Image

The use of plain text is subject to visual conventions too, especially if we consider letters not only as the equivalents of phonemes, but as graphic elements, that is, as *images projected onto a projection plane*. It is always possible to add detail to the figure-ground relationship between letters and the background, and by doing so, to emphasize the distance between the two basic depth planes that the visual structure of plain text as image is constructed of (see Figure 3).

Fig. 3. Tridimensional text samples

However, the conventions of the codex format as is best exemplified in books such as novels, foresee that all depth clues are minimized as much as possible, and that eye movement (the articulation of the reading line) is structured and guided so as to take place only along the x and y axis of the figure plane (Figure 4).

[1] To clarify this point and the used notation: In linguistics, a signifier is shown as an absolute |S|. The reason for this notation is to express that a signifier is not the same as the meaning itself, but a form indifferent to meaning until it is associated with a signified "S" so as to gain a certain meaning S. To give an example from a popular video game, Pac Man [6]: the signifier | | is not the same as the meaning Pac Man, because under the order of a different language, this signifier could be associated with a different signified and take on meanings such as sliced pizza or cut cheese. It is only after the association between the signifier | | and the signified "Pac Man" takes place that we recognize in it the meaning Pac Man.

Deploying at GitHub
github.com

Deploying is a big part of the lives of most GitHub employees. We don't have a release manager and there are no set weekly deploys. Developers and designers are responsible for shipping new stuff themselves as soon as it's ready. This means that deploying needs to be as...

How we keep GitHub fast
github.com

The most important factor in web application design is responsiveness. And the first step toward responsiveness is speed. But speed within a web application is complicated. Our strategy for keeping GitHub fast begins with powerful internal tools that expose and explain...

blog@timschroeder.net
blog@timschroeder.net • by Tim

Sometimes it is useful for an app to launch at login. While a user can always accomplish this in the system preferences, having the possibility to turn on auto-launching inside the app is better. While in the glorious past this could be implemented in a number of ways, now...

Make your photos look good in any app with our control of the week: an impressive image pi...
us2.campaign-archive1.com

Hello, welcome to another Cocoa Controls roundup, and – for all of you here in the United States – happy Labor Day! I hope you get to take the day off, do some barbecuing, and relax. Or at least hack on...

JavaScript Weekly Issue 94 - August 31, 2012
javascriptweekly.com • by David Herman

Issue #94 - August 31, 2012. Effective JavaScript: A Forthcoming Book by David Herman. Mozilla and TC39's David Herman is working on 'Effective JavaScript', a new book that promises an in-depth look at JavaScript and using it...

Secure Mac Programming : An apology to readers of Test-Driven iOS Development
Secure Mac Programming

I made a mistake. Not a typo or a bug in some pasted code (actually I've made some of those, too). I perpetuated what seems (now, since I analyse it) to be a big myth in software engineering. I uncritically...

Fig. 4. Graphic style and reading conventions in the codex format

Due to its graphical nature, it is always possible to emphasize in printed text the distance between figure and ground. This would leave the impression of the presence of a z-axis, and it would even become possible to ask the reader to *read (and write) along this illusory z-axis* (Figure 5). But in the codex format this is usually out of the question.

Fig. 5. Reading a text along the z-axis

Game scholars (for an example, see [7]) therefore tend to think of text as one dimensional or even zero dimensional since they perceive the conventions in regard to the visual construction of the reading line in printed text as their intrinsic properties rather than seeing these as the product of the visual conventions that must be held up in order to make the act of reading work in this "one-dimensional" way.

This is a very important point, because the question of dimensionality in printed text is not very different than that of dimensionality in video games. For example one cannot fail to recognize the impact of the codex format on the visual structuration of early video games (Figure 6). These games follow simple rules of the codex format in book design:

- The use of highly abstract figure and ground elements so as to emphasize the figure plane and hold up a sense of flatness
- The restriction of both object movement and the player's reading activity to the x and/or y axis along the "surface" of said figure plane.
- A format with an area orientation that resembles that of a single sheet of paper.

Examples of such codex games are *Pong* [8], *Space Invaders* [9] and *Centipede* [10].

Fig. 6. Pong, Space Invaders, and Centipede

From the elaborations above, we infer that most of the games that we tend to call 2-D games are games that assign to the projection plane a dual sense of serving as both figure and ground plane of the image. The level of abstraction, that is, the absence of significant depth clues in the visualization, results in an extreme sense of flatness. However, we must not forget that figure and ground relationships are already indicative of a third dimension, hence, what we tend to call 2-D is always already 3-D. There is no escape from a third dimension because the total absence of any kind of volume duality or figure-ground relationships would make it impossible to express relative distance between objects and observer, even if that distance is depicted as

"near-zero". Hence, there would be no chance to create the sense that things happen "there" because a marking of space as "place" wouldn't take place:

"Empty space gives us no clues to distance, because nothing is either near to or far away from us. Various objects help define the empty space and make it possible to perceive distance – a third dimension. [...] positive volumes articulate the negative volume of empty space." [11]

On the other hand, it also becomes clear that the illusion of navigable space is closely related to the way in which the image is structured in terms of depth planes and the position of the observer in regard to their arrangement. What we tend to call 2-D gameplay does not mean that there is a lack of third dimension, but rather that object movement and the reading line of the image is structured so that the act of "reading" and "writing/moving" is restricted to the surface of the figure plane of the image. This is, again, an achievement, and not an intrinsic aspect. Unfortunately, we mostly deal with conventions that are so well established and commonly used that we take their arbitrary nature as facts.

2.4 Are the X, Y and Z Values Intrinsic to the Axes They Represent?

According to Herbert Zettl [11], primary motion, that is, the movement of objects, is always judged from the camera's or observer's point of view: "no primary motion is intrinsically an x or z-axis motion. It becomes so only in proximity to the camera." [11]. In other words, the same type of motion will be perceived as x or z-axis motion depending on whether the movement occurs laterally to the camera, or toward and away from it [11]. This principle reveals the arbitrary nature of how the movement axis gains its status as x, y or z-axis within game space, and how this status depends on the preferred spatial discourse. When the camera position configures the discourse space differently, the player constructs a different mental map of the story space and her movement in it. This is a point that classic models of game spatiality fail to address, since they assume that the x, y and z value that the axes take, are intrinsic to them. On the other hand, it is exactly this dependency on spatial discourse that the game *Perspective* exploits in order to provide its unique game space and gameplay features.

The arbitrary nature of the way in which an axis is associated with its implied direction can also be observed in games such as *Home Run* [12] where the y-axis, which would according to established conventions normally indicate height, indicates movement towards or away from the observer, that is, movement along the z-axis (Figure 7).

Fig. 7. The principle of height in plane applied in the game Home Run

Games in which the y-axis functions as a depth clue use a graphic principle called height in plane: "assuming that no contradictory distance clues are evident and that the camera is shooting parallel to the ground, we perceive an object more distant, the higher it moves up in the picture field." [11]. Fernandez-Vara, Mateas and Zagal [13] have stated in their study on game spatiality that they didn't come across any instance of a game of two-dimensional cardinality that allows for the use of only the y and z-axis. It could be said that a reason for this is the principle of height in plane. Games whose gameplay cardinality would be limited to y and z-axis movement would most certainly fail to clarify whether the movement of in-game entities signifies that they walk toward or away from the camera, or whether they move up and down within the screen area. On the other hand, the developers of *Perspective* may well consider developing a sequel to their game that utilizes exactly this ambiguity as a novel gameplay feature.

3 Summary and Conclusion

Games such as *Perspective* pose a challenge onto largely accepted models of spatiality in game studies. In this paper I dealt extensively with this challenge and my review of commonly accepted notions and thoughts on game spatiality allowed me to come to the following conclusion:

1 Aspects in regard to dimension and navigation are not intrinsic to the visual elements that are utilized but must be seen as the result of the interplay of (at least two) spatial signifiers. In this light, it is important to realize that for example the signifier |x-axis| is never the same as the meaning *x-axis*, for the ultimate meaning that a signifier expresses always depends on its relationship with other signifiers and how reading conventions order the reader to traverse the chain of signifiers.

2 Related to this point is the fact that the value of an axis is the result of the spatial discourse that presents object motion relative to camera or observer. It must be understood that both a sense of depth and a sense of flatness are achievements and not qualities that are intrinsic to the space in question, and therefore not simply reflected in its representation. This counts also for the ways in which a sense of navigable space is achieved. All these aspects must be crafted by, and help up, through discourse.

3 Another conclusion of this paper is in regard to the question whether the notion of 2-D games still makes sense. While this notion seems to have practical use in the game industry and seems to hold a strong place in the register of game researchers, it seems to hide the fact that all games can be said to maintain an illusory third dimension. What we seem to try to express with this term is rather the situation in which a player's ability to move entities around is limited along the x and y-axis of the figure plane. As long as we agree to use 2-D in this sense, we may avoid problems, but we should put more effort into spreading the idea that 2-D game worlds do not exist, and that the third dimension, while being inevitable, is always strictly an illusory one.

4 This review has also shown that we need to develop a better understanding of text as image and stop calling text one-dimensional or zero-dimensional. This isn't only wrong, but this way of seeing also creates confusion in our understanding of the reading line. This way of seeing is the main reason behind arguments such as "text is linear" and "games are non-linear". Following a certain reading line is inevitable, yet the way in which this reading line is fixed is arbitrary, and the notion of the reading line itself has nothing to do with the linearity or non-linearity of the narration. Furthermore, I showed that the "linear" reading line of the codex format, which is often seen as the "nature" of narratives, is a convention, and that text may not only be three-dimensional, but that it can be also read along this third dimension. This is in my opinion a very strong call to give up on our cliché thinking in regard to text and narrative, and to realize that no narrative, be in presented in book format or in game format, is linear or one-dimensional by its very nature.

References

1. Borgen et al.: Perspective (Computer Game). DigiPen Corp., Seattle (2012)
2. Aarseth, E.: Allegories of Space: Spatiality in Computer Games. Zeitschrift für Semiotik 23(3-4), 301–318 (2001)
3. Aarseth, E., Smedstad, S.M., Sunnana, L.: A Multi-Dimensional Typology of Games. In: Copier, M., Raessens, J. (eds.) Level Up Digital Games Research Conference, pp. 48–53. Universiteit Utrecht Press, Utrecht (2003)
4. Elverdam, C., Aarseth, E.: Game Classification and Game Design: Construction Through Critical Analysis. Games and Culture 2(1), 3–22 (2007)

5. Ryan, M.-L.: Beyond Myth and Metaphor – The Case of Narrative in Digital Media. Game Studies 1(1) (2001)
6. Pac Man (Computer Game). Atari Inc., New York (1981)
7. De Mul, J.: The Game of Life: Narrative and Ludic Identity Formation in Computer Games. In: Raessens, J., Goldstein, J. (eds.) Handbook of Computer Game Studies, pp. 251–266. MIT Press, Cambridge (2005)
8. Pong (Computer Game). Atari Inc., New York (1972)
9. Space Invaders (Computer Game), Taito, Tokio (1978)
10. Centipede (Computer Game), Atari Inc., New York (1981)
11. Zettl, H.: Sight Sound Motion: Applied Media Aesthetics. Wadsworth Publishing Company, Belmont (1990)
12. Home Run (Computer Game), Atari Inc., New York (1978)
13. Fernandez-Vara, C., Mateas, M., Zagal, J.: Evolution of Spatial Configurations in Gameplay. In: Proceedings of 2005 DIGRA Conference (2005)

Video Game Mise-En-Scene
Remediation of Cinematic Codes in Video Games

Ivan Girina

University of Warwick
Coventry, CV4 7AL, UK

Abstract. This paper aims to discuss two primary points. Firstly, I argue that due to the complex development of Game Studies as a field and to the constant technological innovation, it is important to elaborate a reflection on the current state of video game aesthetics and its relationship with other audiovisual media. Secondly, the relevance of film-related analytical and theoretical tool is explored through the analysis of video game mise-en-scene and its tools of representation. I want to highlight the similar aesthetic strategies and, at the same time, to underline the shifts occurred in terms of functions. Finally, I describe two relevant aesthetic tendencies in the current video game generation: the *scripted staging* and the *expressive lighting*.

Keywords: Film Studies and Game Studies, video game aesthetics, film language, mise-en-scene, staging, lighting, remediation, cinema and video games.

1 Cinematic Language in Video Games

As audiovisual entertainment whose content is largely representational, video games have a lot more in common with film and television than merely characters and plotlines. [1]

M. J. P. Wolf

Is there an aesthetic relation between film and video games? If yes, what kind of relation is it? Can we talk about "linguistic influence" between these two media? What is film language in relation to video games and how are its strategies and codes adapted to the medium specificity?

These questions may seem elementary or rhetorical, but they are also crucial in order to proceed with debates concerning the relationship between cinema and video games. Nonetheless, many of them remain unanswered, fragmented in a variety of case studies that don't account entirely for the organic nature of this process. The debate around the relation between cinema and video games is rooted in a more general juxtaposition between two theoretical perspectives: the one of ludology and the one of narratology. In fact, this debate took the form of a dichotomy between the ludic nature of the video game medium –defended by the ludologists– and its increasing narrative attitude –claimed by the narratologists [2]. Due to the growing interest in video games and the increasing involvement of scholars coming from different fields –often using narratological approaches considered to be applicable to most media–

H. Koenitz et al. (Eds.): ICIDS 2013, LNCS 8230, pp. 45–54, 2013.
© Springer International Publishing Switzerland 2013

game scholars reacted by claiming the need for developing an autochthonous discipline [3]. For a long time, the contrast between these positions determined the focus of the debate on the status of the discipline and its relations with adjacent fields, and only marginally on the interplay between video games and other media. This debate faded eventually into a paradox, leading authors to even question its existence [4]. During the last ten years a new generation of video game studies surpassed this dichotomy [5]. Authors such as Michel J. P. Wolf [6], Geoff King and Tanya Krzywinska [7], and more recently Michael Nitsche [8] and Alexander Galloway [9] explored in different ways the aesthetic and formal influence between video game and cinema. Drawing from these authors, my research aims to retrace the influence of film language on the development of video game audiovisual language and, in doing so, to develop analytical tools for the analysis of video game aesthetics.

Starting with Bolter and Grusin's speculations on remediation between cinema and videogames [10], it is by now clear that video games are not 'interactive cinema' [7, p. 25]. Despite of the volume of critical literature produced on this topic, I argue that cinema and its theories have still much to offer to the analysis of the video game medium for two reasons. Firstly, the resistance generated by the narratologists vs ludologists debate –whether it 'took place' or not– combined with the skepticism of the Film Studies community towards the representational and artistic capabilities of the video game medium, led to a partial disengagement of films scholars from practicing aesthetic and textual analysis on video games. Secondly, while endorsing the notion of 'graphical regimes' [11] against the technological determinism that permeates the discourses on video game aesthetics, the technological evolution of this medium over the past ten years has been so dramatic that it calls for an updated research on the audiovisual strategies adopted by contemporary titles. In fact, the development of new graphical and physic engines and the increased level of literacy of video game players allow today for the implementation of a more sophisticated audiovisual code in video games. Although these elements may not always innovate the gameplay dynamics, nevertheless they expand and amplify the emotional impact of the game on the player, favoring to the expressive evolution of the medium.

Regardless of the theoretical debates, narration in video games has been thriving over the past decade, deploying film language in order to convey characters, worlds and events to the player. Best selling franchises such as Tomb Raider, Resident Evil, Call of Duty, Uncharted, Fable, Mass Effect, Assassin's Creed, heavily rely on their storylines in order to motivate the player to proceed in the game, as well as integrate some of the gameplay dynamics within their narrative specificities. If on the one hand the survival character of Resident Evil is motivated by its story which puts the characters in constant danger and threat, the skillful protagonists of Assasin's Creed impose their stealth style on the gameplay, reflecting the secretive character of their mission.

The role of cinema is not only fundamental on the level of narrative contents, but also on a formal level through the codification of an established audiovisual language that is adopted across different platforms, including the one of video games. It is, in fact, the mediation of audiovisual cinematic codes that allows the merging of performance and spectatorship, solving the dichotomy between games and stories. In fact, Michael Nitsche defines the process of audiovisual presentation within the mediated

space [8, p. 15], pointing to the mediating role of the cinematic language in video games. The debate between ludological and narratological perspectives, partially based on the irreducible distance between the figure of the player and that of the spectator, is eventually solved through the mediation of the cinematic audiovisual language. According to Andrew Mactavish, the video game player experiences two different kinds of pleasure: admiration, which leads to a state of awe, and participation, which instead is connected to the feeling of immersion [12]. Thus, the cinematic codes work as filters between performance and spectatorship, allowing them to merge in one cultural object.

Given the role of cinematic language as described so far, its relevance to the field of Game Studies is evident not only in order to understand the interplay between cinema and video games on a theoretical level, but it also highlights the possibility of investigating games through the analytical means and tools developed in other fields – such as those of Film Studies– adapting and reinventing them in accordance with the specificities of the object of the investigation. The cinematic language is complex and its analysis is articulated in different layers that give account of different ways in which this creative process takes place. On a schematic level, we can identify three levels of signification: staging, shooting and editing. Those categories are by no means isolated and their elements are instead deeply interconnected, determining the model provided here as only one out of many possible [13]. Nevertheless, this model can be seen as useful both on a synchronic and diachronic way, being capable of accounting for the historical debate around the cinematic medium and its parts, but also the different moments in the process of film production. The first level, presented in this article, is that of the mise-en-scene. This level provides a variety of examples in order to understand the importance of cinematic language in video games.

2 Mise-En-Scene in Video Games

This investigation aims to develop a number of analytical tools for the understanding of this level of audiovisual articulation in the video game medium. Secondly, it aims to describe formal and aesthetic elements, instances and patterns of film language that reached video games through the remediation process and developed in new and independent ways. As a consequence, this section highlights not only the changes undertaken by these formal and aesthetic elements in the passage from one medium to the other, but also their shift in function, according to the specificity of the medium. A preliminary overview of the discourses around mise-en-scene and staging techniques –the two terms are often used interchangeably but historically they differentiate for the inclusion or exclusion of the framing process [14]– points to the importance of the relationship between theatre and cinema, making explicit the transmedial relevance of this element.

The main question for this section concerns the possible relation between mise-en-scene in films and in video games, primarily through means of comparison. One of the specificities attributed to the video game medium is the importance of space central to the narrative and ludic activities. While Henry Jenkins [15] individuates space

as the center of the narrative process, Michael Nitsche [8] elaborates a parallel between game design and architecture, detaching video games from the reality of narration. Nevertheless, beyond the definition of theatrical staging, authors such as Stephen Heath [16], Mark Garrett Cooper [17], Bordwell and Thompson [13] stress the importance of mise-en-scene as a set of tools to direct the attention of the spectator and make sense out of space. Therefore the relevance of space as an element of the meaning-building process is common and shared by both media.

While in films, mise-en-scene is intended to guide the spectator's eye through each sequence, scene and shot, in video games this function is limited by the (mostly) interactive status of the frame, which is used as a window that gives the player access to the virtual environment. The cinematic device in video games works as a mediating *dispositif* that negotiates between the freedom granted to the player's activity and the driving force of the narrative instance. For this reason, the staging process –intended as the process of creating environments out of spaces, with the inclusion of characters, objects and events– is at least as important in video games as it is in cinema. Through the staging process, the video game develops strategies to guide the player's attention without constricting him within a fixed framing path. More specifically, the argument made in this section is that the technical evolution in terms of graphic calculus power (hardware) and, consequently, graphical engines in video games (software), eventually led to the implementation of an increasing number of cinematic techniques and the enhancement of the expressive capabilities of these tools. Today, at the end of the current console generation (Xbox 360, PlayStation 3 and Nintendo Wii), video games make use of the expressive potential of cinematic language to the point of favoring the development of a specific genre –the *action adventure*– that hybridizes itself with the others because of its intrinsic cinematic potential. Titles such as *Tomb Raider* and *Uncharted* not only became increasingly popular, absorbing some of the puzzle mechanics typical of *adventure games*, but even *role playing games* and *first person shooters* often imitate some of the strategies of the *action adventure* titles in order to deliver a more cinematic experience.

The availability of better graphical resources and instruments allowed designers to explore more expressive aspects of video games' audiovisual language. Games such as *Uncharted 3: Drake's Deception* [18], *Mass Effect 3* [19], *Dead Space 2* [20], *Far Cry 3* [21], *God of War 3* [22] and *Assassin's Creed 3* [23] deploy staging and framing techniques which stress the expressive qualities and functions of the virtual environments. In these games, the environments reflect/interpret/inform/affect the avatars' inner worlds and provide a more detailed characterization through means of staging, lighting and, ultimately, framing. At the same time, both the aesthetic appeal and the narrative quality can benefit from the expressive use of the virtual environments. The analysis of these techniques highlights some new tendencies in video game aesthetics –the one of *scripted staging* and that of *expressive lighting*– that show the extent to which staging becomes one of the founding moments in video game production.

2.1 Scripted Staging

According to Henry Jenkins, video games provide narration through their virtual spaces –*environmental storytelling* [15, p. 123]– allowing the player to trigger and

unfold the story in an active and participated way. This model is particularly useful in order to understand the different functions of the mise-en-scene at the cinema and in video games. Jenkins describes two possible typologies of environmental narration: the *embedded narrative* and the *emergent narrative* [15, p. 123]. While in the first case the narrative elements are inscribed within the environment to be spatially or temporally triggered by the player, in the second case the narrative is generated on the fly by the interaction of the player with the procedural system.

Franchises such as *Uncharted, Mass Effect* and *Call of Duty* heavily rely on the embedded narrative in order to deliver an extremely cinematic experience. Staging is used to contain the player activity in time and/or space, in order to keep him/her on track following the designed path. *Scripted staging* is a form of virtual staging that allows for a compromise between the freedom granted to the player and the control guaranteed to the narrative instance. The ultimate goal of staging is to believably convey the illusion of free will while channeling the player's activity on a predetermined route. Typically, these environments are designed as systems of corridors (of variable dimensions and complexity) that contain the player, encouraging and eventually forcing him/her to follow waypoints and activate predetermined events. The structured nature of space and the predetermined character of the events are disguised by the staging techniques. In the *Uncharted* series, for example, the environments are constantly changing (a burning chateau [18, Chapter 7: Stay in the Light]), moving (a chase on and off a train rooftop [24, Chapter 13: Locomotion]), reshaped and modified (a collapsing building [24, Chapter 6: Desperate Times]) by events that justify the urge of the player to follow the only possible path, the one designed by the authors. In all these cases, staging is used not only to provide spectacle, but it is instead functional for the creation of a believable path and contained environment. The dynamic character of the space is a feature commonly deployed in order to infuse the environment with a life-like sense, as well as to build a constant tension that does not allow the player to question possible alternative paths during these sections.

The *Call of Duty* franchise, for example, achieved success thanks to the scripted nature of its gaming experience that stages extremely cinematographic moments [25]. The opening mission of *Call of Duty 4: Modern Warfare* [26, Crew Expandable] marked a turning point in the history of the FPS through its use of scripted sequences and events that display a strong cinematographic quality. One of these moments portrays the assault on a terrorists' ship in the middle of a sea-storm (fig. 1). The player is taken on a helicopter and follows the action in first person –here the interaction is limited to the rotation of the camera with no spatial movement allowed at this point. The squad climbs down a rope to reach the prow of the ship (fig. 2), and finally the player is given full control of the avatar to join the action (fig. 3). The soldiers position themselves in formation and execute the crew inside the command cabin. Nevertheless, the events on the ship –which affect the main narrative progression– and the actions of the other squad members are predetermined by the designers through scripts (fig. 4 and 5), guaranteeing the spectacular and dramatic impact of the section (fig. 6). Not only does the scripted nature of this event provide a highly cinematographic depiction of spectacle, but it also favors the implementation of iconic cinematic moments. The entire scene is flavored with tropes borrowed from action and war/military movies, building on a sense of comradeship and heroism.

Fig. 1. - 6. Call of Duty 4: Modern Warfare – Crew Expandable

2.2 Expressive Lighting

Some of the most important technological developments in recent times concerning video games involve improvements of the lighting and rendering systems, allowing for a greater control over the illumination of environments and characters, which lead to a substantial improvement of their expressive quality. These techniques add *décor* to the environments, set moods and tones with various color palettes, shadows and shades. Once again, a fixation with realistic representation and, at the same time, with intrinsic spectacle and technological awe is connected with the representation of the natural world and its most basic elements, with the intention of making the virtual world more believable. Throughout the history of video games, discourses of lighting –often tied to elements that generate and/or affect them such as fire, water, wind, smoke, sand, clouds– are prominent not only among the specialized press (reviews, previews and articles highlight the development of these techniques in certain titles) but also among the industry that exploits them as core elements for marketing strategies. Nevertheless, lighting techniques provide more than spectacle and technical developments have improved their relevance both on an aesthetic/expressive level and on a gameplay/functional one.

Lighting is one of the most important tools of expression at the cinema, not only for 'making things visible' [27, p. 16] but also in order to determine their importance within the frame. Lighting enables the creation of relationships between multiple elements within and outside the frame, through space and time, characterizing them with certain colors, tones and shades capable of conveying emotions and establishing the mood of a shot, a scene and, sometimes, an entire film. Based on analytical tools developed for cinematic lighting, it is possible to reflect on the growing role of *expressive lighting* in contemporary video game productions. The increased quality of hard-light and hard shadows in video games such as *L.A. Noire* [28] and *Mass Effect* [29] have led to a better expressive capacity for virtual characters whose emotions are reflected and affected by the surrounding illumination. This possibility favored the implementation of more close-ups, functional for gameplay dynamics in sections of dialogue that allow for multiple choices. In *Uncharted 3* the protagonist, Nathan Drake, finds himself lost and wandering in the desert [18, Chapter 18: The Rub al

Khali] In this sequence, the passage of time is conveyed through the alternation of day/night cycles, showing the oceans of sand change from bright, warm yellows to cold, distant blues. Illumination and light reflections on the sand are used to convey the mirage of water that takes form before the protagonist's eyes only to disappear soon after. Finally, the lighting that slowly blurs the contours of the objects amplifying the sense of extreme rising heat through increased color saturation, brightness and reflections convey the sense of exhaustion that consumes Drake right before he passes out. Moreover, in *God of War 3* lighting is used to convey information about the character's inner world [22, The Darkness in Chapter 9: The End] Towards the end of the game, the protagonist, Kratos, loses consciousness during a fight against Zeus, and in the following section he wanders through a completely dark environment that mirrors his subconscious. Here, Kratos roams, witnessing episodes from his life that question his choices and appeal to his guiltiness for the violence of his actions. The player has to follow the lights displayed by Pandora, who tries to help him out of the nightmare, in order to successfully traverse the environment. Moreover, the sequence makes great use of colors, portraying the character and everything in monochromatic black and greys. The tattoo on Kratos's body is depicted in vivid red, symbolically recalling the blood shed by the character during his journey and the guilt for which he deserves to be punished. Two other colored elements are the burning cities in the background and the trail of blood that leads Kratos from memory to memory, representing the victims of his wrath. Finally, a bright blue light is associated with Pandora's light which mitigates the vivid reds previously described, reflecting the character's supportive role in the narration. The digital status of the image in video games nullifies the rigid distinctions and opposition between different chromatic codes, allowing their fusion of multiple codes and the experimentation for new expressive results [30]. Not only does this level reflect the character's emotions, sense of guilt and memories on an aesthetic level, but at the same time its gameplay, which is based on the player having to follow light and colors in order to escape the dark labyrinth, uses these tools to highlight the expressive power of this sequence.

Among others, *Alan Wake* relies heavily on the illumination system to reflect the theme of the game on an iconographic and metaphoric level by establishing a precise atmosphere and tone. Alan, a successful writer facing a creative block, retires to a cottage for a holiday with his girlfriend. The game starts right before the disappearance of the woman, an incident that provides the motivation for Alan's quest. The protagonist finds himself lost between light and dark, between sanity and insanity as the pages that he finds during his journey come to life before his eyes. Throughout the game he continuously questions his non-heroic character, as his written works seem to be somehow connected to the events. The plot of the game develops a complex tale across the memories of the protagonist, his hallucinations and nightmares, blurring the lines between fantasy and reality. With the progression of the plot, the mise-en-scene emphasizes the clash between Alan's real and oneiric dimensions, while the darkness becomes increasingly overwhelming (fig. 7), eventually making it hard to distinguish the two layers. On a formal and aesthetic level, the theme is conveyed through the juxtaposition between bright lights and dark shadows, which constitutes the most prominent aspect of the mise-en-scene in this game. Regardless of the environment in

Fig. 7. – 10. Alan Wake

which the characters are framed –this being a cabin, a motel, a wood, a parking lot–darkness constantly surrounds them, becoming a source of tension (fig. 8). Threats are hidden in the shadows, making it hard to spot enemies, traps and even to individuate a safe path through the levels. On the other hand, light and the sources of illumination become not only visually recognizable due to the contrast with the overwhelming obscurity, but also meaningful elements that provide a (relatively) safe route for the player that follows them in order to orientate him/herself within the environment (fig. 9). The light coming from signs, cabin windows, streetlights, and even a lighthouse stand out in the black backgrounds to create a pathway for the player to follow, or a goal to reach. Finally these elements become an important part of the gameplay dynamics: the creatures faced by the protagonist are made from the darkness, thus sensitive to the light. For this reason, the player is given a flashlight and flares that Alan uses as main weapons against the darkness and its inhabitants (fig. 10). Moreover, Alan can find shelter and a safe space under sources of light, creating a shield against his enemies. This reinforces the necessity to follow the light –in all its forms– throughout the entire game, proving not only the aesthetic value, but also the functional purposes of expressive lighting in recent video games.

3 Mise-En-Jeu

The examples of *scripted staging* and *expressive lighting* make explicit the potential of using analytical film tools in order to better understand the relevance of audiovisual codes in contemporary video game productions. Though it can be argued that this potential is emerging from technological evolutions of the current console generation,

on an expressive audiovisual level these techniques have been employed and developed in other media –such as film– that participate in their codification. It is now clear that video games are not films (not even interactive ones), but the definition of narration and game as functions that can coexist in the same object allows us to reframe the player as performer and, at the same time, spectator of his/her own performance. Cinematic audiovisual language is used in order to convey performance, and technological improvements in modern hardware now allow for its expressive qualities to emerge. In this way, the expressive tools of the cinematic mise-en-scene can not only be replicated in video games, but they have also adapted to medium's specificity and have occasionally been successfully translated into gameplay dynamics and a fully realized *mise-en-jeu*.

References

1. Wolf, M.J.P.: Inventing Space: Toward a Taxonomy of On- and Off- Screen Space in Video Games. Film Quarterly 51(1), 11–23 (1997)
2. Murray, J.: From Game-Story to Cyberdrama. In: Wardrip-Fruin, N., Harrigan, P. (eds.) First Person - New Media as Story Performance and Game, pp. 2–11. MIT Press, Cambridge (2004)
3. Aarseth, E.: Genre Trouble: Narrativism and the Art of Simulation. In: Wardrip-Fruin, N., Harrigan, P. (eds.) First Person - New Media as Story Performance and Game, pp. 45–55. MIT Press, Cambridge (2004)
4. Gonzalo, F.: Ludologists love stories, too: notes from a debate that never took place. In: Level Up Conference Proceedings (2003), http://www.digra.org/wp-content/uploads/digital-library/05163.01125.pdf (retrieved)
5. Wolf, M.J.P., Perron, B. (eds.): The Video Game Theory Reader 2, p. 4. Routledge, New York (2009)
6. Wolf, M.J.P. (ed.): The Medium of Video Game. University of Texas Press, Austin (2001)
7. King, G., Krzywinska, T. (eds.): ScreenPlay: cinema/videogames/interfaces. Wallflower Press, London (2002)
8. Nitsche, M.: Video Game Spaces: Image, Play, and Structure in 3D Game Worlds. MIT Press, Cambridge (2008)
9. Galloway, A.: Gaming, Essays on Algorithmic Culture. University of Minnesota Press (2006)
10. Bolter, J.D., Grusin, R.: Remediation, Understanding New Media. MIT Press, Cambridge (1999)
11. Arsenault, D., Côté, P.M.: Reverse-engineering graphical innovation. G|A|M|E, Games as Art, Media and Entertainment 2(1) (2013), http://www.gamejournal.it/reverse-engineering-graphical-innovation-an-introduction-to-graphical-regimes/#.UhYm52R5xi4 (retrieved)
12. Mactavish, A.: Technological Pleasure: The Performance and Narrative of Technology in Half Life and other Hight-Tech Computer Games. In: King, G., Krzywinska, T. (eds.) ScreenPlay: Cinema/Videogames/Interfaces, pp. 33–49. Wallflower Press, London (2002)
13. Bordwell, D., Thompson, K.: Film Art: An Introduction, 7th edn. McGraw Hill, New York (2004)
14. Gibbs, J.: Mise-en-scene – Film Style and Interpretation. Wallflower, London (2002)

15. Jenkins, H.: Game Design as Narrative Architecture. In: Wardrip-Fruin, N., Harrigan, P. (eds.) First Person - New Media as Story Performance and Game, pp. 118–130. MIT Press, Cambridge (2004)
16. Heath, S.: Narrative Space. Screen 17(3), 68–112 (1976)
17. Cooper, M.G.: Narrative Space. Screen 43(2), 139–157 (2002)
18. Uncharted 3: Drake's Deception [video game] Naughty Dog, USA (2011)
19. Mass Effect 3 [video game] BioWare, Canada (2012)
20. Dead Space 2 [video game] Visceral Games, USA (2011)
21. Far Cry 3 [video game] Ubisoft Montreal and Ubisoft Bucharest, Canada/France (2012)
22. God of War 3 [video game] SCE Santa Monica Studio, USA (2010)
23. Assassin's Creed 3 [video game] Ubisoft Montreal and Ubisoft Bucharest, Canada/France (2012)
24. Uncharted 2: Among Thieves [video game] Naughty Dog, USA (2008)
25. Gallegos, A.: Call of Duty: Black Ops 2 – A Bold New Future. In: I. IGN.com (May 01, 2012), http://uk.ign.com/articles/2012/05/02/call-of-duty-black-ops-2-a-bold-new-future (visited on February 19, 2013) (retrieved)
26. Call of Duty 4: Modern Warfare 3 [video game] Infinity Ward, USA (2011)
27. Millerson, G.: The Technique of Lighting for Television and Film, 3rd edn. Focal Press, Oxford ([1972] 1991)
28. L.A. Noire [video game] Team Bondi and Rockstar Games, USA (2011)
29. Mass Effect [video game] Bioware, USA (2007)
30. Misek, R.: Chromatic Cinema: A History of Screen Color. Wiley-Blackwell, Oxford (2010)

Mapping the Evolving Space of Interactive Digital Narrative - From Artifacts to Categorizations

Hartmut Koenitz[1], Mads Haahr[2], Gabriele Ferri[3],
Tonguc Ibrahim Sezen[4], and Digdem Sezen[5]

[1] University of Georgia, Department of Telecommunications, 120 Hooper Street
Athens, Georgia 30602-3018, USA
hkoenitz@uga.edu
[2] School of Computer Science and Statistics, Trinity College, Dublin 2, Ireland
Mads.Haahr@cs.tcd.ie
[3] Indiana University, School of Informatics and Computing, 919 E Tenth St, Bloomington,
Indiana, USA
gabferri@indiana.edu
[4] Istanbul Bilgi University, Faculty of Communications, santralIstanbul, Kazim Karabekir Cad.
No: 2/13, 34060 Eyup – Istanbul, Turkey
tonguc.sezen@bilgi.edu.tr
[5] Istanbul University, Faculty of Communications, Kaptani Derya Ibrahim Pasa Sk. 34452
Beyazit - Istanbul, Turkey
dsezen@istanbul.edu.tr

Abstract. Categorizing Interactive Digital Narrative (IDN) works is challenging because artistic and technological approaches constantly evolve. At the same time, a range of theoretical approaches from neo-Aristotelian perspectives to applications of post-classical narratology have applied many markedly different analytical perspectives, making an overall comparison difficult. This position paper expresses the need for novel, dynamic and multidimensional mappings and explores an early selection of categorizations for IDN works across different approaches.

Keywords: Interactive Digital Storytelling Theory and Practice, Interactive Digital Narrative, Story, Narratology, Digital Media.

1 Introduction

When it comes to understanding Interactive Digital Narrative (IDN) in its many incarnations, from Interactive Fiction to Game Narratives and art pieces, research has been facing a dilemma: while new technology empowers creators, theoreticians are challenged by the difficulty of establishing a canon and a shared methodology to explore and compare IDNs. With this position paper we introduce a research effort that applies spatial and comparative mappings as to solve this dilemma. In outlining this ongoing research direction [1], we concentrate on the process rather than presenting definitive conclusions. We recognize that IDN is inherently multiform,

H. Koenitz et al. (Eds.): ICIDS 2013, LNCS 8230, pp. 55–60, 2013.
© Springer International Publishing Switzerland 2013

dynamic and thus resistant to interpretations based on a single, fixed schema. Therefore, rather than working towards one generalized diagram, we argue for processes based on small corpora and ad-hoc comparisons between select artifacts to visualize relevant characteristics.

2 Mapping the Evolving Space

The purpose of classifications is to synthesize observations into a structure capturing their general characteristics and aiding the general understanding of the field. Current research recognizes specific qualities in IDN – *affordances* such as being procedural or participatory, *experiential* qualities such as agency, immersion or transformation [2] and *new structures* such as system, process and product [3]. From this starting point, we will outline a research direction mapping the conceptual space of IDN. As a first example, the experience gathered in a workshop at the ICIDS 2011 conference will be discussed as a preliminary step towards a wider research initiative. On that occasion, small clusters of "fringe" cases at the border of the IDN field were examined and compared with more accepted works. We define fringe works as problematic in regards to essential affordances of interactive narrative, for example Natalie Bookchin's *Intruder* [4], uses interactive mechanics to traversing a narrative but affords no agency over the narrative's structure, content, or outcome. Similarly, the interactive documentary app *Condition One* [5] allows the user to choose a different vantage point but not to change the narrative. Toni Dove's installation piece *Archeology of a Mother Tongue* [6] inserts a layer of separation by having another person than the audience act on the audience's behalf. This arrangement structures the experience and the piece can be described as a hybrid human-machine with digital and analog/biological elements.

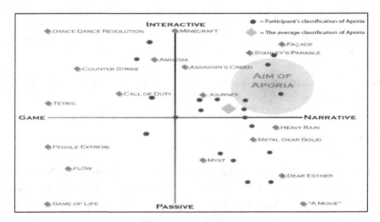

Fig. 1.The P.I.N.G model

Other authors have proposed mappings; for example, the P.I.N.G. model [7] (Figure 1) is based on a two-dimensional space where one axis is a continuum

between a high and low level of agency (Passivity vs. Interactivity) while the other represents the tension between playing and listening to a story (Narration vs. Game). Differently, Stephane Bura (Interactive storytelling symposium in Mountain View, CA, May 10, 2013) recently proposed a system of coordinates (Figure 2) along the axes of exploration (story vs. system) and control (user control vs. system control).

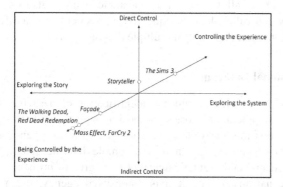

Fig. 2. Stephane Bura's mapping of IDN works along the axes of exploration and control

We strongly argue for further extensions of these two-dimensional approaches. In our workshop, we discussed a system of potentially unlimited number of bidirectional coordinate vectors - with more pairs to be added as the practice of IDN evolves. The rationale for such an approach is flexibility, allowing for the extension of the descriptive framework to accommodate future specific features of new artifacts as IDN matures. Such a system would also allow the examination of the same corpus from multiple points of view.

2.1 Multiple Dichotomies

As starting point, we identified a high number of oppositions, to allow different works to be compared according to their relative positions. Amongst several possible vectors, the early test cases included:

- Flexible Narratives vs. Fixed Narratives: Do interactors have the agency to radically alter the narrative development?
- Multi-Sequential vs. Uniform: Does the narrative structure include flashbacks or flash-forwards or does it follow a unilinear development?
- Affect the world vs. cannot affect the world: Are the interactor's actions permanent even across different sessions?
- Scripted vs. Procedural: Does the artifact react to users' actions and integrate them in the narrative development?
- Multi user vs. Single user: How many users can experience the IDN at the same time? Does everyone occupy an active role in the experience?
- Author's control vs. Audience's/Player's control: How much control and power are kept by the author, and how much the audience can contribute to the final instantiation?

It should be noted that not every axis in the schema is always relevant for every piece: by choosing a specific combination, the analyst may highlight the desired characteristics of a corpus in relation to the desired research questions. Such an approach was briefly sketched in our workshop to underline the usefulness of identifying a high number of structural oppositions in IDN works. However, the difficulty of correlating all vectors in a repeatable manner also emerged, as some might not be fully generalizable. Consequently, we also envision a different approach emphasizing the interrelation amongst multiple dichotomies.

2.2 N-Dimensional Diagrams

Where the first approach started with the identification of particular traits, our next approach starts from general categories and positions pieces within an N-dimensional space (Figure 3). For this early demonstration the axis are agency (the variety of actions that a user can undertake), narrative complexity (the quantity of concurrent narrative developments) and dramatic agency (the degree of influence the user has on the course of the narrative). The X axis represented agency, the Y axis narrative complexity and the Z axis dramatic agency (control over the narrative). A relative positioning was used: each piece is set in relationship to other artifacts in the diagram and the placement is the result of the discussion in our workshop. To help with the placement, a "reference plane" was introduced, cutting diagonally across the space from the famous novel *War and Peace* (representing high narrative complexity and low agency) to the video game *Portal* (representing the other extreme with high agency and low narrative complexity).

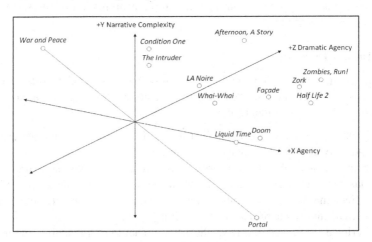

Fig. 3. Agency on the X axis, Complexity on the Y axis, Agency on the Z axis

The following IDN works were established as a corpus representing different approaches as well as fringe cases: *Condition One* [5] (interactive documentary), *LA Noire* [8] (video game), *Afternoon, A Story* [9] (hyperfiction), *Façade* [10] (interactive drama), *WhaiWhai* [11] (location-based narrative travel guide), *Zork* [12]

(text-based interactive fiction), *Liquid Time* [13] (interactive installation piece), *Doom* [14] (early first person shooter video game), *Half-Life* [15] (advanced first person shooter video game), *Zombies, Run!* [16] (location-based video game), and *The Intruder* (Interactive narrative with game mechanics).

The pieces were placed in the diagram according to the following ranking:

- *Condition One*: very high complexity, low agency, low dramatic agency,
- *LA Noire*: medium complexity, low-medium agency, high dramatic agency),
- *Afternoon, A Story*: very high complexity, medium agency, high dramatic agency,
- *Façade*: low complexity, medium agency, high dramatic agency,
- *Whaiwhai*: low-medium complexity, medium agency, medium dramatic agency,
- *Zork*: medium complexity, medium-high agency, very high dramatic agency,
- *Liquid Time*, no narrative complexity (due to the absence of an overt narrative), medium-high agency, low dramatic agency,
- *Doom*: very low complexity, high agency, low dramatic agency,
- *Half Life 2*: low complexity, high agency, high dramatic agency,
- *Zombies, Run!*: medium complexity, high agency, low dramatic agency,
- *The Intruder*, high complexity, high agency, low dramatic agency.

This second attempt complements the first mapping, producing better comparable results - although the relative low number of parameters makes it difficult to discriminate between more closely related pieces. For a more fine-grained comparison, we attempted to create a table of weighted categories.

2.3 Table of Weighted Categories

A third mapping focuses on the understanding of relations between IDN artifacts – it is challenging to visualize more than three dimensions in diagrams and for this reason we returned to a more abstract level by using numerical values in comparing specific characteristics. For the preliminary test, a scale from 0 to 10 was used (with each value to be understood as relative to others, not as an absolute) and the following four dimensions were selected: "Procedural Complexity" describes to what extent an IDN work applies computational algorithms while "Complexity of Narrative Design" refers instead to the construction of the narrative development; "Agency for Interactor" maps the impact users can have on the storyworld and "Potential Meaningful Engagement" describes immersion through both narrative and pragmatic agency. This way, a descriptive table for *Façade, Half-Life 2, Zork, The Sims* [17] and *Spore* [18] was produced, allowing a more immediate comparison between each dimension for every case considered. Still, such a mapping also presents difficulties in quantifying a numerical value - albeit only a relative one - for each case.

3 Conclusions

Interactive Digital Narrative is a field in which advancing technologies come together with novel expressive narrative concepts to advance the way we create and perceive

narratives. It has been highlighted how such an ever-changing nature makes it almost impossible to reach an absolute canon of pieces on which to found a shared theoretical approach. Instead, we aim towards a research effort exploring dynamic and relative mappings and embracing the quick pace of innovation in the IDN field. Such an endeavor is still moving its first steps and, in this position paper, the research questions at its base were explored and a tentative analytic process was outlined. Mappings have been presented as a set of means to understand and categorize this evolving space. While conventional taxonomies are challenged by the dynamic nature of the IDN space, needing constant re-definitions and re-arrangements of categories, spatial mappings can be easily extended, enabling analytical and comparative work against the backdrop of continuous developments in Interactive Digital Narrative.

We have presented three mappings here as working examples of our active research directions. Future work in this area will explore other types of conceptualizations - adding new vectors to examine different objects, with the long-term objective of developing a shared repertory of dynamic taxonomical tools.

References

1. Koenitz, H., Haahr, M., Ferri, G., Sezen, T.I.: First Steps Towards a Unified Theory for Interactive Digital Narrative. In: Pan, Z., Cheok, A.D., Müller, W., Iurgel, I., Petta, P., Urban, B. (eds.) Transactions on Edutainment X. LNCS, vol. 7775, pp. 20–35. Springer, Heidelberg (2013)
2. Murray, J.: Hamlet on the Holodeck. The Free Press, New York (1997)
3. Koenitz, H.: Towards a Theoretical Framework for Interactive Digital Narrative. In: Aylett, R., Lim, M.Y., Louchart, S., Petta, P., Riedl, M. (eds.) ICIDS 2010. LNCS, vol. 6432, pp. 176–185. Springer, Heidelberg (2010)
4. Bookchin, N.: The Intruder (1999), http://bookchin.net/intruder/index.html
5. Condition One [iPad App]. Condition One, Inc. (2011-2013)
6. Dove, T.: Archeology of a Mother Tongue. The Banff Centre for the Arts, Canada (1993)
7. Bevensee, S.H., Dahlsgaard Boisen, K.A., Olsen, M.P., Schoenau-Fog, H., Bruni, L.E.: Project Aporia – An Exploration of Narrative Understanding of Environmental Storytelling in an Open World Scenario. In: Oyarzun, D., Peinado, F., Young, R.M., Elizalde, A., Méndez, G. (eds.) ICIDS 2012. LNCS, vol. 7648, pp. 96–101. Springer, Heidelberg (2012)
8. LA Noire. Team Bondi. Rockstar Games. Various platforms (2011)
9. Joyce, M.: Afternoon, a Story. Eastgate Systems, Watertown (1991)
10. Mateas, M., Stern, M.: Façade. PC/Mac (2005)
11. Whaiwhai (series). log607. Marsilio. iPhone/Paper book (2009-2011)
12. Zork (series). Infocom. Various platforms (1980-1989)
13. Utterback, C.: Liquid Time [installation piece]. Various exhibitions (2000-2002), Documentation online: http://camilleutterback.com/projects/liquid-time-series/
14. Doom (series). iD Software. Activision. Various platforms (1993-2012)
15. Half-life (series). Valve Software. Electronic Arts. PC (1998-2007)
16. Zombies, run! (series). Six to Start. Android/iOS/Windows phone (2012-2013)
17. The Sims (series). Maxis. Electronic Arts. Various platforms (2000-2013)
18. Spore. Maxis. Electronic Arts. PC (2008)

Conceptualizing Productive Interactivity
in Emergent Narratives

Sebastian Hurup Bevensee and Henrik Schoenau-Fog

Department of Architecture, Design and Media Technology,
Section of Medialogy, Aalborg University, Copenhagen,
A.C. Meyers Vænge 15, 2450 Copenhagen, Denmark
sbeven09@student.aau.dk, hsf@create.aau.dk

Abstract. Contemporary projects examining how to design for emergence in virtual environments have suggested very applicable and plausible design-oriented material. However, authors of such works cannot avoid influencing the experience by providing pre-written narrative material which can become trivial for the user after just a few times. This paper suggests an alternative viewpoint on the issue, by involving the user in the authoring process during the experience, such that it affects other users' story constructions and experiences, in an attempt to solve this potential authoring issue. The study will focus on creating a practical concept, based theoretically on Ryan's idea of productive interactivity and Jenkins' description of emergent storytelling, in order to discuss the shortcomings and potential of this conceptual design.

Keywords: Emergent narrative, productive interactivity, game design, the narrative paradox.

1 Introduction

Designers of games and interactive storytelling experiences have been trying to solve *The Narrative Paradox*—a task which has proven to be extremely difficult [1] because it may result in the *Combinatorial Explosion*, for which several theoretical attempts at solving have also been made [5]. Often, emergent narratives are considered as the emergence that arises through dialogue interaction with intelligent AI programmed characters or through written text [8]. However, this paper operates within Jenkin's definition of emergent narratives providing narrative material through a rich environment and intelligent characters, with which the user is able to associate, interpret, and ultimately construct his/hers own understanding of the story [6]. Nevertheless, even though the experience might be different if being played again, it cannot be avoided that it will be influenced by pre-authored material, which delimits the experience of the replay value and its interpretive potential. Designing for diversity in these experiences has often been ignored, resulting in the same events taking place in the same locations. It is this specific diversity-lacking issue in emergent narratives that will be addressed in this paper. This authoring problem has also been addressed in previous works [7] [9], but the concept in the present study deals more with the

H. Koenitz et al. (Eds.): ICIDS 2013, LNCS 8230, pp. 61–64, 2013.

diversity of the environment as a story world instead of diversity in a written story or through character dialogue.

2 Productive Interactivity

The proposed conceptual idea uses Ryan's 'productive interactivity' [3] as a foundation. Ryan proposes two types of productive interactivity, one of which is more pertinent to this project in particular and is defined as *"[participating] in the writing of text by contributing permanent documents to a database or a collective literary project"* [3]. Despite Ryan mentioning this as a part of the motivation for submitting input, it can also be a form of pure interactivity which potentially can be added to Ryan's interactivity circle in her eight forms of interaction (Combinations of Ergodic, Electronic and Interactive) and can be seen as the interaction of 'leaving a mark'. It is from this perspective that the proposed concept will use productive interactivity and rephrase the description thereof in a more concrete context that suits the aim of this concept:

"To participate in the process of modifying narrative material through writing, navigating and interacting with objects embodied in an open world computer game, resulting in dramatic elements to the 'next' player."

The elements that can be modified in the description are not fixed, but they can and might change depending on which productive actions the user can perform.

3 Elaborating the Concept

The study will use Little Red Riding Hood to represent the concept, since it provides a good foundation for exemplifying an open-world environment.

Fig. 1. Early visualisation of the concept. The process loops in such a way that the user on the right influences a new user on the left.

The conceptual idea is to decrease the narrative influence of the authors and to increase the diversity of the experience, by creating a dynamic and emergent interactive

narrative which changes each time it is experienced. It is not intended, though, to exclude the authors from the writing process, but rather to set up a framework, in order to let the users affect the story mutually between each other.

The following example will illustrate how one user may affect the experience of the next user: The user starts as Little Red Riding Hood in her own home. She can roam freely around the house, but her mother will ask her to deliver a basket of goods to her grandmother. The user must accept this task as an initial goal/motivation, in order to proceed in the experience. In the forest along the road the wolf reveals himself and engages in a conversation with the user. The user answers all questions about where her grandmother lives, but takes out a note to write that the wolf seems wicked and should be avoided, and then leaves the note on the road. The user starts walking off the road to pick up flowers, but drops a compass from her basket. Arriving at an impassable river, the user decides to knock down a rotten tree to cross the river. At the grandmother's house, the user chooses to open a window at the back of the house, where she encounters the wolf having eaten grandmother. The story ends more or less in the same way as the classical story whereby the woodcutter saves both Riding Hood and the grandmother. However, the actions the user performs in this experience will now influence the next user's experience.

The next user will have the ability to find the note in the forest, probably avoid the wolf, find the compass in the forest, cross the already built 'bridge' over the river, and then find the woodcutter's bloodied clothes (because the wolf has now have had time to eat him instead of Riding Hood). Now the user may pick up the woodcutter's axe, go to the grandmother's house, enter through the (now open) window, see the wolf having eaten both the grandmother and the woodcutter, and attack the wolf from behind with the axe to save both of them and conclude the story.

4 Design Considerations

The major gameplay elements of the application will consist of productive interactivity and more classical interactivity such as picking up objects and using them. Both of these interaction possibilities should be meaningful, corresponding with Salen & Zimmerman's (2004) term "Meaningful Play" [4], where the outcome of the user's actions makes sense with the performed action here and now and at later stages. A plan of how these objects, locations, events, and the authored material should be productive and dramatic has been implemented already. The concept also works with *Constituative* (user actions), *Operational* (mechanics of the system), and *Implicit* (rules outside the game context) rules according to Salen & Zimmerman (2004), where each action performed by the user is considered and classified in the context of these three rules [4].

Several practical issues can be discussed in this respect. The system will need to manage events, objects, and locations, in order to ensure the most optimal amount of drama. Users might differ in their motivation for being productive in the experience and therefore leave most of the game world unchanged. As such, one will need to figure out potential solutions for encouraging the user for doing so, e.g. by rewards or

making the productivity more interesting than other game elements and narrative goals. This could, for example, involve making sure the first user is aware which actions are productive, and then introduce the first user's productivity to the second user and vice versa.

5 Conclusion

In an effort to solve the potential lack of diversity in authored material in emergent interactive narrative experiences, this paper suggests a concept for including the user in the authoring process of the story world. Based on a design for emergent narratives and the general game design concepts posited by Salen & Zimmerman (2004), the product is currently being developed in Cryengine 3 SDK [2] aiming at a successful interactive storytelling game experience, including rules, goals, and meaningful play. As such, specific algorithms are required to present interesting characters and to keep the dramatic experience and story construction going between the users. It is believed that the concept has potential as an alternative solution for authoring emergent narratives. Nevertheless, one can hope that researchers and the designers of interactive storytelling keep looking into creative solutions for existing challenges and become more aware of specific design solutions, whether on a conceptual or a prototypical level, such that user experience can help evaluate the concept at an early stage. After all, interactive narratives are created as an experience for the user and not the designer.

References

1. Aylett, R.: Emergent narrative, social immersion and "storification". In: Proceedings of the 1st International Workshop on Narrative and Interactive Learning Environments, pp. 35–44 (2000)
2. Crytek: CryEngine v.3.4.5: 3D Game Engine (2013), http://www.crytek.com
3. Ryan, M.-L.: Narrative as Virtual Reality. The Johns Hopkins University Press (2001)
4. Salen, K., Zimmerman, E.: Rules of Play: Fundamentals of Game Design. MIT Press, Massachusetts (2004)
5. Stern, A.: Embracing the Combinatorial Explosion: A Brief Prescription for Interactive Story R&D. In: Spierling, U., Szilas, N. (eds.) ICIDS 2008. LNCS, vol. 5334, pp. 1–5. Springer, Heidelberg (2008)
6. Jenkins, H.: Game Design as Narrative Architecture. In: Wardrip-Fruin, N., Harrigan, P. (eds.) First Person: New Media as Story, Performance, and Game, pp. 118–130. MIT Press, Cambridge (2004)
7. Swanson, R., Gordon, A.S.: A data-driven case-based reasoning approach to interactive storytelling. In: Aylett, R., Lim, M.Y., Louchart, S., Petta, P., Riedl, M. (eds.) ICIDS 2010. LNCS, vol. 6432, pp. 186–197. Springer, Heidelberg (2010)
8. Louchart, S., Swartjes, I., Kriegel, M., Aylett, R.: Purposeful Authoring for Emergent Narrative. In: Spierling, U., Szilas, N. (eds.) ICIDS 2008. LNCS, vol. 5334, pp. 273–284. Springer, Heidelberg (2008)
9. Szilas, N.: IDtension – Highly Interactive Drama (Demonstration). In: Proc. of the 4th Conference on Artificial Intelligence and Interactive Digital Entertainment (AIIDE 2008), pp. 224–225. AAAI Press, Menlo Park (2008)

Suitability of Modelling Context
for Use within Emergent Narrative

John Truesdale, Sandy Louchart, Helen Hastie, and Ruth Aylett

MACS, Heriot-Watt University, Riccarton, Edinburgh, EH10 4AS, UK
{JTT5,S.Louchart,H.Hastie,R.S.Aylett}@hw.ac.uk

Abstract. In Emergent Narrative it can be asked that without manda-
tory author-controlled way-points, how does a story remain emotionally
significant to an interactive user? A plausible solution lies in the use of
contextual information in order to create emotionally relevant, and there-
fore emotionally significant, interactions. If context could be defined and
modelled accordingly, it could present a novel approach for the creation
of interactive user experiences within affect-based systems.

Keywords: Emergent Narrative, Context, Narrative Theory.

1 Introduction

The ability for artificial agents to make the most believable decisions in the most
unusual of situations is a highly desirable trait for modern *Artificial Intelligence*
research. In order for agents to invoke a true sense of human-like behaviour, the
necessity lies in their ability to make decisions at run-time, reflective of user
input. When placed within a narrative structure, affective agents might take the
route that makes the most sense from a planning perspective or the one that
meets their own individual needs regardless of a 'plot'. These decisions might not
reflect the original narrative structure nor have the desired emotional impact on
the user, or better known, interactor that was originally intended.

In *Emergent Narrative* (EN) the conceptual approach is to place an interactor
within an interactive environment from which the narrative dynamically alters
based on individual actions of both the interactor and any involved agents. Sim-
ply altering the story based on the interactor's decisions requires the narrative
to dynamically adjust, possibly conflicting with the author's original structure.
Aylett and Louchart describe this as the *'Narrative Paradox'*: *"How to reconcile
the needs of the user who is now potentially a participant rather than a spectator
with the idea of narrative coherence - that for an experience to count as a story
it must have some kind of satisfying structure"*. [1] Additionally questioned is
that interactivity within a narrative is a spectrum and not a binary attribute
and that there exists a *participant/spectator spectrum.* [2]

From this, in order for affective agents to make sensible yet believable nar-
rative decisions and for narrative systems to provide emotional consistency and
pacing with relation to interactors and the core narrative, an additional concept

H. Koenitz et al. (Eds.): ICIDS 2013, LNCS 8230, pp. 65–70, 2013.

is required. This initial theory suggests that the prospect of both defining and modelling context with regards to both an interactor's and agent's interactions, in correlation with the author's intended emotional experience, could provide an additional basis from which affective agents could act upon. It aims to address whether or not context modelling will be seen as beneficial or detrimental to EN. The aim of this paper is to accurately **define the semantics of context within EN** and provide an argument from which context could effectively contribute towards the development of affective agents in EN.

2 Reviewing Current Definitions of Context

Many issues arise when discussing the term context: what exactly constitutes as context, how can it be used, and what would be an appropriate model for use within EN? A thorough definition of the term context remains a popular area of debate due to the highly subjective nature of the term itself. Schilit et al developed context for use within mobile computing development, which led to the start of *Context-Aware Computing*. Schilit stated that the three important aspects of context were: *"where you are, who you are with, and what resources are nearby"*, for instance location. [3] Here Schilit's definition of context relies on a set example, which becomes problematic, as future interpretations require a piece of information not listed within the example. Does new information still constitute as context if no guidelines exist to assert for or against it? In avoiding the use of examples in defining context, synonyms have been used, defining context in terms such as *'environment'* [4] or *'situation'*. [5] Here difficulties arise in how to apply such a definition in practice due to its generality.

Semiotic research, best defined by Eco: *"Semiotics is concerned with everything that can be taken as a sign."* [6] highlights similar characteristics to context but proves to be outwith the scope of this proposal due to the many theoretical stances of its validity. Additionally context has been applied in the field of *Interactive Systems* and *Spoken Dialogue Systems* where it has been used to improve performance and user satisfaction. Defined as the *'interaction history'*, [7] it interoperates the user information stored in the *'user model'*. [8] Yet these definitions, and subsequent applications, of context are too abstract or too specific for application and do not provide a desirable dynamic within EN. There is a clear need for context to be defined in an operational manner, avoiding the pitfalls of defining context too specifically, or too abstractly.

Dey's [9] operational definition of context can be seen as the most widely accepted and one of the most plausible: *"Context is any information that can be used to characterize the situation of an entity. An entity is a person, place, or object that is considered relevant to the interaction between the user and the application, including the user and the application themselves"*. In addition Dey states that context leads to the *'characterization'* of the entity, which within the scope of EN, could be interpreted to be both an interactor and autonomous agents. Dey states that in order to create entities, context is required. Contrastingly, Pascoe states that context is an attribute, and that: *"A location on its own*

has no value unless we know what entity it is locating". [10] Pascoe states that context has no value without an entity it is relevant to. Together, Dey and Pascoe conclude a circular system: context is collected with regards to a particular entity, and in turn that entity requires the context for its characterisation.

The basis for the definition of context can be further extended when considering the relationship between an entity and its interactions, as supported further by Henricksen: *"The context of a task is the set of circumstance surrounding it that are potentially of relevance to its completion".* [11] Henricksen concludes that context is directly related to the goals of a particular entity. This crucially implies that context can not only provide justification on past actions, but also motivation for future interactions. Furthermore Chen states that context, *"Extends to modelling the activities and tasks that are taking place in a location".* [12] Chen's aim is to consider interactions within a location, implying that the definition of an entity is not as limited and can be extended to include both activities and locations.

Zimmerman et al provide the most operational definition of context to date and defines context by breaking it down into five categories: *"individuality, activity, location, time, and relations."* [13] From this, Zimmerman expanded that each of these sub-components of context were directly related to an entity, for instance the relations sub-section would store all the relationships for a particular entity. Although one of the, if not the, most robust operational models for context to date, where it does succeed in minimizing the scope of context as a whole, it does not minimize the scope of context for an individual entity. Issues remain in to what extent context should be collected for any of these sub-sections, in order for the definition to remain practical, and that the model itself has no regard for narrative application. The necessity for an abstract, yet operational definition or model of context can be seen as a paradoxical approach in that any definition for context is itself context. Yet with Zimmerman's basis in hand, and all subsequent issues aforementioned, the most robust definition of context within an EN system would require the exploration of narrative theory in order to correlate a relationship between the narrative and an interactive system.

3 Application of Narrative Theory

Currently the notion of context within a narrative system is dictated by a 'plot' which in turn determines all available actions. From this approach, it is easy to keep track of and thus a story can be altered to fit any desired outcome. The problem that arises lies in how to fit the characters, both the interactor and agents, actions and decisions to fit such an outcome, thus the issues of behaviour and personality coherence become apparent. Yet from a EN perspective it is the opposite as the characters are always coherent, that is a given since they cannot make a decision that does not match their goals; it is a process of which narrative information, or relevant context, is not represented.

The notion of narrative within interactive environments has long been under research yet the desire for narrative to be considered a key component within the scope of narrative games and playable stories was first highlighted by Ryan.

[14] The popular question that arises asks whether or not this partnership is beneficial for contemporary game design, in that does a strong story birth a strong game and/or does a strong game require a strong story? With regards to EN, characters are considered the key component as evaluation of an EN system is focused on the impact of the story just as much as the mechanics of the system itself. The basis for context has already been attributed to entities but just to what degree narrative defines context itself and how it subsequently is composed must be expanded upon.

It can be ascertained a 'plot' can be perceived differently based on ones perspective, yet within EN a story is referred to as the user narrative experience, or the way in which they make their way through hypothetical plot lines. Aylett and Louchart state that the very validity of the concept of a plot is compromised due to the sensitivity of interactivity, suggesting it has *"Dramatically altered the inherent nature of narrative in Virtual Reality."* [15] or that once one introduces interactivity, a 'plot' becomes plural and consists of a series of hypothetical plots rather than a single plot line. It can then be suggested that characters don't act for the plot, but that the plot is the result of character interactions and can be considered core to context within a narrative scope.

Currently context can be considered to be the way in which information is expressed but upon further examination it could additionally consist of the way in which information is constructed and the expected effect it will have upon reciprocation. The present expression is in the form of an interaction, with the past and future information reliant on character motivations, thus providing a way for the character to construct narrative. Within a tragedy, Aristotle stated that the fourth element is *'Diction'*, [16] which is the style or choice of words for any expression. It could then be suggested that if context is considered to be any information attributed to an entity, then the exact choice of words for a narrative, and any characters involved, could also be considered context.

It could be therefore said that any element which does not derive nor depend on an interaction is both plot and diction. Since plot can be considered irrelevant in EN, the concept of diction is left to be explored. The basis for narrative construction was first explored by Propp who coined the terms *'fabula'* and *'syuzhet'* which are respectively the material of the story and the way in which it is organised. [17] Chatman stated narrative theory is composed of: *"A story (histoire), the content or chain of events (actions, happenings), plus what may be called the existents (characters, items or setting): and a discourse (discours), that is, the expression, the means by which the context is communicated".* [18] The process of interpretation for the audience goes much further though as stated by Chatman: *"They must fill in the gaps with essential or likely events, traits and objects which for various reasons have gone unmentioned".* [18] In narrative there is a sense of what a character intended to say and what the interactor perceives, effectively from the words chosen by the character, or diction. Ryan takes it a step further in stating that literary semantics describe three ways of reporting the speech or thought of characters: *"direct discourse, indirect discourse and free indirect discourse".* [19] Yet within EN, a thin line is drawn as how these

dynamics can be controlled given that narrative is being dictated by characters and not an overlying sense of plot.

With the definitions of diction in place, the elements of narrative theory can be directly related to the core dynamics of context within EN; characters make up the plot, expressions are their interactions, and existents are agents and locations; all of which make up context in narrative. Thus for the purpose of EN, the way in which a story is told is determined by the interactions of its characters via their underlying choice of words and actions. Narrative structures provide a solid grounding from which to build a definition of context for EN as it has effectively distributed the elements of narrative into the underlying construct for an entity. Additionally in doing so, it has provided a basis for the reduction of context within a narrative scope.

4 Suitability of Defining and Modelling Context for Emergent Narrative

Now that the fundamentals of context have been examined within the scope of EN and all applicable narrative theory addressed, this paper can now present a definition for context: *"Context is information relevant to a narrative, specifically the **user, author, agents,** and **setting** and all subsequent **actions** or **relations** of these entities"*.

With context now defined within the realm of EN, the question that remains is what effect it would have on both affect-based agents and EN. The basis for a model would propose the means to create a narrative-centric interactive experience, where the story is emotionally driven and entirely constructed by the characters. The author's intended emotional significance would construct the drives and desires of the characters, agents, within the narrative setting, whilst effectively reflecting the interactor's interactions and relationships with them, thus making the resulting experience emotionally significant. The innate nature of such a contextual model when placed within the action-selection mechanism of affect-based agents would allow for decision-making to not only reflect the goals and needs of the agents but address the narrative as well. Future research would need to assign intended emotional value to events, justify the allotted weightings, and dynamically adjust at run-time.

5 Conclusion

The core of this paper was aimed at providing an operational definition of context within the scope of EN, which in turn provided the basis for the approval of the construction of an appropriate model in the future. First by investigating and evaluating current definitions of context, it was concluded that they were too abstract or too specific for use within the scope of EN, yet provided a solid basis for initial construction of a new definition. By investigating and integrating narrative theory into the core concept, a new definition of context was presented with the notion of modelling it considered for future development.

Acknowledgements. This project is partially funded under the EPSRC grant RIDERS EP/I032037/1.

References

1. Aylett, R.: Emergent Narrative, Social Immersion and "Storification". In: Narrative and Learning Environments Conference, NILE 2000, Edinburgh, Scotland (2000)
2. Aylett, R.S., Louchart, S.: Being there: Participants and Spectators in Interactive Narrative. In: Cavazza, M., Donikian, S. (eds.) ICVS-VirtStory 2007. LNCS, vol. 4871, pp. 117–128. Springer, Heidelberg (2007)
3. Schilit, B., Adams, N., Want, R.: Context-Aware Computing Applications. In: Workshop on Mobile Computing Systems and Applications, Santa Cruz, CA, pp. 85–90 (1994)
4. Hull, R., Neaves, P., Bedford-Roberts, J.: Towards Situated Computing. In: The First International Symposium on Wearable Computers, Cambridge, MA (1997)
5. Brown, P.: The Stick-e Document: a Framework for Creating Context-Aware Applications. Electronic Publishing, 259–272 (1996)
6. Eco, E.: A Theory of Semiotics. Indiana University Press (1979)
7. Bos, J., Klein, E., Lemon, O., Oka, T.: DIPPER: Description and Formalisation of an Information-State Update Dialogue System Architecture. In: 4th SIGdial Workshop on Discourse and Dialogue, pp. 115–124 (2003)
8. Zukerman, I., Litman, D.: Natural language processing and user modeling: Synergies and limitations. User Modeling and User Adapted Interaction 11, 129–158 (2001)
9. Dey, A.: Understanding and Using Context. Personal and Ubiquitous Computing 5(1), 4–7 (2001)
10. Pascoe, J., Ryan, N., Morse, D.: Issues in Developing Context-Aware Computing. In: Gellersen, H.-W. (ed.) HUC 1999. LNCS, vol. 1707, pp. 208–221. Springer, Heidelberg (1999)
11. Henricksen, K.: A Framework for Context-Aware Pervasive Computing Applications, Ph.D. Thesis, University of Queensland, Queensland (2003)
12. Chen, H.: An Intelligent Broker Architecture for Pervasive Context-Aware Systems, Ph.D. Thesis, University of Maryland, Baltimore County (2004)
13. Zimmermann, A., Lorenz, A., Oppermann, R.: An operational definition of context. In: Kokinov, B., Richardson, D.C., Roth-Berghofer, T.R., Vieu, L. (eds.) CONTEXT 2007. LNCS (LNAI), vol. 4635, pp. 558–571. Springer, Heidelberg (2007)
14. Ryan, M.: From Narrative Games to Playable Stories. StoryWorlds: A Journal of Narrative Studies 1 (2009)
15. Louchart, S., Aylett, R.: Managing a Non-linear Scenario - A Narrative Evolution. In: Subsol, G. (ed.) ICVS-VirtStory 2005. LNCS, vol. 3805, pp. 148–157. Springer, Heidelberg (2005)
16. Butcher, H. (translation): The Poetics of Aristotle, Penn State Electronic Classics Series Publication,
http://www2.hn.psu.edu/faculty/jmanis/aristotl/poetics.pdf
17. Cobley, P.: Narratology, The Johns Hopkins Guide to Literary Theory and Criticism, 2nd edn. John Hopkins University Press, London (2005)
18. Chatman, S.: Story and discourse: Narrative structure in fiction and film. Cornell University Press (1980)
19. Ryan, M.: Narrative as Virtual Reality. The Johns Hopkins University Press (2000)

Production and Delivery of Interactive Narratives Based on Video Snippets

Wolfgang Müller[1], Ulrike Spierling[2], and Claudia Stockhausen[3]

[1] University of Education Weingarten,
Leibnizstr. 3, 88250 Weingarten, Germany
[2] Hochschule RheinMain, University of Applied Sciences,
Unter den Eichen 5, 65195 Wiesbaden, Germany
[3] Goethe-University Frankfurt,
Robert-Mayer-Str. 10, 60054 Frankfurt, Germany
mueller@md-phw.de, ulrike.spierling@hs-rm.de,
stockhausen@gdv.cs.uni-frankfurt.de

Abstract. We propose digital audio/video streaming as highly expressive representation form for interactive storytelling on the web, in spite of widespread assumptions that pre-authored videos may reduce flexibility. To address the latter, we present our new end-user client for dynamic ad-hoc playback of video or audio snippets managed by a multi-agent conversational platform, as well as a way to include video (or pre-rendered animation) production in an iterative prototyping cycle tailored for that system.

Keywords. interactive storytelling, video snippets, authoring, prototyping cycle.

1 Introduction

Sophisticated interactive storytelling (IS) experiences, including conversations with virtual characters as well as physical actions, require highly dynamic and frequent reactions to user input. At the audio-visual representation levels of IS applications including video games, the first choice to address this challenge for variability has often been procedural animation of virtual actors as 2D/3D rendered characters and ad-hoc speech synthesis technologies. Such fully generative approaches promise to offer interesting and flexible behavior. However, beyond research prototypes, achieving character expressivity and voice quality is technically difficult, especially when non-programmers are to be integrated as authors within a loop of story generation [16]. For media designers, convincing emotions are still easier to communicate with recorded human actors and voices than with parameterized graphical agents. On the other hand, recorded audio and video as linear media have been mostly dismissed in the field of interactive digital storytelling due to poor adaptivity and high production effort. In this paper, we describe our approach to nevertheless involve audio/video media streaming as representation layer for a conversational narrative platform, being aware of and working around its principal limitations. The contribution consists of a new digital audio/video playback client for an existing conversational IS engine, ad-hoc combining short video snippets. It extends our system that used simple rule-based 3D animations with an alternative

H. Koenitz et al. (Eds.): ICIDS 2013, LNCS 8230, pp. 71–82, 2013.
© Springer International Publishing Switzerland 2013

possibility to interactively deliver the end result. Without aiming at a fully generated flexible conversation, we allow a middle way between conditioned branching and rule-based approaches, providing a comprehensible authoring interface at the same time. We also explored the production steps involved. Case studies in student seminars demonstrated that we can achieve higher acceptance rates than with the previous basic 3D animation [5], and that the expected high production effort is still feasible, given that a structured modus operandi is followed.

The paper is organized as follows: First, we present our methodology for authoring and producing snippet-based non-linear narratives. We discuss our experiences in practice that extend previous work in authoring for the same platform with a basic real time character representation. Further, we describe a web-based delivery infrastructure for interactive narrative experiences using audio or video streaming content, and we analyze the technological challenges of such solutions leading to future work.

2 Related Work

The solutions presented in this paper combine different fields of interactive video, hypervideo and interactive storytelling (IS). Hypervideos, or hyperlinked videos, are video streams that contain embedded user-clickable anchors, allowing for navigation between video and other hypermedia elements. Thus, they provide narrative possibilities similar to hypertext. The frequently cited HyperCafe [13], one of the first hyper-video examples, was envisioned primarily as a cinematic experience of hyper-linked video scenes. It granted users a selection of narratives, but authors had no control over the flow of the narrative. An even older example, the interactive video-disc installation Deep Contact [7], allowed users to change the course of a narrative based on location-specific interactions with a virtual actress.

Lately, a main focus in hypervideo research was on the efficient definition of interactive regions in and tracking of moving objects segmented from video images. For example, VideoClix [18], ADIVI [1], and Innovid's iRoll Suite [9] are authoring tools for defining such flexible hyperlinks and actions on a video. However, they do not directly support the development of interactive narratives and the management of corresponding media elements.

For IS, video has been utilized sporadically. Lin et. al. [10] presented an interactive system for storytelling based on video content. It supports creators to develop non-linear stories interactively from existing video material. The Vox Populi system [2] allows for automatic generation of video documentaries, making use of verbal annotations in the audio channel of video segments. Ursu et al. [17] presented a framework for the production and delivery of interactive TV narratives. Without mechanisms for automatic story generation, their system enables story variations based on rearrangements of video segments. Porteous et al. [12] go one step further towards a more generative approach. Their system generates multiple alternative storylines from a baseline video, by employing film segmentation, the application of video summarization techniques for the segments, and a recombination of such summarized story events making use of AI planning techniques. De Lima et al. [3] take a similar approach, also adding methods to ensure cinematographic continuity of

generated videos. Interlude.fm [8] enhanced online videos with choice possibilities that provide a completely seamless flow after each selection of story continuation. While apparently restricted to a limited number of branches and predefined branching points, this approach – similarly to ours – also appears to integrate mechanisms for ensuring the availability of relevant video snippets at the client side for seamless presentation of subsequent videos. WeR Interactive [19] presented an online game based on video segments following IS principles. The video camera assigns a first-person point of view to the user. In summary, only few existing approaches utilizing video streaming in interactive storytelling focus on the process of developing interactive video-based narratives from scratch, which is the key aspect of this paper.

While in this contribution we mainly stress the video-snippet approach of the representation levels of our system, there is also related work in the field of conversational storytelling systems. The aspect of having a multi-party verbal conversation of one player with two debating virtual characters has first been presented within Façade [11]. Our system "Scenejo" utilizes a less sophisticated drama manager, putting the focus on easy access for authoring instead [15], an aspect missing in Façade. The success of handling verbal user input of our chatbot-based approach depends on authoring suitable semantic categories together with templates for playback. This is possible within constraints that also limit the Façade interaction [4]. We now further extend our system with a new video client towards expressing more mimetic actions, either within the story or concerning user actions expressed with GUI elements.

3 Case Studies in Authoring and Production

Our previously existing conversational IS engine "Scenejo" enables multi-party con-versations between several digital 'chatbots' and a user [14]. Our traditional bot representation has been a 3D talking head with a synthetic voice, enabling ad-hoc rendering of authored dialog lines. The resulting interactive narrative experience was dominated by the verbal conversational aspect, especially suited for debates to let players experience (or solve) conflicts in a storyworld with several characters.

The system (available for download) has been employed for education and exercises in IS authoring, targeted at non-programmers and novices in interactive storytelling and conversational systems [16]. One result of these authoring studies has been the „Office Brawl" demonstration [5], created by students of Media Management in the context of a game design class at RheinMain University in Wiesbaden. This content idea prompted the development of the video-based representation described here, to obtain a more lively and funny characterization of two debating opponents. With the Office Brawl project, also a production method for this nonlinear video snippet approach has been explored. The resulting method has then been verified by teaching it to a new group of students at the University of Education in Weingarten. This group came up with a new idea, "Max's Discovery", having almost no difficulties in applying the method. In the following, both cases are briefly described.

3.1 Office Brawl

For this piece, its authors took up the problem of representing characters synthetically (like in the previous version of our system) as a topic for a self-referential argument. The platform's procedural output, 3D talking heads (in Java 3D) with real-time synthetic text-to-speech (TTS), has been ideal during the development process, because newly designed dialog pieces can be experienced ad-hoc. However, mainly the synthetic voices (and also the graphics depending on technical and artistic skills) raised issues of acceptability. In this context, the team found that the success of Interactive Storytelling is differently judged by artists/designers and by computer scientists concerned with the underlying technology. As a result, the two characters Lucy and Ben have been designed, who have a controversy about this in an office setting:

- **Lucy** is the creative director in the team, arguing that Interactive Storytelling can only be successful if voices and visuals are more up to realistic standards, so that they can express emotionally compelling content.

- **Ben** is the chief programmer, a nerdy character who does not care that much about aesthetics, but argues that focusing on recorded output interferes with dynamic generative content in reaction to users.

They refuse to continue the work on their current project, because they are stuck in their "office brawl", bashing each other without constructive arguments, rather using insults and reproaches. The player then is in the role of the project manager, with the goal to lead them back to a constructive discussion and finally make them continue working. If he/she fails to moderate the debate, the situation escalates.

This user interaction is handled through typing natural language text into a chat window. It may change the course of the further dialogs and story, which is controlled by the system's plot engine, based on an abstract definition of the possible paths in the story.

Because of the expressed representation problem, we explored alternative visuals and audio together with a workflow for achieving a more humane AV representation. Two alternative possibilities of video production have been explored (see Fig. 1). First, we tested a complete production with actors in full-video. Second (and finally), we used audio recordings and synchronized these with photo animations in Reallusion's Crazytalk animator. We chose this alternative, because the results appeared to be funnier and more flexible for potential changes during post-production.

A typical challenge in Interactive Storytelling is that conception and technical production are no clearly separated steps. Several iterations of conceptual authoring, technical authoring (implementation of the content), test playing, and debugging are needed before the content of an interactive conversation is finished. The abstract design principles for structuring a conversation matching our system have been described in [15] in detail. In short, the conception steps consist in

- defining characters and their changeable attributes,
- abstracting dialog acts as semantic units from hand-written utterances,
- structuring the dialog at 'discourse management level' including rules and conditions for the selection of next utterances for each 'bot', and
- tuning arithmetic rules to affect variable character attributes.

Fig. 1. Project tasks: Dialog concept, technical authoring with synthetic representation, and test of two possible final representation forms (recorded animation or live film)

All conversations can be combined from minimum chunks at sentence level. A dialog structure can quickly get complex, which is why it is impossible to just sketch it sufficiently in a picture before the production phase. Instead, it is necessary to experience the implemented narrative before the structure can be finally judged. The conception included paper prototyping, distributing single bot utterances to playing cards. Fig. 2 shows an iterative principle of our process. Production steps then include the implementation of the dialogs in our authoring tool [14] and the audio-visual creation of the end result.

During authoring, we still use our default graphics – Java3D heads with TTS – to interactively experience the result and test the structure. Besides that, a text-only version is also available for play-testing. However, to get a better feeling of the duration of the dialogs including the pacing of the user interaction in turns alternating with the characters, hearing the ad-hoc voices is closer to the end result.

Ideally, the production of the video snippets is the last step, after the game has reached a state in which no changes to the conversations are expected any more. In our runtime system, sentences are complete units that cannot be regenerated with alternatives during interaction. However, alternative dialog lines can be made available through authoring, and their conditions for occurrence are variable. Authoring the dynamic structure is all about defining these conditions, including the possibility for random selection or dependence on certain story states. Authored sentences are structured into single turns of each bot character, while the user turns are not rendered. During production, for each such turn, one video has to be produced and saved as a file. Not only full spoken sentences, but also non-lexical dialog acts, such as grunting or sighing, or non-verbal physical acts such as frowning or rolling one's eyes can be included.

As mentioned above, for the final OfficeBrawl result we chose to record human voices and combined them with photo animations in the CrazyTalk system. Besides

having more control over possibly necessary reproductions of snippets, we obtained an overall wiggly impression of the animations that added character to the representation. As an advantage over the cleanly filmed actors (Fig. 1), this also provides the result with a little more tolerance towards possible disruptions between video streams. The playable demonstrator contained about 320 such clips of character turns between 3 and 20 seconds, including idle videos of several minutes. Based on the finalized structure including all written utterances, all audio was recorded in 2 days, and animations were produced by a team of 3 students in about 2 weeks.

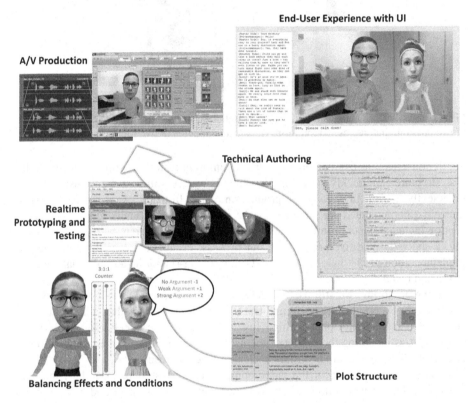

Fig. 2. It is essential to iteratively construct and playtest the conversation before the production of the video representation

3.2 Max's Discovery

We directly applied the OfficeBrawl approach in a second project with students from Media Education and Management in an Edutainment class at the University of Education Weingarten. A student team was requested to develop an educational story and conversation, and to implement this based on our authoring framework. In the resulting story, the 14 year old Max discovers in a Biology class project that a local animal feed company applies antibiotics at a large scale. The user takes the role of Max's aunt/uncle, being asked by Max to act on behalf of him in the next local council

meeting, to oppose an expansion of the animal feed company. The game experience involves an exchange of arguments with the mayor and the owner of the company as part of the local council.

Similar to OfficeBrawl, the conception of the conversational story started by paper prototyping with cards, allowing for an 'offline' playtesting of the distribution of utterances to the main characters. As before, the authors were asked to consider a discourse structure that let abstract dialog acts make changes to designed attributes. Further, the game was step-by-step implemented and playtested with the authoring system. Not before the dialog structure revealed sufficient variety and consistence, video snippets were produced, again utilizing CrazyTalk photo animator. The final piece contained around 60 video snippets, corresponding to about 50 dialog acts plus idle snippets, as well as backstory and ending videos. While these numbers may not seem overwhelming, they already implied a level of complexity for the dialog structure that would have been difficult to manage on a purely theoretical basis with script writing 'on paper'. Following the iterative prototyping method (Fig. 2) employing early interactive playback with synthetic actors therefore supported not only the technical authoring, but also the content conception. Fig. 3 depicts two animated video frames from the resulting short interactive story, which has been done in German language.

Fig. 3. Two animated video frames from Max's Discovery

An informal evaluation with students participating in the project based on individual interviews revealed that once the general idea of interactive narrative and the proposed approach for developing such interactive experiences got understood, structuring the dialog at 'discourse management level' and specification of utterances were straightforward using the framework. Especially the possibility for immediate playtesting of the authored conversation, postponing the burden of final media production, was acknowledged to be helpful to understand principles of discourse structuring. The only criticism mentioned concerned some usability problems of the authoring tool, which leads us to improve this.

4 Narrative Structure and Interaction

All working case studies that have used our conversational storytelling approach [14] so far, including the new ones reported here using the video snippet solution, are based on the same character-based philosophy. Conversations are to be abstracted in

such a way that single turns are defined for each character separately with precondi-tions. Each turn can consist of an abstract dialog act and several possible ways to utter (or otherwise represent) that act. In order to not only have a verbal conversation, but also a kind of narrative progression, it is essential to make utterances depend not only on previous utterances, but also on important story world states. Authors are asked to take this into account, by thinking of the most important changeable attributes that characters would consider for choosing their actions (for example, a 'trust'-like attribute like in Max's Discovery). Also the other way around, all actions and dialog acts, and especially user acts, need to potentially make changes to those attributes.

A typical other challenge of interactive narrative is to let users experience the re-sults of their own actions, especially if these consist in affecting some inner states of characters. One way to render these inner reactions is by choosing a suitable sentence that contains an emotional direct response, which sometimes is a challenge to do in a convincing way. We decided to add further graphic elements to the video-based client, to give authors the possibility to make selected states visible. In Office Brawl, Lucy and Ben's mood attributes are rendered as a layer on top of the video frame, with a kind of emotional thermometer that will give immediate feedback to the user upon effects of successful interactions and acts of other characters (compare Fig. 5).

There are now more elements that become necessary to be considered during au-thoring and media production, due to the new video client solution:

- Interaction attempts of players – in other words, their turns performed – can last some time, if they are typing at a keyboard. Our client will register the attempt and let the server stop selecting next dialog acts of the virtual cha-racters. This gap needs to be filled with 'idle'-video snippets, which means we need more video material that does not represent core actions.
- In such a case, we distinguish between general 'idle'-snippets or video snip-pets that make characters appear listening to the user during his/her input as a back-channeling mechanism.
- Non-verbal or paralinguistic non-lexical dialog actions can be rendered crea-tively in a video and therefore can be considered as conceived dialog acts. For potential text rendering, a text description should be added (for example, interjections or 'comics' expressions such as "phew", "sigh", "groan" etc).
- Dynamic graphical elements can be added as an abstract layer to the video output (see Fig. 5), which also means that authors need to consider these in their conception including the layout of video frames.

In general, all successful cases so far made an effort to present clear affordances to the player concerning the possibilities of verbal interaction, because ad-hoc verbal generation of unprepared content is not an option with a video-based client. This also needs to be considered during conception of the whole narrative frame:

- There should be a diegetic (story-related) reason why it is impossible for the player's fictional role to know exactly what to type to get a suitable answer. In Office Brawl, we have capricious characters that are not easy to make lis-ten. In Max's Discovery, there is a content-related reason why Max needs to tell his Uncle what exactly he should bring forward at the court, giving him kind of a 'cheat sheet'.

- The framing stories need to present clear missions with some hints to interact, where giving these can be justified by the story.
- After typing, immediate feedback can be presented more easily by the visualized changing of introduced attribute's states than by following utterances.

Concluding, the system is not to be compared with a general conversational dialog system, as it pursues different goals. Instead of neither open-ended nor task-based dialogs between human and machine, it can be used for conversational stories with some well-framed interaction possibilities for a player. It is possible to include GUI-based visualizations for expressing actions and states.

5 Delivery

In our approach we aim for a web-based delivery for interactive narrative experiences based on video content. As a consequence, our system is based on a client/server approach, where the server controls the logical story flow and provides the video data, while the client manages the user interface for video playback, user input, and visualization of additional information elements.

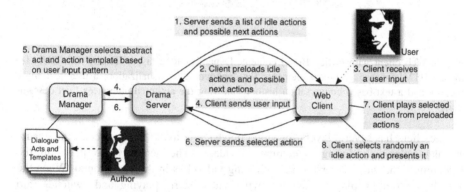

Fig. 4. Process of communication and interaction between the several components of the system and the user

During implementation of our system, several challenges regarding the video delivery arose. For a high user acceptance, seamless switching between videos had to be implemented. After entering a verbal contribution, the system should react by playing seamlessly the next video. In general, several videos may be candidates to follow on a presented video clip. A major challenge lies in the preloading of all candidate videos within a short time frame. In our scenarios so far, these video elements had durations between three seconds up to two minutes for idle videos. In our solution, the client receives a list of possible subsequent videos from the server and starts preloading once playback of a specific video has been started (see Fig. 4). The video client is web-based and realized with Flash/HTML5. The video playback component of the client is realized in Flash. Other parts of the client are implemented using HTML5/JavaScript.

The server sends the file name of the video which has to be played next to the client. Taking into account possible user input, the authored structure and evaluated conditions, our system selects the next video. The communication with the video client is initiated by the server in terms of HTTP push methods. In our solution, message content exchanged between server and client is encoded in JSON format to allow for easy extensibility by using a standardized content encoding.

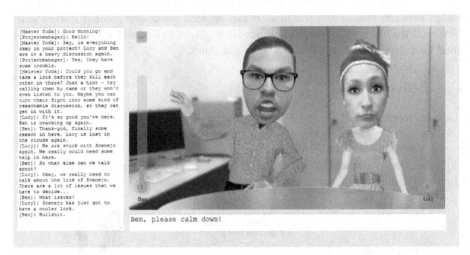

Fig. 5. Web client with Office Brawl content: Dynamic video layers (Flash) with GUI elements, HTML5-based graphical elements for dynamic state visualization, a user text input section, and a text-based conversation history (showing the authored utterances / act descriptions)

The client has several layers for video playback to avoid black screens and ensure seamless playback during switching of videos. The actual video plays in the foreground, the video layer for the following video lies in the background. When the actual video stops playing, the following video starts playing and switches into the foreground after a delay of a few milliseconds. Additionally, the user interface of the web client includes elements like a textbox for user input and the course of the conversation. Further visualization elements, such as that of the mood parameters, and a menu with video controls overlay the video.

We analyzed the technological challenges of such solutions. Many challenges arise due to the interaction of the user:

- Client/server communication: Delays in communication can lead to the issue that the server is ahead of the user. This can lead to the skipping of very short videos. It is resolved by a handshake in our communication protocol.
- Preloading a large amount of possible following videos for seamless playback: For videos on a local hard disk the problem of seamless playback is resolved best.
- Seamless playback: Resolved by idle sequences that are randomly chosen for playback between videos while waiting for user input.

- Enhanced synchronization in the interactive discourse by letting the client trigger the server to pause dialog processing during user input.
- Combination of video player with the presentation of other media elements and interactive elements controlled by the drama manager for enhanced story experience: Solved by HTML 5 elements, which lay on top of the video.

Especially the interaction between user and the system turned out to be a challenge. While the user types text at the GUI, the client needs to wait for input completion by letting the server pause the logic story progression and by playing an idle sequence after finishing the current video; otherwise the system might be ahead of the user's answer. On the other hand, also if the user does not react until the end of a video's playback, the system needs to play idle sequences instead of stopping video playback completely, to appear interactive to the user.

6 Summary and Future Work

The focus of this paper has been an approach for production and delivery of video-snippet-based interactive narratives. We developed an architecture for interactive narrative experiences using audio/video streaming content. Main media-related technical challenges for delivering such experiences in a Web browser lie in the need for prompt responses to user actions and for seamless switching between videos, getting around potential delays in server/client communication. To reach a broader target audience and to offer a better support of mobile devices in the future, the video component will further be implemented in HTML5/JavaScript completely instead of using Flash.

The success of this approach relies on authoring audio or video content in a structured way that takes into account the abstraction of narrative dialog acts or physical acts, in line with produced elements. This necessary effort is supported by the circumstance that the approach is accessible, which has been verified by two case studies conducted in student seminars, in which participants rather had intermediate media production experience than programming knowledge.

Future work concerns the extension of the mostly conversation-based content structure so far towards including also more action-based elements within abstracted templates. We also will further investigate issues of distributing the IS system for better response behavior, and the integration of video processing techniques for more cinematographic consistency of presented video stories.

Acknowledgments: We thank our project members of the Scenejo project [14] for technical support, and the student authoring teams of Office Brawl as well as Max's Discovery for content authoring (full credits see [14]).

References

1. ADIVI – add digital information to video. Product homepage, InnoTeamS, http://www.adivi.net/ (last accessed: August 22, 2013)
2. Bocconi, S., Nack, F.H.L.: Using Rhetorical Annotations for Generating Video Documentaries. In: IEEE International Conference on Multimedia and Expo (2005)
3. De Lima, E.S., Feijó, B., Furtado, A.L., Ciarlini, A.E.M., Pozzer, C.T.: Automatic Video Editing for Video-Based Interactive Storytelling. Monografias em Ciência da Computacção 17(11) (2011), ftp://ftp.inf.puc-rio.br/pub/docs/techreports/11_17_lima.pdf
4. Dow, S., Mehta, M., MacIntyre, B., Mateas, M.: Eliza Meets the Wizard-of-Oz: Blending Machine and Human Control of Embodied Characters. In: Proceedings of ACM CHI 2010, pp. 547–556. ACM, New York (2010)
5. Glock, F., Junker, A., Kraus, M., Lehrian, C., Schäfer, A., Hoffmann, S., Spierling, U.: "Office Brawl" – A Conversational Storytelling Game and its Creation Process. In: Proceedings of the Eighth International Conference on Advances in Computer Entertainment Technology (ACE 2011), Lisbon, Portugal (2011)
6. Hausenblas, M.: Non-linear interactive media productions. Multimedia Syst., 405–413 (2008)
7. Hershmann, L.: Deep Contact: The First Interactive Sexual Fantasy Videodisc (1984-1989). In: Shaw, J., Weibel, P. (eds.) Future Cinema. The Cinematic Imaginary after Film, p. 221. The MIT Press, Cambridge (1989, 2003)
8. Interlude Homepage, http://interlude.fm/ (last accessed: August 22, 2013)
9. iRoll Suite. Innovid, http://www.innovid.com/ (last accessed: August 22, 2013)
10. Lin, N., Mase, K., Sumi, Y., Katagiri, Y.: Interactive Storytelling with Captured Video. In: Ubicomp 2004, Adjunct Proceedings, Nottingham, England, pp. 7–10 (2004)
11. Mateas, M., Stern, A.: Natural Language Understanding in Façade: Surface-Text Processing. In: Göbel, S., Spierling, U., Hoffmann, A., Iurgel, I., Schneider, O., Dechau, J., Feix, A. (eds.) TIDSE 2004. LNCS, vol. 3105, pp. 3–13. Springer, Heidelberg (2004)
12. Porteous, J., Benini, S., Canini, L., Charles, F., Cavazza, M., Leonardi, R.: Interactive storytelling via video content recombination. In: ACM Multimedia, pp. 1715–1718 (2010)
13. Sawhney, N., Balcom, D., Smith, I.: HyperCafe: narrative and aesthetic properties of hypervideo. In: Proceedings of the Seventh ACM Conference on Hypertext, pp. 1–10. ACM, New York (1996)
14. Scenejo project home page, http://scenejo.interactive-storytelling.de/ (last accessed: August 22, 2013)
15. Spierling, U.: Introducing Interactive Story Creators to Conversation Modelling. In: Proceedings of the Eighth International Conference on Advances in Computer Entertainment Technology (ACE 2011), Lisbon, Portugal (2011)
16. Spierling, U., Hoffmann, S., Szilas, N., Richle, U.: Educational Material for Creators (Non-Computer Scientists) on AI-based Generative Narrative Methods. Deliverable 3.2, IRIS NoE FP7-ICT-231824 (2010), http://iris.scm.tees.ac.uk/
17. Ursu, M.F., Kegel, I.C., Williams, D., Thomas, M., Mayer, H., Zsombori, V., Tuomola, M.L., Larsson, H., Wyver, J.: ShapeShifting TV: Interactive screen media narratives. Multimedia Systems 14(2), 115–132 (2008)
18. VideoClix. Product homepage, VideoClix Technologies, http://www.videoclix.tv/ (last accessed: August 22, 2013)
19. WeR Interactive: I AM PLAYR, http://werinteractive.com/games/iamplayr (last accessed: August 22, 2013)

Telling Stories on the Go: Lessons from a Mobile Thematic Storytelling System

Alex Mitchell[1] and Teong Leong Chuah[2]

[1] Department of Communications and New Media
[2] Keio-NUS CUTE Center
National University of Singapore, Singapore
alexm@nus.edu.sg, teongleong@gmail.com

Abstract. Although mobile devices make it easier for travellers to share stories both during and after their travels, these postings are often time-based, with minimal narrative structure. This paper describes an observational study of *Travel Teller*, a storytelling system designed to help tourists share their experiences as stories by providing thematic recommendations for mobile postings. Interestingly, although our design assumed people want to tell stories while travelling, our observations suggest otherwise. Rather than actively telling a story as they travel, participants stated a preference for remaining in the moment, and only later reflecting on and structuring their experience as a story. They viewed recommendations as approximate destinations, taking photos of things they stumbled upon rather than of the recommendation itself, and often put recommendations "on hold" to be resumed later. This suggests tools should support distinct story-gathering and story-telling activities, aim to inspire not prescribe, and flexibly track "pending" recommendations.

Keywords: mobile storytelling, travel stories, empirical studies.

1 Introduction

People have always enjoyed sharing and reading travel stories, from the travel narratives of the Song dynasty [1], the letters, journals and diaries of the English aristocracy taking part in the "grand tours" of the 1820s and 1830s [2], through to the recent resurgence in travel literature [3]. The use of mobile devices has made it increasingly common for tourists to post online to share these stories with friends and family, not just after a trip, but also while still on location [4]. However, these postings are usually shared in a time-based "stream" with little of the organization or structure found in traditional narratives [5]. This suggests that there is a need to provide mobile tools to help travellers to structure and share their stories *as stories*.

One way to address this problem is to develop a system that can automatically identify potentially interesting stories from a tourist's postings as they are posted, and then suggest additional tourist activities by prompting the tourist with ways that she could continue the story. To explore this approach, we designed *Travel Teller*, a mobile storytelling system that keeps track of the *themes*

H. Koenitz et al. (Eds.): ICIDS 2013, LNCS 8230, pp. 83–94, 2013.

present in a user's postings, and recommends what the user may want to post next based on these themes. This paper discusses our observations of the use of our prototype, and presents implications for the design of future systems.

The focus of this paper is on how participants in our study responded to our system, particularly in terms of their desire to remain in the moment, their need to reflect on their experiences before structuring them as a story, and how they used the recommendations when deciding what to photograph next. What this paper does not address is whether the use of thematic recommendations actually helped our participants to write their stories, and how those recommendations influenced either the content or structure of their stories. We plan to carry out further analysis of the materials gathered in our observational study to address these questions, and will report the results in a separate paper.

The rest of this paper is structured as follows. We begin with an overview of the related work and a description of our research problem. This is followed by a discussion of the concept behind the thematic recommendation system, and a description of our prototype. We then discuss our observational study and the implications of our findings, concluding with an overview of possible future work.

2 Related Work

Related work falls into four categories: location-based recommendations, generation of location-based stories, manual authoring of stories during a trip, and automated support for telling stories after a trip. We now summarize each area.

There has been extensive research into the generation of location-based recommendations, such as planning travel routes based on large sets of photos [6] and matching a user's profile with the profiles of contributors to a large database of photos [7]. These projects use information about the traveller's context and past behaviour to recommend what the traveller might want to experience.

Research on mobile story generation mainly focuses on automatic generation of stories from content contributed by other travellers [8–10]. For example, *StoryStream* [10] provides a traveller with an oral narrative about a city neighbourhood based on a combination of the traveller's location and behaviour, preexisting user-contributed story materials, and some notion of narrative structure.

Several commercial projects support travellers creating their own stories in a mobile context, including *Trip Journal* and *BackSpaces*. These systems provide manual tools for capturing photos and writing captions related to the photos, with the resulting stories displayed either as a timeline or as locations on a map.

There has also been work to provide intelligent assistance for the retrospective creation of stories by a user from the user's own materials [11, 12]. *Raconteur* [11], for example, helps a traveller to tell stories about travel photos to a friend, via an online chat system, after a trip has been completed. The system attempts to detect story patterns in the user's utterances, and then helps the user to tell a coherent story by makes recommendations as to what photographs to show to the friend next.

3 Research Problem

From the above survey of the related work, we can see that although there has been some work around the problem of helping travellers to tell stories about their trips, there has not been any work that looks at both providing proactive support for the telling of stories from the traveller's own content, and support for doing so during a trip.

The related work on travel recommendation systems focuses on determining a traveller's preferences, and then recommending things to see based on similarities with other travellers' behaviour. This does not consider the story the tourist may want to tell or make any attempt to help structure the experience as a story.

Research that does consider story focuses either on the generation of location-based stories for a traveller from other people's contributions, or on the manual creation of stories with no proactive assistance. Systems that generate stories for travellers based on user-generated content, such as *StoryStream*, make use of user behaviour to create stories, but are focused on generating stories from existing content, rather than helping the traveller to create her own story. Commercial systems that do support travellers telling their own stories about their trip while travelling provide tools for capturing and sharing story material, but do not do anything to either proactively help with this process, or to help to ensure that the captured materials will form a narrative.

Systems that provide proactive assistance for storytelling, such as *Raconteur*, do so after the trip is over, based on a traveller's complete collection of photographs. However, although these systems do proactively help travellers to create their own stories from their own media, they do so retrospectively rather than during the trip. This leaves open the question of how to actively assist travellers with the authoring of their own stories while they are still travelling.

To explore this problem, we can begin by looking at how tourists currently share their posts. Traditional social networks such as *Facebook* generally provide a simple stream-based format for sharing [5]. While travel-specific applications such as *Trip Journal* do provide additional map-based views, they also tend to follow a chronological approach. However, a series of posts about a travel experience, regardless of how it is presented, does not necessarily form a story. Instead, the posts can be seen as a chronicle, a series of temporally-sequenced events [13]. What is often lacking is some form of *narrative structure*. This raises the question: how can a mobile storytelling system proactively help tourists to give some form of narrative structure to their posts?

4 Travel Teller

To explore this question, we developed and tested *Travel Teller*, a system which can generate story-appropriate recommendations for tourists based on the *themes* present in their posts. In this section, we briefly describe the thematic model which forms the basis for our approach, and then explain how we adapted this model for use in our prototype thematic recommendation system.

4.1 A Thematic Model of Narrative

According to Prince [14], a story can be seen as having three different types of macrostructures or frames: action (plot), existents (characters and setting), and ideas (theme). To help a traveller bring some narrative structure to her postings about her travels, a system could take note of the elements which form one of these macrostructural categories as the posts are created, and make suggestions that would help the traveller to develop that structure in subsequent posts.

For our system, we chose to focus on theme. Tomashevsky defines theme as "the idea that summarizes and unifies the verbal material" [15, p. 67] of a story. This suggests that theme can provide a way to structure and unify the posts that make up a travel story. We focused on theme, as opposed to plot, character or setting, as we felt that the basic indicators of an emerging theme could be more easily identified from individual posts, as opposed to, for example, the plot of the story, which may require retrospective awareness of the entire story.

The thematic model in our prototype extends Hargood's [16, 17] work on thematic narrative generation. According to Hargood's thematic model, stories consist of narrative atoms, or *natoms*, which are the smallest unit of a narrative. An example of a natom is a posting (photo, caption and tags) which a tourist makes when creating a travel story. Natoms contain certain visible, computable elements or *features*, such as the captions or tags on a photo. These features denote certain *motifs*, which in turn connote *themes* within the story.

A specific natom may be considered to have a numerical *thematic quality* with respect to a given theme. The thematic quality can be used to compare natoms and determine which are more closely related to the theme. Thematic quality is calculated based on the average of the *component coverage* (the percentage of motifs and sub-themes that connote the desired themes which are present in the natom) and the *thematic coverage* (the percentage of the desired themes that are present in the natom). Hargood's *Thematic Montage Builder* (TMB) [16] uses this model to generate stories based on the themes present in a caption.

4.2 The Prototype

We will now describe the *Travel Teller* prototype (see Figure 1), and explain how we have adapted Hargood's thematic model for use in our thematic recommendation system.[1]

The prototype allows a tourist to capture a photo and add a caption to the photo (see Figure 1a), which together constitute a natom which the tourist has just added to the developing story. Given this natom, we want to determine what the tourist should be encouraged to photograph such that her *next* posting is likely to continue to develop the same theme(s). The idea is that, by helping the tourist to post a sequence of thematically-related photos, the system will also be helping the tourist to create a story with a consistent thematic structure.

[1] The prototype was implemented using HTML5 and Javascript. The implementation of the thematic model was ported from the Java code used for the studies in [16, 17].

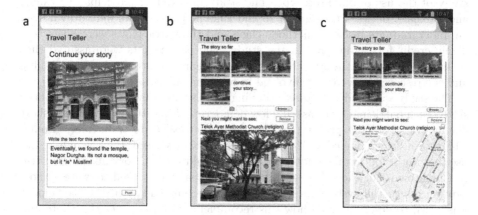

Fig. 1. The *Travel Teller* prototype

To do this, we constructed a database of potentially interesting landmarks and attractions which are geo-tagged and thematically tagged, and a hand-crafted database of motifs and themes based on these photos. Together, these databases form the basis for the thematic recommendations.

When a photo with a caption is posted, we search the caption for known features. These features are used to determine which motifs are denoted by the photo, which are in turn used to determine which themes are connoted by the photo. We then use Hargood's algorithm to select a single location (the highest ranked based on thematic quality within a given distance threshold) from the database of interesting landmarks. The resulting location is presented to the tourist as a recommendation for what she may want to visit next, either as a location name and a photograph (see Figure 1b) or a map with a walking route from the current location to the recommendation (see Figure 1c).

It is important to note that a travel story will most likely consist of a series of photographs, and that themes may span across many photographs. Our basic algorithm only considers the themes present in the latest post. To address this limitation, we maintain a window of N recent photos, and add the occurrences of themes in these earlier photos to the current list of themes, with a weightage function applied to the list such that more recent photos contribute more to the themes, whereas the contribution of older photos gradually drops off. We used a window of 3 photos, with a weightage function which has the weightage of themes drop by 50% in each subsequent posting. In addition, a distance threshold of 300m was used to ensure recommendations were within an easy walking distance.

5 Observational Study

To investigate how people respond to the idea of using thematic recommendations to support storytelling while travelling, we conducted an observational

study of the use of our prototype. The study involved 12 participants, 5 male and 7 female, between the ages of 19 and 25. The participants were drawn from an undergraduate research methods class, and the participants were given academic credit for taking part in the study. The participants were assured that their performance in the study would have no bearing on their academic results, and the researchers were not involved in teaching the class in any way.

The study was conducted on-site in Singapore's Chinatown. At the start of the study, each participant was asked a few demographic questions and given a short demonstration of the prototype. They were then asked to walk freely around Chinatown, accompanied by the researcher. As they walked, they were asked to use the prototype to take photographs that would form a story about their trip to Chinatown. For each photograph, the participant was asked to write a short caption. Once the system responded with a recommendation, the participant was asked to describe aloud how this recommendation relates to the photo and caption. They were free to choose whether to follow the recommendation.

Participants continued to take photographs for roughly 30 minutes. The researcher then conducted a short semi-structured interview, during which the participant was asked to review the sequence of photographs, and describe how they are related to each other. The participant was then asked to write, with paper and pen, a short story based on these photographs. While writing the story, the participant was given the opportunity to look back over the photos and captions. Finally, the participant was asked to look over the recommendations and discuss the relationship between recommendations, photos and story.

Audio was recorded for later analysis, and the reviewer took notes during both the use of the prototype and the semi-structured interview. The photographs, captions and recommendations were also captured for use in the analysis. Transcripts of the audio were coded for key incidents, and these incidents were used to develop insights into how participants were using the prototype.

6 Results

When designing the *Travel Teller* prototype, our overall assumption was that people want to tell stories about their travels *as they are travelling*. We had also assumed that people would generally follow the system's recommendations, and would do so sequentially. Our observations suggest otherwise.

Surprisingly, most (9 out of 12) of the participants said that they were reluctant to write detailed captions for their photos on-the-spot. This suggests both a desire to stay in the moment, and also a need for some distance from the experience before they could reflect on their experience and begin to see it as a story. In addition, although they found the recommendations useful, participants viewed them more as providing a general direction or rough destination to head towards, rather than specifying a particular landmark to be photographed. They expected to encounter interesting, unexpected photo-opportunities *on the way* to that landmark, and often wanted to put recommendations "on hold", to possibly be returned to later. We will now discuss these observations in detail.

6.1 Staying in the Moment

Many of the participants were not willing to write captions immediately, stating instead a desire to "stay in the moment", and to caption and upload photos later. For example, participant 2 observed that "right now its very stressed, so if I take a lot of photos in one go I'd be just like upload them first when I get some place to rest." Similarly, participant 11 explained that "as a tourist you prefer spending time just walking around the streets and if you stop you might waste some time so what I usually do is I just take photos and then go back to my hotel or something and then I look at the photos and then write down my thoughts." These comments show a desire to share the photographs *soon* after taking them, but not immediately, as this would detract from the experience.

There was also an element of social involvement that discouraged writing captions immediately. For example, participant 10 mentioned that "I don't like having to stop somewhere and then write captions and then walk again. So say you were going with a group of people then if you do that right you'll be left behind." In this case, it is the potential disruption of the social experience which makes participant 10 reluctant to take the time to write captions.

However, not all participants were unwilling to write captions. Participant 3 in particular was willing to write long descriptions. Although he only took 4 photographs, the captions were an average of 18 words, with the longest being 31 words. All of his captions described a scene, and were thematically linked to the photographs. When questioned about his detailed captions, he said that he felt he wouldn't mind writing more for each photo as he took them.

In fact, despite their stated reluctance to write captions, all participants did write captions, with only four participants (P1, P2, P9 and P10) leaving some captions blank. The length of the captions, however, varied greatly, with half of the participants writing on average less than 5 words. This suggests that participants did want to write something about the photographs, and were able to do so, but did not want this to interfere with their experience of the moment.

6.2 The Need to Reflect and Edit

It was not just the desire to stay in the moment which led participants to state a preference for waiting until later to write their captions and upload their photos. They also claimed that they needed to take some time to review and edit their postings, and to reflect back on the experience before retelling it as a narrative.

For example, after taking the first photo participant 9 observed that "usually I'll do it [write captions] later when I'm looking at all of them." She stated that she was not thinking about the story while taking the photos, but instead would think of the story "only after I've experienced everything and like only after I've taken the photos, sat down and uploaded them, looked at them and then I see that there's some sort of story to it, but as I'm actually taking the photos I don't actively try to think that I'm telling a story." At the end of the session she said she felt more confident that she could find a story because "then maybe I can come up with or find a string of events." And in fact she successfully wrote a

story based on the photos at the end of the study. This suggests that there was a need to reflect on the totality of her experience before constructing a story.

Even those participants who were willing to write longer captions wanted some time to reflect before sharing. For example, participant 3 observed that he preferred to upload the photos in batches, saying that "maybe after like 10 photos when I'm ready to upload it then I would probably sit down in a cafe and just do some last-minute touch-up." Similarly, participant 6 wanted to write more detailed captions as she took the photos, but would prefer to take some time to craft the story after the trip. Interestingly, it turned out that she regularly blogs about her travels. When asked about how she does this, she explained that she tends to think about the story for her blog, not as she's taking photos, but when she gets back to the hotel. She reflected that although she wanted to write captions for her photos immediately, she also wanted go back and craft them into a story later: "I probably would want to like, maybe after the whole thing I'd probably want to sort out the whole thing and then like rewrite the story."

This suggests a tension between gathering or creating story fragments while experiencing a location, and taking time later to craft these materials into a story. This tension can be seen in participant 11's comments at the end of the study. As mentioned above, participant 11 claimed that she did not want to write captions on the spot, preferring to spend her time "walking around the streets" rather than thinking about her story. When reflecting on this during the post-session interview, she observed that "at first I said I would rather go back and do it [write captions] because it gives some time, because I craft my captions, but I guess it would be useful to craft it [the caption] on the spot because when you go back you might forgot what you've seen or how you felt at that point in time." We will discuss this tension between story-gathering and storytelling in more detail in Section 7.

6.3 Encountering Unexpected Discoveries

In the previous two sections we have discussed participants' feelings about writing captions and thinking about their story as they take photos. We will now discuss their reactions to the recommendations given by the system. Participants tended to see recommendations as somewhere to head towards, rather than a fixed target which they definitely had to photograph. They were interested to see what they might encounter "on the way", with these unexpected discoveries often holding more interest for them than the original recommendation.

For example, when asked if the recommendations were helping him to decide what to photograph next, participant 3 said: "not really, they were helpful in guiding me to the next location or giving me choices." So although the recommendations didn't help him decide what specifically to photograph, they did open up options and provide general guidance for *where* to go.

For participant 12, the recommendations were a way to come across unexpected, surprising things to photograph. When asked if the recommendations were relevant, he initially said that "most of them were pretty accurate to what I was looking for." However, on later reflection he said: "I am very surprised by

the recommendation actually because I don't see a relation, but...the surprises are definitely nice." Even though he didn't see a clear relation between his postings and the recommendations, he still felt they were useful as they provided surprising things for him to see.

6.4 Putting Recommendations on Hold

This desire to stumble across interesting or surprising things on the way to a recommended location suggests that there is a complex relationship between what is recommended by the system and what the participant actually decides to photograph. This often involved starting towards a goal but then seeing something interesting on the way, in which case the participant might want the system to "remember" the original destination but "put it on hold" for later.

For example, participant 6 was heading towards a recommendation when her attention was drawn to a temple, and she stopped to take a photo. The system then recommended a different temple, which she found interesting but did not want to pursue "because I might end up there and then see more other stuff and then I'll forget [the original recommendation]." She did not want to head towards the new recommendation for fear of getting yet *another* recommendation and losing track of the previous recommendation. Having multiple "active" recommendations potentially becomes too much for her to keep in memory.

This suggests that there is the need for a more flexible way to keep track of "active" recommendations which have not yet been pursued or rejected, and some way of "resuming" these deferred recommendations. We discuss this and other implications of our study in the next section.

7 Discussion

Our observations have a number of implications for the design of mobile support for tourists telling stories about their travels: systems should recognize that story-gathering and story-telling are separate but interconnected activities; recommendations should allow for serendipitous discoveries rather than prescribing where to go; and systems should support flexible planning and putting of recommendations "on hold" while the tourist explores these unexpected discoveries.

7.1 Story-Gathering Separate From But Connected to Story-Telling

We initially assumed that tourists would want to make use of mobile devices, not just to capture photos, but also to tell stories *as they are experiencing them*. This is in line with other discussions of tourist storytelling. For example, Gretzel [4] observes that "[n]ew media increasingly allow travellers to easily narrate and share their experiences when they occur rather than having to recount them in the form of stories after the trip is completed." This would imply that allowing tourists to write captions for their photos immediately, and providing support for structuring their stories as they take photos, would help them to tell stories.

However, our observations suggest that, rather than wanting to tell stories as they are occurring, tourists want to continue to be involved in their immediate experience, and would actually prefer to tell stories about their travels *after* the experience. The reluctance to tell the story on-the-spot was the result both of the desire to remain in the moment, and the need to have some time to reflect on the experience and edit the materials before structuring the photos into a story. This observation is supported by theories of creative writing such as Sharples' [18] model of writing as "creative design", which separates creative writing into three distinct but related activities: planning, composing and revising.

The implication is that, rather than focusing on story-*telling* on the fly, a system should support but recognize as distinct both storytelling and story-*gathering*. This could be done by encouraging tourists to capture what is important and interesting about their trip without losing the feeling of being in the moment, and only afterwards look back over this material to structure the story. What it means to tell the story "afterwards" is complex – it may involve stopping briefly during a particular expedition to reflect on and share experiences, or looking back over the trip much later after returning home.

The difficulty that our participants faced when trying to think about story in the moment also suggests that focusing exclusively on theme may not be sufficient. Thinking about story while simultaneously experiencing the events which will form the basis for the story may also necessarily involve other types of narrative structure, such as action and existents. Understanding this process, how it relates to existing models of creative writing, and how to support it, requires further work.

7.2 Inspiring Rather Than Prescribing

We had also assumed that tourists would want to be directed towards interesting locations that they may want to photograph so as to continue their story. These recommendations were based on a thematic analysis of the captions posted in the previous photographs. The fact that our participants did not want to write their story on-the-fly makes this assumption problematic, as the captions that were written to accompany the photographs were often short, not necessarily reflecting the story which the tourist would later write. In addition, participants viewed the recommendations more as a suggestion for an interesting place to go, on the way to which they may encounter something surprising, rather than as a destination which itself would be photographed and included in the story.

This implies that, rather than trying to recommend locations where the tourist should go to take a photo, the system designer should think of ways to provide inspiration for the traveller. This changes the problem from one of attempting to identify the emerging structure of the story and making recommendations which will continue to develop that structure, to one of identifying appropriate prompts which will inspire the tourist to gather materials which can later be used to tell their own story. How these inspirations would be used by a tourist and how a tourist would eventually structure the resulting photographs into a story is not clear, and requires further investigation.

7.3 Flexible Planning and Putting Recommendations "On Hold"

A closely related observation is that participants wanted to put recommendations "on hold" when they stumbled across something interesting. This highlights a final assumption in our original design – that tourists would pursue a single recommendation, and then move on to the next recommendation. In fact, there were quite complex patterns emerging in our study, with participants expecting to be able to accept or reject recommendations, to maintain a list of previous recommendations to which they could return, and to possibly have multiple recommendations for a single photograph.

This implies that the system should allow tourists to keep track of a series of recommendations, and support their desire to either pursue a recommendation or put aside their goals as and when other interests arise.

8 Conclusion

In this paper, we have presented our observations of the use of *Travel Teller*, a prototype mobile thematic storytelling system. Our observations suggest that systems designed to support travellers telling stories as they are travelling should recognize that story-gathering and storytelling are related but distinct activities, should provide recommendations that are inspiring rather than prescriptive, and could allow for flexible planning and putting of recommendations "on hold". This is quite different from our original design, which was based on the premise that the system should help tourists to tell stories on-the-fly by detecting the thematic structure of an ongoing story and making specific suggestions as to what the tourist should photograph next to continue the story.

Our findings suggest a number of areas for future work. Given that our participants did not want to be distracted from being in the moment, one next step would be to explore ways in which a system can help a tourist gather materials for a story without disrupting the tourist's engagement with the location. It would also be interesting to explore ways to provide evocative, inspiring recommendations which help tourists to discover story material. Finally, our participants' desire to reflect on and have some distance from the events being experienced before crafting a story suggests we need to better understand how to support the storytelling process in a situated context. This raises questions as to what can be considered "enough" distance for reflection, and how a storytelling system can help to encourage reflection and storytelling as events are taking place.

Indeed, a major question raised by our study is whether someone can both experience and tell others about a story while they are still actively engaged with the events as the events are happening. Any insights that can be gained into this problem would have applications for interactive storytelling in general.

Acknowledgments. This research is supported by the Singapore National Research Foundation under its International Research Center Keio-NUS CUTE Center @ Singapore Funding Initiative and administered by the IDM Program Office.

References

1. Hargett, J.: Some preliminary remarks on the travel records of the song dynasty (960-1279). Chinese Literature: Essays, Articles, Reviews (CLEAR) 7(1/2), 67–93 (1985)
2. Towner, J.: The grand tour: a key phase in the history of tourism. Annals of Tourism Research 12(3), 297–333 (1985)
3. Russell, A.: Crossing boundaries: postmodern travel literature. Palgrave Macmillan (2000)
4. Gretzel, U., Fesenmaier, D., Lee, Y., Tussyadiah, I.: Narrating travel experiences: the role of new media. Tourist Experience: Contemporary Perspectives 19, 171 (2010)
5. Harper, R., Whitworth, E., Page, R.: Fixity: Identity, time and durée on facebook. Selected Papers of Internet Research (2012)
6. Lu, X., Wang, C., Yang, J.M., Pang, Y., Zhang, L.: Photo2trip: generating travel routes from geo-tagged photos for trip planning. In: Proc. ACM Multimedia 2010, pp. 143–152. ACM Press (2010)
7. Cheng, A.J., Chen, Y.Y., Huang, Y.T., Hsu, W.H., Liao, H.Y.M.: Personalized travel recommendation by mining people attributes from community-contributed photos. In: Proc. ACM Multimedia 2011, pp. 83–92. ACM Press (2011)
8. Schöning, J., Hecht, B., Starosielski, N.: Evaluating automatically generated location-based stories for tourists. In: CHI 2008 Extended Abstracts, pp. 2937–2942. ACM Press (2008)
9. Nack, F., El Ali, A., van Kemenade, P., Overgoor, J., van der Weij, B.: A story to go, please. In: Aylett, R., Lim, M.Y., Louchart, S., Petta, P., Riedl, M. (eds.) ICIDS 2010. LNCS, vol. 6432, pp. 74–85. Springer, Heidelberg (2010)
10. Vriesede, T., Nack, F.: StoryStream: Unrestricted mobile exploration of city neighbourhoods enriched by the oral presentation of user-generated stories. In: Si, M., Thue, D., André, E., Lester, J., Tanenbaum, T.J., Zammitto, V. (eds.) ICIDS 2011. LNCS, vol. 7069, pp. 231–242. Springer, Heidelberg (2011)
11. Chi, P., Lieberman, H.: Intelligent assistance for conversational storytelling using story patterns. In: Proc. IUI 2011, pp. 217–226. ACM Press (2011)
12. Packer, H., Smith, A., Lewis, P.: Memorybook: generating narratives from lifelogs. In: Proc. Narrative and Hypertext 2012, pp. 7–12. ACM Press (2012)
13. Ryan, M.L.: Narrative in real time: Chronicle, mimesis and plot in the baseball broadcast. Narrative 1(2), 138–155 (1993)
14. Prince, G.: A Dictionary of Narratology (revised edition). University of Nebraska Press (2003)
15. Tomashevsky, B.: Thematics. In: Russian Formalist Criticism: Four Essays, pp. 61–95. University of Nebraska Press, Lincoln (1965)
16. Hargood, C., Millard, D.E., Weal, M.J.: A semiotic approach for the generation of themed photo narratives. In: Proc. Hypertext 2010, pp. 19–28. ACM Press (2010)
17. Hargood, C.: Semiotic Term Expansion as the Basis for Thematic Models in Narrative Systems. PhD thesis, Faculty of Engineering and Applied Science, Department of Electronics and Computer Science, University of Southampton (2011)
18. Sharples, M.: How We Write: Writing as Creative Design. Routledge, London (1999)

Towards Automatic Story Clustering
for Interactive Narrative Authoring

Michal Bída, Martin Černý, and Cyril Brom

Charles University in Prague, Faculty of Mathematics and Physics,
Malostranské nám. 2/25, Prague, Czech Republic

Abstract. Interactive storytelling systems are capable of producing many variants of stories. A major challenge in designing storytelling systems is the evaluation of the resulting narrative. Ideally every variant of the resulting story should be seen and evaluated, but due to combinatorial explosion of the story space, this is unfeasible in all but the smallest domains. However, the system designer still needs to have control over the generated stories and his input cannot be replaced by a computer. In this paper we propose a general methodology for semi-automatic evaluation of narrative systems based on tension curve extraction and clustering of similar stories. Our preliminary results indicate that a straightforward approach works well in simple scenarios, but for complex story spaces further improvements are necessary.

1 Introduction

Development of interactive storytelling (IS) systems is a challenging process involving multi-disciplinary knowledge. Despite this, a number of working interactive storytelling systems was developed through the years. Some examples of these systems involving intelligent virtual agents are games such as Façade [1] or Prom Week [2], research projects such as ORIENT [3] or BierGarten [4], educational games such as FearNot! [5] or immersive IS systems such as Madame Bovary [6].

Evaluation of these systems is a demanding process often requiring extensive effort. State of the art evaluation of IS systems involves either surveys with users, e.g. [7], or technical evaluations such as comparing length and complexity of generated stories. Neither of these approaches is well suited for practical development. While well designed user surveys can capture the quality of generated stories correctly, they are costly and take a lot of time and thus it is problematic to make them part of a regular development cycle. Since combinatorial explosion of the story space is in most cases a desirable property of an IS system, it necessarily follows that for large-scale IS systems a thorough sampling of the story space by human users is costly at least and unfeasible at worst. While technical evaluations of the narratives are feasible for much larger story spaces than user studies and are significantly cheaper, they are only loosely related to the actual enjoyment of the stories by the user and do not allow the story author to understand what is happening in the generated stories and to shape them according to his artistic vision. In this paper we will consider a method allowing

H. Koenitz et al. (Eds.): ICIDS 2013, LNCS 8230, pp. 95–106, 2013.

for computer-assisted evaluation of stories generated by an IS system. In general, the human designer is kept in the loop, but the computer aggregates data from the system so that only relevant parts of the story space need to be inspected directly. We will focus on meaningful clustering of generated stories to groups with similar properties.

This paper is organized as follows: First, we will survey related work concerning drama analysis. Then we will describe our methodology of drama analysis and present some preliminary results on data gathered from two versions of our IS system [8] and [27]. We will conclude the paper with discussion and future work.

2 Related Work

In this section we present an overview of literature relevant to semi-automatic story evaluation. To our knowledge only little work has been done on story clustering. This overview is mostly a list of interesting ideas that could be reused in the context of automatic narrative evaluation and clustering.

In [9], Brewer and Lichtenstein propose a structural-affect theory of stories with three main aspects – surprise, suspense and curiosity. They claim that these aspects affect how much the reader likes the story. They outline how these aspects manifest in stories. In our approach we consider only tension (suspense) curve so far, however surprise and curiosity curves may be good candidates for additional story features.

In [10], y Perez and Sharples describe MEXICA, a system capable of producing emergent stories with user assistance. Among others, it uses tension curve of the stories to evaluate interestingness based on tension degradation and improvement in time. In our work we are currently only interested in overall tension curve shape.

Ware et al. [11] present four quantitative metrics describing narrative conflict. The measurement and conflict detection are based on a planning representation of the narrative, making them harder to employ in non-planning IS systems. Their evaluation showed the automatic evaluation matched user evaluations of conflicts. An interesting future work may be to detect conflicts in the story, evaluate these conflicts based on [11] and use the output as additional story features.

Weyhrauch [12] implements several evaluation functions for his emergent narrative system. These functions encode the accumulated domain knowledge of the author and hence are tightly bound with his storytelling system domain. However these functions provide a good example of what can be measured in IS and how it can be done.

In [13] Ontañón and Zhu propose an analogy-based story generation system, where they evaluate the quality of resulting stories by measuring their similarity to "source" stories (input human-made stories). The similarity metric is based on MAC/FAC model [14]. This work provides an alternate approach to similarity measure based on case based reasoning.

Cheong et al. [15] present a system capable of extracting the story plan from game logs and generating a visual story summarization. Although the system is not concerned with story evaluation directly, story abstractions created by this method could be a good input for an evaluation metric.

Schoenau-Fog [7] discusses how to evaluate interactive narratives with users by questionnaires and intrusive methods. Although the techniques are not automatic, some of the ideas may be transferrable to automatic evaluation systems.

In [16], Rabe and Wachsmuth propose an event and an episode similarity metric for their virtual character. Although they are not using this in the context of story evaluation, the features they are working with might be reused in this context.

Zwaan et al. [17] propose and test a model of how readers construct the representations of situations occurring in short narratives. They claim that the readers of stories update their mental models along five indices: temporality, spatiality, protagonists, causality and intentionality. These ideas could be used as a basis of automatic evaluation systems.

Porteus et al. [18] use Levenshtein string distance to measure differences between various stories generated by their storytelling system.

Aylett and Louchart [19] propose the use of double appraisal to increase the dramatic tension of an action. Their characters choose next actions based on their current emotions and based on the emotional impact of their actions on other characters in the story. To simulate emotions and to measure emotional impact, OCC based model is used. The difference between their and our approach is that we are using the output emotional impact to compute the tension curve and not to influence the decision making of our characters.

Kadlec et. al [20] uses compressibility and conditional entropy to measure similarity between sequences of actions gathered by human tracking and by daily corpora simulator.

Narrative evaluation is a complex topic involving general narrative and drama theories, human and computational story abstractions, algorithms allowing for comparisons and evaluations of these abstractions and data gathering methods. In our approach we have put together the following ideas presented above: a) the use of tension curve to represent the story, b) measurement of story similarity to group stories together and c) the use of string metrics to define difference between stories. The novel part of our approach is our tension curve extraction mechanism and the use of a standard machine learning clustering algorithm for grouping the stories together. Our methodology will be described in detail in the next section.

3 Methodology

We propose semi-automatic narrative analysis by a meaningful clustering of narratives into groups with similar stories. This would work as follows: a) the developer uses his system to generate large number of stories, b) the developer runs our clustering algorithm dividing the stories into groups and c) the developer now needs to see only several stories from each group to evaluate the system as the other stories in the group are similar, saving development time. Our clustering is based on two general features of stories: a) a story action sequence and b) a story tension (dramatic) curve. As a clustering algorithm, we use k-means [21] (details in section 3.2).

To evaluate the methodology we have conducted experiments on our IS system SimDate3D (SD) level one detailed in [8]. SD level one is a simple 3D dating game where the goal of the user is to achieve that a couple – Thomas and Barbara – gets to the cinema. The game comprises a sketchy conversation through comic-like bubbles called emoticons and the user partially controls one of the characters actions. There are three possible endings of this story: a) characters get to the cinema safely, b) characters get angry and part and c) characters interaction is too positive, so they decide to skip the cinema and head home. Recently, we have developed a sequel – SD level two [27] (Fig. 1) – an extended scenario, where Thomas is now dating two girls at the same time. All game sessions end with all three characters meeting and engaging in an argument. The outcome of this argument depends on previous user actions and there are four endings: a) Thomas staying with Barbara and breaking up with Nataly, b) Thomas staying with Nataly and breaking up with Barbara, c) both girls breaking up with Thomas and d) Thomas staying in the relationship with both girls.

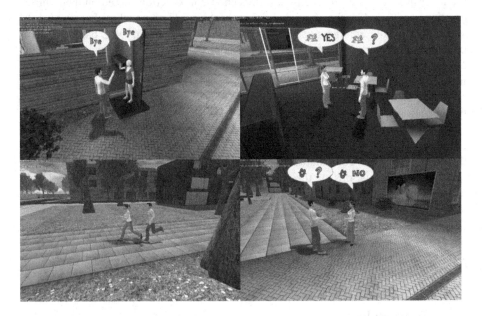

Fig. 1. Screenshots from SimDate3D showing interactions between characters

3.1 Tension Curve Extraction

The dimension of tension was proposed by Freytag in his book [22] where he expanded the Aristotle's theory of dramatic events. Most narratives of mainstream books and movies follow one of the standardized tension curve shapes. Hence stories generated by IS systems should usually follow one of the curves as well. Indeed, tension curves have been explicitly or implicitly modeled by multiple IS systems (e.g. [1]). But how to extract a tension curve from generated stories in general? One possible way is to let the authors annotate each action or plot sequence with a tension

value. The tension curve of the story could then be constructed from individual tension values. The problem here is that the tension of actions often depends on the current story context, which makes such annotations very difficult.

On the other hand story tension is often related to emotions experienced by the story protagonists. Thus the tension could be extracted from character emotions, if the IS system does explicitly represent them. Note that this approach also has its limitations. For example consider a situation where a dark figure is following someone in a deserted part of the town. As the figure gets closer the tension in the story indeed rises. However, this may not be represented well by character emotions as the one who is followed may not be aware that someone is following him. One of the ways of solving this issue is to generate tension from emotion model simulating the user emotions directly based on what the user perceives in the story at the moment. A method involving double appraisal [19] might be a reasonable candidate.

In our IS system, characters are equipped with OCC-based [23] emotion model, which directly influences their decision making. We have defined tension in our IS system as follows: Every 250 ms we have made a snapshot of all characters' emotions. Then we took the sum of these emotions where every positive emotion was counted with a minus sign and every negative emotion was counted with a plus sign. The resulting number encoded the tension value at the moment. The tension curve is then simply the piecewise linear function defined by these values.

3.2 Clustering

To compute clusters for stories in our IS system we have used k-means clustering algorithm [21]. The k-means clustering algorithm is a method of analysis which aims to partition n samples (in our case stories) into k clusters (k groups of stories) such that the distance between stories within a single cluster is minimized. The distance is computed with a user specified metric. The k is fixed and given by developers. The k-means algorithm requires initialization of the starting position of clusters. Afterwards it works in two stages. First it assigns the "nearest" cluster to each sample. Then it moves all clusters by computing the average of members in the cluster and shifting the cluster towards this new average. These two stages are repeated until the clusters become stable or a maximum number of steps is reached.

The idea of using k-means is that if we define the "distance" between stories right, then every resulting cluster will contain stories that are somehow similar to each other. We have tested and compared four distance metrics. One was based on the tension curves of the stories and three were based on the action sequences of the stories.

To compute the distance between stories using tension curves, we simply computed the distance between tension values from one story to values from the other and summed absolute values of the differences as seen in formula (1), where x and y are tension curve vectors of respective stories and n is the length of the vectors. If the tension curves differed in length, the shorter was expanded to match the size of the larger by adding zeros.

$$\text{distance}(x, y) = \Sigma_{i=1..n} |x_{(i)} - y_{(i)}| \qquad (1)$$

To compute distance between action sequences, we have first encoded the action sequences as *action strings*. The raw actions extracted from our system look like "Thomas greets Barbara", "Barbara greets Thomas", "Thomas asks Barbara to go to the cinema", etc. We have assigned a single letter to encode every action type (e.g. the action "says hi" is represented by "A" regardless of who said it). The action string is formed by concatenating letters representing the individual actions in the sequence. There are around 50 possible actions in our scenario (we used upper and lower case letters and numbers to encode them). For level two we have added one more letter per action representing the character performing the action (see 4.1 and 4.2 for examples).

To measure distance of action strings we have tested three standard string difference metrics – Levenshtein distance [24], Jaccard index [25] and Jaro-Winkler distance [26]. To summarize, the distance between stories in this case was defined by the string difference metrics working on *action strings* of the stories.

Motivation for using string metrics in the analysis is twofold. Firstly, the action sequence is a natural representation of the story. Secondly, string distance is a well studied subject and many techniques that could be directly applied to our case were tested and developed in a different field. And in case of Levenshtein distance being applied on our *action strings*, the string editing procedure which defines the metric can be perceived as a rudimentary form of story editing.

To run k-means clustering with the distance metrics presented in this section we needed to solve two issues: a) random initialization of clusters and b) computation of cluster average from its members with a given distance metric. Concerning a) the random initialization of clusters sometimes caused undesirable behavior where one or more of the clusters were so far from the samples that they stayed empty the whole time. To compensate for this we have initialized clusters as follows. For each cluster we have selected one story from the sample set at random that defined the initial position of the cluster. Concerning b) the problem was that for string distance metrics it may not be clear what an average of several action strings means. When computing the average from cluster members with string distance metric we have simply iterated over all members of a cluster and picked the member with the lowest sum of distances from the other members. This member then became the new cluster average.

3.3 Evaluation

Our goal in this stage was to evaluate the quality of k-means clustering based on story distance definitions above. We have examined the performance on two domains – SD level one and SD level two. Level one presented a simple domain and level two a complex domain. For level one we have run k-means clustering with three, four and five clusters (defining the resulting number of clusters). Level two was run with k set to four, five and six clusters. It is known that k-means clustering may converge to local optima. To account for this we have run each setting of k-means clustering eight times, e.g. k-means with four clusters and tension curve distance metric was run eight times on level one and the results were averaged.

As there is no generally accepted method for evaluating the quality of clustering independent of the application, we have resorted to ad hoc method suitable for our

scenario. Our goal in this stage was to confirm whether the k-means algorithm with a specific distance metric is capable of detecting some of the meaningful features of the input stories, i.e. whether it would group stories with similar values of the feature in one cluster. In level one, we have examined a single feature and in level two we have examined two features. First and the most important feature of the story was defined by the story ending (both levels feature multiple endings). The question then was: "Do stories grouped in one cluster end the same when using a particular input distance metric?" This is represented by *precision* of the metric. To obtain precision we first identified the most frequent ending within each cluster. Then we defined the cluster precision as the fraction of the stories with this ending inside the cluster. The resulting precision for input distance metric was then weighted average of precisions of all resulting clusters. Precision thus takes values between zero and one. Precision was used both in level one and in level two.

In level two we have also inspected how much time (in seconds) Thomas interacts with girls and how much time he stays alone. If the clustering works well with respect to this feature, we would expect stories in the same cluster to have similar values, e.g. Thomas interacts with Barbara in each story from one group roughly the same time. To measure this we define *time deviations* of a cluster that are the standard deviations of the respective times gathered from stories in that cluster. E.g. cluster with two stories where Thomas interacts with Barbara for 60 and 120 seconds has higher deviation than cluster with three stories where the respective times are 110, 120 and 130 seconds. The lower the deviation the more "similar" the stories are.

To summarize we have run k-means algorithm with four story distance metric on two domains with different resulting number of clusters multiple times. Story distance metric for k-means were tension curve distance and Levenshtein, Jaccard and Jaro-Winkler distance on action strings. We compared how similar are stories in resulting clusters according to two features – story ending and time the characters spend together in the story. As a baseline we used a random cluster assignment where the clusters were not determined by k-means but every story was assigned to a cluster at random – this randomization was repeated 8 times and results were averaged, precisely as with regular clustering runs.

4 Results

We have run the analysis on two datasets. First dataset was 1135 play sessions of game SimDate3D level one generated automatically with user input being simulated by a random algorithm. Second dataset was 41 human play sessions of game SimDate3D level two which exhibits more complex domain with more game endings.

4.1 Level One

From 1135 play sessions of game level one, 608 stories ended with characters getting angry with each other and parting, 479 ended with characters being too positive and not reaching the cinema, 16 stories ended with characters getting to the cinema and 32

stories endings were undefined (because of some technical issues). To compensate for having only 16 stories endings with characters getting to the cinema, we have used multi-sampling by a factor of 15 for these types of endings (meaning that each "cinema" story was present 15 times in the dataset). The low number of these stories is not surprising as it is necessary to "steer" the conversation between agents intelligently to assure they will get to the cinema – a thing that the randomized user input did not account for. Since there are three possible endings we clustered into 3 – 5 clusters.

Two level one stories with intimate ending:

"AABDBHHIMOIOIOJDFLCCDYHGLQPHPHPHPHPHPHPHPHPHPHPHLHQDFGIODFGIOODYGLHIDMH
NMNPHPHPHPHPHNHIOU<u>UUUUVQWDP</u>"

"AABDBHHMNIOIODFGLLCCPHPHPHPDMHNU<u>UUUUVQWDP</u>"

Two level one stories with breakup ending:

"AACPDMADPDD<u>ZG00123</u>"

"AABDBHHMNIOMNJ6LCDMHMCMHNIOTLDTHMNMPHPHPHPHPHPHPMHNbDTTM<u>ZG00123</u>"

Fig. 2. Level one stories action strings examples. The figure shows action strings of two stories with intimate ending and of two stories with breakup ending. Notice that the last few actions are the same for intimate endings and breakup endings (underlined).

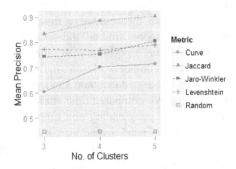

Fig. 3. Level one clustering results. Cluster precision weighted averages can be seen for three, four and five clusters. The results are averaged over eight clustering runs with different initial cluster positions.

Our results indicate that all of k-means distance metrics were able to cluster the simpler domain of level one with high cluster precision (Fig. 3). Quite surprising is the high value of precision for Jaccard index. Jaccard index compares only the number of same actions in both samples (their intersection divided by their union) not taking action positions into account. We believe that one of the causes of Jaccard index doing well is that two of the endings had pre-scripted final action sequences (Fig. 2) which biased the string distance metrics. For this reason, we removed all pre-scripted actions at the end of the stories for the experiments in level two. Other reason of string metrics doing well in the scenario in general is the relative simplicity – more negative actions in the scenario meant the probability of negative ending increased and vice versa. These straight-forward influences created a bias favoring the string

metrics in level one. The tension curve scored the worst with precision ranging from 0.6 for three clusters to 0.76 for five clusters. All metrics scored significantly better than the random cluster assignment.

4.2 Level Two

From 41 play sessions of level two, 14 stories ended with Thomas staying with Barbara, 21 stories ended with Thomas staying with Nataly, 4 stories ended with both girls breaking up with Thomas and 2 stories ended with Thomas staying in relationship with both girls. To compensate for the low number of endings of the latter two we have used multi-sampling by a factor of two for the stories with these endings. Since there are four possible endings we have tried clustering into 4 – 6 clusters. More clusters were not tried, because already with 6 clusters present, some of them were almost empty due to lower initial number of stories. Example action strings for level two are shown in Fig. 4.

Two level two stories with "stay with Barbara" ending:

```
"ABACDBDEF4APDQDNAOD1AkDEDrACA9D5DQDNAOAPACDEA2D2A2DQDNAPAOD1ACAKDKALDQD
NAPDMACANDQDNAPAOACAPDQDNAOFQDNACAJAPDQDNAOFQDQF4D1"
"ABACDBDEF4DKAkDkAkDkAkDkDQDtAtAPABDBAGDEAPDQAGDED1A1D1AID1AmDrAJD1A9FQF
cF4"
```

Two level two stories with "stay with Nataly" ending:

```
"DBDEABACF4APDQDnAnDBABDEAqD1AkDkAkDkAkDIAIDIAIDIDQDhAMAPD1A9DQDhAqA2AgA
PDQDhAgFQDQDhAgFBFQDQAqF4DEAPDL"
"F4ABACDBDEAmDJAkDQDtAtAPABDBAGDEAPDQAGDEDQDjAjAPABDBATDEAPDQATDEDJAmDmA
1D1A1D1A1D1DQDhAMAPFQDQDhAgFBFQATDQAKF4"
```

Fig. 4. Level two stories action strings examples. Notice the sequences are longer than level one sequences. There are two reasons for this: a) level two takes longer to complete and thus more actions are performed and that b) in level two each action is coded by two letters, first letter marks the character that performed the action (D – Thomas, A – Barbara and F – Nataly), second letter marks the action, e.g. "AB" marks Barbara performing action "set focus".

The preliminary results on level two show a drop in cluster precision of string based metrics indicating the higher complexity of the domain. The tension curve metric demonstrated the highest precision. Without multisampling, the mean precision of curve metric for 5 clusters was 0.66, while random clustering had precision of 0.58. Multisampling has resulted in an increase of precision (0.73). See Fig. 5, upper left for overall trends with other distance metrics. The time deviations of all metrics were lower than that of random cluster assignment (see Fig. 5), however the gap is not large enough to allow for strong conclusions. Note however, that for "Nataly" and "Alone" time deviations the tension curve performs the worst, although only by a small margin. Still, no string distance metric performs better than tension curve considering the 4 tasks together.

The good performance of the tension curve may be an indicator that the tension curve scales better than the somewhat naïve string distance metrics. The problem of

the string distance metrics might be that they do not make any abstraction of the story from the qualitative point of view and may be misled by action sequences that look different, but are not different from the story perspective (e. g. talking about weather and talking about yesterday lunch both represent casual conversation but have different action sequences). Moreover, the action sequences contain actions that may not be directly related to story tension, e.g. move actions and set focus actions. One of the ideas how to improve the performance could be to prune actions like this from the sequence. However, note that results for level two are preliminary and the trends need to be confirmed by running the clustering on larger data sets and different domains.

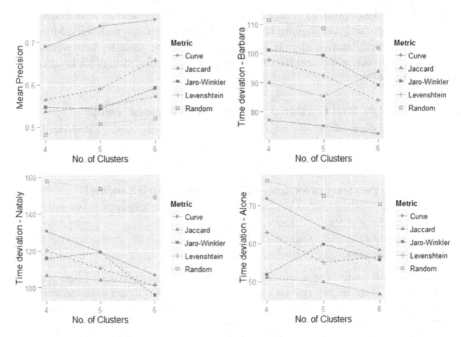

Fig. 5. Level two clustering results. Clusters precision plot (upper left) shows tension curve outperforming string metrics suggesting that it scales better. Time (in seconds) deviation plots for Barbara and Thomas interaction (upper right), Nataly and Thomas (lower left) and Thomas alone (lower right) show that all metrics are doing better than a random assignment (lower deviation means the stories are "closer" to each other in this sense). The results are averaged over eight clustering runs with different initial cluster positions.

5 Conclusion and Future Work

We have presented a methodology for semi-automatic evaluation of interactive storytelling systems based on a meaningful clustering of similar stories with k-means algorithm that could be plugged in an IS development cycle.

First results indicate that considering precision on a simple domain string distance metrics outperform tension curve metric (results from experiments on SimDate3D

level one), but they fail to scale well on a complex domain of SimDate3D level two, where tension curve metric outperformed them. This hints us that the tension curve metric is likely to scale better, but this needs to be confirmed by further experiments. The results for time deviations in level two are less clear and best metric could not be determined for that case.

The next steps are to evaluate this methodology on other domains and larger data sets. We are now in the process of gathering more data for SimDate3D level two.

As our future work we want to investigate the possibilities of using the tension curve to detect more fine-grained features of the input stories, e.g. conflict detection and classification. Other candidates for new features include separate evaluation of emotional state for each pair of characters. So far we have used k-means clustering with one distance metric at once, but k-means algorithm allows for combination of distance metrics. This could increase the clustering performance on stories.

More work could also be done to develop "smart" random user that would be able to explore parts of the story space more intensively, as instructed by the designer.

Acknowledgments. This work was partially supported by the student research grant GA UK 559813/2013/A-INF/MFF, by the SVV project number 267 314 and by the grant P103/10/1287 from GAČR.

References

1. Mateas, M., Stern, A.: Façade: An experiment in building a fully-realized interactive drama. In: Game Developer's Conference: Game Design Track (2003)
2. McCoy, J., Treanor, M., Samuel, B.: Prom Week: social physics as gameplay. In: Proceedings of the 6th International Conference on Foundations of Digital Games, pp. 319–321 (2011)
3. Aylett, R., Kriegel, M., Lim, M.: ORIENT: interactive agents for stage-based role-play. In: Proceedings of the 8th International Conference on Autonomous Agents and Multiagent Systems, vol. 2, pp. 1371–1372 (2009)
4. Endrass, B., Rehm, M., André, E.: Planning Small Talk behavior with cultural influences for multiagent systems. Computer Speech & Language 25(2), 158–174 (2011)
5. Aylett, R., Vala, M., Sequeira, P., Paiva, A.: FearNot! – an emergent narrative approach to virtual dramas for anti-bullying education. In: Cavazza, M., Donikian, S. (eds.) ICVS 2007. LNCS, vol. 4871, pp. 202–205. Springer, Heidelberg (2007)
6. Cavazza, M., Lugrin, J., Pizzi, D., Charles, F.: Madame bovary on the holodeck: immersive interactive storytelling. In: Proceedings of the 15th International Conference on Multimedia, pp. 651–660 (2007)
7. Schoenau-Fog, H.: Hooked! – evaluating engagement as continuation desire in interactive narratives. In: Si, M., Thu, D., André, E., Lester, J., Tanenbaum, T.J., Zammitto, V. (eds.) ICIDS 2011. LNCS, vol. 7069, pp. 219–230. Springer, Heidelberg (2011)
8. Bída, M., Brom, C., Popelová, M.: To date or not to date? A minimalist affect-modulated control architecture for dating virtual characters. In: Vilhjálmsson, H.H., Kopp, S., Marsella, S., Thórisson, K.R. (eds.) IVA 2011. LNCS, vol. 6895, pp. 419–425. Springer, Heidelberg (2011)

9. Brewer, W., Lichtenstein, E.: Stories are to entertain: A structural-affect theory of stories. Journal of Pragmatics (1982)

10. y Pérez, P., Sharples, M.: MEXICA: A computer model of a cognitive account of creative writing. Journal of Experimental & Theoretical Artificial Intelligence 13(2), 119–139 (2001)

11. Ware, S.G., Young, R.M., Harrison, B., Roberts, D.L.: Four quantitative metrics describing narrative conflict. In: Oyarzun, D., Peinado, F., Young, R.M., Elizalde, A., Méndez, G. (eds.) ICIDS 2012. LNCS, vol. 7648, pp. 18–29. Springer, Heidelberg (2012)

12. Weyhrauch, P., Bates, J.: Guiding interactive drama. PhD. Thesis (1997)

13. Ontañón, S., Zhu, J.: On the role of domain knowledge in analogy-based story generation. In: Proceedings of the Twenty-Second International Joint Conference on Artificial Intelligence, pp. 1717–1722 (2011)

14. Forbus, K., Gentner, D., Law, K.: MAC/FAC: A model of similarity-based retrieval. Cognitive Science 19(2), 141–205 (1995)

15. Cheong, Y., Jhala, A., Bae, B., Young, R.: Automatically generating summary visualizations from game logs. In: Proc. AIIDE, pp. 167–172 (2008)

16. Rabe, F., Wachsmuth, I.: An Event Metric and an Episode Metric for a Virtual Guide. In: Proceedings of the 5th International Conference on Agents and Artificial Intelligence, vol. 2, pp. 543–546 (2013)

17. Zwaan, R.A., Langston, M.C., Graesser, A.C.: The construction of situation models in narrative comprehension: An event-indexing model. Psychological Science 6(5), 292–297 (1995)

18. Porteous, J., Charles, F., Cavazza, M.: NetworkING: using character relationships for interactive narrative generation. In: Proceedings of the 2013 International Conference on Autonomous Agents and Multi-Agent Systems, pp. 595–602. IFAAMAS (2013)

19. Aylett, R., Louchart, S.: If I were you - Double appraisal in affective agents. In: Proc. of 7th Int. Conf. on Autonomous Agents and Multiagent Systems (AAMAS 2008), pp. 1233–1236 (2008)

20. Kadlec, R., Čermák, M., Behan, Z., Brom, C.: Generating Corpora of Activities of Daily Living and towards Measuring the Corpora's Complexity. In: Dignum, F., Brom, C., Hindriks, K., Beer, M., Richards, D. (eds.) CAVE 2012. LNCS, vol. 7764, pp. 149–166. Springer, Heidelberg (2013)

21. Hastie, T., Tibshirani, R., Friedman, J.: The Elements of Statistical Learning. Springer, New York (2001)

22. Freytag, G.: Technique of the Drama: An Exposition of Dramatic Composition and Art (1863)

23. Ortony, A., Clore, G.L., Collins, A.: The cognitive structure of emotions. Cambridge University Press, Cambridge (1988)

24. Levenshtein, V.I.: Binary codes capable of correcting deletions, insertions, and reversals. Soviet Physics Doklady 10(8), 707–710 (1966)

25. Jaccard, P.: Étude comparative de la distribution florale dans une portion des Alpes et des Jura. Bulletin de la Société Vaudoise des Sciences Naturelles 37, 547–579 (1901) (in French)

26. Winkler, W.: String Comparator Metrics and Enhanced Decision Rules in the Fellegi-Sunter Model of Record Linkage. In: Proceedings of the Section on Survey Research Methods (American Statistical Association), pp. 354–359 (1990)

27. Bída, M., Černý, M., Brom, C.: SimDate3D – Level Two. In: Koenitz, H., Sezen, T.I., Ferri, G., Haahr, M., Sezen, D., Çatak, G. (eds.) ICIDS 2013. LNCS, vol. 8230, pp. 128–131. Springer, Heidelberg (2013)

Breaking Points — A Continuously Developing Interactive Digital Narrative

Hartmut Koenitz[1], Tonguc Ibrahim Sezen[2], and Digdem Sezen[3]

[1] University of Georgia, Department of Telecommunications, 120 Hooper Street
Athens, Georgia 30602-3018, USA
hkoenitz@uga.edu
[2] Istanbul Bilgi University, Faculty of Communication, Santralistanbul,
Kazim Karabekir Cad. No: 2/13, 34060 Eyup – Istanbul, Turkey
tonguc.sezen@bilgi.edu.tr
[3] Istanbul University, Faculty of Communications, Kaptani Derya Ibrahim Pasa Sk. 34452
Beyazit - Istanbul, Turkey
digdemsezen@gmail.com

Abstract. *Breaking Points* is an interactive digital narrative (IDN) that puts the user in the position of a young woman who feels trapped in a daily routine she would like to escape from. The narrative design connects more important decisions with seemingly trivial ones and presents the user with immediate and delayed consequence in the form of narrative feedback, for a complex and more life-like experience. By aligning the experience of a single walkthrough with a day in the life of the heroine, the project invites replay. The project is also a study of authorial challenges and opportunities offered by different authoring modes, namely the switch from coding from scratch to the ASAPS environment. As the project is prepared for release on touch-based tablets, the paper focuses on how changes in the underlying technology have afforded continuous reshaping of the narrative.

Keywords: Narrative Design, Authoring Tools, Narrative Decisions and Delayed Consequences, Narrative Feedback, Replay, Protostory, Affordances of Authoring, Interactive Digital Storytelling Interactive Digital Narrative.

1 Introduction

The drudgery of a daily routine, an existence stuck in a boring, dead-end job, and how to escape from it, but also the issue of perception, the inability of a character to see the small joys and the opportunities offered to her – these are the main topics of the interactive digital narrative (IDN) *Breaking Points* The project explores how small and seemingly unimportant choices impact a character's life as much as decisions we place greater importance on. The related idea of the famous "butterfly effect," that a small insect's movement over the Andes mountain can cause a tornado in far away Florida, is a fruitful basis for interactive narrative experiments. A computational system can process many such small choices and select or generate alternate paths accordingly. Replay then allows the user to experience different paths and outcomes.

H. Koenitz et al. (Eds.): ICIDS 2013, LNCS 8230, pp. 107–113, 2013.

In *Breaking Points* the notion of repeating and retrying is a key meaning-making element. The underlying narrative concept has been refined continuously in several releases since 2006. In its current form, this IDN project is implemented for touch-screen tablets under iOS.

2 The Narrative

Breaking Points is partly inspired by time-loop stories like the movie *Groundhog Day* [1]. The nameless heroine is indeed trapped in a loop – everyday she follows the same routine: She wakes up, gets ready for work, takes the same bus, repeats the same actions at work and returns to her apartment alone. However, she secretly wants to break out of the loop to become a fashion designer and is making steps towards that goal. On this backdrop, the narrative explores a rich amount of variations in her daily life, caused by small and large changes in her behavior, and tracks her progress and mood between hope and desperation.

Breaking Points is similar in presentation to the predominantly Japanese IDN genre visual novel [2] i.e. *Phoenix Wright: Ace Attorney* [3] with still images, animations and text. Likewise, the interaction is either in the form of conversation choices or by selecting embedded hot spots. Where our work differs is in the narrative design, which emphasizes narrative development in the form of varied paths. Instead of a long-draw out narrative, our *Breaking Points* focuses on variety within a loop, created by consecutive presentations of the heroine's daily life.

We applied two main concepts in the narrative design – first, a web of interconnected major and trivial decisions and secondly a balance between immediate and delayed consequences in the form of narrative feedback. We balance interactive, turn-based situations with sequences of screens that present the resulting consequences as narrative feedback in contrast to solutions that apply on-screen elements like progress meters or level-based designs for feedback. In this way, the user makes a series of decisions for the heroine, some of which seem trivial like where to start with the make-up in the morning. (Figure 1)

Fig. 1. A seemingly trivial choice – Where to start with the make-up?

Other decisions are expected to be potentially life-changing, for example whether to accept an invitation to a date by a male colleague. (Figure 2). While the user will most likely expect the "big" choices to be the major factor for change in the narrative, the narrative design complicates this expectation. Some actions, like the decision to answer the phone, will immediately result in missing the bus, but will also have secondary effects like meeting an old friend at the bus stop and annoying the boss at work. Other decisions, like which dress to wear or where to start with the makeup will not result in any immediate consequence, but will affect the heroine's path later. For example, choosing the red dress will make it more likely for her to be asked out for a date by one of the men she encounters, but this relation is complicated by other factors, for example if she will be on time for work by not missing the bus. Such delayed consequences, which are influenced by additional factors result in more variety in the narrative and incentive for replay. This complicated relationship between decision and outcome attempts to mimic real-life experiences and the often opaque and indirect relations between our actions and the results. While the work ostensibly asks the user to help the heroine to change her life, it really focuses on narrative development, on the variety of choices and consequences rather than on a particular outcome. As a consequence, the narrative does not employ any difficult puzzles or hard choices; in addition, by aligning a single walkthrough with a day, we attempt to make replay – as an experience of the next day in the circle of life – seem natural and even inevitable.

Fig. 2. A major decision – accept the invite or not?

In the current version, the nature of the relationship between actions and consequences is not statically pre-determined, but controlled by procedural elements which evaluate the current position in the narrative and earlier decisions. In addition we introduced limited randomness to control the appearance of NPC; for example the heroine might not meet a potential romantic interest in one walkthrough, which will be there in another. Finally, there are aspects of the narrative are static, to provide orientation for the user and reflect the theme of a daily routine. For example, the user

has to endure mundane actions such as stamping papers to connect her more deeply with character's situation.

Each run of *Breaking Points* creates a coherent narrative with different events based on the factors described above. Yet while a single experience is meaningful by itself the full depth of the procedural narrative can only be appreciated through several plays. Regardless how hard we try, our actions large and small together form a complicated web of interdependent consequences, which in turn affect the outcome and limit our agency. Replay (or *rereading* in Mitchell and McGees's terms [4]) is essential to understanding this key message of the narrative.

3 Authoring

The first version of *Breaking Points* was implemented in Adobe Flash [4] in 2006 [5], by a creative team, including cinematographers, graphic artists and coders. This original project was designed as a branching narrative consisting of still images with links embedded in invisible hotspots. Characters and scenery were drawn over photographs taken on location with actors, resulting in a look inspired by both comic books and rotoscoped animations seen in films like *A Scanner Darkly* (2006). A major limitation of this production technique was that it produced, single, complete screens, which made it difficult to re-use or re-arrange these assets. Similarly, when finished the original structure could not be easily changed or even fine-tuned after the original version was finished and the team disbanded, exposing what we consider a common problem encountered in many IDN works after the initial release.

In order to avoid the unmanageable nature of linear branching structures (captured in Andrew Stern's term "linearity hell" [6]), decision points folded back to a mostly linear structure (Figure 3). The resulting work offered only limited variants and lacked a memory of the overall state. Consequently, informal feedback from users focused on the lack of consequences of their actions. For example, the user might have met a new male colleague in one walkthrough, a possible date. Users considered this encounter meaningful, but expressed their frustration with the lack of consequences. In that sense the original version failed to fully capture our vision.

Fig. 3. Original structure (sideways) with folding branches (enlarged inset)

In 2008 the project was recreated and expanded in the ASAPS authoring system [7,8] with new characters and additional choices. This time the production team was much smaller and consisted of non-coder authors. Even so, with its user-friendly authoring environment and reconfigurable narrative building blocks (beats), ASAPS allowed experimenting with different structures and greater flexibility over the earlier implementation. The different types of beats and procedural elements, like tools for progress tracking, opened up new possibilities beyond simple branching. The result was not only an enhanced structure (Figure 4), which afforded greater variety and more control over the narrative experience, but also the system of interconnected decisions, immediate and delayed consequences described earlier. In ASAPS, every user decision affects the overall state by adding to a particular counter, setting a global variable, changing the contents of a character's inventory or affecting a timer. In turn, the author can use any of these procedural elements as a basis for a decision which beat to call up next. For example, the decision to wear the red dress is represented in a variable, which in turn is used by condition checking beats throughout the narrative to send her on path to romantically themed encounters with men. However, several stacked condition checks complicate these branching decisions, for example if the heroine misses the bus, her boss will not ask her out, regardless of what dress she wears. The addition of these procedural elements constitute the move from a simple branching systems to a finite state machine. From this perspective, the branching diagram created by the ASB authoring component is incomplete, as it does not visualize the potential states. We found that the availability of "state memory" dramatically reduced the need for both branching structures and asset production and therefore results in more time that can be spent on other aspects.

Fig. 4. Breaking *Points* enhanced structure in ASAPS

As ASAPS's capabilities expanded, *Breaking Points* developed along with it. For example, the current version uses the recently implemented randomness beat to make certain NPCs appearance unpredictable. This compares favorably to our earlier method of withholding information from the user, which lowered agency in an undesired way.

Currently, an ASAPS iOS playback engine is in active development by one of the authors. From a research perspective, the most important addition in this version is anonymous user tracking. The data is stored in a database and will be used for the

statistical analysis of user's behavior as part of the ongoing research project. We know from informal observations since 2006 that only after several completed runs do users start to really reflect about their decisions and which consequences they might face, an observation supported by Mitchell and McGee's empirical work [4]. Also initial feedback regarding the current version suggest that the addition of procedural elements results in a much more coherent and readable experience for the users. The new version of ASAPS will allow us to record user interactions in detail and form the basis of an extended user study to verify these observations.

4 Conclusion

The protostory [10] and narrative design of *Breaking Points* have evolved as the move to the ASAPS IDN authoring tool has allowed the authors to improve upon an earlier version and more fully the realize the narrative idea of a short loop with many varied paths. The original folding branch structure has been transformed into a finite state machine that remembers and evaluates users' decisions. The project now uses seemingly small choices and randomness to influence the trajectory of bigger, decisive choices. In addition, the consequences of decisions are often presented in a delayed fashion. The result is a more life-like and realistic experience that offers its full meaning through varied replays. A planned user study will help to determine the success of this strategy.

At the same time, it is the original narrative concept that has carried the project for several years now. The topic of a daily routine a character wants to escape from has wide appeal. Unlike the stories of old, interactive digital narrative allows us to make decisions and experience the frustration and small victories as the consequences of our choices. It is this kind of narrative that IDN does best – narratives that speak to a shared issue, a common feeling, while giving us agency to try (and fail) for ourselves.

References

1. Albert, T., Ramis, H. (Producer), Ramis, H. (Director): Groundhog Day [Motion picture]. Columbia Pictures (1993)
2. Lebowitz, J., Klug, C.: Interactive Storytelling for Video Games: A Player-centered Approach to Creating Memorable Characters and Stories. Focal Press, Burlington (2011)
3. Phoenix Wright: Ace Attorney [Video game, iOS version], Capcom (2010)
4. Mitchell, A., McGee, K.: Reading Again for the First Time: A Model of Rereading in Interactive Stories. In: Oyarzun, D., Peinado, F., Young, R.M., Elizalde, A., Méndez, G. (eds.) ICIDS 2012. LNCS, vol. 7648, pp. 202–213. Springer, Heidelberg (2012)
5. Flash [Software], Adobe (1996-2013)
6. Isikoglu, D., Sezen, T.I.: Creating an Interactive Story: Behind the Scenes of "Breaking Points". In: Gezgin, S., Kandemir, C. (eds.) Interkulturelle Kommunikationsbruecke – Beitraege von den I-II. Tuerkish-Deutschen Sommerakademien, pp. 191–196. Istanbul University Faculty of Communication Press, Istanbul (2006)
7. Stern, A.: ICIDS 2008 Keynote, Erfurt (2008)

8. Koenitz, H.: Extensible Tools for Practical Experiments in IDN: The Advanced Stories Authoring and Presentation System. In: Si, M., Thue, D., André, E., Lester, J., Tanenbaum, T.J., Zammitto, V. (eds.) ICIDS 2011. LNCS, vol. 7069, pp. 79–84. Springer, Heidelberg (2011)

9. Koenitz, H., Chen, K.-J.: Genres, Structures and Strategies in Interactive Digital Narratives – Analyzing a Body of Works Created in ASAPS. In: Oyarzun, D., Peinado, F., Young, R.M., Elizalde, A., Méndez, G. (eds.) ICIDS 2012. LNCS, vol. 7648, pp. 84–95. Springer, Heidelberg (2012)

10. Koenitz, H.: Towards a Theoretical Framework for Interactive Digital Narrative. In: Aylett, R., Lim, M.Y., Louchart, S., Petta, P., Riedl, M. (eds.) ICIDS 2010. LNCS, vol. 6432, pp. 176–185. Springer, Heidelberg (2010)

The Role of Gender and Age on User Preferences in Narrative Experiences

Michael Garber-Barron and Mei Si

Cognitive Science Department, Rensselaer Polytechnic Institute, Troy, New York
{barrom2,sim}@rpi.edu

Abstract. Storytelling is interactive - storytellers seldom recite the same content, instead, they adapt the narrative to their audience. Storytellers both introduce new topics from time to time, and elaborate on the topics the audience has previously shown interest on. In our previous work, we created a digital storytelling system that simulates this process. The goal of this work is to investigate what is a good balance between the novel topics and the audience's existing interests. We conducted an empirical evaluation using our digital storytelling system. Distinct preferences were observed in relation to both age and gender, with women in general enjoying a more gradual shift in the presentation of novel material.

1 Introduction

Storytelling is an important aspect of our lives. It is both a major form of entertainment, and allows us to obtain new knowledge and communicate beliefs. Unlike playing a digital recording, storytelling when happening face to face is interactive. People adapt how the story is presented to their audience, by answering questions, elaborating on topics the audience has shown interest in before, and introducing new topics from time to time to attract attention. In our previous work [1, 2], we created an automated storytelling system that attempts to engage the audience in a similar way as a human narrator. While telling the story, the system periodically estimates the user's interest and preference based on his/her questions and comments. The system biases its subsequent storytelling towards content related to the user's inferred interests while accounting for the introduction of novel topics and maintaining topic consistency.

There is a variety of work on user modeling in interactive narratives [3–5]. Our system addresses a similar goal, however, in a different context. The listeners have no agency in the story, and they may not identify with a character in the story. Therefore, the listener's models cannot be created based on the models of the characters.

We found several interesting works that concentrate on inferring and adapting storytelling to the audience's experiences. The Papous system [6] proposes to adapt storytelling based on the listener's emotional experiences. The Virtual Storyteller [7] uses autonomous agents to interact with each other and present a story to the audience. The interaction is steered by the positive or negative feedback from the audience members. In IRST [8], the story is developed around the notion of interest. A fixed story is presented to the user, but optional information can be presented to add details about characters or events. As the user views the scenes they can explicitly demonstrate their interest through an adjustable slider, which is used to indicate which characters interest

H. Koenitz et al. (Eds.): ICIDS 2013, LNCS 8230, pp. 114–120, 2013.

the user. Suspenser [9] manipulates the presentation and order of a story's content to optimize suspense.

Primarily, our approach is inspired by IRST. We also try to adapt a story around the interests and preferences of the user. In this work we go further by trying to balance between providing new content that is more along the lines of where the user has already shown interest and presenting novel material that can trigger new interests from the user.

In our previous work [2] we evaluated the efficacy of our storytelling system. In that study, younger individuals (40 and below) identified stories with additional novel content as being more engaging. In this work, we want to further investigate what type of novelty is preferred and whether there are any gender or age preferences. In particular, we compared two approaches for introducing novel content, one that gradually introduces novel content and accounts for the user's interests, and the other which introduces varied and novel topics as much as possible without incorporating the user's interests. In the next sections, we will briefly review our storytelling system (see [1, 2] for more details), and then present the empirical study.

2 Story Representation

We represent a story as a set of connected events with preconditions which define what can and cannot happen before the event. Each event is either a physical event that progresses the story or an informational event that describes the characters' background, beliefs, or motivations.

We modeled a Chinese fantasy story – "The Painted Skin" [10] for this study. The story revolves around a man named Wang, his family, and their interactions with a demon disguised as a girl who eventually murders Wang.

For enabling our system to *understand* the progress of the story and the user's interests, the events described by the narrator and the statements the user can say to the narrator are tagged using a set of predefined labels. For example, the event "Wang hoped that the priest could find some way of protecting his family" is labeled with [Wife, Fear, Love, Wang].

2.1 User Interest Representation

In our system, the user's interests are represented as a set of interest *profiles*. Each *profile* represents a possible set of the user's inferred interest towards the various labels used for modeling the story, for example: [Wife: 0.4, Fear: 0.3, Love: 0.2, Wang: 0.1]. These profiles are randomly initialized, and get updated as the user interacts with the system. When planning for future content, these profiles are combined in order to represent the user's interests (see [1] for further details).

2.2 Storytelling

The storytelling system plans for the presentation of the future narrative each time the user has made a comment or asked a question, at which point the user's interest profiles are also updated. For storytelling, we want the user to hear more about the type of content they've already shown interest towards as well as to discover new interests.

To realize this goal, first, the events that can immediately proceed in the story, in other words, whose preconditions are satisfied are selected. Then, an interest score is generated for each event. This score is an indicator for not only how well the event itself will interest the user, but also how well the future story trajectory which is likely to follow this event will interest the user. This score is a weighted combination of two factors: Novelty and Topic Consistency.

Novelty measures how similar/different the labels in the trajectory are from the user's current interest profiles. The smaller the similarity is, e.g. the trajectory contains a label which has been rarely utilized or the user has showed no interest towards previously, the more novel the trajectory is (see [1] for further details.)

For this study, we compared two approaches for incorporating novelty in storytelling: gradual novelty and immediate novelty. For achieving gradual novelty, we want the storytelling algorithm to gradually transition among topics. Gradual Novelty is modeled as $\left| 1 - \frac{1}{distance from current step} - similarity \right|$. Thus, for the same amount of similarity/difference, the further away the event is, the more (gradually) novel it is considered. Using immediate novelty, the storytelling algorithm continually tries to find the most varied and differing content, and novelty is simply defined as, $|1 - similarity|$.

Topic Consistency measures whether events in succession are similar in terms of the labels they address, independent from whether the trajectory is novel to the user (see [1] for further details.) This factor is incorporated to prevent the system from oscillating between topics. This procedure remains the same for both models of novelty. When used together with the gradual model of novelty, the storytelling system will switch topics less abruptly compared to when used with the immediate model of novelty.

2.3 Experimental Design

A between subjects design was used with three independent variables: gender, age and the type of novelty. We partitioned subjects' ages into three groups: group 1, 30 and below; group 2, 30 to 40; group 3, 40 and older. As previously described, the type of novelty has two levels: gradual novelty and immediate novelty. In both conditions, the topic consistency aspect of the algorithm was untouched, so that the story presented to the user is intended to always be reasonable.

For this evaluation, instead of having the subjects directly interact with the system, we manually simulated users interacting with the system, and showed the histories of these interactions to the subjects. The subjects were asked about what they think of the (simulated) users' experiences of interacting with the system.

We simulated a positive user, which is modeled as having a preference for positive events and relationships such as care, love, protection, etc. We simulated this user so as to clearly distinguish the user's interests from the mood of the overall story which has a darker tone.

After reading the interaction between the simulated user and the system, the participants were asked to rate the following questions using a 7 point Likert scale with 7 being the strongest.

Questions: $[INT]$: "To what degree did the story seem interesting to the user?", $[ENG]$: "Given the user's responses to the narrator, to what degree do you think the story

was engaging for the user because it was consistent with the user's personality?", [APP]: "Given the user's responses to the narrator, to what degree do you think the elements of the story were appropriate for the user's personality?", [NOV]: "Given the user's personality and responses to the narrator, how novel did the elements of the story presented feel to the user?", [RAND]: "Given the user's personality and responses to the narrator, how random did the elements of the story presented feel to the user?", [PLOT_APP]: "How well did the plot elements seem appropriate to the user's personality?", [APP_YOU]: "How well did the plot elements seem appropriate to your personality?", [ENG_USR]: "How engaging did the user find the story?".

These questions are intended to examine the subjects' impressions on engagement ([INT, ENG, ENG_USR]), the appropriateness of the content ([APP, PLOT_APP, APP _YOU]), and how novel or random the content seems ([NOV], [RAND]).

2.4 Procedure

We conducted this experiment as an anonymous survey on Amazon's Mechanical Turk. A total of 185 subjects participated, 80 of them were women and 105 were men. The subjects' ages range from 18 to 66. There were 115 in group 1, 33 in group 2 and 37 subjects in group 3, and 3 subjects did not specify their gender and were excluded from the analysis.

Each subject was randomly assigned to a novelty condition. In each condition, the subjects read an interaction history consisting of eight segments that corresponded to their condition. In each segment, as shown in Figure 1, a picture that represented the development of the story is displayed, followed by the narrator's description of the story, the choices the user could pick from, the choice picked by the user and the narrator's response in sequence. At the end, the subjects were asked to rate the items listed in the previous section.

Story described by Narrator:

Her parents had sold her to a cruel master and she had just fled... Wang offered to let her stay at his residence.

Options the user can direct to the narrator:

1. Whoa, that is really nice of Wang to do for her.
2. Wang is way too trusting. Nowadays you would be be more cautious, she could be a serial killer.

Option chosen by user: Statement 1

Narrator's response: Indeed, it does appear that way.

Fig. 1. Text Version

2.5 Data Analysis and Results

Because participants were asked to evaluate 8 questions in this study, we first performed a Pearson's bivariate correlation analysis, which indicates a high correlation among the variables (p<.01 for all the comparisons except $[RAND]$ which had a relatively neutral relationship with most of the other variables). Due to the significant covariance, we decided to perform a three-way MANOVA test instead of individual ANOVA tests. The Roy's Largest Root test was used for significance testing.

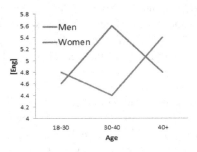

Fig. 2. Age and Gender Interaction

The MANOVA test revealed a significant interaction effect of gender and age (p<.05). The follow up ANOVA tests on each independent variable only revealed significant interaction effects between gender and age groups on $[ENG]$ – the participant's view of the user's level of engagement with the story (p<.05).

As seen in Figure 2, the relationship of age and gender correlate to participants' perception of the user's engagement in each story. Male and female participants demonstrated different preferences with men in the 30-40 age bracket rating the $[ENG]$ question the lowest (Mean=4.6) comparing to other age groups, and women rating it the highest comparing to other age groups (Mean=5.6).

Table 1. Female Ratings

	$[INT]$	$[ENG]$	$[APP]$	$[PLOT_APP]$	$[APP_YOU]$	$[ENG_USR]$	MEAN
Immediate	5.4	4.9	4.8	4.8	4.3	5.4	5.9
Gradual	5.7	4.9	5.1	4.7	4.9	5.4	6.1

Women appeared to have a greater preference towards the gradual novelty condition. Table 1 lists the average rating of female subjects for each question. We performed the same MANOVA test with only female subjects. This test revealed a marginally significant main effect of novelty type (p=.078). No other significant effects were observed.

3 Discussion and Future Work

The large difference in ratings in the 30-40 age range for women and men suggests that there are significant population trends. This result suggests that while we seek to

model each individual's preferences, accounting for each user's demographic information would allow for a better initial estimate of what should be presented. Further, the differences in preferences for women (Table 1), and the marginally significant effect suggest that novelty type may be more relevant for women. Nevertheless, our primary evaluation of novelty type did not reveal a significant difference between the two conditions. However, given the short time frame (Mean=4.5 minutes), it may be the case that there is simply not enough content for participants to observe the gradual novel condition as clearly distinctive from the immediate novel condition.

Ongoing work is being directed towards several goals including repeat the experiment with the subjects directly interacting with the storytelling system, and modeling a longer version of the story with more details. We are also interested at exploring automating the initialization of the profiling component.

4 Conclusion

In this work, we evaluated the subjects' preferences over two different approaches for incorporating novel topics in storytelling using our automated storytelling system. A marginally significant effect was observed for women. Women subjects seem to enjoy stories that switch topics gradually more than those that switch abruptly. Further, significant interaction effects were observed between gender and age. Future work has been planned on further investigating these differences and improving the initialization process of the storytelling system.

References

1. Garber-Barron, M., Si, M.: Towards Interest and Engagement: A Framework for Adaptive Storytelling. In: Proceedings of the 5th Workshop on Intelligent Narrative Technologies Collocated with AIIDE (2012)
2. Garber-Barron, M., Si, M.: Adaptive Storytelling Through User Understanding. In: Proceedings of AIIDE (2013)
3. Si, M., Marsella, S.C., Pynadath, D.V.: Proactive Authoring for Interactive Drama: An Author's Assistant. In: Pelachaud, C., Martin, J.-C., André, E., Chollet, G., Karpouzis, K., Pelé, D. (eds.) IVA 2007. LNCS (LNAI), vol. 4722, pp. 225–237. Springer, Heidelberg (2007)
4. Yu, H., Riedl, M.: A Sequential Recommendation Approach For Interactive Personalized Story Generation. In: Proceedings of AAMAS, pp. 71–78 (2012)
5. Thue, D., Bulitko, V.: Procedural Game Adaptation: Framing Experience Management as Changing an MDP. In: Proceedings of AIIDE (2012)
6. Silva, A., Raimundo, G., Paiva, A.: Tell Me That Bit Again.. Bringing Interactivity to a Virtual Storyteller. In: Balet, O., Subsol, G., Torguet, P. (eds.) ICVS 2003. LNCS, vol. 2897, pp. 146–154. Springer, Heidelberg (2003)

7. Theune, M., Faas, S., Heylen, D.K.J., Nijholt, A.: The Virtual Storyteller: Story Creation By Intelligent Agents. In: Proceedings of the Technologies for Interactive Digital Storytelling and Entertainment (TIDSE) Conference, pp. 204–215 (March 2003)
8. Nakasone, A., Prendinger, H., Ishizuka, M.: ISRST: Generating Interesting Multimedia Stories on the Web. Applied Artificial Intelligence 23(7), 633–679 (2009)
9. Cheong, Y.-G., Young, R.M.: Narrative Generation for Suspense: Modeling and Evaluation. In: Spierling, U., Szilas, N. (eds.) ICIDS 2008. LNCS, vol. 5334, pp. 144–155. Springer, Heidelberg (2008)
10. Sung-Ling, P.: The Painted Skin. In: Strange Stories from a Chinese Studio, pp. 47–51. University Press of the Pacific (1916)

Constructing and Connecting Storylines
to Tell Museum Stories

Paul Mulholland, Annika Wolff, Zdenek Zdrahal, Ning Li, and Joseph Corneli

Knowledge Media Institute, The Open University, Walton Hall,
Milton Keynes, MK7 6AA, UK
{firstname.lastname}@open.ac.uk

Abstract. Over the past decade a number of systems have been developed that tell museum stories by constructing digital presentations from cultural objects and their metadata. Our novel approach, informed by museum practice, is built around a formalization of stages of museum storytelling that involve: (i) the collection of events, museum objects and their associated stories, (ii) the construction of story sections that organise the content in different ways, and (iii) the assembly of story sections into a story structure. Here we focus in particular on this final stage of building the story structure. Our approach to providing intelligent assistance to story construction involves: (i) separating overlapping or conflicting story sections into separate candidate storylines, (ii) evaluating candidate storylines according the criteria of coverage, richness and coherence, (iii) assembling storylines into linear, layered or multi-route structures and (iv) ordering the story sections according to their setting within the storyline.

Keywords: Museum storytelling, storylines, ATMS, clustering.

1 Introduction

Museum professionals, such as curators and educators construct stories that encompass multiple museum objects. These may take the form of e.g. an exhibition, website or museum tour. The aim of our work is to provide intelligent assistance to this storytelling process. A number of systems have been developed that construct presentations with, or facilitate navigation between, multiple museum objects [1, 2, 3, 4]. However, our work is driven by an investigation of how the museum storytelling process is carried out and how it can be supported.

Many previous systems aim at building chains of cultural content, whether they are realized as a web-based presentation or instructions of how to navigate a physical museum space. Work in narrative and hypertext has also considered a wider range of narrative structures that offer branching and choice to the reader [5]. Sharples et al [6] consider four narrative structures and their use n museums: tree branching, braided, an interconnected rhizome structure and a linear diary. Gudmundsdottir [7], in a curriculum design context describes a narrative structure comprising a main horizontal strand and subsidiary vertical strands. In our work we investigate how some of these structures can be employed to assist museum storytelling.

H. Koenitz et al. (Eds.): ICIDS 2013, LNCS 8230, pp. 121–124, 2013.
© Springer International Publishing Switzerland 2013

2 The CURATE Ontology and Storyscope

The aim of the web-based environment Storyscope and the CURATE ontology[1] is to provide a way of constructing and modelling museum stories and some of the underlying reasoning that goes into them.

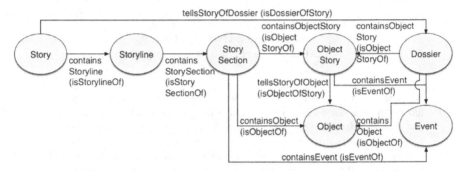

Fig. 1. Overview of main classes and properties in the CURATE ontology

Museum storytelling processes informed the structure of the CURATE ontology, shown in 21. A dossier (shown top right of figure 1) contains object stories, events and references. Events are things that have happened that are of relevance to the story to be told. They provide a particular interpretation or description of a known event in the context of a story. Events inside the story may reinterpret events described using other event schemas such as the one provided by CIDOC CRM [8]. A dossier also contains Object stories. These are stories that can be told about a museum object. This may be a story depicted by the object, a story of its construction, or something that has happened to it since. Both dossiers and object stories can also cite reference materials that support the story (not shown in the figure).

The storyteller starts to build what they wish to say by constructing story sections (center of figure 1). Each story section collects together and edits some number of object stories and events. Story sections form the seed of what could become a chapter in a booklet or page in a hypertext presentation. Finally, the author builds the presentation structure in the form of a story comprising a number of storylines (left of figure 1). Each storyline is a sequence of story sections. The same story section may feature on multiple storylines, potentially allowing branching and reader choice in the final presentation structure.

3 Assisting Story Construction

This formalization of the structure of the museum storytelling process allows us to develop intelligent assistance for the storyteller, recommending additional content or structure. Three types of recommendation have been developed: (i) suggesting

[1] http://decipher.open.ac.uk/curate

additional events to add to the dossier based on the current content, (ii) suggesting story sections, and (iii) suggesting a set of storylines that provide a way of navigating the sections of the story. The first two of these, the suggestion of events and story sections, are described in in Wolff et al [9]. The remainder of this paper will focus on the computational construction of story structures.

Storyscope supports the author in assembling story sections from the events and object stories of the dossier. Software for recommending events and story sections essentially introduces events similar to those already in the dossier and brings together similar or related events in story sections. By contrast, our approach to the construction of storylines pushes apart similar story sections into separate storylines. For example, two story sections may cover overlapping content, may cover similar content but on different levels of detail, or may provide alternative perspectives on the same underlying events. Our rationale in adopting this approach is to produce independent subsets of the overall story that can then be selected and combined to produce narratives serving different purposes such as: summarizing; linking an overview to further detail; or identifying alternative routes or perspectives within the story. This is initially by separating story sections that duplicate specified types of item, for example contain the same object, event or alternative interpretations of the same event. An AI program called an Assumption Truth Maintenance System (ATMS) [10] is used to split the story sections into alternative candidate storylines.

The candidate storylines generated by ATMS can be evaluated and ranked in a number of ways. We identify three criteria against which candidate storylines can be ranked: coverage, coherence and richness. *Coverage* measures how much of the story as contained in the dossier is covered by the storyline. This is measured as the sum of unique events found in the story sections contained in the storyline. *Richness* is a measure of how many object stories are associated with the story sections of the candidate storyline. It can be expected that generally richer storylines will be preferred which interconnect a greater number of museum-related stories. *Coherence* is the extent to which the themes of the story sections (the key people, objects, etc. featured in the story section) are consistent (i.e. do not vary) across the storyline. The three criteria used to evaluate storylines are similar to criteria proposed by Shahaf et al [11] for the ranking of what they term Metro Maps, which are reading pathways calculated to span a set of documents.

We identified three types of story structure to be constructed from the set of storylines. Each structure has distinct affordances for storytelling. The three types of structure are linear, layered and multi-route (see figure 2). The linear structure provides a single route through some or all of the story sections of the dossier. The layered structure, motivated by the vertical and horizontal narratives of Gudmundsdottir [7], comprises a horizontal backbone that guides the reader through key story sections. Each story section on the backbone can link to related story sections that provide, for example, additional detail or alternative perspectives. The mutli-route structure offers a greater level of choice from a number of interconnected paths.

The simplest implementation of the linear story structure is the selection of the top-ranked storyline. This structure is linear and also can be thought of as providing a précis or summary of the dossier. The layered story structure takes as its backbone the

top-ranked storyline. Other sections are then linked to the backbone section with which they are most similar. The multi-route structure also starts by selecting the top-ranked storyline. Further storylines are then added in rank order that introduce additional story sections to the network. The multi-route structure therefore places alternative or overlapping story sections on alternative routes within the overall structure. An evaluation of this approach to story construction is currently in progress.

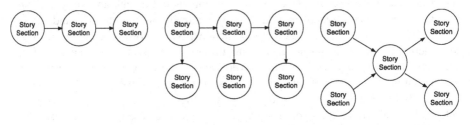

Fig. 2. Linear (left), layered (middle) and multi-route (right) story structures

Acknowledgements. This work was supported by the DECIPHER project (270001), funded by the EU 7th Framework Programme in the area of Digital Libraries and Digital Preservation.

References

1. Hyvönen, E., Palonen, T., Takala, J.: Narrative semantic web - Case National Finnish Epic Kalevala. Poster papers, Extended Semantic Web Conference, Heraklion, Greece (2010)
2. van Hage, W.R., Stash, N., Wang, Y., Aroyo, L.: Finding Your Way through the Rijksmuseum with an Adaptive Mobile Museum Guide. In: Aroyo, L., Antoniou, G., Hyvönen, E., ten Teije, A., Stuckenschmidt, H., Cabral, L., Tudorache, T. (eds.) ESWC 2010, Part I. LNCS, vol. 6088, pp. 46–59. Springer, Heidelberg (2010)
3. Lim, M.Y., Aylett, R.: Narrative construction in a mobile tour guide. In: Cavazza, M., Donikian, S. (eds.) ICVS 2007. LNCS, vol. 4871, pp. 51–62. Springer, Heidelberg (2007)
4. Van den Akker, C., Legene, S., van Erp, M., et al.: Digital hermeneutics: Agora and the online understanding of cultural heritage. In: WebSci, Koblenz, Germany (2011)
5. Ryan, M.: Avatars of story. University of Minnesota Press, Minneapolis (2006)
6. Sharples, M., Fitzgerald, E., Mulholland, P., Jones, R.: Weaving location and narrative for mobile guides. In: Schrøder, K., Drotner, K. (eds.) The Connected Museum: Social Media and Museum Communication (2013)
7. Gudmundsdottir, S.: Story-Maker, Story-Teller: Narrative structures in the curriculum. Journal of Curriculum Studies 23(4) (1991)
8. Crofts, N., Doerr, M., Gill, T., Stead, S., Stiff, M. (eds.): Definition of the CIDOC Conceptual Reference Model (2010), http://www.cidoc-crm.org/official_release_cidoc.html
9. Wolff, A., Mulholland, P., Collins, T.: Storyscope: Using Theme and Setting to Guide Story Enrichment from External Data Sources. In: ACM Conference on Hypertext and Social Media, Paris, France (2013)
10. De Kleer, J.: An assumption-based TMS. Artificial Intelligence 28(2), 127–162 (1986)
11. Shahaf, D., Guestrin, C., Horvitz, E.: Metro Maps of Information. SIGWEB Newsletter Spring 2013 (2013)

Night Shifts – An Interactive Documentary for the iPad

M. Zimper, M. Lepetit, N. Lypitkas, and N. Thoenen

Zurich University of the Arts, Design Department,
CAST Audiovisual Media Program,
Ausstellungsstrasse 60, 8005 Zurich, Switzerland
{martin.zimper,marc.lepetit nico.lypitkas,nina.thoenen}@zhdk.ch

Abstract. Night Shifts is a digital magazine developed for the iPad that depicts articles and videos with a structured and explicit approach. The magazine-app displays seven different personalities that work over night in Zurich- the portraits' running time is 56 minutes. Classical print magazines inspire the design and ergonomics of Night Shifts. The interactive part of the App is reduced to few intuitive navigation possibilities. The App is programmed with C+ and runs on the iPad native. Thanks to pre-loading the high quality video content runs with no delay. The authors developed a colour concept, icons, typography concept and narrative concept to suite the thematic field of Night Shifts. The combination between text, photos and videos creates an inspiring body of work that captivates the reader by opening a new world of fascinating stories and personalities.

Keywords: interactive, documentary, ipad, narrative, cross media, app, storytelling, magazine

1 The Stories

Seven stories, seven persons. Amongst them are a G-string designer, a night watchman, a firefighter, a burlesque dancer, a printing craftsman, a club-host and a street cleaner. These people are connected through one thing, the night.

With the use of this magazine-app, the reader learns more about the personalities' stories. The objective of creating a documentary magazine was to produce a high quality audiovisual work, and to visualize these sub-stories. Each episode narrates someone else's life, and is catchy in its own way.

2 The Process

Bachelor students of the Cast / Audiovisual Media Program assigned the task to develop an e-book on the topic of documentary. Between October 2012 and January 2013, CAST / Audiovisual Media Program and the German Astronaut Magazine collaborated with the aim of publishing an iPad-Magazine.

Night Shifts is clearly inspired by iPad magazines such as Astronaut Magazine or Wired Magazine. Besides exploring narrative forms of text, photography, video and info graphic also forms of marketing and distribution where adapted and explored.

H. Koenitz et al. (Eds.): ICIDS 2013, LNCS 8230, pp. 125–127, 2013.
© Springer International Publishing Switzerland 2013

The central motivation of the project is to push forward the creative use of video content in the age of digital platforms. This group work required the multiple skills the students learned during their studies of CAST / Audiovisual Media Program at the Zurich University of the Arts.

It is our pleasure to show you the first interactive Swiss Documentary Magazine.

Trailer: http://youtu.be/JQChQ_vv__M

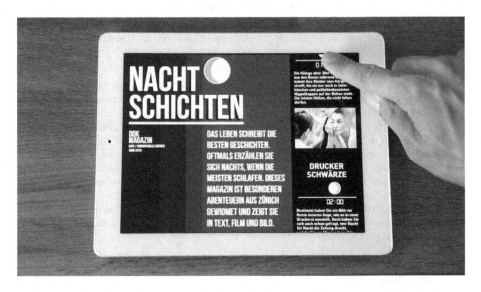

Fig. 1. Title page of Night Shifts with navigation bar on the right

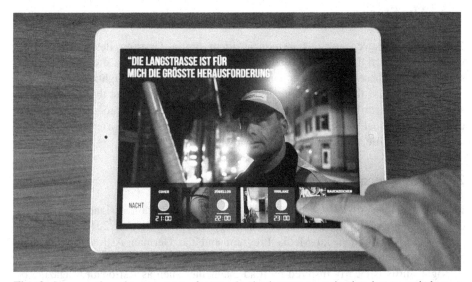

Fig. 2. Story section about a street cleaner. At the bottom a navigation bar to switch to a different story.

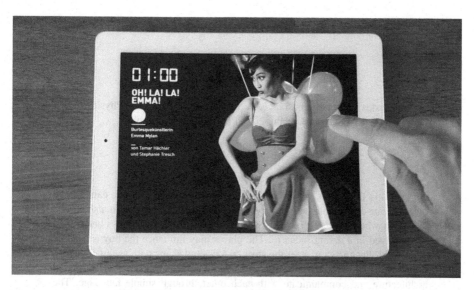

Fig. 3. Title page of the story of a burlesque dancer

SimDate3D – Level Two

Michal Bída, Martin Černý, and Cyril Brom

Charles University in Prague, Faculty of Mathematics and Physics,
Malostranské nám. 2/25, Prague, Czech Republic

Abstract. In this demo, we present a working example of a simple game based
on character-centric interactive storytelling. The game is situated in a small vir-
tual town where three characters, two girls and a boy (or two boys and a girl)
are involved in a dating scenario. The player may influence the boy and guide
his actions, his goal is to steer the story to a desired shape with as few interven-
tions as possible. The individual agents feature an affect-modulated BDI-based
architecture and communicate with each other through simple language. The
scenario culminates in a simulated confrontation of all three characters. Based
on the current state of relationships between the characters, it results in one of
multiple possible endings. The game is intended as both a testbed for interactive
storytelling technologies as well as a source of data for evaluation of automatic
analysis of generated stories.

1 Introduction

Creating believable human-like characters is an ongoing endeavor on the intersection
of artificial intelligence, computer graphics, game design and psychological model-
ing. Such characters can then be involved in various settings, including but not limited
to entertainment computing, psychological simulations and educational games.
Among the possible applications of believable characters, character-centric interactive
storytelling (IS) is one of the most difficult, since the characters are not only supposed
to behave plausibly during interaction with the user, but also to interact with each
other to create an interesting story. Lessons learned from the development of charac-
ters for storytelling systems present a great source of information that can be further
used to improve believable character design in many other applications.

In this paper, we present SimDate3D Level Two (SD) (Fig. 1) – a simple game
based on character-centric IS. SD is an evolution of our previous work [1]. The set-
ting of the game is as follows:

*Thomas, Barbara and Nataly live in a small town. Thomas has a girlfriend - Barbara
- and... well... yet another girlfriend - Nataly. The girls don't know about each other.
One day Thomas is on a date with Barbara when suddenly Nataly appears and things
start to happen.*

H. Koenitz et al. (Eds.): ICIDS 2013, LNCS 8230, pp. 128–131, 2013.
© Springer International Publishing Switzerland 2013

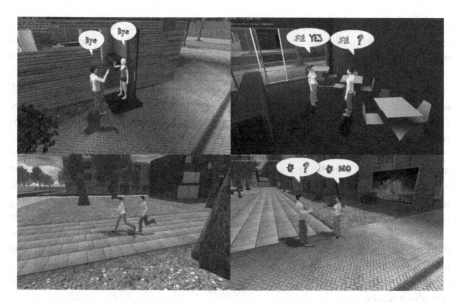

Fig. 1. Screenshot from the SimDate3D showing character interactions

The game also features a symmetrical variant where there is one girl and two boys. For the sake of clarity we strictly refer to the first situation as described above.

The user is not directly present in the game, but observes the scenario as a floating invisible entity. The user is able to instruct Thomas to execute specific actions in order to achieve the highest score possible. The score is gained whenever Thomas performs certain activities with a girl (e.g. watch movie at cinema). When the user does not interact with the game, the characters will continue to act on their own according to their current goal behaviors and emotional state. This natural behavior however results in boredom and indifference between the characters, which is not desired by the user as it does not generate any score. Each intervention of the user to this natural story flow imposes a small score penalty. So to achieve the greatest score, the user tries to make maximum influence on the story flow with as few actions as possible.

The motivation of building this system is twofold. Firstly, we use it as a testbed for IS and believable characters technologies, secondly, we use this system as a source of data for evaluation of automatic analysis of generated stories. The analysis we perform is based on automatic extraction of tension curve and clustering of stories. The process is detailed in [2].

2 Related Work

Here we review only the most relevant related work – IS systems that are both games and freely available. Façade [3] is an interactive drama featuring two virtual characters – a couple with relationship issues. The user plays a role of an old friend, who was invited to the dinner at their place. The scenario is non-linear and the outcome

depends on user actions. The main differences between Façade and SD are a) in SD the characters communicate through emoticons (Fig.1) while in Façade they use speech and text input, b) SD is set up in a full 3D environment, c) in Façade the overall approach is more story-centric as a central drama manager controls the flow of the story (in SD it is more character-centric) and d) in SD the user does not have full control over a character. The reduced character control in SD creates a new type of gameplay and is more suitable for studying believable character behavior, as the protagonists need to be able to act completely without user intervention.

The Prom Week [4] is a social simulation game featuring high school students. The gameplay takes place in the last week before students Prom. The goal of the user is to solve social puzzles, e.g. "How to get Zoe to date the Zack, who is not popular in the class", etc. The SD features somewhat similar scenario in a smaller scale (with only one "level" to solve) with characters communicating through emoticons and set up in a 3D world. Our experience shows that shifting from a constrained, almost static environment as in Prom Week to a full-fledged 3D environment poses significant challenges for character design (e.g. animation synchronization, navigation, etc.). It is important to overcome these challenges for wider applicability of believable characters in practice.

3 Technical Description

The individual agents feature affect-modulated BDI-based architecture (detailed in [1]) and communicate with each other through a simple language represented by emoticons (Fig. 1). To connect to the virtual world, Pogamut [5] middleware is used. To simulate affect we have used OCC based [6] emotion model ALMA [7]. The resulting emotions are reduced to one dimensional value we call "feeling" that ranges from -1 to 1 and represents the relationship between characters. Feeling is used when selecting the next action by the currently active agent behavior. Behaviors are implemented as finite state machines. A single behavior per agent is always active and it is the one with the highest priority. An example of the behavior may be "an agent is going with another agent to the cinema and they are talking". Behaviors available to the agent and their priorities change according to current situation.

The user plays the game by "instructing" Thomas. She can trigger Thomas to say something (e.g. tell a joke), propose activities to the girls (e.g. go to cinema) or go to places (park, home, restaurant and cinema). The game ending comprises all the characters meeting together entering an argument. The outcome of this argument is based on previous user activity in the game (e.g. if Barbara likes Thomas more than Nataly likes him, there is a good chance Barbara stays with Thomas after the argument). The argument is fully simulated using beat-based scene coordination techniques [8].

User-evaluations of our previous work [8] have shown that the believability of characters is hugely dependent on various non-AI aspects. For example a girl that is badly dressed is often deemed not believable by the user regardless of actual behavior. The quality of animation, smoothness of movement and other aspects also play an important role. Thus a large body of work has been done to improve those "non-AI" aspects of believability. The complete list of lessons learned during this process is out

of scope of this paper, but one of the most prominent is that believable AI can never be done without reliable and polished character navigation.

Preliminary evaluation [2] shows that there are many ways the game may unfold and that a multitude of simple and understandable dating-related narratives emerges out of the character actions. The game challenge is based mostly on user's desire to achieve all possible endings, which is not at all simple. At the same time two play sessions are very rarely identical, so replaying the scenario should be rewarding.

4 Conclusion

We present a working example of a simple character-centric IS system. The system integrates several components that we consider well suited for this line of work: BDI agent architecture, OCC emotion model and beat-based scene coordination. We show that even such relatively simple architecture allows for replayability of the game and the emergence of a narrative. We were also forced to address many unforeseen challenges inherent in actually implementing a scenario in a 3D environment including working with animations and character navigation. We plan to use this system to evaluate our metric for automatic evaluation of emergent narrative (details in [2]).

Acknowledgments. This work was partially supported by the student research grant GA UK 559813/2013/A-INF/MFF, by the SVV project number 267 314 and by the grant P103/10/1287 from GAČR.

References

1. Bída, M., Brom, C., Popelová, M.: To date or not to date? A minimalist affect-modulated control architecture for dating virtual characters. In: Vilhjálmsson, H.H., Kopp, S., Marsella, S., Thórisson, K.R. (eds.) IVA 2011. LNCS, vol. 6895, pp. 419–425. Springer, Heidelberg (2011)
2. Bída, M., Černý, M., Brom, C.: Towards Automatic Story Clustering for Interactive Narrative Authoring. In: Koenitz, H., Sezen, T.I., Ferri, G., Haahr, M., Sezen, D., Çatak, G. (eds.) ICIDS 2013. LNCS, vol. 8230, pp. 95–106. Springer, Heidelberg (2013)
3. Mateas, M., Stern, A.: Façade: An experiment in building a fully-realized interactive drama. In: Game Developer's Conference: Game Design Track (2003)
4. McCoy, J., Treanor, M., Samuel, B.: Prom Week: social physics as gameplay. In: Proceedings of Foundations of Digital Games 2011, pp. 319–321 (2011)
5. Gemrot, J., et al.: Pogamut 3 Can Assist Developers in Building AI (Not Only) for Their Videogame Agents. In: Dignum, F., Bradshaw, J., Silverman, B., van Doesburg, W. (eds.) Agents for Games and Simulations. LNCS, vol. 5920, pp. 1–15. Springer, Heidelberg (2009)
6. Ortony, A., Clore, G.L., Collins, A.: The cognitive structure of emotions. Cambridge University Press, Cambridge (1988)
7. Gebhard, P.: ALMA - A Layered Model of Affect. In: Proceedings of AAMAS 2005, Utrecht, pp. 29–36 (2005), http://www.dfki.de/~gebhard/alma/ (June 6, 2013)
8. Brom, C., Babor, P., Popelová, M., Bída, M., Tomek, J., Gemrot, J.: Controlling Three Agents in a Quarrel: Lessons Learnt. In: Kallmann, M., Bekris, K. (eds.) MIG 2012. LNCS, vol. 7660, pp. 158–169. Springer, Heidelberg (2012)

Acting, Playing, or Talking about the Story: An Annotation Scheme for Communication during Interactive Digital Storytelling

Mariët Theune, Jeroen Linssen, and Thijs Alofs

Human Media Interaction, University of Twente
P.O. Box 217, 7500 AE Enschede, The Netherlands
{m.theune,j.m.linssen}@utwente.nl, t.alofs@gmail.com

Abstract. In this paper we investigate the communication of children playing with an interactive digital storytelling system. What users say during their interaction with a digital storytelling system can tell us much about how they relate to the characters and how engrossed they are in the storytelling activity. We propose a communication annotation scheme that combines ideas about framing from research on pretend play and role-playing games, and use it to analyse children's utterances gathered in a small-scale user experiment. Our results show that certain kinds of communication are prevalent among the children's interactions. We conclude that this can be attributed to the design of our system, and we envisage future use of the annotation scheme to inform the design of other interactive storytelling systems.

1 Introduction

In the field of interactive digital storytelling, evaluation has received considerably less attention than system design and development, and there is no generally accepted methodology for the empirical evaluation of interactive digital storytelling systems. Methods that have been used in user studies include questionnaires [3,12], interviews [5,8], analysis of system logs and created stories [11,13], and observations of user behaviour [1,5,8,11]. Aspects of the interactive narrative experience that are considered include the user's sense of presence and immersion, enjoyment, feelings of agency and control, believability of and identification with the characters, and system usability aspects.

We are not aware of any user studies that systematically analyse the communication of people interacting with a storytelling system. However, users' communication can be a rich source of information about, among other things, their level of identification with the characters, what they think of the story, and their understanding of the system's interface. Consider for example the following transcript[1] of an interaction with our digital storytelling system, in which children control the actions of some of the characters to create a story together.

[1] Translated from Dutch.

H. Koenitz et al. (Eds.): ICIDS 2013, LNCS 8230, pp. 132–143, 2013.

(1)
System [narrating an action by Child 1]: Red skips to the beach.
System [narrating an action by Child 2]: Granny bursts out in tears.
Child 2 [in character, addressing Child 1]: *Because you are leaving me!*

In this fragment, Child 2 is role-playing as his character, Granny. He addresses the other child (Red) in character, providing a motivation for Granny's emotional outburst. He is actively taking part in the story creation process, identifying himself with the character he is playing.

Not all of the children's communication demonstrates the same level of immersion in the story being created. In the next fragment we see Child 6 taking a game-playing rather than a role-playing approach to the storytelling activity:

(2)
System [narrating an action by Child 5]: Red eats the birthday cake.
System [narrating an action by Child 6]: Granny shuffles to the beach.
Child 6 [addressing Child 5]: *Then it's your turn.*
System [narrating an action by Child 5]: Red does the dishes.
Child 6: *And now Granny.* [selects an action] *That one, I think.*

In this paper, we present a study of children's communication with an interactive storytelling system. We focus on the question to what extent the children are focused on the story they are creating, and what perspective they take on it. In an effort to obtain quantitative results, not just anecdotal evidence, we designed a multi-layered scheme for annotating the children's utterances. The scheme is based on the notion of framing as used in research on role-playing games [6] and children's pretend play [9]. We have used it to annotate the transcripts of eight interaction sessions with our storytelling system, involving four pairs of 8-11 year old children. Below, we present and discuss the results.

First, we describe the interactive storytelling system in Section 2. We present our proposed annotation scheme, with a discussion of its foundations, in Section 3. We describe our analysis of children's communication in Section 4, followed by a discussion about the validity of the annotation scheme in Section 5. The paper ends with conclusions and suggestions for future work in Section 6.

2 The Interactive Storyteller

Our interactive digital storytelling system is called the Interactive Storyteller [1,11]. It allows users to control the actions of one or more characters in a simulated story world, where they interact with other characters controlled by artificial intelligence (AI). There is no scripted storyline; stories emerge from the actions that the characters (either user-controlled or system-controlled) take in the simulated story world. This *emergent narrative* approach [3] is closely related to improvisational theatre and to children's dramatic play.

The system has a multi-touch tabletop interface, which resembles the setting of a tabletop board game. To reinforce the resemblance with board games, we use tangible playing pieces to represent the characters. Its board game interface distinguishes our system from other AI-based storytelling systems such as FearNot! [3] and TEATRIX [8], both well-known systems specifically aimed at

children. Storytelling systems that do have tabletop interfaces, such as Reac-toon [2], TellTable [5] and StoryTable [13] are aimed at facilitating children's storytelling and do not incorporate intelligent agents as characters in the story.

Fig. 1. Children playing with the Interactive Storyteller (tangible version).

The story world of the Interactive Storyteller is inspired by the story of Lit-tle Red Riding Hood. It has three characters (Red, Granny, and Wolf) and five locations (Red's house, Granny's house, a forest clearing, a lake, and a beach). Possible character actions include moving between locations, talking to other characters, and baking, eating and poisoning cakes. The story world is repre-sented visually on a multi-touch table, using a top-down map view, as shown in Figure 1. The map shows the characters, the locations (marked by light blue circles), and the paths between the locations.

To change characters' locations in the story world, physical toys representing the characters can be moved from one location to the next. The use of these tangibles is optional; we also developed a touch-only version of the interface with graphical representations of the characters that can be moved by dragging them across the table surface. Apart from the character representations, the touch-only version of the interface is the same as the tangible version.

Users can select non-move actions for the characters through a menu. Actions are carried out in a turn-based fashion. When a character gets the turn, the system determines which actions are possible for that character given the current state of the story world, and displays them in the menu.

When a character performs an action, this action is expressed using a simple sentence and narrated using Loquendo text-to-speech. The written sentences are added to scrolls recording the story text. One of these scrolls can be seen in the bottom left corner of the table in Figure 1 (there is another one on the other

side of the table). Spoken narration of the sentences provides the users with immediate feedback about what is happening in the story.

Because character actions are selected by the users via touch, and all actions are narrated by the system through both speech and writing, spoken communication between users is not strictly necessary when they are using the system to create a story together. However, our experiments with children showed that they did frequently talk to each other while interacting with the system, as illustrated by the transcripts shown in Section 1. In fact, the multi-user tabletop interface of the system was designed to stimulate such social interaction [1].

3 User Communication Annotation Scheme

In this section we describe the annotation scheme we devised to analyse the communication between the users of our system. It combines ideas from the work of Sawyer [9] and Fine [6]. A central notion for both is that of *framing*, a term that was first introduced by Bateson [4], and greatly expanded on by Goffman [7]. Frames can be seen as the organizing principles of experience, which define how messages should be interpreted within a communicative situation. Bateson's classic example is that of play-fighting monkeys: because the monkeys' bites are framed as 'play', they do not get assigned the same meaning that they would have in a non-playful context. The playful bite is metacommunicative in the sense that the act itself communicates that it should be taken as 'play'. Similarly, human activities such as children's pretend play are metacommunicative in nature: it is the communication that defines the play frame.

3.1 Sawyer: Blending of Frames

Given that our approach to interactive storytelling is closely related to children's improvised dramatic play, we first looked to work in this field for inspiration. Sawyer [9] categorizes metacommunication in pretend play along two dimensions: *frame* and *explicitness*, distinguishing four levels within each dimension.

Explicitness only concerns children's proposals to modify the play frame (i.e., change the story world). In the Interactive Storyteller this is done via the system, so we do not discuss this dimension further here, focusing only on frame. The communication's frame can range from in-frame (in-character) to out-of-frame, with two blended levels in between, as shown in Table 1. In the blended frames, reference is made to objects or events from the other frame.

Sawyer's notion that in-frame and out-of-frame communication are not wholly separated realms, but that they can be blended, is a useful starting point. However, we feel that Sawyer's scheme is insufficient for our purpose. In the Interactive Storyteller, unlike dramatic play, the children do not only interact with each other directly but also via the system, which provides a shared visual representation of a story world and external characters that can be controlled. This means there is a division between the story that is created during play and the play itself. Sawyer's annotation scheme for frames cannot account for this distinction, which means that a more fine-grained annotation scheme is called for.

Table 1. Sawyer's annotation scheme for the frame dimension (adapted from [9])

Level	Frame	Example communication
1	In-frame	Imitating voices, referring only to in-frame objects or events, e.g., *Watch out for the earthquake!*
2	Blended frame (in-character)	Speaking in-character, but referring to the world outside play, e.g., in a character's voice: *I need more blocks!*
3	Blended frame (out-of-character)	Speaking out-of-character about the play itself, e.g., *Let's say my guy was killed in the earthquake.*
4	Out-of-frame	Speaking out-of-character, not about the world in the play frame, e.g., *Let's play house now.*

3.2 Fine: Three Frames, Linked to Identity

Whereas Sawyer only distinguishes two basic frames, play and non-play (with blending between them), Fine [6] distinguishes three frames in his study of fantasy role-playing games. Each of the three frames is linked to a different side of the role-player's identity:

1. The "primary framework" of reality, with participants as persons in the real world;
2. The framework of the game, with participants as players manipulating their characters within the rules and constraints of the game;
3. The framework of the fantasy, with participants 'being' the characters that they play.

Interactive storytelling with our system is similar to fantasy role-playing, in that players assume the roles of characters in an imaginary world of which the setting is given, and do so within a (non-competitive) game context with certain rules and procedures. This makes Fine's frame structure suitable for our system. The interaction fragments from the introduction illustrate two of Fine's frames: the child as character in fragment 1 and as player in fragment 2. An example of a child's utterance in the primary framework is *He's still filming us!* referring to the video recordings that were made during our user experiments (see Section 4.1).

Fine observes that during the game, the players are constantly oscillating between frames, and that participants are "able to operate on several levels nearly simultaneously" [6, p. 240]. However, unlike Sawyer, he does not explicitly distinguish blended frames as separate levels.

3.3 The P×R Annotation Scheme: Perspective and Reference

In our opinion, both Sawyer's and Fine's frameworks are not fine-grained enough to capture the different types of communication that occur during interaction

with our storytelling system and, presumably, other systems. However, we feel that the two can complement each other to allow for sufficiently rich annotation. Sawyer's scheme incorporates the possibility of blending, which is necessary because communication can be in one frame while referring to another frame. Fine's scheme includes a game frame, which is necessary to allow for annotation of communication about game play. Therefore, we combined Sawyer's and Fine's ideas to create a new annotation scheme that we call P×R. The new scheme includes Fine's three frames but also allows for blending between frames.

Table 2. The P×R annotation scheme, including shorthand notation for the different communication categories

		Reference		
		Story	*Game*	*Reality*
Perspective	*Character*	CS: In-character utterances and imitations	CG: In-character references to game elements	CR: In-character references to events or objects outside play
	Player	PLS: Action suggestions and proposals referring to the story	PLG: Communication about game aspects	PLR: Including real-life events or objects in the game frame
	Person	PES: Observations about events that happened in the story	PEG: Observations about the interface, opinions about the game	PER: Communication about events or objects outside play

Our annotation scheme (see Table 2) is based on the notion that a user of an interactive storytelling system can take on different *perspectives* (P) toward different frames of *reference* (R). In other words, the scheme indicates which identity a speaker takes on (perspective) and what he or she speaks about (reference). We want to be able to annotate how a user relates to the story: as a character in the story, as a player controlling a character in the story, or as an observer of the story. These classes of utterances are captured by the CS, PLS and PES categories respectively. We also want to distinguish whether the user is referring to the story, the game or the reality. This is an extension of Sawyer's distinction between in-frame and out-of-frame references, with Fine's game frame as an added out-of-character level.

By combining the two dimensions of perspective and reference, we broaden the scope of Fine's categorisation, which would only allow for annotation of the classes on the diagonal of our scheme (CS, PLG and PER). A mapping of Sawyer's scheme to our own yields the following correspondences of our categories to his frame levels: (1) = CS; (2) = CG, CR; (3) = PLS, PLG, PES, PEG; and (4) = PLR, PER. This illustrates our scheme allows for distinctions that Sawyer's cannot make.

As shown above, the P×R annotation scheme offers several refinements of Sawyer's and Fine's schemes. There are however some classes that are less

intuitive, namely the CG, CR and PLR classes. A fictional example of a CG utterance would be a child speaking as Red about the game saying that *It's too bad I have to wait for Granny before I can do anything*, indicating in-character that she would have to wait for her turn in the game. Granny might also exclaim *Oh, Red, we are being filmed!*. This would be annotated as a CR utterance, as it is an in-character reference to an event taking place outside the story and game frames. Lastly, a PLR utterance (a user speaking as a player about the reality frame) would be one in which a user tries to incorporate an object or event from the reality frame (outside the game and story) into the game. For example, this would be the case when a user says that she can only go swimming at the beach when it is sunny outside (she introduces a game rule based on the reality frame).

4 Analysis of Children's Communication

In this section we describe the communication data to which we applied the P×R annotation scheme. We also describe the annotation process, and we present and discuss the results.

4.1 Data and Annotation

The communication data were collected in a small-scale experiment, in which four pairs of 8-11 year old children played with the Interactive Storyteller (see [1,11] for details). All participants were pairs of siblings or friends. One child controlled the character Red; the other controlled Granny. Wolf was always controlled by the system. Each pair of children carried out two play sessions with the system, one with and one without tangibles (in a counterbalanced order).

At the start of each run of the experiment, the children were told that they could use the system to create a story, and the basics of the user interface were explained to them. Because we were interested in their spontaneous behaviour while interacting with the system, we did not give them a specific goal to achieve, nor did we ask them to talk or think aloud. The entire experiment was recorded on video, see Figure 1. On average, the play sessions lasted 12 minutes (min. 9, max. 14 minutes), amounting to almost two hours of play in total. All character actions (selected by either the children or the system) were logged, and the children's communication during the play sessions was transcribed.

Transcripts were segmented into utterances based on speaker turns, bounded by silence or speech by the other child or the system. When a speaker turn consisted of multiple utterances that should each be assigned a different label, the turn was split. This was done in only four instances; all other speaker turns were treated as one utterance.

All utterances were annotated by the first two authors, using the coding scheme from Table 2. First we carried out two practice rounds, annotating one and two play sessions respectively, and comparing and discussing the results to come to a shared understanding of the annotation scheme. The remaining five sessions were annotated independently (Cohen's κ: 0.74). As a final step, all differences between the annotators were resolved by discussion.

In total, 640 utterances were annotated. This number excludes those cases where we could not make out what a child was saying.

4.2 Results and Discussion

In Table 3 we show the annotation results. They are separated by session, because the children's first and second interaction sessions had different utterance type distributions.

We found some individual differences in communication between the pairs of children: Pair 1 talked more in character, Pair 2 talked more from a 'person' perspective, and Pair 4 communicated more in general than the other pairs. However, the overall image was similar for all pairs.

In their first sessions with the system, the children communicated more about the game, while in their second sessions they communicated more about the story. In both cases, they were mostly speaking from a player perspective. These findings may be explained by the fact that in the second sessions, the children were more familiar with the system's interface and its rules and constraints. This led to fewer discussions about, for example, turn taking or which locations were accessible to the characters (both annotated as PLG) and fewer comments on the quirks of the interface (annotated as PEG). In addition, by the second session they had discovered more of the things the characters could do in the story world, resulting in more mutual action suggestions and discussing plans for their characters (annotated as PLS). An example is the following exchange:

(3)
> System [narrating action by Wolf]: Hello, says Wolf to Red.
> Child 7: *You have to give him the cake!*
> Child 8: *It has to be poisoned first.*
> Child 7: *(...) I will do that, alright?*

That such PLS exchanges occurred more often in session 2 is in line with our findings in a previous study, in which we investigated the coherence of the stories created by the children [11]. In that study, we found that the stories created in the second sessions contained longer causal chains of events, thus showing more coherence. Another, very noticeable, difference between the first and second sessions is that the children generally talked more in session 2. This is probably because by the second session, the children had become more at ease with the experimental setting and thus talked more freely.

We also compared the utterance type distributions of interactions with the tangible or the touch-only version of the system. Here, the only remarkable difference in the children's communication was that the children more often took on a 'person' perspective with the tangible version than with the touch-only version. A possible explanation for this is that when the characters were personified as tangible objects, the children were more likely to see them as separate entities, and therefore identified less with them. On the other hand, exchanges such as the following (coded as PEG) show that the children did see the tangibles as representations of themselves:

Table 3. The annotation results of the children's communication in their first and second sessions with the interactive storytelling system

| | Session 1 (230 utterances) | | | | | Session 2 (410 utterances) | | | |
	Story	*Game*	*Reality*	Total		*Story*	*Game*	*Reality*	Total
Char.	6%	0%	0%	6%	*Char.*	7%	0%	0%	7%
Player	25%	32%	0%	57%	*Player*	36%	22%	0%	58%
Person	13%	23%	1%	37%	*Person*	15%	16%	4%	35%
Total	44%	55%	1%	100%	Total	58%	38%	4%	100%

(4) Child 1: *Oh, you are so fat as Granny! Granny is fat.*
 Child 2: *[...] In reality, I'm really thin!*

As can be seen in Table 3, relatively little of the communication was carried out in character (CS; 6% on average). This is not surprising, because the design of the system did not particularly encourage it. As mentioned in Section 2, all character actions are narrated through speech by the system, in principle making it unnecessary for the children to add their own dialogue. Nevertheless, the children did speak in character to express story elements that were not available in the system, such as certain character emotions (*Oooh, I'm scared!*) and goals (*Especially for you, Red!* when baking a cake). In-character communication also frequently involved miming character actions such as shuffling, diving and eating, and expressing the characters' emotions through sounds and facial expressions.

We noted that in most PES utterances the children talked about their characters in the third person, while in most PLS utterances they used first person pronouns (*I am going to bake the apple pie*). Pronoun use is an interesting aspect to investigate further, as the users' choice of pronouns indicates how strongly they identify with their character, and, in general, to what extent they are engrossed in the activity [10].

5 Validity of the Annotation Scheme

In the previous section we showed that applying the P×R scheme to the children's communication data provided us with several useful insights. In this section, we discuss the scheme's reliability and examine its validity by viewing the results through the lens of the other frameworks. We also mention some points for improvement of the annotation scheme.

For the five sessions that were annotated independently (see Section 4.1), we computed an inter-annotator agreement of 0.74 (Cohen's κ), which indicates good agreement and thus reliability of the coding scheme. The only main disagreements between the annotators concerned utterances in which the players commented on the actions of Wolf, the computer-controlled character. One annotator coded all of these utterances as PES, seeing them as person-perspective observations on the story (specifically, Wolf's actions within the story). The other annotator coded several of these utterances as PLS, because they referred to Wolf as a fellow player of

the game rather than as a character in the story. This is illustrated by the following conversation fragment:

(5)
> Child 4: *Doesn't Wolf have any ideas anymore?*
> Child 3: *Wolf is trying to think of a plan.*
> Child 4: *Yes, but he can't do that because the cake has already been eaten.*

This disagreement was solved by coding all utterances of this kind as PLS.

With our scheme, we were able to pinpoint which perspective a user assumed and which frame he or she referred to. In contrast, as we argued in Section 3, both Sawyer's and Fine's annotation schemes only allow for limited annotation of communication in the context of interactive storytelling systems.

Sawyer's approach to in-frame and out-of-frame communication does not distinguish between player and person perspectives. With Sawyer's scheme, all utterances in our PLS, PLG, PES and PEG categories would have been annotated as level 3, as they are all out-of-character observations about the play (taken to include both story and game elements). Table 2 shows that in that case, 91% of all utterances would have been classified as level 3. This makes it clear that when using Sawyer's approach, we would not have been able to distinguish between the majority of utterances.

Fine's framework does not include blending between frames, which means that certain nuances would be lost when applying it to our communication data. This can be explicated by fragments 2 (coded as PLG) and 3 (coded as PLS). In Fine's scheme, the communication in these fragments would be classified as being in the context of the game and therefore as communication from a player perspective. Both fragments indeed show a player-perspective, but fragment 2 refers to rules of the game, while fragment 3 is about taking action in the fantasy world. In Fine's classification, the latter fragment's reference to the story frame could not be made explicit.

Compared to the frameworks of Sawyer and Fine, P×R gives a more fine-grained view of the users' communication by giving insight into both the perspective of the user and the frame that is referred to. However, with respect to certain classification categories the scheme could be said to be overly fine-grained. Of the categories for CR, CG and PR communication, only one instance was found in our data: a child's tangible prop was insulted out of character by the other child, and she reacted with being 'angry' in character. This instance, labelled as CR, occurred in session 2 as only one of the 410 annotated utterances.[2] Although theoretically possible, we found no instances of either the CG or the PR categories in our data. Note that CR and CG correspond to Sawyer's frame level 2; it is unknown how often this category occurred in his pretend play data [9].

[2] As such, it made up only 0.24% of the total number of utterances in session 2 and was rounded to 0 in Table 3.

There are also some distinctions the P×R scheme cannot make. We observed that references to the story made from a 'person' perspective (PES) included utterances that were explicitly addressed to one of the characters, for example *Now, now Granny!* and *Bad Wolf!* These were coded as PES, because they were neither spoken in character nor from a player perspective. However, such utterances did show great involvement in the story: the children addressed the characters as if they were 'real'. This distinguished these utterances from other PES utterances that showed a higher degree of detachment from the story world, such as comments on the events in the story (*Now it's getting scary*) and on the characters (*Wolf is not very smart*), and cases where the children read aloud parts of the story text from the scrolls. The P×R scheme still seems not sufficiently fine-grained to capture these nuances. This, together with the finding that CR, CG and PR communication was lacking in the play sessions, encourages further research on our annotation scheme.

6 Conclusions and Future Work

The P×R annotation scheme proposed in this paper combines ideas from Sawyer [9] and Fine [6], leading to a relatively fine-grained coding framework that distinguishes two communication dimensions (*perspective* and *reference*) with three levels each, resulting in nine annotation categories. Applying the scheme to our communication data of children playing with an interactive storytelling system showed how the children's focus of attention shifted between the game and the story over time, and at what level they related to the story being created. Some of the categories specified by the P×R scheme turned out not to be used in the annotation, whereas other categories might still have been overly broad. This suggests that the scheme could possibly be further refined.

We believe that, with further refinement, the P×R scheme can be used to inform the design of interactive storytelling systems. It yields insight into the type of experience the users are involved in, revealing among other things whether users are mainly concerned with the story, game or reality frame. Future work could then look into how certain design decisions influence users' experiences. For example, the results could indicate which factors in an interactive storytelling system incite in-character behaviour (CS) (desirable for systems aimed at entertainment) and which factors incite more reflective behaviour from an out-of-character perspective (PES, PLG or PER) (useful for interactive storytelling systems with an educational purpose). In short, we expect that the knowledge gained by coding user communication in terms of our proposed P×R scheme could enhance the utility of interactive storytelling systems.

Acknowledgements. We thank the children and their parents for their participation in our experiment; the people at T-Xchange (in particular Thomas de Groot) for the use of their lab and multi-touch table; and Ivo Swartjes for his work on the Interactive Storyteller. We also thank our anonymous reviewers for their comments and useful suggestions to improve the paper. This publication was supported by the Dutch national program COMMIT.

References

1. Alofs, T., Theune, M., Swartjes, I.: A tabletop interactive storytelling system: Designing for social interaction. International Journal of Arts and Technology (to appear)
2. Alves, A., Lopes, R., Matos, P., Velho, L., Silva, D.: Reactoon: Storytelling in a tangible environment. In: 3rd IEEE International Conference on Digital Game and Intelligent Toy Enhanced Learning, pp. 161–165 (2010)
3. Aylett, R., Louchart, S., Dias, J., Paiva, A., Vala, M.: FearNot! - an experiment in emergent narrative. In: Panayiotopoulos, T., Gratch, J., Aylett, R.S., Ballin, D., Olivier, P., Rist, T. (eds.) IVA 2005. LNCS (LNAI), vol. 3661, pp. 305–316. Springer, Heidelberg (2005)
4. Bateson, G.: A theory of play and fantasy. In: Bateson, G. (ed.) Steps to an Ecology of Mind, pp. 177–193, Chandler, New York (1972); reprinted in Salen, K., Zimmerman, E. (eds.): The Game Design Reader: A Rules of Play Anthology, pp. 314–318. MIT Press (2006)
5. Cao, X., Lindley, S., Helmes, J., Sellen, A.: Telling the whole story: Anticipation, inspiration and reputation in a field deployment of TellTable. In: ACM Conference on Computer Supported Cooperative Work, pp. 251–260 (2010)
6. Fine, G.A.: Shared Fantasy: Role-Playing Games as Social Worlds. The University of Chicago Press, Chicago (1983)
7. Goffman, E.: Frame Analysis: An Essay on the Organization of Experience. Harvard University Press, Cambridge (1974)
8. Prada, R., Paiva, A., Machado, I., Gouveia, C.: "You cannot use my broom! I'm the witch, you're the prince": Collaboration in a virtual dramatic game. In: Cerri, S.A., Gouardéres, G., Paraguaçu, F. (eds.) ITS 2002. LNCS, vol. 2363, pp. 913–922. Springer, Heidelberg (2002)
9. Sawyer, R.: Levels of pretend play discourse: Metacommunication in conversational routines. In: Lytle, D. (ed.) Play and Educational Theory and Practice, pp. 137–157. Praeger Publishers, Westport (2003)
10. Stromberg, P.G.: The "I" of enthrallment. Ethos 27(4), 490–504 (2000)
11. Theune, M., Alofs, T., Linssen, J., Swartjes, I.: Having one's cake and eating it too: Coherence of children's emergent narratives. In: 2013 Workshop on Computational Models of Narrative. OpenAccess Series in Informatics (OASIcs), vol. 32, pp. 293–309 (2013)
12. Vermeulen, I.E., Roth, C., Vorderer, P., Klimmt, C.: Measuring user responses to interactive stories: Towards a standardized assessment tool. In: Aylett, R., Lim, M.Y., Louchart, S., Petta, P., Riedl, M. (eds.) ICIDS 2010. LNCS, vol. 6432, pp. 38–43. Springer, Heidelberg (2010)
13. Zancanaro, M., Pianesi, F., Stock, O., Venuti, P., Cappelletti, A., Iandolo, G., Prete, M., Rossi, F.: Children in the museum: an environment for collaborative storytelling. In: Stock, O., Zancanaro, M. (eds.) PEACH - Intelligent Interfaces for Museum Visits, pp. 165–184. Springer, Heidelberg (2007)

Performative Authoring: Nurturing Storytelling in Children through Imaginative Enactment

Sharon Lynn Chu, Francis Quek, and Theresa Jean Tanenbaum

Texas A&M University,
Simon Fraser University
{sharilyn,quek}@tamu.edu,
tess.tanen@gmail.com

Abstract. This paper presents an empirical study that provides support for the use of enactment in storytelling systems. The overall goal of our research is to facilitate the authoring of stories by children, aged 8 to 10 years. Our findings show that story enactment results in positive effects on the child's storytelling, but only through the mediation of imagination during enactment. Only imaginative enactments support better storytelling. Based on our results, we make a case for enactment as an effective motivator, interface and cognitive tool for children going through a period of development called the Fourth-grade Slump, and we propose the concept of performative authoring for the design of interactive storytelling systems for children.

Keywords: Storytelling, Imagination, Enactment, Children, Creativity.

1 Introduction

Storytelling has a central role in education, especially in elementary school curricula. This reflects the importance of narratives in helping us to make sense of all of our experiences [5], and as a cognitive tool that can help to nurture a child's imagination [15]. In this paper, we look at how to better support children's authoring of digital stories among third- and fourth-graders. Our target age range is motivated by empirical research [35] that has shown that children sharply decrease engagement in creative activities, and so display a lower level of creative thinking during this period of development. This phenomenon called the *Fourth-grade Slump* [31] has already stirred interest among human-computer interaction researchers, and is described in e.g., [12,11,7].

There is a recent trend in elementary schools toward the use of digital storytelling in place of conventional pen-and-paper methods. However, this usually takes the form of simply typing in word processing documents, use of online websites (e.g., Glogster), or use of video cameras. While consumption of digital narratives is relatively easier to facilitate for children, authoring is more of a challenge with children as story designers. Experimental research on the support of children's authoring of digital narratives is still limited although it is gaining momentum in research communities such as in child-computer interaction.

H. Koenitz et al. (Eds.): ICIDS 2013, LNCS 8230, pp. 144–155, 2013.
© Springer International Publishing Switzerland 2013

Currently, the predominant interface for story creation by children is tied to the mouse and keyboard. This paper presents research that provides support for the idea that enactment may be beneficial for children's storytelling. We propose the concept of *performative authoring*, whereby the child employs an embodied interface (in terms of physical enactment and use of tangible objects) for the construction of digital narratives. In the following sections, we first describe theories that may explain the potency of enactment, and review embodied systems for children's story authoring proposed in the literature. We then describe our study, methods of data analysis, and results. We end with a discussion that highlights the significance of the results for the design of interactive digital storytelling systems, and that puts forward the design concept of performative authoring. In this paper, the term 'enactment' is always used to refer to physical enactment.

2 Background

2.1 The Body as Narrative Interface

The proposition of using the body as a narrative interface has been made before in the interactive storytelling community (e.g., [1,19]), but these works argue only in terms of narrative engagement, such as when reading a book [19] or in a narrative-based game [1]. We argue for the use of the body to allow children to engage in story authoring tasks. The rationale for the support of children's story creation through enactment is at least threefold: i) Enactment provides children with the motivation to create by providing pleasure, participation and a sense of empowerment, ii) It provides a way to lower the barrier of expression for children, and iii) It may enable the child to improve their storytelling. These are all important in the context of the precipitous drop in creativity during the Fourth-grade Slump. We expound on each of them below:

Motivation to Create. Motivation, be it intrinsic or extrinsic, is a key factor of any creative process [2]. Without motivation, authoring does not take place. Interacting with a digital narrative supports a wide range of different pleasures. In some cases these pleasures are participatory: the core enjoyment is derived from the experience of being a part of a living story. In other cases the pleasure is expressive: the core enjoyment comes from an opportunity to create or imagine one's own version of the story. Tanenbaum [33] argues that there is a distinction between the pleasures of authoring a narrative and the pleasures of reading it, contending that there is a transformative pleasure that comes from enacting a known narrative script. We posit that for children, authoring through enactment may provide both expressive pleasure, as they are able to materialize their imaginations (see next section), and participatory pleasure, as they review their story and relive it. Both Murray [23] and Laurel [20] have also discussed about the power of enactment to create transformative narrative experiences. Murray [23] argues that enacting the events of a narrative allows participants to assimilate and internalize the central meaning of the narrative in a way that transcends

simply reading about those events. Other concepts in the literature such as immersion, participation, and engagement are all fundamentally concerned with the underlying pleasures and motivations that make a narrative compelling and enjoyable, and may all be impacted positively through enactment.

Lowering the Barrier of Expression. In their work on children's creativity in storytelling, Chu and Quek [9] identified inadequate competence in story expression as a possible demotivating factor that contributes to the Fourth-grade Slump in the domain of storytelling. Hence, lowering the competency barrier to expression may be a key factor to encourage storytelling in children. The third to fourth grade period is a critical turning point in Piaget's stages of development, known as the *Concrete Operational Phase* (COP) [26]. During this phase, the child engages in logical reasoning with physical objects, eliminates syncretic speech in favor of social speech, and increases in social awareness.

Social awareness and social language development bring about a self-evaluation in the child of her competence in creative activity. This conscious self-evaluation coupled with the time needed for the child to achieve competence results in a demotivational downspiral that is a key contributor to the Slump. Modern theories of development and motivation [13,14] emphasize the need for children at this period to gain and demonstrate competence. Bringing these concepts into the storytelling context, we posit that the child's enactment of her imagined stories may be a means to facilitate creative storytelling through concrete embodied expression, and to scaffold the capacity for developing more abstract and richer forms of story imagination/construction. As opposed to current methods using linear, symbolic text for story writing in schools, the child is free to focus first on compositing the story instead of on the technicalities of the mode of expression.

Improving Storytelling. The idea of enactment as an 'externalized' construction of a story idea or concept resonates with the broader concepts of embodied cognition and interaction. Modern gesture studies [16,22], for example, establish the link between embodied actions and thought, where action helps to shape thought and ideas, and not just express it. Gesture enables the speaker/thinker to appropriate the resources of physical space and embodied action (e.g., simulated running or waving) space and action to facilitate thought. Enactment thus may function to actively affect the child's very creative thinking during the story authoring activity.

2.2 Embodied Systems for Children's Story Authoring

We focus on systems that have been proposed for story creation or the authoring of narratives, instead of for listening to or consuming (interactive) narratives. A number of systems making use of body gestures and the manipulation of tangibles have been proposed in relation to children's storytelling, each looking at a different aspect of the matter. The I-Shadows prototype by [25] aims to allow children to build narratives with the aid of an emotion recognition system. The

focus however is not on body gestures, but on emotions expressed. Similarly, StoryFaces [30] allows the child to compose story scenes by combining performative play in the form of self-recorded facial expressions with digital drawings. The PageCraft system [6] focuses on portability and tangibility, and is a prototype that can be folded into a carrying case and allows the child to create digital narrative scenes by placing tangible objects embedded with sensors on a playmat. The digital scene is then constructed through object placements from pre-built images. In this case, the use of the body is not for body enactment per se, but through instrumental, directed actions of object manipulation. Other systems, having children as users in mind, enable the manipulation of dolls to animate virtual characters, possibly creating a story, e.g., [28].

2.3 Investigating Enactment for Children's Storytelling

Although many works present that systems for children's story authoring are based on the rationale of embodiment, few of them provide concrete support for the value of embodiment or enactment per se. Other literature exists on studies that investigate specifically the use of the body (usually via some kind of embodied interface) to amplify allied cognitive gains, e.g., [3,21]. However these most often focus on teaching certain concepts (e.g. programming constructs, music concepts, science themes) to children, rather than on creative storytelling.

In the latter domain, one of the interesting works is that of Wright [36] who describes how children engage in meaning-making through embodiment and narration in a study with 108 five- to eight-year-old children. In her study, children were asked to draw 'what the future will be like' and then tell their story to the interviewer. She notes the children's prominent use of "dramatization, expressive sound effects, gesture and movement" to "bring their stories to life". Similarly, in a study comparing story construction in text to authoring with media by third and fourth graders, Chu, Quek, and Lin [12] describe how children who made use of the media interface enacted their stories offline through gestures and embodied action and produced stories with richer texture.

In our study, we investigate the effects of enactment on the child's storytelling, and focus on imagination in the course of enactment as an active factor by which enactment may be effective.

3 The Study

3.1 Study Design

Our study consisted of an empirical experiment whereby children listened to a stimulus story and were asked to elaborate on parts of it through enactment. We constructed the stimulus story to have three acts, with each act divided up into a series of episodes based on thematic groupings, as illustrated in Figure 1. There were 12 episodes in Act 1, 10 in Act 2, and 13 in Act 3. Children were asked to act out three scenes in each act, with different physical objects given to

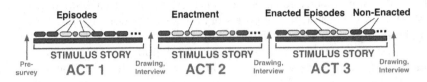

Fig. 1. Structure of the study

them to assist enactment. We refer to episodes that occurred before and after the enactments as 'enacted episodes' as opposed to the other 'non-enacted' episodes. A few episodes occurring after certain enactments did not contain story elements relevant to the enactment and thus were not considered enacted episodes. This resulted into 14 enacted episodes out of the 35 total. The story tells about three dwarves setting out into the caves to collect mushrooms to help their city that will soon be attacked by an ancient enemy. The children were asked to enact three scenes within each act: a scene of the dwarves cooking, a scene of them digging, and a scene of them using a lantern for various purposes, such as driving away bats or spiders.

The stimulus story was conveyed to the children via story narration. In one treatment, the children heard the narration in conjunction with cartoon-style PowerPoint slides, and in the other the video of the narrator sitting in an armchair was played. The three story acts, excluding enactments, were each around 5 to 7 minutes in length in both slideshow and narrative video formats. However, in this paper, we will only address the effects of enactment on the child's storytelling and will not deal with stimulus type. Both stimulus type treatments are grouped together here for our purpose of studying enactment.

3.2 Study Methodology

Twelve children from a 4th-grade class participated in the study over four days. Two additional children were recruited separately, making a total of 14 participants (8 girls and 6 boys), all aged 9 except for one aged 10. All children willingly chose to participate. A packet consisting of a consent form, an information sheet and a personality questionnaire (the Big-Five Inventory-10 scale) was sent to the parents via the teacher a week before the study started. The teacher was also asked to complete a questionnaire to assess (on 7-point Likert scales) the engagement, realism and imaginativeness of the typical performance of each child participant in day-to-day class activities. Two children at a time listened to the story, but enactment was performed individually. Two rooms near the classroom were set up with a laptop, a large 55" display, loudspeakers, floor mats, two video cameras and a voice recorder. Additionally, in each room two boxes were drawn on the floor to act as the 'enactment areas', with a camera on tripod facing each box so that two children standing in the boxes would face away from each other to avoid priming (see Figure 2 for room setup).

On the first day of the study, an experimenter distributed a questionnaire to all the participants asking, on 7-point Likert scales, about their enjoyment of

Fig. 2. Setup of the 'experiment room'

storytelling, their confidence to tell and to act out stories, and their frequency of telling stories. They were guided to fill the questionnaire as a group. Subsequently, one pair of children at a time was sent to each 'experiment room'. At the beginning of the study, the two children were briefed about the study and told that they will be listening to a story and acting out (or pretend play) parts of it with different objects.

At the point of the cooking, digging and lantern scenes in each act, the story was stopped and an enactment prompt slide was shown, asking the child to enact the story events that immediately preceded it with questions in the form of *[Dwarf's name] is frying/digging up/swinging the [target object]. Can you act out how he/she is using the frying pan/pickaxe/lantern?* The children were allowed to enact in any way they want and to use the objects given to them for each scene as they desired. After each act, the children were asked to draw one of the scenes they just acted out on a sheet of blank paper.

First, we were interested to assess how well the child could recount the story. In this paper, we use the term 'storytelling' to mean the concept in general, and 'story telling' to refer to the product of a specific telling of a story. A story telling or retelling is not only a process of retrieving memory experiences, but also a creative act of construction [8,18]. Thus, a story telling not only informs us of what the child recalls, and of the child's understanding and comprehension of the story, but also of the child's imagination in terms of what she adds to the initial story [18]. In a post-act semi-structured interview, the child was asked to retell the story (which could include as much of the stimulus story and her enactments as the child desired). Second, we wanted to look at the creativity of the children's enactments. All enactments were video recorded and interviews were both video and audio recorded. Each child was asked questions intended to help us to assess the enactments (e.g., What were you thinking while you were acting out the [action]?; Did you think about [detail mentioned] just now or back then while acting?). Follow-up questions based on the child's prior responses probed for indications of the depth and detail of her imagination.

4 Data Analysis

4.1 Evaluating Storytelling Quality

After transcription of all interview recordings, each episode from both the stimulus story and the children's story tellings were converted into a list of core idea

units, similar to a 'narrative digest' [27]. The narrative digest of each child's story telling was then compared to the digest of the stimulus story. The stimulus story was used as an objective baseline to enable comparisons across participants. Comparisons were made in terms of narrative coherence and richness.

Following the definition in [24], *narrative coherence* was understood as the need for "both the parts of the story and the story as a whole [to] hang together in a convincing and satisfying way". It concerns assessing the centering of a story as well as the sequence of events narrated. Similar to Berman [4] who devised a coding scheme for assessing the narrative structure of children's stories based on measurements such as the number of references to plot advancing events, the number of of references to plot summations and the types of connectivity markers, we identified the different types of connectors in each child's story telling and totaled them up to obtain a coherence score. Words that significantly described causal (cause and effect), temporal (event sequence) and relationship (clear identification of character relationships or referents) linkages occurring between events were marked as connectors.

For *richness*, prior literature has proposed to assess story retellings through 'holistic grading', which functions on the premise that "the whole of any piece of writing is greater than the sum of its parts", and that one thus has to take into account the "total impression" of the text [18]. However, we found that this procedure did not fit our purpose. We wanted a more objective and consistent method that enables us to evaluate how much the child has fleshed out the narrative with relevant contextual information, in other words, the amount of details included in the telling. Borrowing from news narratives, which are often evaluated based on the 5Ws and 1H principle [17], our analysis comprised of identifying how many idea units addressing the who, what, where, when, why and how are contained in the child's narrative digest of each episode. The outcome of this procedure (summing up the total number of idea units detailing the 5Ws+H per episode) was a score embodying the richness of the child's story telling. All codings were done by two independent coders who conferred upon disagreements.

The Coherence and Richness scores were normalized by the number of idea units in each episode of the stimulus story, subject to a maximum number of units per episode (to minimize penalty due to memory and time constraints for episodes of the story with too many idea units). An overall Story Quality (SQ) score was then generated by summing up the Coherence and Richness scores.

4.2 Evaluating Imagination during Enactment

Assessment of the children's enactments was done using a modified version of MAIA [9] (Methodology for Assessing Imagination in Action), a methodology proposed to measure the level of imagination of children during the process of enacting. Through an integrated coding of the children's enactment videos (coding of micro-actions and story vignettes portrayed in the enactments), post-drawings (coding of meaningful elements drawn) and post-interviews (coding of enactment-relevant details mentioned), MAIA requires coders to score the child's imagination during an enactment on three dimensions: richness, consistency and typicality on scales of

0 to 5. These subscores are then aggregated into an Overall Broader Imagination Score (OBIS). For the purpose of our analysis, we only considered the richness and typicality subscores to generate OBIS since the persistence of the child's imagination across measurement methods (video, drawings, interviews) was not of interest. The two subscores were summed to derive an Enactment Quality score (EQ) for each enactment.

5 Results

5.1 Children's Narratives

Stadler and Ward [32] describe the levels of narrative development as progresssing from 1) basic labeling to 2) listing, 3) connecting, 4) sequencing and finally 5) narrating. They explored these levels with children aged up to only about 5.5. In our study, we found that although the fourth-grade children (mostly aged 9) were able to tell comprehensible and reasonably attractive stories, most of their tellings remained at the second to fourth levels of Stadler and Ward's [32] narrative development scheme. The most common type of connectors seen when coding for coherence was the 'and' connector. In those cases, it was often not evident whether the child meant for the relationship to be temporal, causal or simply sequential. Best guesses were made in cases where it was possible, otherwise they were not coded. This level of narrative may be classified as the listing level of narration whereby one recounts a "topic-centered list of perceptual attributes or character actions" and uses basic conjunctions to connect the items logically. There were also some evidence of more developed narratives at the level of sequencing with causal connectors (examples found included to, because, so, so that, but), and temporal connectors (examples found were then, when, after that, while, soon, first of all, first, a few seconds later).

5.2 Episode Type, Story Quality and Enactment Quality

The story quality and enactment quality scores for all episodes of all participants (35 episodes × 12 participants, resulting in 420 cases) were entered into SPSS. Outlier cases were excluded after descriptive analyses were run, and the final total number of cases was at 412. A one-way between-subjects Analysis of Variance (ANOVA) test was run to see the effect of episode type (the independent variable indicating whether an episode was enacted or non-enacted) on story quality (the dependent variable). It showed a significant difference in means between enacted and non-enacted episodes, $F_{(1, 204)} = 6.245$; $p < .05$. As shown in Figure 3a, enacted episodes resulted in higher SQ (standardized $\bar{X} = .61$) than non-enacted episodes (std $\bar{X} = .33$).

Further, a correlation test was run to investigate the relationship between enactment quality and story quality, and the two were found to be correlated, Pearson R = .317; $p < .05$, although not too highly. Our further analysis explained why. The dataset was split into three files based on the enactment quality scores

to obtain a set of low EQ cases, one of medium EQ, and one of high EQ. The ANOVA test of episode type by story quality was repeated with each of these three sets. Figure 3b shows story quality scores by enactment quality scores grouped into three bins. These ANOVAs testing how much high imagination, medium imagination, low imagination enactments contributed to the difference between SQ scores in enacted and non-enacted episodes showed an interesting pattern. Cases with high EQ resulted in a highly significant difference in SQ scores between enacted and non-enacted episodes, $F_{(1, 147)} = 7.374; p = .007)$. Cases with medium EQ showed a moderate significant difference, $F_{(1, 155)} = 5.020; p = .026)$, and cases with low EQ did not result in a significant difference, $F_{(1, 158)} = .052; p = .819)$. It appears that level of imagination during enactment functioned as a mediator of the positive effect of enactment on storytelling.

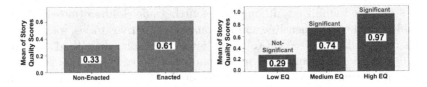

Fig. 3. a. Episode Type × Story Quality Scores; b. Enactment Quality × Story Quality

6 Discussion

Our study investigated the value of enactment for children in a storytelling context to help us determine whether an enactment-based authoring interface may be beneficial. Our results show that at the level of the basic narratives that the children told, enacting improves the child's storytelling, making it richer and more coherent, but highly imaginative enactment improves it even more. Simply enacting seems to contribute little to the child's storytelling, as the non-significance of the low enactment quality cases indicate. In other words, the quality of the story is positively related to the level of imagination during the enactment. These findings not only seem to indicate that an enactment-based interface for storytelling in education may be useful and valid, but they also have significant implications for the design of digital storytelling systems.

With our study as background, we propose the design concept of performative authoring whereby a digital story is literally 'painted' or 'sketched' using motion, gestures or actions. The child engages in a goal-directed creative activity that she attempts to fulfill in the best possible manner, hence a performance for others or even for the self. A system designed around the concept would allow her not only to bring to life her imagined scenes through enactments, but also to build on her own enactments (reflected through a virtual avatar) to broaden her imagination of the scenes and of her story. The child is able to focus on actualizing her ideas instead of on the rules and peculiarities of language. She is able to characterize her ideas with subtleties and nuances that she is able to imagine but may not

have the competence to express yet, adding richness and texture to her story (e.g. complex gestures of wings flapping vs writing "the bird is flying"). Among the few who have similarly suggested that imaginative enactment may act as an effective interface for story creation by children, Romera et al [29] advanced the idea of embodied authoring of animation scenes for teaching computational concepts (e.g., abstraction and modules). They proposed a system design whereby the user, wearing paper markers, records movements via a webcam on a 'magic mirror'. However they provide no empirical evidence for their concept.

We found that it is important for enactment-based systems to not only afford authoring via physical movements, but also to be designed so as to motivate enactments that cross a certain threshold of imagination. Previous research by [10] may provide some ways to guide design toward imaginative enactment. They showed that varying the affordances of physical objects (e.g. culturally-based, generic or arbitrary objects) used may impact the level of a child's imagination during enactment differently. The type of objects that support imaginative enactment effectively appears to show a consistent pattern within gender. The design of enactment-based storytelling systems may also be informed by research in embodied and tangible interaction that have shown findings in line with our results. For example, [34] describe a physical interactive narrative called The Reading Glove in which the affordances of narrative objects shaped the user's enactments. Their work shows a connection between enactment of portions of a narrative and a stronger sense of transformation into the main story character.

The 'enactment rationale' we motivate is more than met by opportunities provided by technology, bringing enactment-based digital storytelling well within reach in both formal and informal educational contexts. Enactment-based digital storytelling requires a technology bridge between the physical actions of the child (with a prop or object, or gesturally with the body) and the digital world in which the story is encoded for view or presentation. This resonates with the growing body-based and object-based interaction possibilities made possible by such innovations as the Kinect, the Wii and other motion tracker systems, motion-aware handheld devices and prototyping kits like the Arduino.

6.1 Study Limitations

Our aim was to investigate the effects of enacting on a child's storytelling. However, a system that fully enables the performative authoring of stories as we propose it combines the enactment and the storytelling process in one task. The main limitation of our study is thus that the story telling was done after the enactment, as a second activity. With this in mind, we took care to code only details that reflected the children's enactments in their story tellings, by using their answers to interview prompts (e.g. Did you think about it now or then?). With triangulation of multiple data sources, we do believe that the effects seen in post-enactment storytelling remain valid and useful.

7 Conclusion

In schools and other educational settings, children are often seen to struggle to become effective storytellers. Yet storytelling is an essential skill throughout life. We began by positing that enactment may be an effective motivator, interface and cognitive tool to support third- to fourth-graders in storytelling. Our experimental study showed that enactment, through imagination, leads the child to better, richer and more coherent storytelling. Based on imaginative enactment, we proposed the concept of performative authoring as a goal for design. We contribute not only to the understanding of the value of enactment in children's storytelling, providing an empirical base for embodied interaction in this domain, but also contribute to implications for the design of enactment-based storytelling systems. Further, we inform possible technological approaches to engage children in creative storytelling during the Fourth-grade Slump.

Much research remain to be done with regards to, for example, the type of creative domains where enactment is beneficial, the type of interaction technologies that can adequately support the relation between a child's story idea and enacted action, and enactment environments that allow a child to experiment with mood and emotions of story characters, temporal aspects of story events, and other aspects that make up a core narrative experience.

References

1. Álvarez, N., Peinado, F.: Exploring body language as narrative interface. In: Oyarzun, D., Peinado, F., Young, R.M., Elizalde, A., Méndez, G. (eds.) ICIDS 2012. LNCS, vol. 7648, pp. 196–201. Springer, Heidelberg (2012)
2. Amabile, T.M.: The Social Psychology of Creativity. Springer, NY (1983)
3. Antle, A.N., Corness, G., Droumeva, M.: What the body knows: Exploring the benefits of embodied metaphors in hybrid physical digital environments. Interacting with Computers 21, 66–75 (2009)
4. Berman, R.: On the ability to relate events in a narrative. Discourse Processes 11, 469–499 (1988)
5. Bruner, J.: The narrative construction of reality. Critical Inq. 18(1), 1–21 (1991)
6. Budd, J., et al.: Pagecraft: Learning in context a tangible int. storytelling platform to support early narrative dev. for young children. In: IDC 2007. ACM (2007)
7. Chu, S.: Nurturing children's creative practice through micro-enactments. In: CHI EA 2013. ACM (2013)
8. Chu, S., Quek, F.: An enactment-based approach to creativity support. In: Wksp on Interactive Tech. that Enhance Children's Creativity at IDC 2013 (2013)
9. Chu, S., Quek, F.: Maia: A methodology for assessing imagination in action. In: CHI 2013 Wksp on Eval. Methods for Creativity Support Env. ACM (2013)
10. Chu, S., Quek, F.: Things to imagine with: Designing for the child's creativity. In: Interaction Design and Children 2013. ACM (2013)
11. Chu, S., Quek, F., Gusukuma, L., Tanenbaum, T.J.: The effects of physicality on the child's imagination. In: Creativity and Cognition 2013. ACM (2013)
12. Chu, S.L., Quek, F., Lin, X.: Studying medium effects on children's creative processes. In: Creativity and Cognition, pp. 3–12. ACM (2011)
13. Eccles, J.S.: The development of children ages 6 to 14. In: The Future of Children, pp. 30–44 (1999)
14. Erikson, E.H.: Childhood and Society. W. W. Norton & Company, NY (1993)

15. Gajdamaschko, N.: Vygotsky on imagination: Why an understanding of the imagination is an important issue for schoolteachers'. Teaching Ed. 16(1), 13–22 (2005)
16. Goldin-Meadow, S.: Hearing Gesture: How Our Hands Help Us Think. The Belknap Press of Harvard University Press, Cambridge (2003)
17. Gupta, V.S.: Elements of News Story - 5Ws and 1H, p. 25. Concept Publishing, New Delhi (2003)
18. Irwin, P.A., Mitchell, J.N.: A procedure for assessing the richness of retellings. Journal of Reading 26(5), 391–396 (1983)
19. Kistler, F., Sollfrank, D., Bee, N., André, E.: Full body gestures enhancing a game book for interactive story telling. In: Si, M., Thue, D., André, E., Lester, J., Tanenbaum, T.J., Zammitto, V. (eds.) ICIDS 2011. LNCS, vol. 7069, pp. 207–218. Springer, Heidelberg (2011)
20. Laurel, B.: Computers as Theatre. Addison-Wesley Longman Publishing Co., Inc., Boston (1993)
21. Malinverni, L., Lopez Silva, B., Pares, N.: Impact of embodied interaction on learning processes: design and analysis of an educational application based on physical activity (2012)
22. McNeill, D.: Gesture and Thought. University of Chicago Press, Chicago (2005)
23. Murray, J.: Hamlet on the Holodeck: the future of narrative in cyberspace. The MIT Press, Cambridge (1997)
24. Nicolopoulou, A.: The elementary forms of narrative coherence in young children's storytelling. Narrative Inquiry 18(2), 299–325 (2008)
25. Paiva, A., Fernandes, M., Brisson, A.: Children as affective designers: I-shadows development process. In: Wksp on Innovative Approaches for Eval. Affective Sys. Humaine Human-Machine Int. Network on Emotions, pp. 20–24 (2006)
26. Piaget, J., Inhelder, B.: Memory and intelligence. Routledge and Kegan Paul, London (1973)
27. Register, L., Henley, T.: The phenomenology of intimacy. Journal of Social and Personal Relationships 9(4), 467–481 (1992)
28. Ribeiro, P., Iurgel, I., Ferreira, M.: Voodoo: A system that allows children to create animated stories with action figures as interface. In: Si, M., Thue, D., André, E., Lester, J., Tanenbaum, T.J., Zammitto, V. (eds.) ICIDS 2011. LNCS, vol. 7069, pp. 354–357. Springer, Heidelberg (2011)
29. Romero, P., et al.: Embodied interaction in authoring environments. In: 2nd Int. Wksp on Physicality at HCI 2007 (2007)
30. Ryokai, K., Raffle, H., Kowalski, R.: Storyfaces: Pretend-play with ebooks to support social-emotional storytelling. In: IDC 2012. ACM (2012)
31. Springen, K.: Fourth-grade slump. Newsweek (2007), http://www.newsweek.com/2007/02/18/fourth-grade-slump.html (accessed)
32. Stadler, M.A., Ward, G.C.: Supporting the narrative development of young children. Early Childhood Education Journal 33(2), 73–80 (2005)
33. Tanenbaum, T.J.: Being in the Story: Readerly Pleasure, Acting Theory, and Performing a Role. In: Si, M., Thue, D., André, E., Lester, J., Tanenbaum, T.J., Zammitto, V. (eds.) ICIDS 2011. LNCS, vol. 7069, pp. 55–66. Springer, Heidelberg (2011)
34. Tanenbaum, K., Tanenbaum, T.J., Antle, A.N., Bizzocchi, J., Seif El-Nasr, M., Hatala, M.: Experiencing the reading glove (January 23-26, 2011)
35. Torrance, E.: A longitudinal examination of the fourth grade slump in creativity. Gifted Child Quarterly 12(3), 195–199 (1968)
36. Wright, S.: Graphic-narrative play: Young children's authoring through drawing and telling. International Journal of Education & the Arts 8(8) (2007)

Player Perspectives to Unexplained Agency-Related Incoherence

Miika Pirtola, Yun-Gyung Cheong, and Mark J. Nelson

IT University of Copenhagen, Rued Langgaards Vej 7, DK-2300 Copenhagen, Denmark
{miap,yugc,mjas}@itu.dk

Abstract. Anachrony in game stories causes incoherence, if the player's actions cause a future that differs considerably from the one already presented. Such game story quirk, if not addressed by design, causes an occurrence of unexplained agency-related incoherence (UARI). Current game studies literature views the issue as problematic. To study the significance and meaning of UARI to players, both anachronic and linear UARI-featuring games were developed. A grounded theory on the topic was devised upon 20 player accounts. Three main perspectives to UARI were identified: With anachrony, an acceptive-ludic perspective views the UARI as inevitable and natural. With both anachronic and linear game stories, an acceptive-diegetic perspective views the UARI as part of the story. With both anachronic and linear game stories, a rejective-logical perspective views the UARI as an unacceptable error in the game's causality.

Keywords: anachrony, coherence, game design, games, incoherence, story.

1 Introduction

Anachrony, the non-linear *order* in narrative chronology [1, p. 11], is an interesting narrative technique in literature and film. Examples of anachrony in games are direct time manipulation in *Braid* [2], imaginary retrospective sequences in *Batman: Arkham Asylum* [3], and the interactive flashback in *Heavy Rain* [4]. Anachrony provides an avenue to postmodernist expression within game stories, as seen in movies such as *Memento* [5], and in other so-called *puzzle films* [6] that represent complex storytelling.

Anachronic game design implies problems for game story *coherence* [7]. An interactive *analepsis* [1, p. 40] potentiates the introduction of *incoherence* into the game's story, if the course of the previously experienced future is changed by the player within the interactive past events. This type of incoherence, where the player's action does not produce a logical result in the next phase of the story, is referred to in this paper as *unexplained agency-related incoherence* (UARI). Currently in anachronic story-based games, UARI occurrences are generally avoided by design. For example, in the interactive flashback of *Heavy Rain,* it is impossible to change the future.

In the literature, anachronic game design is generally viewed as problematic due to UARI. Juul prominently noted it as a problem that hinders anachronic game design [8, para. 41][9, para. 20]. Majewski [10, p. 25-26, 46, 51] and Wilhelmsson [11, p. 64]

H. Koenitz et al. (Eds.): ICIDS 2013, LNCS 8230, pp. 156–167, 2013.

agree. Others, such as Jenkins [12, p. 127], Arsenault [13, p. 43], Pinchbeck [14, p. 51] and Calleja [15, p. 115] criticize Juul's notions, reminding that game stories often visit the past. Some narrative design strategies maintain story coherence in interactive analepses, such as Guy and Champagnant's Uchronia [16], Harris's proactive mediation [17], along with Shyba's and Parker's post-modern game experiment [18]. For Ryan, anachrony does not seem to fit into IF [19, para. 40]. Accordingly, the InStory interactive narrative platform excluded proper interactive analepses [20, p. 88]. The games literature (for example [21][22, p. 4][23, para 15]) also generally assumes the implicit position that the coherence of game stories is important for players and that it should be maintained. However, studies that demonstrate this are either rare or nonexistent. Nevertheless, outside of games, unexplained incoherence manifests as a narrative element, as in Lynch's *Lost Highway* [24], meeting wide audience acceptance.

To provide insight into both the suitability of anachrony in games, and the role of coherence in game stories, we explored the following questions: How do players perceive UARI? How important is the coherence of game story to players? What emotions does UARI evoke? Would players prefer UARI to be removed? For the study, we developed games featuring linear and reversed chronologies, and possibilities for UARI occurrences. The games were played by 20 Ps (participants), and the interview data was analyzed by grounded theory principles.

2 Methods

2.1 Requirements for the First Testbed Game

The first testbed game was developed to fulfill the following requirements that were based on our assessment of the inquiry and the subject area:

1 *An engrossing* [25, p. 1299] *audiovisual presentation, story and setting.*
2 *Sufficient usability and playability* [26][27, p. 53] to prevent any external dissatisfaction from distorting the UARI perceptions.
3 *The world presented should be mimetic* [28] and not *abstract* [29], for the UARI to not be interpreted as an abstraction of the story.
4 *First person perspective.* This is the most mimetic view perspective available.
5 *Story-based,* for the player to concentrate on story events.
6 *Reversed and linear chronology versions* to gain information about UARI perceptions in both scenarios.
7 *Scene-based chronology.* The chronology jumps take place on scene-level.
8 *Possibilities for UARI.* The game should facilitate incoherencies due to player activity, and not give any explanations.

2.2 Description of the First Testbed Game

The first testbed game, referred to here as *the mysterious game*, is a short game, playable in 5 to 10 minutes. It has an eerie lighting setting with gloomy hallways and rooms, and a disturbing soundtrack. The character dialogues expressed a situation of uncertainty for the protagonist's mental health. The purpose of this atmosphere was to

engage the players with the story. The game provides only one UARI possibility, which we reasoned initially to keep the study simple and manageable. The UARI is severe; the death of a notable character in the story.

In the chronologically first scene the protagonist can kill a game character. In the chronologically second and last scene, the same character always arrives at the protagonist's doorstep for a conversation, which results in UARI, if he was killed. Both linear and anachronic versions were prepared. The passage of time between the scenes was indicated by an intermittent text: "Some time later", or "Some time earlier", respectively. The game was subjected to a preliminary testing procedure before the actual testing to iteratively develop the game's developmental quality, usability and playability to a sufficient level.

2.3 Motivation and Requirements for the Second Testbed Game

With the first game, all Ps interpreted UARI as a mysterious event in the story, in both chronological versions. None regarded it as, for example, a story glitch. This motivated us to build another game to record possible different perceptions of UARI, with the following adjustments to the existing requirements:

1 *A more casual, everyday-atmosphere.* We interpreted that in most cases, the UARI was considered as part of the story due to the implied mystery/horror genre, where inexplicable events are common tropes.

2 *The story should be longer and complete, with a clear ending.* Many Ps considered the mysterious game as an epilogue for a longer story, where the incoherence would be explained.

3 *More UARI possibilities, varying severities.* In the mysterious game, Ps frequently noted that a single salient event as the notable character's reanimation would likely be intentional, suggesting us to try multiple UARIs with varying *severities.* As an example of severity, a dead character's reappearance is severely incoherent, whilst a broken background item being fixed is less so.

2.4 Description of the Second Testbed Game

The second game, referred to here as *the casual game,* was designed to fulfill the first and the additional requirements. The casual game has a longer, complete story, and a less eerie everyday-atmosphere, however with some drama in the plot. The game is based on an urban every-day setting. The protagonist is Karen, a depressed female office worker. The game facilitated 4 UARIs, and features 5 scenes and an ending screen, as described below:

1. Karen is working at her office, discussing with a colleague, when she hears that a serial killer is terrorizing her neighborhood. In a bout of depression, Karen can jump out of a high window.

2. Karen is at the office coffee room; a high-severity UARI, if the window was jumped. Here Karen meets John, a colleague, who asks her for an after-hours drink.

3. Karen is escorted to her apartment by John from a bar; a medium-severity UARI, if Karen refused John's request. Karen is appalled at a romantic TV show, and can angrily break the TV.
4. Karen is at a coffee shop. She meets her ex-friend Judith. Karen can scold Judith for the past, or re-establish the friendship.
5. Karen is at her home. John will arrive at her door, asking her for a dinner. The intact TV facilitates a modest-severity UARI. Judith calls, rejoicing the renewed friendship via telephone; a medium-severity UARI, if she was scolded.
6. The ending screen shows a newspaper that describes either Karen's murder or the arrest of the serial killer.

The different dialogue options in the game result in different endings, adding replay value. Audiovisually the game features bright lights, stylized shapes and colors, and a jazzy, light-hearted soundtrack. Linear and reversed chronological versions were developed, with the newspaper screen always concluding the game. Time progression is indicated textually between the scenes. The casual game managed to yield various UARI perceptions among the Ps, as discussed further.

Fig. 1. The mysterious game (left) and the casual game (right)

2.5 The Participant Protocol

Our user study was designed following Creswell's suggestions [30]. 20 gamers, aged between 17-33, participated. The gender division was 17 males and three females. The division of Ps per game was: linear mysterious (LM) 4, reversed mysterious (RM) 5, linear casual (LC) 5, reversed casual (RC) 8. This amounts to 22, because one P, as an explorative account, played LC, RC and RM in this order. The Ps were requested to openly discuss their thoughts during play. Multiple playthroughs were necessary. The Ps were interviewed after each playthrough, and sometimes freshly upon encountering UARI occurrences. The interviews were semi-structured; the P was requested to recall the game's story. Open-ended, neutral questions were asked about the mentioned UARIs. The study data consisted of 26 hours of audio recordings, of which 290 pages were transcribed.

2.6 Research and Data Analysis with Grounded Theory

Strauss's and Corbin's [31] grounded theory (GT) was chosen as a suitable qualitative data analysis methodology according to Creswell's guidelines [32]. In GT, the role of the initial literature review diminishes and the subsequent interviews lengthen as *theoretical sampling questions* [31, p. 201-216] amount and lead the inquiry to new directions. A constant analysis of data evokes these questions, developing the inquiry itself.

We conducted the data analysis according to the three major GT steps: a) *Open coding*; an overall review and codification [31, p. 101-122]. b) *Axial coding*; forming the theoretical connections [31, p. 123-142]. c) *Selective coding*; integration and refinement of the theory [31, p. 146-162]. We sought to, as is the aim in grounded theory research, to not simply to list categories of encountered phenomena, but to discover the interrelationships and dynamics in the context to obtain qualitative explanations for the reasons behind the phenomena [31, p. 142]. Hence, we sought to build a *theory*.

3 Results - A Grounded Theory on Player Perspectives to UARI

According to our theory, based on our data analysis, a player's notion of UARI induces one or more *hypotheses* of the UARI's *purpose* in the player. As each hypothesis is accompanied by either an *acceptive* or a *rejective* attitude towards the occurrence, we refer to them as *attitudinal perspectives* (AP). The player's most plausible hypothesis is the *main* AP. AP formation depends on the game's chronology, and is co-factored by the player's traits. Contextual criteria evaluated when forming the AP include subjectively perceived properties of the game and the UARI, such as the genre of fiction implied, and the plausibility of defectiveness. This study found three distinct APs to UARI.

3.1 Acceptive-Ludic

The *acceptive-ludic* attitudinal perspective (ALAP) views UARI as an inevitable and acceptable result of anachronic game design. From this perspective, causality in the game story is not broken, but reconfigured.

This AP occurred with the reversed casual (RC) game only, and was the main AP for 5/8 Ps who played the RC. The following is a descriptive excerpt: "It is again a tip about … the right order for things … to get the story 'correct', so to say. Then again, it evokes the thought, whether that is the point, or is it to solve it and avoid the death of the protagonist." Here, the P was pondering whether the future in the game was to be reproduced, meaning that the UARIs would have represented a 'failed' course of events, or if the future should be changed. It is relevant to note that in the RC game, the future situation's reproduction or prevention was not something specifically designed as an intentional game mechanic. However, as the game did not inform players about any 'correct' way to play, this was something that the ALAP Ps hypothesized the game's victory condition to depend upon.

ALAP players are initially *confused* and *baffled* by UARI's meaning, then *intrigued*, *puzzled* and *cogitative* by the solution possibilities. The perceived ability to

affect the game's causal chain induces a sense of *empowerment*. ALAP players do not think of UARI as an unacceptable inconsistency in need of re-design.

For the severest UARI (Window), the Ps with mostly ALAP accounts had additional story-based (ADAP) and rejective (RLAP) hypotheses, which conveys that all players seek a certain level of overall plausibility for game events.

Co-factor: A Lusory Attitude. The ALAP players approach the anachronic game with a *lusory attitude,* a term conceived by Suits [33 p. 54-55]. The ALAP players accept anachrony as the structure of the game system, as one ALAP P (RC) expressed: "It (causality) does not break, it just goes to another direction. ... it is a game rule that has to be accepted." Thus, ALAP players accept UARI as the rule's implication, and see the hypothesized underlying system as an interesting challenge. For them, game logic becomes the primary concern, and story logic remains secondary.

Contextual Criterion: Acceptability as a Byproduct of Game Mechanics. UARI is justifiable, when the game story progresses *backwards*. To quote an ALAP P: "If it would've been linear, then it would have bothered me, because it would not have made sense linearly. However, because you go backwards, it creates a puzzle feel to it, Making it ok. ... if you want to make a game that goes backwards, you have to sacrifice such things (story logic) ... for the player to have options"

Contextual Criterion: Implausibility of Erroneousness. The ALAP Ps perceived that despite rough edges in the RC game, its general functionality was not defective. Thus, the ALAP players did not have any weighty affirmation of the UARI as a developmental deficiency, as much as they trusted it to be intentional and necessary. This was in contrast with the RLAP notions discussed later.

3.2 Acceptive-Diegetic

The *acceptive-diegetic* (ADAP) players accept the UARI as an occurrence that can be plausibly explained, or has happened due to events not shown to the player. It occurred with all games. It was the main AP for 4/4 Ps with LM, 5/5 Ps with RM, 2/5 Ps with LC, and 1/8 Ps with RC. An example follows (LM): "If you stab him, you presume he is dead. ... So, either it did not happen, or it is not the same guy. There is the possibility that he has only been dreaming. ... As a fan of the supernatural and mystical, there is always ... the tinfoil hat scenario with space aliens, or a mystical scenario." In this study, the most common ADAP UARI hypotheses were as above; psychological scenarios such as an unreliable experience (f.ex. dream, madness), and supernatural explanations. In the casual game, the less severe UARIs gathered mundane hypotheses, such as the broken TV having been replaced.

The ADAP players are first *confused* and *baffled* by UARI. Then, *interested*, *intrigued* and *puzzled* by the UARI's meaning in the story. One ADAP P (LM) was *neutral*: "I am used to tackling narrative inconsistencies analytically." ADAP players accept UARI as an intriguing property of the story. However, they are interested in possible explanations for the events.

For the mainly ADAP Ps, the Window UARI caused the most confusion, intrigue, and corresponding emotions.

Co-factor: Acquaintance with Incoherence-Permitting Genres. A co-factor for forming the ADAP is the player's preference or close familiarity with genres where incoherence could be regarded as a narrative device. Such player has a tendency to choose to interpret the UARI to belong to and enrichen the story experience. One P (LM) explained: "Perhaps it's more about wanting to think that it (the game) would be done logically after all. ... then if it does eventually go into that kind of direction, it would be much more interesting to play. ... You would be inside the story since the beginning. Otherwise you might have missed a lot of the atmosphere (if one regarded the UARIs as errors)."

Contextual Criterion: Implied Incoherence-Permitting Genre. Certain properties in the game's diegetic setting and atmosphere can *imply an incoherence-permitting genre* such as mystery fiction, which, in addition to the preference or acquaintance with such genres can evoke the ADAP perspective to UARI. The mysterious game was perceived to represent the horror and mystery genres by all Ps. With the casual game, the UARI itself created a delusional atmosphere.

Contextual Criterion: Implausibility of Erroneousness. As for the ALAP, *implausibility of erroneousness* was a co-factor here. A pointer to this conclusion with the mysterious game was the sparsity of other significant events: "Well, it's quite a crucial bug, so I'd say that you would have eliminated that bug ... the amnesia or insanity explanation are much more likely." ADAP Ps gave the games the benefit of the doubt, as they noted that the UARIs, as errors, would have represented an unlikely weak game design. They also expected the UARIs to be eventually explained in some cases by explorable narrative elements, or by a sequel. In the mundane ADAP explanation cases, the less severe the UARI was, it was more likely imagined a plausible explanation for rather than hypothesized to represent an error (RLAP).

3.3 Rejective-Logical

The *rejective-logical* (RLAP) players view the UARI as an error in the game world's causal logic, and in the coherence of its narrative elements. This AP occurred with both versions of the casual game. It was the main AP for 3/5 Ps with the LC, and 2/8 Ps with the RC. An example (LC) follows: "P: First I tried to commit suicide. ... Then I was all of a sudden in the cafeteria. ... I: What emotions did that evoke? P: I thought it was a mistake. ... Perhaps I was expecting for some kind of explanation for why she was there suddenly. ... I: Were you annoyed by getting no explanation? I: Yes. I thought it was a bug, because I got nothing."

The RLAP players, in contrast to the ALAP and ADAP players, are not confused or intrigued by UARI, but unimpressed. They might remain *neutral*. However, a common emotion is *annoyment* by the perceived error, and *disempoverment* due to perceived limited diegetic agency. RLAP players dislike UARI and prefer to have it corrected or explained. The Window UARI was the worst offender for the RLAP Ps.

Co-factor: A Requirement of Diegetic Causality. A co-factoring trait for RLAP players is a pronounced sense of respect for diegetic causality, due to which they dislike and disapprove behaviors contrary to the assumed norms of the game world's logic and causality: "I really hate those kinds of inconsistencies." (RC)

Co-factor: Disapproval of Arbitrary Agency Constraints. The RLAP players, in addition to opposing illogical game world behaviors, disapprove any constraints for agency that seem arbitrary. In the linear chronology case, they perceive UARI to irrationally restrict their power in the game world, leading to frustration and indifference: "it feels a bit like ... nothing I do has any effect here." (LC)

Contextual Criterion: Implied Incoherence-Incompatible Genre. The RLAP players do not see such incoherence to fit the genre they interpret the game to represent, as one P (LC) noted: "P: Usually if you jump from a window, you die (laughs). I: In the real world? P: Yes. I: But, wasn't this a game? P: Yes, but it was, or at least I thought it was a realistic game. ... There was nothing out of the ordinary. It seemed like everyday life. At least there was nothing pointing to it not being so"

Contextual Criterion: Plausibility of Erroneousness. In the games of the study, UARI was caused by choices having no effect in the chronologically subsequent scene, which the RLAP Ps saw as erroneous. In the LC game, this perception was pronounced, as UARI had no particular acceptability as a byproduct of the game design paradigm as with reversed chronology. The casual game's developmental level was seen as fair in general, but the RLAP Ps found the developmental quality slightly lacking, which further increased the error interpretation's plausibility for them.

4 Discussion, Future Work and Suggestions for Game Design

4.1 On Game Story Coherence

When discussing coherence in games context, it is relevant first to address the object the coherence of which is discussed. With games, 'narrative' is a problematic term [34][8, para. 41][9, para. 7]. Thus, we discuss *game stories,* the mental sequences of events that the players construct of the game experience, when discussing coherence. In this study, the Ps' chronological, sequential descriptions of game events, when asked to narrate their game experiences, gave evidence of such constructions: "P: First I tried suicide. ... Then I was in the cafeteria all of a sudden. ... Then the John guy came to talk with me, and asked me for a date, and I refused it." This corresponds to the construction of *fabula* from film viewing [35]. Narratological concepts apply well to the preconfiguration of the diegetic game world [36, para. 49], but not to the event of play [8, para. 41].

Mere sequential recallability is, however, not sufficient to describe the interrelatedness of meaning that story compherenders arguably construe. Thus, cognitive narratologists have theorized that narrative readers form *referential situation models* [37]: "A situation model is a mental representation of the people,

setting, actions and events that are mentioned in explicit clauses" [37, p. 371] Additionally, for the information that is not explicitly mentioned, the reader fills the story gaps by constructing inferences of the other information given, such as "The goals and plans that motivate character's actions" [37, p. 371] in order to achieve local and global story coherence [38, p. 6]. In this study, ADAP accounts gave evidence that players build such models, and fill story gaps. For example, one P (LC) inferred that Judith's positive phone call tone could be untruthful: "I was in disbelief and confusion. I didn't know what she was talking about. Did she think it (getting coffee spilled over her) was funny? Also, could she be lying?"

This voluntary conception of explanations to maintain the plausibility of the experience is, in Coleridgean terms, a form of *willing suspension of disbelief* [39] targeted, if not at the fictional status of the experience itself, at the inconsistencies of the game's story. Karhulahti argues that the additional aspect of simulation in video games demands for a *suspension of virtual disbelief* [40].

Unjustified UARI appears to break immersion. One P, who played the linear casual game, explained: "It feels a bit like … nothing I do has any effect here. Then, either I don't quite want to do anything, as nothing makes sense, or I might just lose control and trash everything. … If many things occur in a game inconsistently with how things occur in real life, it creates a gap between the player and the game. ... If people behave totally differently than in real life, it looks stupid. It is no longer fun, no longer believable … Eventually, it will just be a game that I am playing, but I do not experience identifying with the story and living it" This appeared gap between the player and the game represents an overt *psychical distance*, as Bullough describes [41, para. 27]. This loss of experiential coherence potentially leads to *virtual insanity,* a detachment from the virtual reality, manifesting for example by violent or experimental behavior in the virtual world for the player's amusement, disregarding any implied diegetic behavioral norms.

The significance of this study lies in its position among the first explorations to the value and meaning of game story coherence to players' game experiences. The study shows that in general, players require and strive for a coherent understanding of their game experiences holistically, and not only to be able to parse a coherent story. In particular, players necessitate either a fully coherent story by filling the gaps by themselves if needed, or justifiability for story incoherence by genre tropes or by the interference of game mechanics. Thus, the current prevalent implicit position in the literature that game story coherence is always necessary (as for example in [21][22, p. 4][23, para. 15]) has been compromised by the study.

This study focused on unexplained incoherence, related to the player's activity. However, unexplained incoherence, unrelated to player activity can also occur. The significance and meaning of such incoherence to players should be likewise studied to elaborate further on the topic of game story coherence.

Players' mental situational game story model construction along with the strategical and behavioral planning of future actions, and the filling of story gaps by inference using the surrounding story elements warrant further research.

The games with which coherence was studied were fairly mimetic; the significance of story coherence in more abstract games should be comparatively explored.

Various other scenarios to study UARI responses in exist. Perhaps players are not as apt to form the ALAP or ADAP perspectives to UARI, if a vast game only contains one or few UARIs. This could be studied in the future also.

4.2 On the Viability of Anachrony in Game Stories

The game studies literature in general sees the use of anachrony in games and interactive stories as problematic due to UARI [8][9][10][11]. The implied underlying presentiment is that the game experience would suffer when story coherence would be lost due to incoherence-inducing actions. This study alleviates these concerns. Firstly, one must note that UARI possibilities can be removed from anachronic games, as seen in [16][17][18]. This can be achieved by omitting the UARI-facilitating events from happening, or by explaining the events afterwards (for example by a dream/illusion scenario). Secondly, UARI in anachronic games is by no means automatically a nuisance to players, as in this study, 11/13 players of anachronic games found UARI as an intriguing element, perceiving it as part of the gameplay or the story.

There are no reasonable arguments for excluding anachrony from game stories, and it should be utilized freely. Additionally, anachronic UARI needs not always be prevented. Various anachronic game design scenarios can be imagined, with UARI as an intentional game design element, and not simply as a side-effect of anachrony (which players accept also). For example, such a game could present time paradoxes, changing the future, or puzzles to reproduce future situations in the past. Alternatively, it could represent an element in the story with a peculiar significance. As the results of the study show, there will be an audience for such creations, provided that the game has sufficient production values. Some information of the game's design intentions should be conveyed, however, as unwarranted story incoherence can break the immersion for certain players.

Acknowledgements. This work has been supported in part by the EU FP7 ICT project SIREN (project no: 258453).

References

1. Genette, G.: Narrative Discourse: An Essay in Method. Cornell University Press, Ithaca, NY, USA (1983)
2. Blow, J. (Designer, developer): Braid (video game). Microsoft Game Studios, Number None, Inc. USA (2008)
3. Rocksteady (developer): Batman: Arkham Asylum (video game) Eidos Interactive (2009)
4. Quantic Dream (developer): Heavy Rain (video game) Sony Computer Entertainment (2010)
5. Nolan, C. (director & writer): Memento (Film). Newmarket Capital Group, Team Todd, I Remember Productions, Summit Entertainment, USA (2000)
6. Buckland, W. (ed.): Puzzle films: complex storytelling in contemporary cinema. John Wiley & Sons, Hoboken (2009)

7. Toolan, M.: Coherence. In: Hühn, P., et al. (eds.) The Living Handbook of Narratology. Hamburg University Press, Hamburg (2012), `http://hup.sub.uni-hamburg.de/lhn/index.php??title=Coherence?&oldid=1676` (retrieved March 1, 2012)

8. Juul, J.: Games Telling Stories? - A brief note on games and narratives. Game Studies – The International Journal of Computer Games 1(1) (2001), `http://www.gamestudies.org/0101/juul-gts/` (retrieved March 15, 2012)

9. Juul, J.: Introduction to Game Time. In: First Person (Article Series). Within Electronic Book Review (Peer Reviewed Online Journal) (2004), `http://www.electronicbookreview.com/thread/firstperson/teleport` (retrieved December 25, 2012)

10. Majewski, J.: Theorising Video Game Narrative (Minor thesis). Bond University, Robina (2003)

11. Wilhelmsson, U.: Game Ego presence in video and computer games. In: Leino, O., Wirman, H., Amyris, F. (eds.) Extending Experiences. Structure, Analysis and Design of Computer Game Player Experience, pp. 58–72. Lapland University Press, Rovaniemi (2009)

12. Jenkins, H.: Game Design as Narrative Architecture. In: Wardrip-Fruin, N., Harrigan, P. (eds.) FirstPerson: New Media as Story, Performance and Game. MIT Press, Cambridge (2004)

13. Arsenault, D.: Narration in the Video Game. An Apologia of Interactive Storytelling, and an Apology to Cut-Scene Lovers (Master's thesis). Université de Montréal, Montreal (2008)

14. Pinchbeck, D.: Story as a function of gameplay in First Person Shooters: an analysis of FPS diegetic content 1998-2007 (Doctoral dissertation). University of Portsmouth, Portsmouth (2009)

15. Calleja, G.: In-Game: Immersion to Incorporation. MIT Press, Cambridge (2011)

16. Guy, O., Champagnat, R.: Flashback in Interactive Storytelling. In: Nijholt, A., Romão, T., Reidsma, D. (eds.) ACE 2012. LNCS, vol. 7624, pp. 246–261. Springer, Heidelberg (2012)

17. Harris, J.T.: Proactive Mediation in Plan-Based Narrative Environments (Master's thesis). North Carolina State University, Raleigh (2005)

18. Shyba, L.M., Parker, J.R.: Opening doors to interactive play spaces: fragmenting story structure into games. In: Proceedings of the Second Australasian Conference on Interactive Entertainment, pp. 167–174. Creativity & Cognition Studios Press (2005)

19. Ryan, M.-L.: Peeling the Onion: Layers of Interactivity in Digital Narrative Texts (online article). Based on a Talk Presented at Interactivity of Digital Texts, Münster, Germany (May 2005), `http://users.frii.com/mlryan/onion.htm` (retrieved February 23, 2013)

20. Barbas, H., Correira, N.: The Making of an Interactive Digital Narrative – InStory. In: Euromedia 2009 (2009)

21. Giannatos, S., Nelson, M.J., Cheong, Y.G., Yannakakis, G.N.: Suggesting New Plot Elements for an Interactive Story. In: Workshops at the Seventh Artificial Intelligence and Interactive Digital Entertainment Conference (2011)

22. Mateas, M., Stern, A.: Integrating plot, character and natural language processing in the interactive drama Façade. In: Proceedings of the 1st International Conference on Technologies for Interactive Digital Storytelling and Entertainment, TIDSE 2003 (2003)

23. Ryan, M.L.: Beyond myth and metaphor: The case of narrative in digital media. Game Studies – The International Journal of Computer Games 1(1) (2001), `http://www.gamestudies.org/0101/ryan/` (retrieved February 25, 2013)

24. Lynch, D. (director): Lost Highway. Universal Studios, Universal City (1997)
25. Brown, E., Cairns, P.: A grounded investigation of game immersion. In: CHI 2004 Extended Abstracts on Human Factors in Computing Systems, CHI EA 2004, pp. 1297–1300 (2004)
26. Desurvire, H., Caplan, M., Toth, J.: Using Heuristics to Improve the Playability of Games. In: CHI Conference, Vienna, AT (2004)
27. Calvillo-Gámez, E.H., Cairns, P., Cox, A.L.: Assessing the core elements of the gaming experience. In: Bernhaupt, R. (ed.) Evaluating User Experience in Games, Human–Computer Interaction Series, ch. 4, pp. 47–71. Springer, London (2010)
28. Aristotle: Poetics (335 BCE)
29. Juul, J.: A Certain Level of Abstraction. In: Baba, A. (ed.) Situated Play: DiGRA 2007 Conference Proceedings, pp. 510–515. DIGRA Japan (2007)
30. Creswell, J.W.: Research Design: Qualitative, Quantitative, and Mixed Methods Approaches, 3rd edn. Sage Publications (2008)
31. Strauss, A., Corbin, J.M.: Basics of Qualitative Research: Techniques and Procedures for Developing Grounded Theory, 2nd edn. Sage Publications (1998)
32. Creswell, J.W.: Qualitative Inquiry and Research Design: Choosing among Five Approaches, 2nd edn. Sage Publications (2006)
33. Suits, B.: The Grasshopper: Games, Life and Utopia. Broadview Press, CA (1990/2005)
34. Eskelinen, M.: Six Problems in Search of a Solution: The challenge of cybertext theory and ludology to literary theory. Dichtung Digital (Online Article Base) (2004), http://www.dichtung-digital.de/2004/3/Eskelinen/index.htm (retrieved February 25, 2013)
35. Thompson, K.: Breaking the Glass Armor: Neoformalist Film Analysis, pp. 39–40. Princeton University Press, Princeton (1988)
36. Bogost, I.: Video games are a mess. In: Ian Bogost - Videogame Theory, Criticism, Design (2009), http://www.bogost.com/writing/videogames_are_a_mess.shtml (retrieved October 15, 2012)
37. Graesser, A.C., Singer, M., Trabasso, T.: Constructing inferences during narrative text comprehension. Psychol. Rev. 101(3), 371–395 (1994)
38. Graesser, A.C., Wiemer-Hastings, P., Wiemer-Hastings, K.: Constructing Inferences and Relations during Text Comprehension (Revision 1/15/99). The University of Memphis, Memphis (1994)
39. Coleridge, S.T.: Biographia literaria; or, Biographical sketches of my literary life and opinions, ch. XIV, vol. 2 (1817)
40. Karhulahti, V.-M.: Suspending virtual disbelief: a perspective on narrative coherence. In: Oyarzun, D., Peinado, F., Young, R.M., Elizalde, A., Méndez, G. (eds.) ICIDS 2012. LNCS, vol. 7648, pp. 1–17. Springer, Heidelberg (2012)
41. Bullough, E.: 'Psychical Distance' as a Factor in Art and as an Aesthetic Principle. British Journal of Psychology 5, 87–117 (1912)

Breaching Interactive Storytelling's Implicit Agreement: A Content Analysis of Façade User Behaviors

Christian Roth and Ivar Vermeulen

VU University, De Boelelaan 1081, 1081HV Amsterdam, The Netherlands
roth@spieleforschung.de, i.e.vermeulen@vu.nl

Abstract. Using both manual and automatic content analysis we analyzed 100 collected screen plays of 50 users of the IS system Façade, coding the extent to which users stayed "in character". Comparing this measure for first and second exposure to Façade revealed that users stay significantly less in character during second exposure. Further, related to a set of independently collected user experience measures we found staying in character to negatively influence users' affective responses. The results confirm the notion that the more Façade users keep to their assigned role, the easier they become dissatisfied with the system's performance. As a result, users start exploring the system by acting "out of character".

Keywords: Façade, User Behavior, User Experience, Content Analysis.

1 Introduction

Satisfaction of user expectations is a key element in successful entertainment media [1]. Users have certain expectations on how the product will fulfill their entertainment needs - e.g., provide arousal, flow, suspense, and/or agency. In turn, media creators have expectations on how their product should be used in order to be entertaining. For example, to experience suspense, movie viewers should not fast forward to find out who "dunnit"; to experience flow, players of an action game should play at a level appropriate to their playing skills. Based on these reciprocal expectations, creators and users thus form an implicit agreement that entertainment media, if used in a proper way, will be entertaining.

For new types of media this implicit agreement holds as well. However, new types of media may not be able to fulfill it immediately. The latter seems to be the case with many *Interactive Storytelling* (IS) prototypes. IS users expect to have an impact on story progress and outcomes, and thus to receive meaningful feedback regarding "global agency" [2]. However, many IS prototypes are proofs-of-concepts focusing mainly on technical challenges and only tentatively offer such feedback. Research on the IS application *Façade* for example showed that the system often did not understand user intentions and failed at giving meaningful responses [3]. Another study found that *Façade* users were initially goal oriented, but when realizing their limited control on story progression, increasingly tested

H. Koenitz et al. (Eds.): ICIDS 2013, LNCS 8230, pp. 168–173, 2013.

the system's boundaries by acting against social conventions [4]. A study on the IS prototype *EmoEmma* showed low ratings on key user experience dimensions including overall satisfaction [7]. The current paper focuses on what happens when IS applications do not deliver the entertaining experience users expect.

IS applications attempt to offer entertainment by involving users in an interactive narrative, mostly with a role in the narrative. Building on experiences with commercial video games, users expect keeping to this role—that is, staying "in character"—will result in meaningful system responses and an immersive IS experience. Ironically, however, the more users behave as a natural character in the story, the richer and more complex their inputs will be, and the more challenging it will become for the system to provide meaningful feedback. So, the harder the user tries to "entertain" the system, the less likely it may be to receive an entertaining experience in return. As a consequence, users will likely be dissatisfied and adapt their strategy to try out more unconventional behavior. When they do so, their expectations about the system's performance will lower, and the performance of the system might be better, yielding "out of character" users likely to be more satisfied and entertained. Specifically, we expect: (1) The more IS users behave according to a pre-described role (i.e., stay "in character"), the less meaningful the system response will be, (2) the more IS users stay in character, the less positive their experiences will be, and (3) IS users are less likely to stay "in character" during a second play session.

2 Method

To test these expectations, we tested 50 users (17 males, 33 females; average age $M = 19.8$ years, $SD = 1.73$ years) of the IS application *Façade* [3]. Participants had a moderate degree of computer game literacy ($M = 1.78$, $SD = .71$ on a scale from $1-3$). 10 participants had been exposed to Façade in a previous study. Upon arrival participants were seated in one of six cabins equipped with modern PCs, screens, and peripherals to "test a new prototype system". In an instruction sheet, participants were told about their role (an old friend) and their task (to help the characters with their relationship issues). After interacting with Façade for an average of 18 minutes, stage plays were saved and participants filled out an online questionnaire (av. 12m). Participants were then asked to interact with Façade again, using the same instructions (av. 18m). Stage plays were saved and participants filled out the same questionnaire (av. 10m). The recorded stage plays resulted in around 29.000 lines of dialogue.

To measure *staying in character*, we conducted manual and automated content analysis. Stage plays were put in random order, and participant and session numbers were blinded to prevent subjective biases in the manual coder. Rating involved a scale from 1 to 5, assigned to each individual user utterance. One point (not staying in character) was given for highly inappropriate behavior, for instance repeated kissing or flirting, extreme rudeness, insulting, and repeatedly ignoring of computer characters' intentions. Five points (completely staying in character) were given for highly engaged, appropriate, and on-topic interactions.

Ratings per utterance were averaged in order to obtain an "in character" score per user, per session.

The automatic content analysis-based measurement of users staying in character used the text analysis software *Linguistic Inquiry and Word Count* (LIWC) [8]. Syntax-based indicators for staying in character were the use of question and exclamation marks (indicating natural language use), and (more than) 6 letters words (indicating complex language use). The number of verbal interactions and words per user per session were recorded as an indicator of user effort. Content-based indicators were the use of articles (indicating conventional language use), pronouns (indicating social references), positive (e.g., nice, happy) and negative affect (e.g., hurt, ugly) words, words associated with assent (e.g., agree, okay), social (e.g., friend, family), cognitive (e.g., think, know), and perceptual processes (e.g., see, hear, feel); both latter categories indicate reflection. For all indicator categories relative prevalence (percentages of words used) were calculated. As a negative indicator of staying in character, the percentage of swear words (e.g., damn, fuck) was analyzed.

Building on prior work by the authors [6,7,9],14 *user experiences* were measured on 1 to 5 Likert scales with three items (unless otherwise noted): Flow (4 items, $\alpha_1 = .72$; $\alpha_2 = .73$), perceived system usability ($\alpha_1 = .85$; $\alpha_2 = .83$), presence ($\alpha_1 = .76$; $\alpha_2 = .87$), curiosity ($\alpha_1 = .76$; $\alpha_2 = .84$), aesthetic pleasantness ($\alpha_1 = .83$; $\alpha_2 = .86$), pride ($\alpha_1 = .89$; $\alpha_2 = .84$), positive ($\alpha_1 = .82$; $\alpha_2 = .87$), and negative affect ($\alpha_1 = .57$; $\alpha_2 = .70$). Two-item scales: satisfaction ($r_1 = .57$; $r_2 = .46$), character believability ($r_1 = .35$; $r_2 = .37$), effectance ($r_1 = .82$; $r_2 = .61$), suspense ($r_1 = .47$; $r_2 = .57$), enjoyment ($r_1 = .84$; $r_2 = .85$), and role adoption/identification ($r_1 = .37$; $r_2 = .66$).

Meaningful system responses were manually coded, per utterance, on a 1 to 5 scale. One point (non-meaningful system response) was given for completely wrong responses or ignoring user input. Five points (highly meaningful system response) were given for highly fitting, meaningful responses to user input. Scores per utterance were aggregated by averaging them per user, per session.

3 Results

To see whether the manual coding of users staying in character is reflected in the automated content analysis, we conducted a correlation analysis. Results for the first session show that the more users stayed in character, the more elaborate were their verbal interactions—a higher word count ($r = .494$, $\rho = .000$), and more six letter words ($r = .325$, $\rho = .023$). Staying in character also correlated with the percentage of pronouns ($r = .695$, $\rho = .000$), social words ($r = .566$, $\rho = .000$), positive emotion words ($r = .304$, $\rho = .034$), and words reflecting cognitive ($r = .662$, $\rho = .000$) and perception processes ($r = .461$, $\rho = .000$). Surprisingly, given these results, we found no significant correlations between users staying in character and the LIWC categories for the second session.

For our "ironic" prediction of a negative correlation between users staying in character and meaningful system response we only found evidence in the second

session: More in character users received significantly less meaningful response ($r = -.379$; $\rho = .006$). Further analysis revealed correlations between linguistic indicators of users staying in character and meaningful system responses: For the first session, more verbal interactions correlated with lower meaningful system response ($r = -.282$; $\rho = .047$). This result was also found for the second session ($r = -.319$; $\rho = .025$). In addition, the more words users used, the less meaningful the system responded ($r = -.319$, $\rho = .026$). This seems to confirm our prediction: the more users try to "entertain" the system by providing elaborate input, the less meaningful the system responds.

To test our prediction that users will stay less in character after the first session, we conducted a within-subject t-tests. Results confirm our prediction: users stayed significantly less in character during the second session ($M = 4.09$, $SD = .68$ vs. $M = 4.52$, $SD = .36$); $t(50) = 4.28$, $\rho = .011$.

Comparing linguistic indicators of users staying in character for the first and second session revealed that participants used significantly more articles in the first session ($M = 7.52$, $SD = 1.9$ vs. $M = 2.69$, $SD = 1.75$); $t(50) = 3.12$ $\rho = .007$. This could indicate that in the second session, participants tended to refrain from conventional interpersonal language use. Against our predictions, participants used significantly more exclamations marks in the second session ($M = 3.14$, $SD = 3.6$ vs. $M = 1.66$, $SD = 2.75$); $t(50) = -3.6$, $\rho = .001$, perhaps signaling anger or frustration with the system's responses. Also against our predictions, the second session showed a higher percentage of words in the category of assent ($M = 5.22$, $SD = .48$ vs. $M = 3.69$, $SD = 3.19$); $t(50) = -2.55$, $\rho = .014$ and more positive emotion words ($M = 14.1$, $SD = 5.02$ vs. $M = 11.66$, $SD = 5.81$); $t(50) = -2.11$ $\rho = .041$. Table 1 provides means and standard deviations per session, for all measured variables.

Correlation analysis showed that, for the first session, the stronger users stayed in character, the higher were their self-reported negative affect ($r = .346$; $\rho = .014$) and perceived suspense ($r = .286$; $\rho = .044$). For the second session we also found that staying in character leads to more negative affect ($r = .344$; $\rho = .013$). This confirms our prediction that users who make an attempt to stay in character have less positive user experiences.

We also correlated the linguistic indicators of users staying in character to the self-reported user experience measures for both sessions. However, by testing twice for 196 possible correlations, significant scores will occur due to chance capitalization. We observed 16 significant correlations, which is about the chance level. Moreover, none of the correlations were consistent over both sessions. Therefore this analysis did not provide further evidence for our predictions.

4 Discussion

The key finding of the present study is that the more Façade users stayed "in character", the less meaningful system responses they received. In addition, the more users stayed in character, the more negative affect they experienced. Possibly as a result of both, users stayed significantly less in character during the second session.

Table 1. Paired Sample T-Test Comparison ($N = 50$)

	1st session		2nd session		
	M	SD	M	SD	ρ
Rating					
User staying in character	4.52	.36	4.09	.68	.011[*]
Meaningful system response	3.86	.55	3.90	.50	.618
Number					
Verbal interactions	40.16	19.21	44.34	18.81	.320
Nonverbal interactions	11.68	16.66	22.55	18.97	.004[*]
User words	139.0	68.00	125.0	69.00	.357
Analyzed LIWC dict. words	95.57	3.15	95.35	2.23	.645
Percentage					
Six-letter words	6.60	3.14	7.03	2.96	.480
Pronouns	22.69	6.42	24.01	3.79	.283
Articles	7.52	1.90	2.69	1.75	.007[*]
Swear words	.23	.11	.43	.25	.578
Assent words	3.69	3.19	5.22	.482	.014[*]
Positive emotion words	11.66	5.81	14.1	5.02	.041[*]
Negative emotion words	2.89	1.94	2.44	1.76	.227
Social processes words	16.89	6.41	17.95	5.31	.283
Cognitive processes words	13.91	4.10	13.01	4.57	.263
Perception processes words	2.37	1.76	2.88	1.52	.125
Question marks	5.31	4.51	5.27	3.57	.957
Exclamation marks	1.66	2.74	3.14	3.60	.001[*]

Note: [*] significant difference at $\rho < .05$.

Meaningful system responses are a key condition in the implicit agreement users and producers of interactive media make. Interestingly, in current IS systems meaningful interaction is achieved more easily if users interact less. Façade expects interactions at specific points in the narrative, and at these moments often succeeds in giving meaningful feedback; at other moments it often fails in doing so. Experienced Façade users may recognize good interaction moments and thus have better user experiences. However, more naïve users will try to intervene, take over control, or steer the conversation in a different direction. For such users the system does not seem to give very good results. Users who adapt their verbal behavior by writing less and simpler, following the lead of the computer characters, experience a more coherent and meaningful narrative, resulting in higher perceived effectance, system usability, presence, and flow.

Another interesting finding of the current research is that the manually coded measure for staying in character was corroborated by many of its expected linguistic indicators for the first session, but not for the second. It seems that in the second session, users found other ways of staying in character than by using

conventional interpersonal language. The increased use of assent related words and exclamation marks in the second session might be taken to support our theory that some users started to change their "acting style" or at least their interaction behavior after the first session, in which they learned that the system does often not understand their intentions.

The results of our study are in line with the assumption of an implicit agreement between users and creators of IS applications. Users that behave in character expect the system to respond in a meaningful way. However, the current state of IS technology is not keeping up with these expectations and therefore is likely to yield disappointment. As a response, users adapt their in-game behavior and find different ways to get entertained, for example by acting out of character, behave inappropriately, or by testing the system's boundaries and exploiting its shortcomings. IS creators could benefit from these findings by carefully managing user expectations in order to prevent disappointment in IS's entertainment qualities.

References

1. Blythe, M.A., Overbeeke, K., Monk, A., Wright, P.C. (eds.): Funology: From usability to user enjoyment. Human-Computer Interaction Series. Springer (2005)
2. Klimmt, C., Roth, C., Vermeulen, I., Vorderer, P., Roth, F.S.: Forecasting the Experience of Future Entertainment Technology: "Interactive Storytelling" and Media Enjoyment. Games and Culture 7(3), 187–208 (2012)
3. Mehta, M., Dow, S., Mateas, M., MacIntyre, B.: Evaluating a conversation-centered interactive drama. In: Proceedings of the 6th International Joint Conference on Autonomous Agents and Multiagent Systems - AAMAS 2007, p. 1. ACM Press, New York (2007)
4. Mitchell, A., McGee, K.: Reading again for the first time: A model of rereading in interactive stories. In: Oyarzun, D., Peinado, F., Young, R.M., Elizalde, A., Méndez, G. (eds.) ICIDS 2012. LNCS, vol. 7648, pp. 202–213. Springer, Heidelberg (2012)
5. Roth, C., Klimmt, C., Vermeulen, I.E., Vorderer, P.: The Experience of Interactive Storytelling: Comparing Fahrenheit with Façade. In: Anacleto, J.C., Fels, S., Graham, N., Kapralos, B., Saif El-Nasr, M., Stanley, K. (eds.) ICEC 2011. LNCS, vol. 6972, pp. 13–21. Springer, Heidelberg (2011)
6. Roth, C., Vermeulen, I., Vorderer, P., Klimmt, C.: Exploring replay value: shifts and continuities in user experiences between first and second exposure to an interactive story. Cyberpsychology, Behavior and Social Networking 15(7), 378–381 (2012)
7. Roth, C., Vermeulen, I., Vorderer, P., Klimmt, C., Pizzi, D., Lugrin, J.L., Cavazza, M.: Playing in or out of character: user role differences in the experience of interactive storytelling. Cyberpsychology, Behavior and Social Networking 15(11), 630–633 (2012)
8. Tausczik, Y.R., Pennebaker, J.W.: The Psychological Meaning of Words: LIWC and Computerized Text Analysis Methods. Journal of Language and Social Psychology 29(1), 24–54 (2010)
9. Vermeulen, I.E., Roth, C., Vorderer, P., Klimmt, C.: Measuring user responses to interactive stories: Towards a standardized assessment tool. In: Aylett, R., Lim, M.Y., Louchart, S., Petta, P., Riedl, M. (eds.) ICIDS 2010. LNCS, vol. 6432, pp. 38–43. Springer, Heidelberg (2010)

Satire, Propaganda, Play, Storytelling. Notes on Critical Interactive Digital Narratives

Gabriele Ferri

Indiana University, School of Informatics and Computing, 919 E Tenth St, Bloomington, Indiana, USA
gabriele.ferri@gmail.com

Abstract. Paolo Pedercini, better known through his Molleindustria alter-ego, is a game designer specializing in social critique through apparently simple casual video games - uniting digital storytelling, game-based mechanics with the discursive genres of satire and propaganda. This work examines three recent pieces - Oiligarchy, Phone Story and Tax Evaders - to explore how the affordances of interactive digital storytelling overlap with critical and political discourse.

Keywords: Semiotics, Ludology, Satire, Propaganda, Politics, Critical Digital Narratives, Persuasive Games, Serious Games, Games for Change.

1 Introduction

"Satire, Propaganda, Play, Storytelling" is part of an ongoing work exploring how video game narratives can enter different non-ludic discourses. It aims at demonstrating the unique affordances of interactive digital storytelling for political, satirical and propagandistic discourses [1].

Paolo Pedercini, better known through his Molleindustria alter-ego, is a US-based Italian game designer and scholar. Specializing in social satires, he incorporates apparently simple casual video games in his critical and political statements [2] uniting digital storytelling, game-based mechanics with the textual genre of satire.

In 2008, Pedercini released Oiligarchy [3] and then – in a collaboration with post-Occupy Wall Street activists – two more pieces in 2011 and 2013, Phone Story [4] and Tax Evaders [5]. These titles show a conscious and interesting use of platform-specific digital persuasion [6] applied to a social and political agenda and will be discussed in this work.

2 Molleindustria between Play, Social Critique, Satire and Propaganda

Political satire, socially-engaged art and propaganda are relevant and widespread textual genres. In the context of a wider research on the potentialities of ludic

H. Koenitz et al. (Eds.): ICIDS 2013, LNCS 8230, pp. 174–179, 2013.

activities for social commentary, it is relevant to examine how digital interactive artifacts interact with several types of discourse – with the objective of mapping different design strategies in relations to specific expectations and objectives.

Satirical discourse [7] may be distinguished from comedy and from "simple" entertainment by some outstanding features:

- it constitutes a second-order text (often in the form of mash-up, jamming, subversion) that frequently hijacks the opponent's own voice [8] and/or semiotic system [9];
- it targets recognizable and well-known antagonists;
- it creates a complex emotional engagement, frequently in the form of "bitter" laugh, but also indignation;
- it constructs an ideological axiology within a text, clearly identifying positive and negative actors;
- it actively pursues a cause (through emotion, information and pragmatic effects),
- it contains parodical elements, such as *pastiche*, upbeat elements or stylistic contamination.

Propaganda is related to satire, sharing in different proportions all the above-mentioned characteristics except the first one: in Molleindustria's pieces, propaganda lacks the second-order interpretive ambiguity characterizing satires. While propaganda is indeed part of the broad genre of persuasive discourses, in this corpus, it will be stressed its more pragmatic and concrete calls-to-action (*factitivity*, or "make do" [10]) using procedural rhetorics [6].

2.1 Oiligarchy

At a first glance Oiligarchy seems a simple game of resource management representing an oil-extraction corporation, but Molleindustria designed it to be a playable, satirical examination of the "Peak Oil" theory describing the decline of fossil fuel availability. The game can be explored following two axiological sets of ethical assumptions. In a tutorial before the game, players are instructed to aggressively maximize profits ("profit at all costs is good") and the corresponding gameplay (always keep on extracting to satisfy addicted societies) will conceivably push players towards aggressive policies leading to a loss of balance frequently ending with a nuclear war. When confronted with failure, players may choose instead diminish oil extraction before the peak is reached for a more optimistic conclusion, a transition towards a green economy.

- Ludological genre [11]: Oiligarchy mimics a simulation and management game in which players run an oil-extraction company and its related political lobby;
- Interactor's role: managing oil-extraction; lobbying; allocating and securing resources; generating profits;
- 1st order discourse (apparent): at a first exam, Oiligarchy seems a playful, cheerful, non-controversial game (cp. SimCity, Railroad Tycoon series...);

- <u>1st order voices and parody</u>: the interface, the tutorials and in-game characters express a parodical point of view of lobbies and corporations;
- <u>1st order ideology (apparent)</u>: maximizing profits from oil-extraction is good; a society which depends on fossil fuel is useful;
- <u>Satirical mechanism / emotional engagement</u>: if the player plays "well", i.e. maximizing profits, the simulation triggers a series of negative events connected to oil scarcity. The following *crescendo* of dysphoric events, up to a nuclear apocalypse, is the rhetorical pivot of the game, leading players to a 2nd order satirical interpretation;
- <u>2nd order ideology (supported)</u>: uncontrolled dependency from fossil fuels will have dangerous consequences;
- <u>Suggested ludic strategy</u>: to avoid negative outcomes, players need to disobey the game's voice [8] by not fulfilling genre-related expectations and playing to "lose".

Fig. 1. Oiligarchy (Molleindustria, 2008)

2.2 Phone Story

On September 13, 2011, Phone Story was removed by Apple from the App Store because, according to the official statement, it depicted violence against children and questionable content. Phone Story is a simple game of skills but, while its mechanics are rather dull, its figurative and narrative layers are evidently anomalous: players are called to guard watching slaves in a mine, to operate a safety net trying to save suicidal factory workers, to throw smartphones at mindless consumers and to dispose waste in a Third-World dump.

A synthesized background voice hijacks Apple's identity, addresses the player and directly refers to his phone - for example: "This phone was assembled in China [..] in inhuman conditions. More than 30 committed suicide out of extreme desperation. We addressed this issue by installing suicide-prevention nets" [4].

Fig. 2. and 3: Phone Story (Molleindustria, 2011)

- <u>Ludological genre</u>: casual game - a simple game of skills, composed by four independent mini-games based on swiping movements on the touchscreen to drag objects to the correct part of the playing field at the right time
- <u>Interactor's role</u>: reenacting the manufacturing, marketing, sales and disposal process of a cellular phone;
- <u>1st order discourse (apparent)</u>: documenting the production of a cellphone. The first words spoken by the background voice are particularly significant: "Hello consumer (...). *Let me tell you the story* of this phone, while I provide you with quality entertainment";
- <u>1st order voices and parody</u>: the discourse of advertising and Apple's corporate and brand identity;
- <u>1st order ideology (apparent)</u>: the corporate practices depicted by the game (exploiting workers, consumers and natural resources) appear to be positive, normal and matter-of-facts;
- <u>Satirical mechanism / emotional engagement</u>: the narration hijacks and subverts the corporate voice of Apple and creates a detachment between the tone (cheerful, euphoric) of the narrating voice and the moral content (negative, dysphoric) of the enacted gameplay. Also, platform-specific effects are highly relevant: the disturbing gameplay of Phone Story takes place on the cellphone itself, simulating its own production and marketing process (consumerism demonstrated?);
- <u>2nd order ideology (supported)</u>: Needless consumerism is induced by brands and has negative effects on workers' rights and the environment;
- <u>Suggested ludic strategy</u>: Phone Story cannot be subverted or played to reach a different (better) ending.
- <u>Potential future effects for players</u>: encouraging the decoding/debunking of brand discourses?

2.3 Tax Evaders

Tax Evaders shares the same ideology of the previous pieces but features a different gameplay and discursive structure, closer to propaganda than to satirical discourse. The logos of many corporations are transformed in alien spaceships, similar to Space Invaders: players have to stop them before they "flee the US" without paying their taxes. Tax Evaders lacks the ambiguity between different interpretive possibilities, while compensating with a very effective call to action (launch "Twitter Bombs" to continue playing, publishing real tweets critiquing the target corporations).

Fig. 4. Tax Evaders (Molleindustria, 2013)

- Ludological genre: reverse Space Invaders clone ("aliens" fleeing, not landing);
- Interactor's role: fight the "evaders" to recover taxes; protect the protesters;
- Voice: easily identifiable (post-Occupy Wall Street movements, Molleindustria);
- Ideology: citizens need to be informed and take action against corporations (offline: demonstrations; online: citizen journalism);
- Pragmatic effects: clear call for action - tweet-bombing; grassroots propaganda; raising awareness on corporate tax evasion.

3 Discussion

Satirical discourses are heterogeneous in their semiotic components, often blending different stylistic and emotional tones. Differently from comedy, satire is ideologically biased and focuses against specific targets. Satirists aim for concrete,

pragmatic effects - such as the harsh critique of their intended target - by evoking a wide palette of strong emotions. Prototypical satires are based on the author's indignation or anger channeled through humor in order to embarrass the intended target. These examples show the potentialities of an overlapping between simulation, playful elements and satirical persuasion - suggesting their mutual compatibility and stressing the need for further research in this area.

Clear satirical elements may be identified in Oiligarchy: an ideological perspective (unbalanced capitalist economy will damage society), well-identified antagonists to be shamed (oil-extraction industry and its underlying political system) and a diverse emotional palette (from the satisfaction of playing successfully in the first part of the game, to confusion when apparently-winning strategies bring the players to an unexpected defeat).

Phone Story adopts a more subtle semiotic strategy, hijacking Apple's brand discourse and staging the telling of "the real story" behind the production of a smartphone - while actually presenting Molleindustria's ideological perspective. Identifying not only Apple itself but also the player as criticized antagonists is a defining feature of this piece - a case of guilt by association, having bought the phone that it being used to play the Phone Story game.

Finally, Tax Evaders constitutes the continuation of Molleindustria's discourse into a more action-oriented propagandist genre: it is more pragmatic than the previous pieces, shifting away from satirical ambiguity, crossing the border between satire and propaganda with its clear invite to take action via Twitter and lacking the double interpretive level that characterized Oiligarchy and Phone Story.

References

1. Ferri, G.: Satira politica tramite videogioco. Considerazioni semiotiche sull'uso persuasivo di sistemi algoritmici. In: E|C (2010)
2. Dyer-Witheford, N., de Peuter, G.: Games of Empire: Global Capitalism and Video Games. Minnesota University Press, Minneapolis (2009)
3. Oiligarchy (computer game): Pedercini, P., Molleindustria. Adobe Flash (2008)
4. Phone Story (computer game): Pedercini, P., Molleindustria. iOS/Android (2011)
5. Tax Evaders (computer game): Pedercini, P., Molleindustria. Adobe Flash (2013)
6. Bogost, I.: Persuasive Games. MIT Press, Cambridge (2007)
7. Fabbri, P.: Satira. Alfabeta2 20(6) (2012)
8. Genette, G.: Narrative Discourse: An Essay in Method. Cornell University Press, Ithaca (1980)
9. Eco, U.: The Role of the Reader. Indiana University Press, Bloomington (1979)
10. Greimas, A.J.: Du sens 2. Éditions du Seuil, Paris (1983)
11. Järvinen, A.: Introducing applied ludology. In: Akira, B. (ed.) Proceedings of the DiGRA 2007 Conference - Situated Play. University of Tokyo, Tokyo (2007)

Silent Hill 2 and the Curious Case of Invisible Agency

Sercan Şengün

İstanbul Bilgi University, İstanbul, Turkey
sercansengun@gmail.com

Abstract. This paper outlines the concept of agency in interactive narratives and focuses on the video game Silent Hill 2 as a successful example that defies the very concept. In what ways agency was deemed as an essential part in interactive narratives and narrative video games are summarized. Then the method of agency in Silent Hill 2 is proposed as an alternative to our familiar understanding of the concept agency and is entitled as invisible agency.

Keywords: Interactive Narrative, Agency, Invisible Agency, Autonomy, Silent Hill, Video Game, Narrative Video Game, Video Game Experience.

1 Introduction

This article aims to add an alternative viewpoint for the identification of the balance of roles between the author – or the electronic compositor – of an interactive narrative and its interactor. The main debates around this balance have been aimed to determine the limits at which the interactor could become the author of the narrative himself; or to understand the limits drawn by the author within which the interactor could act. The basic aspects that makes a narrative *interactive* is listed by Meadows as the interactor's abilities to "affect, choose or change the plot" [1].

Various theorists have assessed interactive narrative in their own terms [2-5] yet one concept that seems to be widely cherished is the concept of *agency*. The term is described by Murray as "the satisfying power to take meaningful action and see the results of our decisions and choices" [6]. A recent update to the term, again by Murray, focuses on term's reflection into video games as a "procedural and participatory environment" and entitles this as *dramatic agency* [7].

Applied to an interactive narrative, agency suggests that the interactor is bound to take satisfaction in making decisions about the flow of the narrative and the choices made better pan out with discernible results. One can then deduce that the interactor would like to be aware of the choices within the narrative and preferably would enjoy composing logical links between the choices made and the way the narrative is taking. Consequently the narrative choice is made *consciously* and *visibly* and the outcome is instantly associated with it. Although many links in psychological literature could be found between the application of agency and interactor's overall satisfaction, for the purpose of this article it seems efficient to focus on some examples that emphasize immediate feedback and the possibility to observe the outcome of narrative choices and actions.

H. Koenitz et al. (Eds.): ICIDS 2013, LNCS 8230, pp. 180–185, 2013.
© Springer International Publishing Switzerland 2013

1.1 Agency and Self-Determination Theory

The Self-Determination Theory (STD) by Frederick and Ryan identify intrinsic motivation as the core type of motivation for sports and play and list three factors that support or diminish intrinsic motivation [8]. These three factors are listed as; competence, relatedness and autonomy – and autonomy is the main concept here that could be drawn parallel to agency.

From an outside point of view, the autonomy for being an interactor in an interactive narrative may always seem high because the participation is nearly always voluntary. Yet inside the narrative, the sense of autonomy is expected to rise when the interactor has the perception that he is free to choose what he wants to do and the instructions are non-controlling. This way the interactor becomes free to trace back to the parts he has failed (or even succeeded and passed) and replay them to get better results or to experiment on the different outcomes, rather than forcing the interactor into a singular narrative flow. This assessment of autonomy is almost a reflection of the term agency.

1.2 Agency and Flow State

An interactive narrative or a narrative video game experience could also be matched with Csikszentmihalyi's concept of *flow state* within which it is possible to find strengthening arguments for the concept of agency.

Csikszentmihalyi describes the conditions of flow state activities that will create an engagement with everyday life as to result in happiness [9]. These conditions are applicable to interactive narratives and video game experiences. The described conditions are; clear goals (the interactor/player instantly understands what his goal is and what he must do to achieve it), immediate feedback (the interactor/player can instantly see and understand the results of his actions), challenges matching skills (the interactor/player climbs a learning curve that keeps challenging him since challenges too high or too low for the skill level of the interactor/player will both frustrate him equally), deep concentration, a feeling of control, the alteration of the sense of time, and the activity being intrinsically rewarding.

It seems now possible to define agency in terms of flow state, too. When the interactor is feeling in control - meaning he can take actions and receives immediate feedback for his actions, this forms the basis for the concept of agency – as well as fulfill some requirements of flow state.

2 Silent Hill 2 as a Defiance to Agency

2.1 About the Game

Silent Hill 2 is a survival horror game published by Konami in 2001. The game tells the story of the protagonist James Sunderland, who receives a letter from his dead wife that tells him to come and find her in the town of Silent Hill, a small, rural and fictional American town. The game begins with James arriving at the abandoned town

and follows him as he seeks his wife. By doing so the abandoned town begins to transform into a realm of nightmare filled with darkness, bloodshed and hellish creatures.

The games in the series of Silent Hill, are sometimes referred as psychological horror games and are furnished with subtle references regarding human nature that is prone to narrative and psychoanalytic analysis [10-11].

The game emphasizes exploration rather than fighting action. It is also an exploration of the protagonist's psyche, his shrouded past and his relation to his dead wife Mary. As Perron puts it; "as the player completely uncovers the background story of James Sunderland at the end of Silent Hill 2, it appears that the character has been caught in some sort of psychological hell" [12].

The real story between Mary and James is uncovered slowly during the process of the game. It seems that Mary was terminally ill and bedridden for a very long time and James who was tired and overwhelmed by taking care of her, eventually kills/euthanizes her. The town is possibly a representation of James' guilt over what he did to his wife. In the town James also meets Maria, who physically resembles her wife but dresses and acts in a more seductive way. This is probably a reflection of the subdued sexuality of James as he would have been unable to have a sexual relationship with his sick and bedridden wife for a long time and came to resent her for it. Kirkland's observations seem to support a similar outcome; "[Silent Hill 2's] final boss, a monstrously transformed version of James' dead wife, exemplifies such tendencies. By this final stage attentive players might suspect James' responsibility for Mary's death, due to his conflicting feelings towards her, and that the entire game is a projection of James' tortured imagination. Killing Mary, in this context, represents a repetition of James' act of euthanasia – a misogynistic obliteration of the woman he grew to resent, the manifestation of his guilt and self-loathing" [13].

Among other people who James meet in Silent Hill, one is a young girl named Angela. She seems to be living a personalized nightmare of her own in this town, which gives the impression that the town provides each of its visitors (or victims), a personalized nightmare experience from his or her past. She confesses that her father was sexually abusing her and gives James the knife that she was planning to kill herself with. This knife becomes a paramount item for one ending of the game.

2.2 The Endings and the Invisible Agency

The game has six possible endings and two of them are created as joke endings, irrelevant with the narrative (called "Dog Ending" and "Ufo Ending"). In an ending titled "Leave", James fights the final boss creature Mary and then leaves the town. In "Water", James fights the final boss creature Mary and then commits suicide. In "Rebirth", James tries to resurrect Mary but fights Maria who turned into a monster instead. In "Maria", James fights the final boss creature Mary and leaves the town with Maria (who is heard coughing in the final scene).

So far the game resembles a video game that could possibly employ agency in its narrative flow in the most traditional way, yet the ways in which these endings are achieved disrupts the very concept. Within this article the method employed by this

game will be called the *invisible agency*. This employed method is so radical that if a player has never read a walkthrough of the game and does not know the requirements for each ending beforehand, the ending he achieves may also reflect a psychological profiling for himself.

Silent Hill 2, decides the ending by examining the obscure actions taken by and the overall attitude of the player during the game play – especially when the player was unaware that he was making a decision[1].

For example if the player listens to the directions given by Maria, does not check the photo of Mary in the inventory more than once, keeps close to Maria as he escorts her, protects her from monsters, does not listen to the final conversation of Mary just before the game's final battle - the game decides that James (or the player) has had enough with the memory of Mary and does not carry guilt over her death. The result is James fighting Mary-demon at the end and leaving with Maria.

In the opposite side, if the player mistreats Maria, leaving her behind while escorting her around the town, not listen to her directions, reads and listens to all entries and recordings about Mary - the game decides that James (or the player) feels guilty about killing Mary and still misses her. The result is James fighting Maria-demon, getting forgiveness from Mary and leaving the town to continue with his life.

If the player goes through the game taking a lot of risks, not healing James enough, keeping his health bar flashing red frequently, examines Angela's knife in his inventory more than a few times - the game decides that James has had enough about living and is suicidal. This results in the ending where James kills himself.

2.3 Psyche of the Player vs. the Character

The game uses a rather obscured method of agency to read player's reactions to the game's story. The player never has to make an apparent choice (binary or otherwise) that directs the narrative. In fact, unless he knows otherwise, he never becomes aware that his actions are effecting the outcome of the game. When a player, who has no knowledge of several endings and their requirements, achieves an ending, it is possible to deduce that this ending was involuntarily decided by the player (not in the role of the protagonist James), towards his reactions to the situation James is in.

This is a rather defiant approach and seemingly utilized extremely rare in video games medium (or any other interactive narrative approach as well). The concept of agency has been transformed and taken out of context. In contrast to the definition done in the introduction; the narrative choice is made *un*consciously and *in*visibly and the associated outcome is not revealed till the ending of the game, after a pretty long time investment – thus no instantaneous feedback is available.

Of course the game has agency on the immediate level. The player can direct James wherever he wants or make him do whatever he feels, but the decision of the story's conclusion is directed without the player's awareness (again, unless the player is aware of the game's advancement methods). The choices the player makes are

[1] Silenthillmemories.net lists all these decisions to achieve each ending;
 http://www.silenthillmemories.net/sh2/endings_en.htm

actually projected tendencies and they accumulate results in the long run. The player never makes the choice to take Maria with him or leave her to her fate, but affects the outcome by projecting a distance as he escorts her around the town. The player never makes the choice to forget about Mary or feel remorse about her death, but affects the game's ending by choosing to read and listen to text and recordings about her (or skipping them).

In the end when the player achieves an ending and becomes aware that there are others, he is prone to realize that what brought the story to this ending was his subconscious choices. The player did not really choose an ending for James, he initiated an ending according to his own psyche through his reactions to the presented story.

The realization may trigger a much stronger psychological response than to actually having made apparent choices.

3 The Verdict on Invisible Agency

Did the employment of invisible agency (or the transformation of agency into obscured means) made Silent Hill 2 a successful game? Metacritic.com calculates a score of 89 out of 100, using the assessment of 34 critics and a user rating of 9,1 out of 10, using the rating of 213 users[2] (as of August 2013). It seems that the experience was a memorable and an appreciated one.

Why then, although the game's narrative mechanics contrast the widely accepted narrative and engagement methods of agency and autonomy, can the game still seems to thrive? It is possible that the answer lies inside the assumption that the correct formulation of agency and autonomy is still in progress. Creating a choice for the sake of creating a choice inside a video game may not always support the agency. Forcing a choice and constraining the alternatives or presenting inconsistent alternatives may thwart instead of support the feeling of freedom.

When a player is presented a choice with blatantly obvious means, he may become painfully aware of where the story is going either way. The choice could then be made out of efficiency rather than narrative concerns.

In Bethesda's 2008 release *Fallout 3* there is a system called karma that tracks how good or how bad (evil) your character is. Generally helping in-game characters raises your karma but killing them and stealing from them decreases it. Similar systems exist in various other games, too. Basically there may be two problems with such a choice system based on ethics in terms of agency; patency and inconsistency. When the player is presented two obvious choices on far sides of a spectrum to proceed through the game it is a choice that faintly supports agency. Many moral dilemmas presented may have more solutions than black & white and not being able to act other than completely "good" or "evil" is bound to diminish the agency of the player. The other possible problem arises when the player is allowed to act inconsistently (a good character suddenly decides to become a murderer or vice versa). Although primarily this may be perceived to enhance freedom, being able to make inconsistent choices ruptures the player's attachment with the storyline and the character.

[2] http://www.metacritic.com/game/playstation-2/silent-hill-2

The path *Silent Hill 2* chooses however is to read player's intentions and reactions to the storyline, sometimes without his consent – thus never having the player make an obvious choice. By this way the direction of the narration becomes extremely personal – and almost subconscious. Then the final impact of the overall experience becomes deeply imposing and sometimes even a bit disturbing.

While there are examples of similar intention reading methods in a limited number of other games (such as Christine Love's 2012 game *Analogue: A Hate Story* or Konami's 2004 game *Metal Gear Solid: The Twin Snakes*) this generally covers a small portion of the narrative. Another game such as *Silent Hill 2* that relies completely on invisible agency for its storytelling, seems yet to be produced. Although one example of a video game may seem insufficient to define a complete new term such as invisible agency at first, it seems fruitful to acknowledge its existence and initiate a discussion on its effects.

Is this approach then superior to the video games with apparent agency methods? Not necessarily. Yet it seems disappointing that this method was very under-exploited. The method of invisible agency, still seems, as of today, to be an obsolescent one. Video games that rely on such a method are extremely sparse.

It may look as a brighter and a more diverse future for interactive narrative in which some narrators could forsake blatant choice mechanics for subtle methods of reading the reactions and intentions of the interactor – thus rendering, even some of the agency, invisible.

References

1. Meadows, M.S.: Pause and Effect: The Art of Interactive Narrative, p. 62. New Riders, Berkeley (2002)
2. Laurel, B.: Computers as Theatre. MIT Press, Cambridge (2001)
3. Aarseth, E.: Cybertext: Perspectives on Ergodic Literature. The John Hopkins University Press, Baltimore (1997)
4. Manovich, L.: The Language of New Media. The MIT Press, Cambridge (2001)
5. Ryan, M.L.: Narrative Across Media: The Languages of Storytelling. The University of Nebraska Press, Lincoln (2004)
6. Murray, J.H.: Hamlet on the Holodeck: The Future of Narrative in Cyberspace, p. 126. Simon and Schuster, New York (1997)
7. Murray, J.H.: Inventing the Medium: Principles of Interaction Design as a Cultural Practice, p. 417. The MIT Press, Cambridge (2011)
8. Frederick, C.M., Ryan, R.M.: Self-determination in Sport: A Review Using Cognitive Evaluation Theory. International Journal of Sport Psychology 26, 5–23 (1995)
9. Csikszentmihalyi, M.: Finding Flow. Basic Books, New York (1997)
10. Kirkland, E.: Restless Dreams in Silent Hill: Approaches to Video Game Analysis. Journal of Media Practice 6(3), 167–178 (2005)
11. Santos, M.C., White, S.E.: Playing with Ourselves: A Psychoanalytic Investigation of Resident Evil and Silent Hill. In: Garrelts, N. (ed.) Digital Gameplay: Essays on the Nexus of Game and Gamer, pp. 69–79, McFarland, Jefferson (2005)
12. Perron, B.: Horror Video Games: Essays on the Fusion of Fear and Play, p. 31, McFarland, Jefferson (2009)
13. Kirkland, E.: The Self-reflexive Funhouse of Silent Hill. Convergence: The International Journal of Research into New Media Technologies 13(4), 414 (2007)

The Elements of a Narrative Environment

Exploring User Reactions in Relation to Game Elements

Arne Grinder-Hansen and Henrik Schoenau-Fog

Department of Architecture, Design and Media Technology,
Section of Medialogy, Aalborg University, Copenhagen,
A.C. Meyers Vænge 15, 2450 Copenhagen, Denmark
freaktation@gmail.com, hsf@create.aau.dk

Abstract. Reactions reflecting the psychology behind a user's desire to play games have been addressed in a number of studies. However, this paper focuses on a more inclusive understanding of how game elements, such as controls and objects, play their part in interactive storytelling and games. Based on findings from user studies and game theory, an open game world was constructed, in order to serve as a test environment. A survey was then developed in order to identify reactions and patterns in user responses to frequently used game elements. This study thus attempts to provide an insight into general reactions to game elements in open game worlds, and it aims at laying the foundations for defining a process which can be applied to user relations with game elements. Furthermore, it has potential uses for improved game and interactive storytelling application design.

Keywords: User engagement, game elements, user experience, interactive narrative, emergent narrative, motivation, studies of play, storytelling.

1 Introduction

It has been established that user engagement is important to consider in the development of games (Brockmyer et. al, 2009). It is also known that engagement is just one of several notions of influence in the user experience, such as flow (Csikszentmihalyi, 1990) and immersion (Brown & Cairns, 2004). The prime objective of this study, however, is to investigate how users react to game elements, such as items, objects, and creatures, in open game environments, both in regard to their own reported emotions and through observations of user movement and reactions in order to gain an insight into creating a more effective interaction between the user and the narrative experience, be it an emergent interactive narrative or a more linear narrative structure.

2 Method

In order to explore the effects of game elements, two versions of an open-world game environment – set at the time of the Native American tribes – were developed

H. Koenitz et al. (Eds.): ICIDS 2013, LNCS 8230, pp. 186–191, 2013.

(See Fig. 1). In the first version, the game elements related to the environment, such as natural growth, and buildings were created and placed in accordance with theories gathered by research into human emotion (Sylvester, 2013) (Lazzaro, 2004), game dynamics (Egenfeldt-Nielsen et. al, 2013), triggers of engagement (Schoenau-Fog, 2011), and flow (Csikszentmihalyi, 1990). The game elements identified may be separated roughly into three dimensions: Navigation (movement options), environment (static objects and creatures) and items (obtainable objects which can be used). Based upon these findings, it was concluded that using a rich, open environment facilitated the desire to explore, which is considered one of the reasons why users continue to play a game (Crawford, 1982). In line with exploration and freedom, the experience was created without any specific story in mind; instead, it used game elements to allow for emergent narratives, which can be described as user-constructed narratives based on, for example, elements in game environments (Jenkins, 2004).

Fig. 1. Game environment and humanoid character

In the second version, navigational options were modified by granting increased possibilities for the user to interact with the environment, which also allowed the user increased freedom in interaction and enabled us to judge differences in reactions to the game's elements. Items such as an axe and a bow were included in the game, to further interaction with the environment and to act as rewards (McGonigal, 2011) (Lehrer, 2010). A human character was included due to the relevance of socializing (Chen et. al, 2006) as part of the gameplay, and several events and locations were made to serve both as challenges (Przybylski et. al, 2010), such as a blocked cave and moving animals to hunt or follow, and as something for the user to discover, such as hidden areas or the aforementioned items.

2.1 Procedure

Each user was observed in both playthroughs of the open game environment—first the simple version with the basic controls, and then the version with more advanced movement controls and all game elements included. Upon finishing playing the game, each user was asked to answer a series of survey questions about their experience, demographics, and gaming preferences. The survey consisted of open-ended questions, in order to avoid biasing the results by providing predefined answers and to allow for the discovery of as many different responses as possible in regards to the users' experiences.

A revised second test, with updated functions and corrections to the game environment such as improved ambient music, a graphical user interface, and the inclusion of a map of the game world, was performed after completing the first test. The new group of participants were surveyed and observed as in the first test, and the results were compared to the previous ones, in order to create an understanding of any differences.

3 Results

In total, 15 males (75%) and five females (25%) participated in the first test and responded to the survey. The respondents were selected through convenience sampling, and their ages ranged from 21-25 years. The participants reported the following preferences for games (multiple choice): 50% Role-playing Games, 40% Adventure Games, 25% Strategy, 25% Simulation, 25% Casual, 15% First-Person Shooter, 5% Puzzle, and out of the 20 participants, two reported that they rarely played games. The second test with the updated environment was conducted with five participants, aged from 21 to 25 years of age and consisting of four males and one female, each of whom had the same primary game preferences. All five were selected from a sample similar to those previously tested and to have at least a similar ratio of males and females.

3.1 Results and Analysis

The observations and responses from the survey yielded myriad answers, which were filtered by discarding answers and observations not relevant, such as null replies. Negative responses without any argumentation (such as 'no' only) were considered in a quantitative sense to indicate if the overall effect of the game element had worked as intended, as opposed to positive responses which could form part of a qualitative analysis aiming at an increased understanding of user reactions.

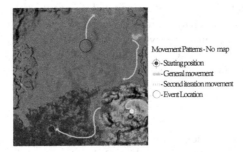

Fig. 2. Map of the testing environment—patterns in the participants' navigation of the world

During the participants' progress in the game environment, patterns in their movements were also noted by an observer, the results for which are depicted in Fig. 2. The patterns show a general tendency for the users to move toward green areas and follow cliffs, totally avoiding the open central prairie until the first green area has been traversed.

Giving the user access to additional movement options in the second version led to several changes whereby they played longer and covered more of the map when able to run, and the ability to jump encouraged them to try to access new areas. These observations indicate that the users might have believed that interaction within the environment had improved, too.

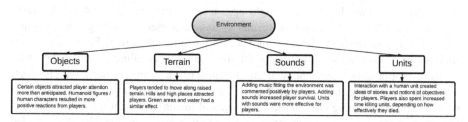

Fig. 3. Findings related to the environment and events taking place therein

Through the users' responses and our own observations it was noted that users who interacted with the only humanoid character in the game played longer and that several respondents thought that it had given them an objective, even though he had not necessarily done so. Most of those who responded that they had constructed a story also based the narrative on their encounter with the humanoid character. The findings can be summarized as follows:

Navigation, such as similarities in routes the users were observed to travel, indicates that users may follow a pattern by preferring green areas and cliffs when they move in an open-world environment, and that this changes when they are able to view a map of the environment.

Environmental objects may have an influence beyond the intended scope, such as an aspect or element nature within the environment which attracts attention (Fig. 3), e.g. a randomly placed cactus with an odd shape.

Movement, such as sprinting, in movement controls may improve user interaction with the environment.

4 Discussion

The primary limitation of the findings is the low amount of test participants and the use of convenience sampling. Thus, one would need to target specific groups of experienced as well as less experienced gamers, and then test whether similar and generalizable results can be gathered. Many of the results are based upon observation, and only some of the reactions observed have been directly explained through the survey. In other cases it cannot be known with certainty why the users acted like they did, hence the risk of faulty interpretations of the observations. Another limitation of the study is the interpretation of answers to open-ended questions, which might be biased by the researcher. This problem could be addressed by performing additional tests to test these interpretations, or to let other researchers analyze the data for comparison.

In addition to the above limitations, it is important to consider the influence of the test environment; consequently, additional testing with other game environments and combinations of elements would result in more validated data.

The relationship between mechanics and fiction is a well-known topic (Murray, 2005). However, the considerations of mechanics are related in practical terms and do not consider the actual effect of using a stack of boxes, for instance, as opposed to using a stack of barrels. While it might appear as a miniscule difference, this study has shown some rather unexpected results as to how a user reacts to game elements, such as trying to jump on them or unexpected narrative attraction. Furthermore, the findings go in line with the notion of environmental storytelling whereby the environment supports the user-generated construction of an emergent narrative (Jenkins, 2004). In such a case, the embedded game elements of the environment also become part of the story, coming close to how elements of the environment have an influence. However, most studies of environmental storytelling have not considered these elements in depth but instead deal with more overall notions of the environment.

In addition, user reactions and movements in the environment can be most likely related to studies into human psychology. The results—such as the users' tendency to feel attracted to certain areas as opposed to others—could be an unconscious behavior which is exhibited, for example, in order to remain oriented in the world (Kaplan, 1987) and which if knowingly used could be used to progress the user in a story. Discovering new items increases user confidence when faced with danger and serves as a motivating factor by allowing the user to 'progress' in the game (Schoenau-Fog, 2011); furthermore, this act of discovery changes how the user views the game – in effect 'changing' the world from a potentially dangerous arena and into a playground. Once again this could be used to avoid breaking a story, if one knew how an item influenced the user's perception of his environment.

This study does not claim to have discovered this influence, especially since it will likely be dependent on each game element in question. However, this is not the aim of the study; instead, the results show that the influence is present and can be used to propose that certain elements meant for similar use may not provide the same experience (and thus story construction) and could actually affect the efficiency of the activity or narrative. Thus, increased understanding can arguably be used to improve or support the emergent narrative, not just in the sense of fitting the scene, but also in regards to its actual appearance.

5 Conclusion

Based on the findings of movement patterns and reactions to objects it can be suggested that game elements in an interactive story experience may have a more significant influence than one might initially realize, meaning that when creating an interactive story it is not enough just to consider what activities one should include in the game, in order to engage or tell a story, but the designer should also consider how these activities are implemented. Hence, one should not only consider narratives and gameplay in game design, but also analyze the psychological impact of the game

elements in greater detail, in order to increase the effectiveness of the game and the communication of the story, which may in turn lead to an improved game experience.

Further studies with additional target groups, various experiences, and more test subjects could lead to the creation of guidelines to follow, in order to use elements to their full potential when creating environmentally-based, emergent interactive narratives and also to both support the game and guide the user.

References

1. Brockmyer, J.H., Fox, C.M., Curtiss, K.A., McBroom, E., Burkhart, K.M., Pidruzny, J.N.: The development of the Game Engagement Questionnaire: A measure of engagement in video game-playing. Journal of Experimental Social Psychology, 624–634 (2009)
2. Brown, E., Cairns, P.: A grounded investigation of game immersion. In: CHI 2004 Extended Abstracts on Human Factors in Computing Systems, pp. 1297–1300. University College London Interaction Centre, Vienna (2004)
3. Chen, V.H.-H., Duh, H.B.-L., Phuah, P.S., Lam, D.Z.: Enjoyment or Engagement? Role of Social Interaction in Playing Massively Mulituser Online Role-Playing Games (MMORPGS). In: Entertainment Computing - ICEC 2006, pp. 262–267. Springer, Heidelberg (2006)
4. Crawford, C.: The Art of Computer Game Design. McGraw-Hill/Osborne Media, Berkeley (1982)
5. Csikszentmihalyi, M.: Flow: The Psychology of Optimal Experience. Harper Perennial, New York (1990)
6. Egenfeldt-Nielsen, S., Smith, J.H., Tosca, S.P.: Understanding Video Games - The Essential Introduction. Routledge, New York (2013)
7. Jenkins, H.: Game Design as Narrative Architecture (2004)
8. Kaplan, S.: Aesthetics, Affect, and Cognition - Environmental Preference from an Evolutionary Perspective. Environment and Behavior 19(1), 3–32 (1987)
9. Lazzaro, N.: Why We Play Games: Four Keys to More Emotion Without Story. In: Game Developers Conference, XEODesign (2004)
10. Lehrer, J.: How We Decide. Mariner/Houghton Mifflin, Boston (2010)
11. McGonigal, J.: Reality Is Broken: Why Games Make Us Better and How They Can Change the World. Penguin Books, London (2011)
12. Murray, J.H.: The Last Word on Ludology v Narratology in Game Studies. In: DiGRA 2005 Conference, Vancouver (2005)
13. Przybylski, A.K., Rigby, C.S., Ryan, R.M.: A Motivational Model of Video Game Engagement. Review of General Psychology 14(2), 154–166 (2010)
14. Schoenau-Fog, H.: The Player Engagement Process – An Exploration of Continuation Desire in Digital Games. In: Think Design Play Proceedings of the 5th International DiGRA Conference, Utrecht, Netherlands (2011)
15. Sylvester, T.: Designing Games: A Guide to Engineering Experiences. O'Reilly Media (2013)

Generating Different Story Tellings
from Semantic Representations of Narrative

Elena Rishes[1], Stephanie M. Lukin[1], David K. Elson[2], and Marilyn A. Walker[1]

[1] Natural Language and Dialogue Systems Lab
University of California Santa Cruz, Santa Cruz
{erishes,slukin,maw}@soe.ucsc.edu
[2] Columbia University, New York City
delson@cs.columbia.edu

Abstract. In order to tell stories in different voices for different audiences, interactive story systems require: (1) a semantic representation of story structure, and (2) the ability to automatically generate story and dialogue from this semantic representation using some form of Natural Language Generation (NLG). However, there has been limited research on methods for linking story structures to narrative descriptions of scenes and story events. In this paper we present an automatic method for converting from Scheherazade's STORY INTENTION GRAPH, a semantic representation, to the input required by the PERSONAGE NLG engine. Using 36 Aesop Fables distributed in DramaBank, a collection of story encodings, we train translation rules on one story and then test these rules by generating text for the remaining 35. The results are measured in terms of the string similarity metrics Levenshtein Distance and BLEU score. The results show that we can generate the 35 stories with correct content: the test set stories on average are close to the output of the Scheherazade realizer, which was customized to this semantic representation. We provide some examples of story variations generated by PERSONAGE. In future work, we will experiment with measuring the quality of the same stories generated in different voices, and with techniques for making storytelling interactive.

Keywords: Semantic Narrative Representation, Natural Language Generation, StoryVariation.

1 Introduction

Sharing our experiences by storytelling is a fundamental and prevalent aspect of human social behavior. A critical aspect of storytelling "in the wild" is that it is socially interactive and situation dependent. Storytellers dynamically adjust their narratives to the context and their audience, telling and retelling the same story in many different ways depending on who the listener is. For example, storytellers tell richer stories to highly interactive and responsive addressees [1], and stories told by young adults "play" to the audience, repeatedly telling a story until a satisfactory peer response is found [2].

H. Koenitz et al. (Eds.): ICIDS 2013, LNCS 8230, pp. 192–204, 2013.

Original Story	Scheherazade	Personage
A hungry Fox saw some fine bunches of Grapes hanging from a vine that was trained along a high trellis, and did his best to reach them by jumping as high as he could into the air. But it was all in vain, for they were just out of reach: so he gave up trying, and walked away with an air of dignity and unconcern, remarking, "I thought those Grapes were ripe, but I see now they are quite sour."	Once, a group of grapes was hanging on a vine and the vine was hanging on a high trellis. A hungry fox saw the group of grapes. The fox jumped in order to obtain the group of grapes. The fox didn't obtain the group of grapes because he wasn't able to reach the group of grapes. The fox walked away from the group of grapes with dignity and with unconcern. The fox said that he had earlier thought that the group of grapes was ripe and said that he now saw it as being sour.	The group of grapes hung on the vine. The vine hung on the trellis. The fox saw the group of grapes. The fox jumped in order for the fox to obtain the group of grapes. The fox did not obtain the group of grapes because the fox was not able to reach the group of grapes. The fox walked away from the group of grapes with dignity and unconcern. The fox said the fox earlier thought the group of grapes was ripe. The fox said the fox now saw the group of grapes was sour.

Fig. 1. "The Fox and the Grapes" Aesop fable with Generated Versions

To have this human capability of telling stories in different voices for different audiences, interactive story systems require: (1) a semantic representation of story structure, and (2) the ability to automatically generate story and dialogue from this semantic representation using some form of Natural Language Generation (NLG). However to date, much of the research on interactive stories has focused on providing authoring tools based either on simple story trees or on underlying plan-based representations. In most cases these representations bottom out in hand-crafted descriptive text or hand-crafted dialogue, rather than connecting to an NLG engine.

Prior research on NLG for story generation has primarily focused on using planning mechanisms in order to automatically generate story event structure, with limited work on the problems involved with automatically mapping the semantic representations of a story and its event and dialogue structure to the syntactic structures that allow the story to be told in natural language [3–5]. Recent research focuses on generating story dialogue on a turn by turn basis and scaling up text planners to produce larger text prose [6–9], but has not addressed the problem of bridging between the semantic representation of story structure and the NLG engine [5, 7, 6, 10, 11]. An example of this work is the STORYBOOK system [3] which explicitly focused on the ability to generate many versions of a single story, much in a spirit of our own work. The STORYBOOK system could generate multiple versions of the "Little Red Riding Hood" fairy tale, showing both syntactic and lexical variation. However, STORYBOOK is based on highly handcrafted mappings from plans to the FUF-SURGE realizer [12] and is thus applicable only to the "Little Red Riding Hood" domain.

To our knowledge, the only work that begins to address the semantic-to-syntactic mapping within the storytelling domain is Elson's Scheherazade story annotation tool [13]. Scheherazade allows naïve users to annotate stories with a rich symbolic representation called a STORY INTENTION GRAPH. This representation is robust and linguistically grounded which makes it a good candidate for a content representation in an NLG pipeline.

In this paper, we present a working model of reproducing different tellings of a story from its symbolic representation. In Sec. 2 we explain how we build on the STORY INTENTION GRAPH representation provided by Scheherazade [14] and the previous work on NLG for interactive stories based on extensions to the PERSONAGE NLG engine [15, 9]. Sec. 3 presents an automatic method for converting from Scheherazade's STORY INTENTION GRAPH output to the input required by PERSONAGE. Using the corpus of semantic SIG representations for 36 Aesop Fables that are distributed in DramaBank [14], we train translation rules on one story and then test these rules by generating 35 other stories in the collection. Figs. 1 and 8 show two Aesop Fables, with both Scheherazade and PERSONAGE generated versions. "The Fox and the Grapes" was the development story for our work, while "The Lion and the Boar" was part of the test set. Fig. 9 gives a feel for the retellings that PERSONAGE is capable to produce once it is coupled with Scheherazade's story representation. Sec. 4 demonstrates our evaluation of the 35 generated stories using the measures of Levenshtein Distance and BLEU score. Sec. 5 summarizes and discusses our future work, where we aim to experiment with models for narrator's and characters' voices, measures of retellings' quality, and with techniques for making story telling interactive.

2 Background

Our work is based on a simple observation: a novel capability for interactive stories can be developed by bridging two off-the-shelf linguistic tools, Scheherazade and PERSONAGE. We integrated these tools in a standard NLG pipeline:

- Content planner that introduces characters and events
- Sentence planner that creates linguistic representations for those events
- Surface realizer that produces text string out of linguistic structures

Scheherazade produces the output we would normally get from a content planner and PERSONAGE plays the role of the sentence planner and surface realizer. We developed an algorithm that creates the semantic linguistic representation from a conceptual narrative structure provided by Scheherazade and generates from it using PERSONAGE. Our algorithm acts as an intermediary producing a semantic-into-syntactic mapping. The immediate goal for this study was to regenerate directly from stories annotated with Scheherazade. Our long term goal is to build on the created infrastructure and turn the intermediary into a conventional sentence planner, capable of one-to-many semantic-to-syntactic mappings, i.e. retelling a story in different voices.

We believe that the combination of Scheherazade and PERSONAGE is a perfect fit for our long-term goal due to the following aspects of the two systems. First, Scheherazade representations are already lexically anchored into WordNet and VerbNet ontologies which allows for lexical variation. Second, PERSONAGE provides 67 parameters that make it already capable of generating many pragmatic and stylistic variations of a single utterance. Below we discuss the functionality of the two systems in more detail.

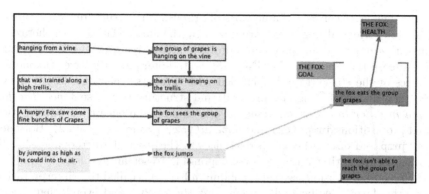

Fig. 2. Part of the STORY INTENTION GRAPH (SIG) for "The Fox and the Grapes"

Scheherazade. Scheherazade is an annotation tool that facilitates the creation of a rich symbolic representation for narrative texts, using a schemata known as the STORY INTENTION GRAPH or SIG [13]. An example SIG for "The Fox and the Grapes" development story, reproduced from Elson [14], is shown in Fig. 2. The annotation process involves sequentially labeling the original story sentences according to the SIG formalism using Scheherazade's GUI. The annotators instantiate characters and objects, assign actions and properties to them, and provide their interpretation of *why* characters are motivated to take the actions they do. Scheherazade's GUI features a built-in generation module in the what-you-see-is-what-you-mean paradigm (WYSIWYM) to help naïve users produce correct annotations by letting them check the natural language realization of their encoding as they annotate [16]). Scheherazade does have a built in surface generation engine, but it is inflexible with synonyms and syntax, thus why we are interested in utilizing PERSONAGE. As a baseline comparison for our method, we use Scheherazade's generation engine to evaluate the correctness of PERSONAGE outputs.

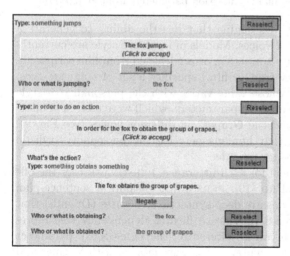

Fig. 3. GUI view of propositional modeling

One of the strengths of Scheherazade is that it allows users to annotate a story along several dimensions, starting with the surface form of the story (see first column in Fig. 2) and then proceeding to deeper representations. The first dimension (see second column in Fig. 2) is called the "timeline layer", in which the story facts are encoded as predicate-argument structures (propositions) and temporally ordered on a timeline.

The timeline layer consists of a network of propositional structures, where nodes correspond to lexical items that are linked by thematic relations. Scheherazade adapts information about predicate-argument structures from the VerbNet lexical database [17] and uses WordNet [18] as its noun and adjectives taxonomy. The arcs of the story graph are labeled with discourse relations. Fig. 3 shows a GUI screenshot of assigning propositional structure to the sentence *The fox jumped in order to obtain the group of grapes*. This sentence is encoded as two nested propositions `jump(fox)` and `obtain(fox, group of grapes)`. Both actions (`jump` and `obtain`) contain references to the story characters and objects (`fox` and `grapes`) that fill in slots corresponding to semantic roles.

The second dimension (see third column in Fig. 2) is called the "interpretative layer"; this layer goes beyond summarizing the actions and events that occur, but attempts to capture story meaning derived from agent-specific plans, goals, attempts, outcomes and affectual impacts. To date, we only utilize the event timeline layer of the SIG encoding.

Model	Parameter	Description	Example
Shy voice	SOFTENER HEDGES	Insert syntactic elements (*sort of, kind of, somewhat, quite, around, rather, I think that, it seems that, it seems to me that*) to mitigate the strength of a proposition	*'It seems to me that he was hungry'*
	STUTTERING	Duplicate parts of a content word	*'The vine hung on the tr-trellis'*
	FILLED PAUSES	Insert syntactic elements expressing hesitancy (*I mean, err, mmhm, like, you know*)	*'Err... the fox jumped'*
Laid-back voice	EMPHASIZER HEDGES	Insert syntactic elements (*really, basically, actually*) to strengthen a proposition	*'The fox failed to get the group of grapes, alright?'*
	EXCLAMATION	Insert an exclamation mark	*'The group of grapes hung on the vine!'*
	EXPLETIVES	Insert a swear word	*'The fox was damn hungry'*

Fig. 4. Examples of pragmatic marker insertion parameters from PERSONAGE

Personage. PERSONAGE is an NLG engine that has the ability to generate a single utterance in many different voices. Models of narrative style are currently based on the Big Five personality traits [15], or are learned from film scripts [9]. Each type of model (personality trait or film) specifies a set of language cues, one of 67 different parameters, whose value varies with the personality or style to be conveyed. Fig. 4 shows a subset of parameters, which were used in stylistic models to produce "The Fox and the Grapes" in different voices (see Fig. 9). Previous work [15] has shown that humans perceive the personality stylistic models in the way that PERSONAGE intended.

After selecting a stylistic model for each utterance, PERSONAGE uses the off-the-shelf surface realizer REALPRO [19]. PERSONAGE outputs a sentence-plan tree whose internal representations are deep syntactic structures (DSyntS) that RealPro expects as input. DSyntS provides a flexible dependency tree representation of an utterance which can be altered by the PERSONAGE parameter settings. The nodes of the DSynts syntactic trees are labeled with lexemes and the arcs of the tree are labeled with syntactic relations. The DSyntS formalism

```
<dsyntnode class="verb" lexeme="jump" mood="ind" tense="past">
  <dsyntnode article="def" class="common_noun" lexeme="fox" number="sg" rel="I"/>
  <dsyntnode class="preposition" lexeme="in_order_to" rel="ATTR">
    <dsyntnode class="verb" lexeme="obtain" mood="inf" rel="II">
      <dsyntnode article="def" class="common_noun" lexeme="group" number="sg" rel="II">
        <dsyntnode class="common_noun" lexeme="grape" number="pl" rel="II"/>
      </dsyntnode>
    </dsyntnode>
  </dsyntnode>
</dsyntnode>
```

Fig. 5. DSyntS for a sentence *The fox jumped in order to obtain the group of grapes*

distinguishes between arguments and modifiers and between different types of arguments (subject, direct and indirect object etc). Lexicalized nodes also contain a range of grammatical features used in generation. RealPro handles morphology, agreement and function words to produce an output string. Fig. 5 shows an example DSyntS structure for one of the sentences from our development story "The Fox and the Grapes". Feature values in bold need to be obtained from the internal Scheherazade representation.

3 Method

Our method applies a model of syntax to a Scheherazade representation of a story (a SIG encoding), in order to produce a retelling of the story in a different voice. A prerequisite for producing stylistic variations of a story is an ability to generate a "correct" retelling of the story. The focus of this study is to verify that the essence of a story is not distorted as we move from one formal representation of the story (SIG) to another (DSyntS). We use Scheherazade's built-in generator, which was customized to the SIG schemata, as a baseline to evaluate our results. Our data comes from DramaBank, a collection of Scheherazade annotated texts ranging from Aesop fables to contemporary nonfiction [14]. Aesop fables from DramaBank serve as our dataset: **one** fable (seen in Fig. 1) is used in development, and then our method is tested by automatically transforming the 35 other fables to the PERSONAGE representation. Figs. 1 and 8 show two Aesop fables, with both Scheherazade and PERSONAGE generated versions. "The Fox and the Grapes" was the development story for our work, while "The Lion and the Boar" was part of the test set. Fig. 6 shows an overview of the method consisting of the following steps:

1. Use Scheherazade's built-in generation engine to produce text from the SIG encoding of the fable
2. Manually construct DSyntS corresponding to the text generated in step 1 (follow the right branch in Fig. 6)
3. Derive semantic representation of a fable from the SIG encoding using Scheherazade API (follow the left branch of Fig. 6)
4. Informed by our understanding of the two formalisms, develop transformation rules to build DSyntS from semantic representation

5. Apply rules to the semantic representation derived in step 3
6. Feed automatically produced DSyntS to PERSONAGE using a neutral NLG model and compare the output with that of step 1. The metrics we used for string comparison are discussed in Sec. 4.

Fig. 6. Our Method

The primary technical challenge was developing a general mechanism for converting SIG semantic encodings into the DSyntS representation used by PERSONAGE's generation dictionary. This involved enforcing syntactic tree structure over the chains of propositions. The challenge was partly due to the variety of ways that VerbNet and WordNet allow nuances of meaning to be expressed. For example, a sentence *the crow was sitting on the branch of the tree* has two alternative encodings depending on what is important about crow's initial disposition: the crow can *be sitting* as an adjectival modifier, or can be *sitting* as a progressive action. There are also gaps in Scheherazade's coverage of abstract concepts, which can lead to workarounds on the part of the annotators that are not easily undone by surface realization (an example is *whether later first drank* in Fig. 8, where adjectival modifiers are used to express *which of [the characters] should drink first* from the original text).

The transformation of Scheherazade's semantic representation into syntactic dependency structure is a multi-stage process, illustrated in Fig. 7. First, a syntactic tree is constructed from the propositional event structure. Element A in Fig. 7 contains a sentence from the original "The Fox and the Grapes" fable. We use the Scheherazade API to process the fable text together with its SIG encoding and extract actions associated with each timespan of the timeline layer. Element B in Fig. 7 shows a schematic representation of the propositional structures. Each action instantiates a separate tree construction procedure. For each action, we create a verb instance (see highlighted nodes of element D in Fig. 7). We use information about the predicate-argument frame that the action

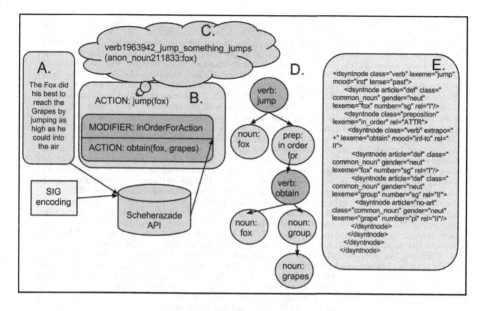

Fig. 7. Step by step transformation from SIG to DSyntS

invokes (see element C in Fig. 7) to map frame constituents into respective lexico-syntactic classes, for example, characters and objects are mapped into nouns, properties into adjectives and so on. The lexico-syntactic class aggregates all of the information that is necessary for generation of a lexico-syntactic unit in DSyntS (element E in Fig. 7). We define 6 classes corresponding to main parts of speech: noun, verb, adverb, adjective, functional word. Each class has a list of properties such as morphology or relation type that are required by the DSyntS notation for a correct rendering of a category. For example, all classes include a method that parses frame type in the SIG to derive the base lexeme. The methods to derive grammatical features are class-specific. Each lexico-syntactic unit refers to the elements that it governs syntactically thus forming a hierarchical structure. A separate method collects the frame adjuncts as they have a different internal representation in the SIG.

At the second stage, the algorithm traverses the syntactic tree in-order and creates an XML node for each lexico-syntactic unit. Class properties are then written to disk, and the resulting file (see element E in Fig. 7) is processed by the surface realizer to generate text. Fig. 8 shows the "Lion and the Boar" fable from our test set, with its generated versions.

Although the emphasis of this work is on generating a "correct" retelling of a story, this infrastructure allows us to alter the story stylistically. Fig. 9 illustrates how we can now piggy-back on the transformations that PERSONAGE can make to produce different retellings of the same story. The FORMAL voice triggered no stylistic parameters of PERSONAGE. "The Fox and the Grapes" was generated directly from DSyntS by the surface realizer. Fig. 4 provides examples of how different parameters played out for the SHY and LAID-BACK voices.

Original Story	Scheherazade	Personage
On a summer day, when the great heat induced a general thirst, a Lion and a Boar came at the same moment to a small well to drink. They fiercely disputed which of them should drink first, and were soon engaged in the agonies of a mortal combat. On their stopping on a sudden for breath for the fiercer renewal of the strife, they saw some Vultures waiting in the distance to feast on the one which should fall first. They at once made up their quarrel, saying: "It is better for us to make friends, than to become the food of Crows or Vultures, as will certainly happen if we are disabled."	Once, the air was hot. A boar decided to drink from a spring, and a lion decided to drink from the spring. The boar quarrelled about whether later first drank from the spring, and the lion quarrelled about whether later first drank from the spring. The boar began to attack the lion, and the lion began to attack the boar. The boar stopped attacking the lion, and the lion stopped attacking the boar. The boar above saw a group of vultures being seated on some rock, and the lion above saw the group of vultures being seated on the rock. The group of vultures began to plan – if the boar were to later die, and the lion were to later die – for the group of vultures to eat. The boar sobered, and the lion sobered. The boar said to the lion that – if the lion were to not kill the boar – the group of vultures would not eat the boar, and the lion said to the boar that – if the boar were to not kill the lion – the group of vultures would not eat the lion. The boar didn't kill the lion, and the lion didn't kill the boar.	The air was hot. The lion decided the lion drank from the spring. The boar decided the boar drank from the spring. The boar quarreled. The lion quarreled. The lion attacked the boar. The boar attacked the lion. The boar above saw the group of vultures was seated on the rock. The lion above saw the group of vultures was seated on the rock. The group of vultures planned the group sobered. The lion sobered. The boar said the group of vultures did not eat the boar to the lion. The lion said the group of vultures did not eat the lion to the boar. The boar did not kill the lion. The lion did not kill the boar.

Fig. 8. "The Lion and the Boar" Fable from the test set, with Generated Versions

Personage FORMAL	Personage SHY	Personage LAID-BACK
The group of grapes hung on the vine. The vine hung on the trellis.The fox saw the group of grapes. The fox jumped in order to obtain the group of grapes.The fox didn't obtain the group of grapes because he couldn't reach the group of grapes.	Well, the group of grapes hung on the vine. The vine hung on the tr-tr-trellis. The fox saw the group of grapes. It seemed that he was hungry. Err... the fox jumped in order to obtain the group of grapes. The fox didn't collect the group of grapes.	Ok, the group of grapes rested on the vine. The vine hung on the trellis, didn't it? The fox saw the group of grapes. He damn was hungry. The fox jumped in order to obtain the group of grapes, okay? Oh the fox failed to get the group of grapes, didn't obtain it, because he couldn't reach the group of grapes, you see?

Fig. 9. Retellings of "The Fox and the Grapes"

The corresponding renderings of the story demonstrate lexical (*grapes hung/grapes rested*), syntactic (*didn't get/failed to get*) and stylistic variation.

4 Results

To evaluate the performance of our translation rules we compare the output generated by PERSONAGE to that of Scheherazade's built-in realizer, using two metrics: BLEU score [20] and Levenshtein distance. *BLEU* is an established standard for evaluating the quality of machine translation and summarization systems. The score between 0 and 1 measures the closeness of two documents by comparing n-grams, taking word order into account. *Levenshtein distance* is the

minimum edit distance between two strings. The objective is to minimize the total cost of character deletion, insertion, replacement that it takes to transform one string into another. In our case, we treat each word as a unit and measure word deletion, insertion, and replacement. We used word stemming as a preprocessing step to reduce the effect of individual word form variations. The results are shown in Table 1. **Scheherazade-Personage** compares the output of the PERSONAGE generator produced through our automatic translation rules to that of the Scheherazade generation. Because the rules were created on the development set to match the Scheherazade story, we expect these results to provide a topline for comparison to the test set, shown in the bottom table of Table 1.

Table 1. Mean and Standard Deviation for Levenshtein Distance (Lower is Better), and BLEU (Higher is Better) on both the DEVELOPMENT and TEST sets

DEVELOPMENT	Levenshtein	BLEU
Scheherazade-Personage	31	.59
Fable-Scheherazade	80	.04
Fable-Personage	84	.03

TEST	Levenshtein Mean (STD)	BLEU Mean (STD)
Scheherazade-Personage	72 (40)	.32 (.11)
Fable-Scheherazade	116 (41)	.06 (.02)
Fable-Personage	108 (31)	.03 (.02)

Although our rules were informed by looking at the Scheherazade generation, Table 1 also includes measures of the distance between the original fable and both Scheherazade and PERSONAGE. **Fable-Scheherazade** and **Fable-Personage** compare the original fable to the Scheherazade and to the PERSONAGE generation respectively. Note that these results should not be compared to **Scheherazade-Personage** since both of these are outputs of an NLG engine. The two-tailed Student's t-test was used to compare the two realizers' mean distance values to the original fables and determine statistical significance. The difference in Levenshtein distance between **Fable-Scheherazade** and **Fable-Personage** is not statistically significant (p = 0.08) on both development and test sets. This indicates that our rules generate a story which is similar to what Scheherazade generates in terms of closeness to the original. However, Scheherazade shows a higher BLUE score with the original fables (p < 0.001). We believe that this is due to the fact that our translation rules assume a simple generation. The rules did not attempt to express tense, aspect or stative/non-stative complications, all of which contribute to a lower overlap of n-grams. The assignment of tense and aspect was an area of particular focus for Scheherazade's built-in realizer [21].

5 Conclusions and Future Work

In this paper we show that: (1) Scheherazade's SIG annotation schemata provides a rich and robust story representation that can be linked to other generation engines; (2) we can integrate Scheherazade and PERSONAGE (two off-the-shelf tools) for representing and producing narrative, thus bridging the gap between content and sentence planning in the NLG pipeline; and (3) we have created an infrastructure which puts us in a position to reproduce a story in different voices and styles. In this paper, we presented quantitative results using Levenshtein distance and BLEU score. However, since our long term goal is to generate different retellings, these metrics will be inappropriate. Here we were primarily concerned with the correctness of the content of the generators; in future work we will need to develop new metrics or new ways of measuring the quality of story retellings. In particular we plan to compare human subjective judgements of story quality across different retellings.

There are also limitations of this work. First, the PERSONAGE realizer needs to extend its generation dictionary in order to deal with irregular forms. The current system generated incorrect forms such as *openned*, and *wifes*. Also we were not able to make tense distinctions in our generated version, and generated everything in past simple tense. In addition, we noted problems with the generation of distinct articles when needed such as *a* vs. *the*. There are a special set of surface realization rules in Scheherazade that are currently missing from PERSONAGE that adds cue phrases such as *that* and *once*. We aim to address these problems in future work.

It should be mentioned that despite being domain independent, our method relies on manual story annotations to provide content for the generation engine. DramaBank is the result of a collection experiment using trained annotators; as they became familiar with the tool, the time that the annotators took to encode each fable (80 to 175 words) as a SIG encoding dropped from several hours to 30-45 minutes on average [14]. The notion of achieving the same semantic encoding using automatic methods is still aspirational. While the SIG model overlaps with several lines of work in automatic semantic parsing, as it has aspects of annotating attribution and private states [22], annotating time [23] and annotating verb frames and semantic roles [24], there is not yet a semantic parser that can combine these aspects into an integrated encoding, and developing one falls outside of scope of this work.

In future work, we also aim to do much more detailed studies on the process of generating the same story in different voices, using the apparatus we present here. Examples of stylistic story variations presented in this paper come from modifications of narrator's voice. In future work, we plan to apply stylistic models to story characters. An extension to Scheherazade to distinguish direct and indirect speech in the SIG will allow give characters expressive, personality driven voices. Once a story has been modeled symbolically, we can realize it in multiple ways, either by different realizers or by the same realizer in different modes.

References

1. Thorne, A.: The press of personality: A study of conversations between introverts and extraverts. Journal of Personality and Social Psychology 53, 718 (1987)
2. Thorne, A., McLean, K.C.: Telling traumatic events in adolescence: A study of master narrative positioning. Connecting Culture and Memory: The Development of an Autobiographical Self, 169–185 (2003)
3. Callaway, C., Lester, J.: Narrative prose generation. Artificial Intelligence 139, 213–252 (2002)
4. Turner, S.: The creative process: A computer model of storytelling and creativity. Lawrence Erlbaum (1994)
5. Riedl, M., Young, R.M.: An intent-driven planner for multi-agent story generation. In: Proc. of the 3rd International Conference on Autonomous Agents and Multi Agent Systems (2004)
6. Cavazza, M., Charles, F.: Dialogue generation in character-based interactive storytelling. In: AAAI First Annual Artificial Intelligence and Interactive Digital Entertainment Conference, Marina del Rey, California, USA (2005)
7. Rowe, J.P., Ha, E.Y., Lester, J.C.: Archetype-Driven Character Dialogue Generation for Interactive Narrative. In: Prendinger, H., Lester, J.C., Ishizuka, M. (eds.) IVA 2008. LNCS (LNAI), vol. 5208, pp. 45–58. Springer, Heidelberg (2008)
8. Lin, G.I., Walker, M.A.: All the world's a stage: Learning character models from film. In: Proceedings of the Seventh AI and Interactive Digital Entertainment Conference, AIIDE 2011. AAAI (2011)
9. Walker, M.A., Grant, R., Sawyer, J., Lin, G.I., Wardrip-Fruin, N., Buell, M.: Perceived or not perceived: Film character models for expressive NLG. In: Si, M., Thue, D., André, E., Lester, J., Tanenbaum, T.J., Zammitto, V. (eds.) ICIDS 2011. LNCS, vol. 7069, pp. 109–121. Springer, Heidelberg (2011)
10. Montfort, N.: Generating narrative variation in interactive fiction. PhD thesis, University of Pennsylvania (2007)
11. McIntyre, N., Lapata, M.: Learning to tell tales: A data-driven approach to story generation. In: Proceedings of the Joint Conference of the 47th Annual Meeting of the ACL and the 4th International Joint Conference on Natural Language Processing of the AFNLP, Singapore, pp. 217–225 (2009)
12. Elhadad, M.: Using Argumentation to Control Lexical Choice: a Functional Unification Implementation. PhD thesis, Columbia University (1992)
13. Elson, D.K., McKeown, K.: A tool for deep semantic encoding of narrative texts. In: Proceedings of the ACL-IJCNLP 2009 Software Demonstrations, pp. 9–12. Association for Computational Linguistics (2009)
14. Elson, D.K.: Detecting story analogies from annotations of time, action and agency. In: Proceedings of the LREC 2012 Workshop on Computational Models of Narrative, Istanbul, Turkey (2012)
15. Mairesse, F., Walker, M.A.: Controlling user perceptions of linguistic style: Trainable generation of personality traits. Computational Linguistics (2011)
16. Bouayad-Agha, N., Scott, D., Power, R.: Integrating content and style in documents: a case study of patient information leaflets. Information Design Journal 9, 161–176 (2000)
17. Kipper, K., Korhonen, A., Ryant, N., Palmer, M.: Extensive classifications of english verbs. In: Proceedings of the Third International Conference on Language Resources and Evaluation (2006)
18. Fellbaum, C.: WordNet: An Electronic Lexical Database. MIT Press (1998)

19. Lavoie, B., Rambow, O.: A fast and portable realizer for text generation systems. In: Proceedings of the Third Conference on Applied Natural Language Processing, ANLP 1997, pp. 265–268 (1997)

20. Papineni, K., Roukos, S., Ward, T., Zhu, W.J.: Bleu: a method for automatic evaluation of machine translation. In: Proceedings of the 40th Annual Meeting on Association for Computational Linguistics, ACL 2002, pp. 311–318. Association for Computational Linguistics, Stroudsburg (2002)

21. Elson, D.K., McKeown, K.: Tense and aspect assignment in narrative discourse. In: Proceedings of the Sixth International Conference on Natural Language Generation, INLG 2010. Citeseer (2010)

22. Wiebe, J.M.: Identifying subjective characters in narrative. In: Proceedings of the 13th Conference on Computational Linguistics, COLING 1990, vol. 2, pp. 401–406. Association for Computational Linguistics, Stroudsburg (1990)

23. Pustejovsky, J., Castao, J., Ingria, R., Saur, R., Gaizauskas, R., Setzer, A., Katz, G.: Timeml: Robust specification of event and temporal expressions in text. In: Fifth International Workshop on Computational Semantics, IWCS-5 (2003)

24. Palmer, M., Gildea, D., Kingsbury, P.: The proposition bank: An annotated corpus of semantic roles. Comput. Linguist. 31, 71–106 (2005)

Theoretical Considerations
towards Authoring Emergent Narrative

Neil Suttie[1], Sandy Louchart[1], Ruth Aylett[1], and Theodore Lim[2]

[1] School of Mathematics and Computer Sciences, Heriot-Watt University, Edinburgh,
Scotland, UK, EH14 4AS
[2] School of Engineering and Physical Sciences, Heriot-Watt University, Edinburgh,
Scotland, UK, EH14 4AS
{ns251,S.Louchart,r.s.aylett,T.Lim}@ hw.ac.uk

Abstract. Unlike linear storytelling, an Emergent Narrative only truly exists at run-time and can only be visualized retrospectively. The author is engaged in creating a hypothetical narrative space on the basis of individual character behaviors, story interventions and likely occurrences. While an Emergent Narrative approach allows for a flexible and adaptable run-time rendering of a scenario, it also causes considerable strains on the authoring process. If such a concept is to prove both tangible and produce qualitative outputs, creative writers need to be able to relate to it as a potential mode of expression. In this discussion article, we aim to explore theoretical considerations towards authoring Emergent Narrative, provide a discussion on the context surrounding the authorial process and the structure it should follow. Finally, we introduce the concept of Intelligent Narrative Feedback as a necessary core element for an efficient authoring process for EN experiences.

Keywords: Discussion Paper, Emergent Narrative, Authoring, AI, Autonomous Agents, Non-Linear storytelling.

1 Introduction

Interactive Storytelling (IS) systems are intrinsically complex dynamic mechanisms. These systems necessarily require some level of story understanding at run-time and tend to rely heavily on sophisticated Artificial Intelligence (AI) in order to inform the dramatic decisions they take. While this level of complexity is necessary if one is to dynamically manage an unfolding narrative experience, it consequently blurs the lines between dramatic and technical authoring. The authoring generally associated with low-level AI action-selection mechanisms (ASM) creates a gap between drama-oriented non-functional authoring and purely functional system-oriented authoring. This is a well-known issue faced by most that can be illustrated by the reportedly considerable development efforts for both the Façade [1] and Fearnot! [2] applications in the mid 00's. Nearly a decade on and despite significant research in IS authoring [3, 4, 5], the balance between technology and craft still represents a hurdle for most. More recently, Chris Crawford, for instance, partly attributed the failure of the

H. Koenitz et al. (Eds.): ICIDS 2013, LNCS 8230, pp. 205–216, 2013.
© Springer International Publishing Switzerland 2013

Storytron storytelling system [6] to its inability to craft a compelling scenario. It is our opinion that the generally highly-coupled nature of IS systems makes it difficult to clearly define the boundaries between the underlying technology, the authored content and the drama value resulting from the end user's act of co-creation [4, 7].

This problem is however particularly acute when authoring Emergent Narrative (EN) scenarios. The EN approach is quite particular in the sense that it is conceptually removed from articulating or sequencing narrative artefacts (e.g. events, staging, actions etc.) [8]. As a result, a narrative performance is the product of a real-time simulation rather than the orchestrated journey of a user/audience. The EN concept is primordially based on the principle that it is easier and more effective to maintain narrative coherence via goal-based character decision-making (autonomous agents) than to rely on an extensive set of specifically written rules [9]. The point being that as a scenario grows in complexity (number of characters, locations, etc.) the rules set necessary to maintain narrative coherence disproportionally grows as it is conditioned by an exponential number of distinct narrative possibilities. In essence, the EN concept circumvents the issue by lowering context-based decisions to the character level, thus dissociating narrative potential outcomes and contextualized information. In this context, a character is limited to make decisions based on action availability, a condition determined by both the context of the story environment and goal activation. In essence, a character cannot, in any case, carry out a decision that is contrary to the current narrative setting or its role/personality goals.

While theoretically sound, it is however practically very difficult to develop a scenario for an EN experience. For instance, the complexity issue discussed thus far tends to be exacerbated by the fact that character authoring is generally done at a very low operational level and requires the author to fully understand the inner workings of complex agent goal structures [4, 10]. Furthermore, it is also difficult to manage EN authoring due to the relative dissociated structure of the narrative space. An EN scenario consists of character agents, story events, personalities, goals and actions. These are all developed independently from one another and do not form a whole until a simulation is run. Thus, the benefits gained from simulating autonomous and independent narrative components at run-time are counter-balanced by a distinct lack of visibility and usability at authoring time. The hypothetical and dynamic nature of the narrative space also requires a radical re-think of the authoring paradigm as authoring EN focuses on the development of a set of individual narrative components written so that their hypothetical synergies contribute towards a specific narrative experience. This represents a very different proposition than the traditionally accepted definitions of narrative authoring processes.

In this article, we propose to discuss the conceptual boundaries to authoring EN with a view to develop a process model through which it can be done more intuitively. In section 2, we first discuss, in-depth, the conceptual roadblocks impeding an effective authoring process for EN artefacts and make the case for an Intelligent Narrative Feedback (INF) mechanism (Section 3). Finally, in section 4, we outline the dimensions for such a mechanism, propose a conceptual model and investigate the practical considerations towards its development.

2 Conceptual Considerations towards Authoring Emergent Narrative

Previous work in the field have provided us with relevant considerations, classifications and requirements for IS systems. Spierling and Szilas [4] approached IS from a structural perspective and proposed for its artefacts to be considered as two separate components (story world and runtime engine) which, once combined to user interaction form the complete IS experience. Thus identifying the story world authoring as the prime authorial effort. Madler and Magerko [11] decomposed the authoring process and identified six necessary requirements, in addition to content creation, that a good authoring tool should possess:

- *Generality*-The authoring process should (as much as possible) be independent of the story world representation and of the runtime implementation.
- *Debugging*-As IS systems increase both in size and complexity, we can expect an increase in possible problems in both the content and system behavior. Poor design or a lack of understanding of the runtime engine can result in unexpected agent behavior, redundancy in the storyline, dead-ends, and poor pacing or timing.
- *Usability*- The tool should in fact make the process of authoring stories easier. This includes issues surrounding learning curves, efficiency and stability.
- *Environment*- Stories are written for different interactive environments that differ in narrative structure, mechanics and user interaction paradigms.
- *Pacing and Timing*- Pacing and timing are crucial components of any story. They help to structure the narrative and bring dramatic considerations to the narrative. The tool should allow the author to define considerations to this end.
- *Scope*- IS story worlds consist of many elements (characters, dialogue, plans, etc.). The authoring tool should preferably cover all these elements.

Swartjes and Theune, still with authoring in mind, proposed an iterative authoring approach based on co-creation [12] in which a rough version of the story world (representative of the author's intent) is first created and then further refined through successive iterative cycles. Similarly, Kriegel and Aylett investigated co-creation through crowd sourcing as a method for IS content generation [13]. Finally Pizza and Cavazza [7], focused on the purpose of authoring tools and proposed to classify them along two dimensions: *Visibility* and *Generativity*. They determined, that current authoring tools favour one property over the other, while, ideally an authoring tool should grant access to both the generative power of its representation and visibility of long-term dependencies between actions to carried out during planning operations.

While all relevant to this discussion, a number of these considerations, namely: debugging, visibility, generality and pacing are particularly problematic when discussed in the context of the EN concept.

2.1 Dissociated Authoring

As previously mentioned (see section 1), the EN concept is primordially a bottom-up approach to IS and this is reflected in the way scenarios are created and authored. It is thus necessary to author characters based on their role within the scenario rather than the role they play from a narrative perspective. There is a subtle difference but it means that actions/decisions should not be forced on characters but that dramatic situations must be engineered in order for these to happen in-line with a character's own set of emotions and motivations [9]. This aspect particularly blurs the boundaries between the realities of bottom up authoring and our nurtured experience of top down authoring. The risk being that if one does not willingly refrains from doing so, EN authoring could amount to something akin to scripting. This is a difficult issue to content with and while its root cause resides in the hypothetical nature of EN (see section 3.2), authoring complex interdependencies is not an exercise that comes natural to most. The current authoring process for character-based IS such as the EN concept primarily consists of authoring narrative components (e.g. characters, agents, goals, story events, and user interventions) independently from one another while still keeping track of their potential interactions and interdependencies. For instance, if one is to author a specific action for a character, it is essential to take into consideration and input its impact on other characters or potential significance for the overall narrative (for drama-management purposes) [14, 15]. In the context of the authoring process, these inputs need to be incorporated to the task of creating an action as otherwise, the set of interdependencies would grow to the point where it would be very difficult to consider them all retrospectively. This approach is diametrically opposed to the common authorial paradigm of creating direct causal relationships between narrative elements towards a determined set of narrative structures. In the case of emergent narrative, narrative elements, while carrying emotional values, are not created with direct causal relationships in mind (just their emotional impact for others) and cannot be referred towards pre-determined narrative constructs.

Practically, EN authoring is essentially dissociated from its potential outcome, a direct consequence of the conceptual decision to adopt a bottom-up approach to narrative unfolding. This, in turn, raises the issue of authoring hypothetical narrative structures where causal relationships are determined by indirect factors (such as emotional impact [14]) rather than a direct and more predicable mechanism. The current authoring process is akin to the way in which expert systems perform knowledge elicitation tasks and offers no direct or indirect feedback as to how a scenario development could relate to potential narrative artefacts. Feedback, at this stage can only be gathered through simulating the environment and observation.

Our position is that the lack of qualitative feedback between authoring narrative elements and potential outcomes (i.e. visibility of long term dependencies [7, 16] does not allow, even at a hypothetical level, to visualize the narrative space being created. While conceptually bound to a dissociated form of authoring, it is essential for the author to still gather information regarding the likelihood of character goals being fulfilled or the potential levels of emergent storylines (see section 3.2) potentially

generated by the system. Furthermore, it does not provide feedback as to the emotional context in which character actions are or are not being triggered. Going back to the points made earlier by Pizza, and Cavazza [7], Madler and Magerko [11], it is clear the there are very limited visibility for the author in the context of the EN.

We have determined, in this section that authorial feedback, in the specific case of EN, should relate, in order to be effective, on 1) Providing the author with a clear representation of the narrative space (depicting interdependencies) at story-world level and 2) Providing the author with a good understanding of the narrative unfolding at run-time from the perspective of the characters' internal motivations and decision making. Thus practically exploiting the conceptual nature of bottom-up narrative unfolding in order to inform authorial decision-making, thus aligning with the iterative approaches proposed by Swartjes et al. [12] and Koenitz [17].

2.2 Hypothetical Narrative Space

We have in the previous section touched upon the common issue of visualizing interdependencies at authoring time. In this section, we focus our attention to the hypothetical nature of EN at run-time and the discrepancies between authored and simulated narrative spaces.

As previously stated, an EN story only truly exist at run-time and can only be visualized retrospectively. By this, we mean that the diversity or depth of the narrative space created by the author is not necessarily representative of the realities of run-time simulations. It is often the case, when authoring EN, that certain character actions or decisions consistently precede others and thus prevent other potential dramatic actions to ever take place. While in-line with the conceptual approach of the EN concept, we argue that this specific issue sums up perfectly the intricacies of authoring EN scenario. Practically, this means that the author would have to revise his/her initial emotional mapping of actions and interdependencies in order to ensure that the narrative space's diversity is actually represented/possible at run-time. This again blurs the boundaries between story world authoring and the system's execution of the authorial intent and points us back to our discussion in the previous section on the important difference between direct, traceable causal interdependencies and indirect causality. The two main practical consequences to this are that 1) Feedback has to be based on run-time simulations and is, in its current form, an approximate in that it does not represent the whole narrative space spectrum (just what happens in a specific simulation) and 2) There are no built-in mechanisms preventing individual actions to have unforeseen consequences and lead to potential dead ends. Both of these issues are key to efficiently represent (visually) the narrative space at both story world level and run-time. The EN approach makes this task a little bit more difficult by conceptually advocating for the author to exercise less authorial control at run-time than most other IS approaches. Thus effectively dissociating authorial and run-time responsibilities.

There are no current solutions to this problem, although Weallans et al. [15] implemented a drama management solution in which EN characters would co-ordinate their decision-making with regards to a pre-determined user-character

emotional trajectory. This, in effect, allowed the author to gain visibility as to whether or not a scenario would support a specific experience and to exercise some level of authorial control at run-time. It does not, however, provide any level of visibility as to how much of the narrative space is represented nor does it give a clear analysis of what actions should be taken in order to 1) Fully exploit the narrative space and 2) Optimize the way in which an emotional trajectory (akin to authorial intent) could be achieved. The EN concept blurs the lines between the role of author, system and user and it becomes clear that some mechanism must be engineered in order to better relate story world authoring to run-time execution. We argue, in this article, that the search for an intuitive authoring mechanism for EN must exercise some level of narrative intelligence if it is to succeed. The process of authoring EN must allow the author to draw clear conclusions from run-time simulations as to the state of the narrative space, the emergence spectrum it offers and the root causes of limitations and dead ends within a scenario. We propose to develop a model for INF in which both story world and run-time interdependencies are represented and guidance is provided with regards to specific user-character experiences and narrative specificities (e.g. genre, timing and form).

3 Towards an Effective Authorial Feedback System

In this section we propose a feedback classification, consisting of several feedback mechanisms (operating on increasing levels of abstraction) and discuss the existing conceptual issues that must be addressed if we are to provide authors with an effective authorial feedback system towards designing EN scenarios. Finally, we address the need for Intelligent Narrative Feedback as a mean of not only designing meaningful stories but as an effective mechanism towards expressing specific authorial intent.

We have previously determined (section 2.1), that authorial feedback, in order to be effective, must provide the author with a clear representation of the narrative space (i.e. depicting interdependencies) at story-world level and an understanding of the potential narrative at run-time from the perspective of the characters' actions and motivations. Within EN, the narrative space is often compared to a surface or landscape across which the user may traverse. The user's journey through the narrative landscape is determined by their interactions with characters and the environment, with their decisions determining the path they take. The highly conceptual nature of this process proves problematic for authors who are accustomed to designing narratives in linear progressions of events structured via plots, acts and scenes.

3.1 System Feedback

EN systems are highly complex software artefacts. They include characters equipped with sophisticated Artificial Intelligence algorithms, dynamic story world representations, and high level Drama Management concerns. System level feedback should serve to increase the usability of the authoring tool, while distancing the author from the specific runtime implementation. EN Scenarios may exist as a product of

several distinct configuration files (such as XML documents) for characters, goal libraries, world information and dialogue. While, an authoring tool may serve to abstract the technical complexity of authoring through graphical representation, the remaining complexity may still lead to authoring activities that allow for the input of erroneous content. We must therefore, include efficient debug mechanisms so as to ensure conformity to syntax, correctness and completeness of representation. This is the lowest form of feedback and should be performed at the point of authoring prior to simulating aspects of the narrative environment in order to prevent erroneous results or runtime errors.

3.2 Structural Feedback

While the EN approach to IS allows for a greater number of stories and thus, a greater variety in the narrative structure, it is unlikely for any singular path to result in a dramatically interesting narrative. We must therefore structure our scenario description in such a manner as to maximize its potential to produce both meaningful and believable narratives. Many IS develop narrative structures from a modular perspective based on pre-defined narrative components. The user advances through the narrative in stages of interaction. These stages may be represented by events, scenes actions or sequences of actions [1, 18]. Completing an event or sequence of events allows the story to progress to the next stage. Each possibility must be pre-defined, with respect to the stages that both precede and follow it. These approaches can require an enormous amount of pre-definition for even the simplest scenario [1]. However, while lacking in generative capability such methods do allow us as authors, to visualize any one of the many paths through the narrative spaces prior to runtime with simple plot-graph representation. [18].

The EN concept, on the other hand, is conceptually removed from pre-defining sequences of narrative artefacts. The resultant narrative structure is the product of a real-time simulation as opposed to a pre-defined set of stages through which the player may navigate. Thus, we are presented with a number of authorial challenges which prevent the author from knowing, with any degree of certainty, the likely sequencing of events.

As with any emergent system, a critical mass of content is required before emergent properties can arise. Thus, in terms of EN, it is expected for the author to develop a certain level of narrative content before interesting narratives start to emerge from the scenario design. It is therefore important to determine a way to assess the narrative potential of an EN story-world at authoring time as a matter of feedback. This 'emergent potential' should be measured not only in quantity but also in density (i.e. how well the content serves to promote different paths through the narrative space) [10]. Structural feedback should thus determine when a particular EN scenario reaches the required critical mass for an EN and whether each particular addition (e.g. character, action, goal, etc.) widens or reduces the boundaries of the narrative landscape.

Furthermore, It is possible to author an EN such that a number of dead-ends exist, that is, that the narrative reaches a point where no more story development is possible. These generally result from a lack of content e.g. a character with a goal whose

preconditions for activation can never be achieved. However, achieving 'emergence potential' does not guarantee a lack of dead ends or that the EN has the potential to tell the story the author desires. Thus, we conclude that the main functions of structural based feedback should be to detect dead-ends, measure 'emergence potential, and ensure that complete narrative structures can arise from the hypothetical narrative space.

3.3 Experiential Feedback

While each possible path across the narrative landscape may represents a unique story, they do not necessarily represent a unique experience. Weallans et al. [15] approach to Distributed Drama Management (DDM) allows EN characters to co-ordinate their decision-making with regards to a pre-determined user-character emotional trajectory. While, this allows the author to gain visibility as to whether or not a scenario maps out for a specific experience, this approach, however, is still reliant of the intuition of the author to craft a narrative landscape which has at least the potential for his/her envisioned path to be realized. In other words, the author must have prior experience regarding how the scenario should be structured in order to target a desired emotional trajectory.

Furthermore, even when a correct trajectory has been designed we cannot guarantee it will prove successful under end-user conditions. Every user is different in terms of age, gender, preference and experience. Thus, while two user may take the same path across the landscape they may have widely different emotional experiences. It is necessary when simulating a virtual user for the user character to make different choices so as to explore the wealth of options for the player and explore the potential paths through the narrative space.

Finally, while emotional trajectories allow us to target specific emotional journeys they again do not take into consideration the wider narrative experience and it is thus possible that widely different stories share the same emotional trajectories.

3.4 Towards Intelligent Narrative Feedback (INF)

An EN scenario is a complex dynamic representation, as it grows in complexity (number of characters, locations, etc.) it quickly becomes too difficult, if not, impossible for authors to visualize the hypothetical narrative space, determine the inherent dramatic potential, and then produce a compelling end-user experience. As a result, generated scenarios rarely conform to the author's initial intentions. In order to target specifics experiences and realize authorial intent the hypothetical narrative space should be represented to authors and support the provision of informed recommendations or interventions.

However, while a great deal of research has been conducted towards narratives and dramatic structures [1, 18], we lack a deeper understanding of how to structure meta-narratives towards different types of end-user experience. We argue, however, that role play practitioners already exercise this level of narrative intelligence [20] in the design and implementation of Pen and Paper (PnP) and live action role playing games (LARP). Storytelling in pen and paper (PnP) and larps shares many aspects with the

"Emergent Narrative" hypothesis [9, 19]. In particular, both approaches can be expanded upon by inviting the prospect of a drama manager; either in form a human storyteller or digital drama management system. Role-play, as with EN, comprises of narrative functions to be distributed between actors in order to drive the story and incorporate them in meaningful actions. Both forms of storytelling, therefore result in an experience that is at the same time unique, yet difficult to manage, structure or enforce. One participant in particular, the Game Master (GM) designs, structures and manages the overall plot of the games story [19]. They are required to interpret player actions, anticipating and compensating for those action which may skew or disrupt the plot. PnP role-play can last for days, years or even decades. The GM is therefore, tasked not with simply designing plots but an open-ended experience dynamically adapted for participating players. We argue, that they are actively involved in managing a hypothetical narrative space in real-time and maintaining an unfolding experience towards their intended experience.

It is likely therefore, that existing PnP role playing games form pure examples of EN systems and that their design and specifically, how games masters handle character interactions in real-time may inspire the design of more capable INF mechanisms.

4 Proposed Model for Narrative Feedback

Having examined the theoretical considerations towards authoring EN, we have discussed the need for the treatment of EN as an ongoing process as opposed to that of complete authored artefact (Section 2), and finally, we have proposed the concept of INF as a potential solution to current EN authorial problems (Section 3). The EN concept is essentially one of simulation. Thus, we propose to leverage this characteristic through a continuous run-time simulation of the story world, and provide real-time feedback throughout the authorial process. With this simulative approach we can provide the author with informed authorial feedback at the time of writing and enable the construction of a compelling experience.

However, the question remains as to what role the Intelligent Feedback should play within the authorial process. In this section, we present a model for narrative feedback based on the authorial process for EN. We also further discuss the boundaries of narrative feedback and the functions of INF within an iterative approach to EN authoring.

The pre-authoring stage (Fig. 1) is where the author outlines the goals and requirements of the narrative that will ultimately influence the decisions made by the INF mechanism. This may include elements such as the type of experience being targeted (i.e. educational role-play), the time over which the experience is to last, aims of the experiences and settings for expected audience preference or prior experience. This information allows us to generate a generic template from which the author can begin constructing the individual characters and events that will define their specific scenario. The authoring stage (Fig. 1) is where the author further defines his/her scenario in terms of the characters and individual story components. Authoring

individual characters for EN involves defining characters personalities, behaviours through goals and actions, as well as emotional and reactionary tendencies to specific actions and events. This process aims towards the design of low level character actions in terms of pre-conditions, post-conditions and tendencies.

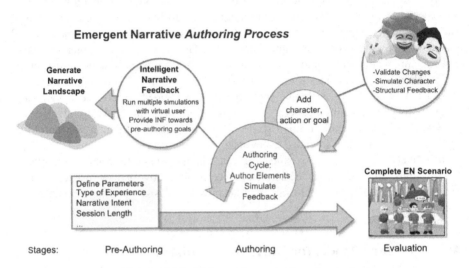

Fig. 1. Proposed Feedback Model for an Emergent Narrative Authoring process

As the author builds up the scenario, each addition is validated against the system requirements of the current run-time environment in terms of validity and completeness, with respect to the constraints (i.e. XML Schemas) of the targeted run-time engine. This system level feedback serves to further abstract the author from the specific run-time environment and inform towards structural errors in the story worlds data representation. Furthermore, through continual character simulation at this authorial level stage we aim to address the structural concerns of redundancy, dead-ends and emergence potential (Section 3.2). By examining, actions or goals as they are added, structural feedback can inform the user whether the conditions for goals activation are satisfied and prompt the user to author appropriate actions. While, validating the ability to meet the criteria for goal activation can be seen as strictly system level activity, it is the problem that some goals can be met, yet do not elicit enough emotional reaction to elicit further responses and the story stalls. Thus, it is necessary that simulation be carried out to further verify the structural completeness.

Finally, in order to address the desire for emergence potential, as each element is added we must provide the user with data regarding their likely effect on the narrative structure. For example, if an action replicates the effects of a pre-existing authored actions but fails to expand the boundaries of the narrative space, leading to further possible states it can be considered redundant and the author may wish to have it removed.

The role of the Intelligent Feedback mechanism is twofold 1) To expose the hypothetical narrative space to the author and 2) Provide recommendations towards the realization of the the pre-process description. As the author constructs the scenario it falls on the INF mechanism to make informed suggestions based on these

meta-structural considerations. Again, at this evaluation stage (Fig. 1) we provide further simulation of EN scenario being constructed by the author. However, while at the authoring stage we simulate with respect to individual characters, we now simulate the scenario with respect to a virtual user. As each user is potentially unique, in both their initial emotional state and reactions to story events, we are required to run multiple simulations for a variety of users. This allows us to explore the wealth of options for the player and get an idea of the possibilities present within the hypothetical narrative space. The author can now view the space in terms of long-term dependencies and the narrative trajectories that exist between characters and with regard to the virtual user. As the user interacts with the narrative representation, it falls on the INF to provide informed feedback towards their intended end-user experience. INF serves to determine when characters goals and actions work towards achieving the authorial intent, what these actions may be and where they should be placed to further refine the narrative experience.

5 Conclusion

In this discussion paper, we investigated the theoretical context surrounding the EN concept in order to develop a better understanding of the issues related to the authorial process and proposed, we believe, an appropriate authorial process. In doing so, we explored the theoretical considerations such as narrative visualization, structural representation and experiential design. We proposed the importance for the existence of efficient feedback mechanisms within the authorial process. Finally, we positioned the concept of INF mechanisms as key element towards meaningful authoring of EN scenarios and presented a model for its implementation.

We have touched upon the similarities between the authorial activities performed by a Games Master during traditional role-playing games and the goals of INF. We greatly suspect that by studying the techniques employed by GMs in traditional role-playing games, we can identify techniques and strategies employed at both the authorial stage and during run-time that can be adapted to serve our INF mechanisms.

While a number of questions remain towards the application of efficient INF, we have established research avenues that may provide those answers and contribute to the advancement of EN, specifically towards the authorial process. In this article we aimed to position our research so as to establish the basis and potential for INF, towards authoring meaningful EN scenarios with consideration towards specific authorial intentions. We aim, with future research to paint a clearer theoretical and practical picture of INF and how it can be translated into applications for entertainment or education.

Acknowledgments. This project is partially funded under the EPSRC grant RIDERS EP/I032037/1.

References

1. Mateas, M., Stern, A.: Façade: An Experiment in Building a Fully-Realized Interactive Drama. In: Game Developers Conference, Game Design Track (2003)

2. Aylett, R.S., Louchart, S., Dias, J., Paiva, A.C.R., Vala, M.: FearNot! - An Experiment in Emergent Narrative. In: Panayiotopoulos, T., Gratch, J., Aylett, R.S., Ballin, D., Olivier, P., Rist, T. (eds.) IVA 2005. LNCS (LNAI), vol. 3661, pp. 305–316. Springer, Heidelberg (2005)

3. Koenitz, H.: Extensible Tools for Practical Experiments in IDN: The Advanced Stories Authoring and Presentation System. In: Si, M., Thue, D., André, E., Lester, J., Tanenbaum, T.J., Zammitto, V. (eds.) ICIDS 2011. LNCS, vol. 7069, pp. 79–84. Springer, Heidelberg (2011)

4. Spierling, U., Szilas, N.: Authoring Issues beyond Tools. In: Iurgel, I.A., Zagalo, N., Petta, P. (eds.) ICIDS 2009. LNCS, vol. 5915, pp. 50–61. Springer, Heidelberg (2009)

5. Kriegel, M., Aylett, R.: Crowd-sourced AI authoring with ENIGMA. In: Aylett, R., Lim, M.Y., Louchart, S., Petta, P., Riedl, M. (eds.) ICIDS 2010. LNCS, vol. 6432, pp. 275–278. Springer, Heidelberg (2010)

6. Crawford, C.: Storytron website, http://www.stroytron.com/ (last accessed May 1, 2013)

7. Pizzi, D., Cavazza, M.: From Debugging to Authoring: Adapting Productivity Tools to Narrative Content Descriptions. In: Spierling, U., Szilas, N. (eds.) ICIDS 2008. LNCS, vol. 5334, pp. 285–296. Springer, Heidelberg (2008)

8. Aylett, R.: Emergent Narrative, Social Immersion and "Storification". In: Procs. Narrative Interaction for Learning Environments (NILE 2000), Edinburgh, UK (2000)

9. Louchart, S., Aylett, R., Tychsen, A., Hitchens, M., Figueirdo, R.: Managing Emergent Character-Based Narrative. In: The Second International Conference on Intelligent Technologies for Interactive Entertainment (ICST INTETAIN 2008) (2008)

10. Louchart, S., Swartjes, I., Kriegel, M., Aylett, R.: Purposeful Authoring for Emergent Narrative. In: Spierling, U., Szilas, N. (eds.) ICIDS 2008. LNCS, vol. 5334, pp. 273–284. Springer, Heidelberg (2008)

11. Medler, B., Magerko, B.: Scribe: A Tool for Authoring Event Driven Interactive Drama. In: Göbel, S., Malkewitz, R., Iurgel, I. (eds.) TIDSE 2006. LNCS, vol. 4326, pp. 139–150. Springer, Heidelberg (2006)

12. Swartjes, I., Theune, M.: Iterative Authoring Using Story Generation Feedback: Debugging or Co-creation? In: Iurgel, I.A., Zagalo, N., Petta, P. (eds.) ICIDS 2009. LNCS, vol. 5915, pp. 62–73. Springer, Heidelberg (2009)

13. Kriegel, M., Aylett, R., Dias, J., Paiva, A.: An Authoring Tool for an Emergent Narrative Storytelling System. AAAI Fall Symposium on Intelligent Narrative Technologies. Technical Report FS-07-05, pp. 55–62. AAAI Press, Arlington (2007)

14. Louchart, S., Aylett, R., Dias, J.: Double Appraisal for Synthetic Characters. In: Pelachaud, C., Martin, J.-C., André, E., Chollet, G., Karpouzis, K., Pelé, D. (eds.) IVA 2007. LNCS (LNAI), vol. 4722, pp. 393–394. Springer, Heidelberg (2007)

15. Weallans, A., Louchart, S., Aylett, R.: Distributed Drama Management: Beyond Double Appraisal in Emergent Narrative. In: Oyarzun, D., Peinado, F., Young, R.M., Elizalde, A., Méndez, G. (eds.) ICIDS 2012. LNCS, vol. 7648, pp. 132–143. Springer, Heidelberg (2012)

16. Spierling, U., Weiß, S.A., Müller, W.: Towards Accessible Authoring Tools for Interactive Storytelling. In: Göbel, S., Malkewitz, R., Iurgel, I. (eds.) TIDSE 2006. LNCS, vol. 4326, pp. 169–180. Springer, Heidelberg (2006)

17. Koenitz, H.: An Iterative Approach towards Interactive Narrative–Early Results with the Advanced Stories Authoring and Presentation System. Paper for KMEL 2011: The 1st International Symposium on Knowledge Management and E-Learning (2011)

18. Arinbjarnar, M., Barber, H., Kudenko, D.: A critical review of interactive drama systems. In: AISB 2009 Symposium. AI & Games, Edinburgh (2009)

19. Tychsen, A., Hitchens, M., Brolund, T., Kavakli, M.: The Game Master. In: Proceedings of the Second Australasian Conference on Interactive Entertainment, pp. 215–222 (2005)

20. Mateas, M., Sengers, P.: Narrative Intelligence. AAAI (1998)

Generating Stories with Morals

Margaret Sarlej and Malcolm Ryan

School of Computer Science and Engineering
University of New South Wales
Sydney, NSW, Australia
{msarlej,malcolmr}@cse.unsw.edu.au

Abstract. Morals play an important role in why storytelling developed, and help provide stories with structure. We describe a storytelling system which generates short stories that convey one of six common morals identified in Aesop's fables. Morals are represented in terms of patterns of character emotions that arise during the course of a story. To evaluate the system's effectiveness, we compare system-generated stories with human-authored stories and random event sequences. We find system-generated stories convey morals significantly better than random.

Keywords: morals, emotion, storytelling, occ theory.

1 Introduction

Storytelling has long been an integral aspect of human culture, particularly as a mechanism for education and conveying important information [1]. To achieve this, most traditional stories and fables were imbued with a message or lesson: the story's moral. This aspect of storytelling can be leveraged by storytelling systems as a framework for story structure, paving the way for interactive stories which adapt to convey appropriate morals based on readers' choices. Such systems could have a significant impact in education, particularly for children. Here we take the first steps towards this goal, by building a storytelling system that generates stories with morals. To achieve this we need to represent morals. Dyer's Thematic Abstraction Units (TAUs) [2] were developed for concepts similar to morals, but have quite a complex structure. We seek a representation using simpler constructs, and propose the use of sequences of character emotions.

2 Related Work

There has been considerable work in applying emotions to storytelling systems. However, this has mostly been for developing character agents [3–5] rather than the structure or plot of a story. A notable exception is *Mexica* [6], which uses emotional links and tensions between characters for plot construction, but it draws on only two emotions. A relationship between emotions and morals has similarly been proposed in existing work [7, 8], but again the focus was on agent design. In our work we use a broad range of emotions for planning story trajectories, rather than governing agent behaviour.

H. Koenitz et al. (Eds.): ICIDS 2013, LNCS 8230, pp. 217–222, 2013.

3 Moral Storytelling System (MOSS)

Even very simple stories require modelling three elements: action, character and plot [9]. The Moral Storytelling System (MOSS) consists of three layers: Action, Emotion and Moral, which correspond to action, character and plot respectively. It was built using Answer Set Programming (ASP) [10], with each layer implemented declaratively as a logic program. We used the Potassco suite of Answer Set solving tools [11] to generate solutions. A Perl script converts the output into a text description of the events, their outcomes and characters' emotions.

3.1 Action Layer

The Action Layer models the physical aspects of the story world. This includes characters, properties of the world (fluents), available actions, their effects, and any restrictions on when actions can be performed, all encoded as ASP rules and constraints. We distinguish between *fluents* (properties of the world that can be true or false) and *consequences* (outcomes of actions, corresponding to changes in value of fluents). To demonstrate that our moral rules can be applied across multiple domains we implemented three distinctly different story worlds.

3.2 Emotion Layer

Of the many emotion theories proposed over the years [12–15] we chose to base our work on the OCC theory [16], which was designed with computational modelling in mind. Table 1 lists the OCC emotions and their definitions in MOSS. Our implementation is largely based on Adam, Herzig and Longin's logical formalisation [17], thus we use their terminology to present our definitions:

- $Bel_i(c)$: Agent i believes consequence c is currently true.
- $Expect_i(c)$: Agent i considers consequence c to be probable and does not believe it is currently true.
- $Des_i(c)$: Agent i considers consequence c to be desirable.
- $Idl_i(a)$: Agent i considers action a to be ideal.

Adam, Herzig and Longin exlcude Love and Hate, which are used in the OCC theory to define other emotions; our definitions are more faithful to the original OCC descriptions in this regard. To keep our belief model simple, characters' desires and ideals do not change as a story progresses, and we assume omniscience.

3.3 Moral Layer

Many morals of varying complexity appear in stories. The morals we investigate are derived from Aesop's fables [18], which we categorised by moral in previous work [19]. In this study we deal with 6 morals: Retribution, Greed, Pride, Realistic Expectations, Recklessness and Reward. We developed rules for each moral in terms of the OCC emotions based on an analysis of the relevant fables. Figure 1 shows the rules for each moral. The time-points are not necessarily consecutive, but in general T1 < T2 < T3. For agent-based emotions, if no target agent is specified the emotion can be felt towards any agent in the story.

Table 1. The OCC emotions and how they are defined in MOSS

Emotion	Type	MOSS Definition
$Joy_i(c)$	Event-based	$Des_i(c)$ and $Bel_i(c)$
$Distress_i(c)$	Event-based	$Des_i(\neg c)$ and $Bel_i(c)$
$Hope_i(c)$	Event-based	$Des_i(c)$ and $Expect_i(c)$
$Fear_i(c)$	Event-based	$Des_i(\neg c)$ and $Expect_i(c)$
$Satisfaction_i(c)$	Event-based	$Joy_i(c)$ and previously $Expect_i(c)$
$FearsConfirmed_i(c)$	Event-based	$Distress_i(c)$ and previously $Expect_i(c)$
$Disappointment_i(c)$	Event-based	$Distress_i(c)$ and previously $Expect_i(\neg c)$
$Relief_i(c)$	Event-based	$Joy_i(c)$ and previously $Expect_i(\neg c)$
$HappyFor_{i,j}(c)$	Event-based	$Bel_i(c)$ and $Bel_i(Des_j(c))$ and $Love_i(j)$
$Pity_{i,j}(c)$	Event-based	$Bel_i(c)$ and $Bel_i(Des_j(\neg c))$ and $\neg Hate_i(j)$
$Resentment_{i,j}(c)$	Event-based	$Bel_i(c)$ and $Bel_i(Des_j(c))$ and $Hate_i(j)$
$Gloating_{i,j}(c)$	Event-based	$Bel_i(c)$ and $Bel_i(Des_j(\neg c))$ and $Hate_i(j)$
$Admiration_{i,j}(a)$	Agent-based	$Idl_i(a)$ and j successfully performs a
$Reproach_{i,j}(a)$	Agent-based	$Idl_i(\neg a)$ and j performs or attempts a
$Pride_i(a)$	Agent-based	$Idl_i(a)$ and i successfully performs a
$Shame_i(a)$	Agent-based	$Idl_i(\neg a)$ and i performs or attempts a
$Love_i(j)$	Object-based	$Admiration_{i,j}(a)$
$Hate_i(j)$	Object-based	$Reproach_{i,j}(a)$
$Gratification_i(a,c)$	Compound	$Pride_i(a)$ and $Joy_i(c)$
$Remorse_i(a,c)$	Compound	$Shame_i(a)$ and $Distress_i(c)$
$Gratitude_{i,j}(a,c)$	Compound	$Admiration_{i,j}(a)$ and $Joy_i(c)$
$Anger_{i,j}(a,c)$	Compound	$Reproach_{i,j}(a)$ and $Distress_i(c)$

4 Evaluation

We conducted a survey asking participants to read MOSS stories, decide whether
each has a moral, and if so select that moral from a list. The proportion of stories
classified correctly provides a measure of system performance. The difficulty is
story interpretation is extremely subjective. Even human-authored stories would
not be expected to score perfectly, but can be considered an upper threshold.
Thus our survey incorporates three story types: MOSS stories, human-authored
stories, and event sequences without any of the emotion patterns corresponding
to MOSS morals (we call these *random*). Authors of the human stories were
instructed to work within the MOSS domains, to ensure a consistent scope for
all stories, and the MOSS text generation script was used to produce the text, so
our results reflect the quality of the story plans rather than the text generation.
We randomly selected 210 stories spread across the domains, story types and
morals; each participant was shown 9 with the option of responding to more.
We expected human-authored stories to perform best, but for MOSS stories to
lie closer to human story performance than random event sequences.

We collected 831 story responses from 78 participants, covering each story an
average of 4.0 times. In aggregate this yields an average of 138.5 responses per
moral. Table 2 presents the data in confusion matrices. Although performance

Time	Retribution Type 1	Retribution Type 2
T1	**anger:** Agent2 at Agent1	**anger:** Agent2 at Agent1
T2	**distress:** Agent1 **reproach:** Agent1 NOT **joy:** Agent1 **pride:** Agent1 **disappointment:** Agent1 **distress:** Agent2	**anger:** Agent1 at Agent2 NOT **anger:** Agent2

Time	Greed Type 1	Greed Type 2
T1	**satisfaction:** Agent1 (about X) **shame:** Agent1 **reproach:** Agent2 at Agent1 NOT **distress:** Agent1	**satisfaction:** Agent1 **shame:** Agent1
T2	**distress:** Agent1 (about -X) NOT **distress:** any other agent	**satisfaction:** Agent1 **shame:** Agent1
T3		**distress:** Agent1 **reproach:** Agent1 NOT **joy:** Agent1 **distress:** any other agent

Time	Pride	Realistic Expectations
T1	**pride:** Agent **joy:** Agent (about X)	NOT **joy:** Agent1 **satisfaction:** Agent
T2	**distress:** Agent (about -X) **reproach:** Agent NOT **distress:** any other agent	**disappointment:** Agent NOT **satisfaction:** Agent

Time	Recklessness Type 1	Recklessness Type 2
T1	**distress:** Agent **satisfaction:** Agent NOT **admiration:** Agent **reproach:** Agent	**fear:** Agent
T2		**fearsconfirmed:** Agent **remorse:** Agent

Time	Reward Type 1	Reward Type 2
T1	**gratitude:** Agent2 at Agent1	**gratitude:** Agent2 at Agent1
T2	**gratitude:** Agent1 at Agent2 NOT **gratitude:** Agent2	**joy:** Agent1 **admiration:** Agent1 NOT **distress:** Agent1 **shame:** Agent1 **relief:** Agent1 **joy:** Agent2

Fig. 1. Rules for morals in terms of the OCC emotions

Table 2. Confusion matrices for individual morals

HUMAN-AUTHORED STORIES (WITH MORALS)								
	Retrib	Greed	Pride	Real Exp	Reckless	Reward	NONE	RECALL
Retribution	**27**	2	0	1	4	1	11	**58.7%**
Greed	16	**19**	1	1	2	0	6	**42.2%**
Pride	12	7	**11**	0	1	1	14	**23.9%**
Real Exp	5	0	3	**6**	4	0	27	**13.3%**
Recklessness	7	2	0	12	**9**	0	16	**19.6%**
Reward	4	0	3	1	0	**26**	10	**59.1%**
PRECISION	**38.0%**	**63.3%**	**61.1%**	**28.6%**	**45.0%**	**92.9%**		
MOSS STORIES (WITH MORALS)								
	Retrib	Greed	Pride	Real Exp	Reckless	Reward	NONE	RECALL
Retribution	**24**	1	1	0	2	2	16	**52.2%**
Greed	14	**12**	0	0	0	1	21	**25.0%**
Pride	11	5	**3**	3	0	1	21	**6.8%**
Real Exp	1	3	1	**10**	1	0	33	**20.4%**
Recklessness	5	1	0	9	**9**	3	20	**19.1%**
Reward	5	2	1	0	0	**27**	13	**56.3%**
PRECISION	**40.0%**	**50.0%**	**50.0%**	**45.5%**	**75.0%**	**79.4%**		
RANDOM EVENT SEQUENCES (WITHOUT MORALS)								
	Retrib	Greed	Pride	Real Exp	Reckless	Reward	NONE	RECALL
Retribution	**1**	2	0	3	1	3	28	**2.6%**
Greed	0	**1**	1	0	2	3	33	**2.5%**
Pride	1	1	**3**	2	2	6	23	**7.9%**
Real Exp	1	4	0	**3**	1	0	26	**8.6%**
Recklessness	0	1	1	2	**1**	1	33	**2.6%**
Reward	1	1	0	1	1	**2**	32	**5.3%**
No Filter	6	2	3	3	1	3	31	
PRECISION	**10.0%**	**8.3%**	**37.5%**	**21.4%**	**11.1%**	**11.1%**		

varies between morals, in most cases the human stories had the best recall and precision, and random stories the worst. As expected, MOSS stories generally lie in between, with the exception of Pride (where they perform worse than random) and Realistic Expectations (where they perform better than human).

5 Conclusion and Future Work

The effectiveness of MOSS stories in conveying morals was comparable to human-authored stories in the given domains, particularly relative to random event sequences. The relatively poor performance of many human stories highlights both the restricted nature of the domains and the ambiguity inherent in storytelling. Although further rule refinement is required, we found emotion patterns corresponding to morals were useful for imparting structure to stories. However, there are several areas for future work. Our emotion model encompasses all the OCC

emotions, but not the associated intensity variables. Assigning a numeric valence to emotions would allow more fine-grained control over a story. Data from other collections of fables could be used to improve the moral rules. Permitting incorrect beliefs would let us investigate a broader range of morals, and with richer story domains we could explore the impact of the domain restrictions.

References

1. Ryan, K.: The Narrative and the Moral. The Clearing House 64(5), 316–319 (1991)
2. Dyer, M.G.: In-Depth Understanding: A Computer Model of Integrated Processing for Narrative Comprehension. The MIT Press, Cambridge (1983)
3. Elliott, C.: The Affective Reasoner: A process model of emotions in a multi-agent system. PhD thesis, Northwestern University (1992)
4. Theune, M., Rensen, S., op den Akker, R., Heylen, D., Nijholt, A.: Emotional Characters for Automatic Plot Creation. In: Göbel, S., Spierling, U., Hoffmann, A., Iurgel, I., Schneider, O., Dechau, J., Feix, A. (eds.) TIDSE 2004. LNCS, vol. 3105, pp. 95–100. Springer, Heidelberg (2004)
5. Marsella, S., Gratch, J.: EMA: A process model of appraisal dynamics. Cognitive Systems Research 10, 70–90 (2009)
6. Pérez y Pérez, R.: Employing emotions to drive plot generation in a computer-based storyteller. Cognitive Systems Research 8(2), 89–109 (2007)
7. Shaheed, J., Cunningham, J.: Agents making moral decisions. In: ECAI 2008 Workshop on Artificial Intelligence in Games (2008)
8. Battaglino, C., Damiano, R.: Emotional Appraisal of Moral Dilemma in Characters. In: Oyarzun, D., Peinado, F., Young, R.M., Elizalde, A., Méndez, G. (eds.) ICIDS 2012. LNCS, vol. 7648, pp. 150–161. Springer, Heidelberg (2012)
9. Ryan, M., Hannah, N., Lobb, J.: The Tale of Peter Rabbit: A Case-study in Story-sense Reasoning. In: 4th Australasian Conference on Interactive Entertainment, Melbourne, Australia. RMIT University (2007)
10. Lifschitz, V.: Answer set programming and plan generation. Artificial Intelligence 138(1-2), 39–54 (2002)
11. Gebser, M., Kaminski, R., Kaufmann, B., Ostrowski, M., Schaub, T., Schneider, M.: Potassco: The Potsdam Answer Set Solving Collection. AI Communications 24(2), 105–124 (2011)
12. Izard, C.E.: Human Emotions. Plenum Press, New York (1977)
13. Plutchik, R.: Emotion: A Phsychoevolutionary Synthesis. Harper & Row, New York (1980)
14. Russell, J.A.: A Circumplex Model of Affect. Journal of Personality and Social Psychology 39(6), 1161–1178 (1980)
15. Frijda, N.H.: The Emotions. Cambridge University Press, New York (1986)
16. Ortony, A., Clore, G.L., Collins, A.: The Cognitive Structure of Emotions. Cambridge University Press, Cambridge (1988)
17. Adam, C., Herzig, A., Longin, D.: A logical formalization of the OCC theory of emotions. Synthese 168(2), 201–248 (2009)
18. Aesop: Aesop: The Complete Fables. Penguin Classics. Penguin Books, London (1998), Translated by Temple, O.,Temple, R.; introduction by Temple, R.
19. Sarlej, M., Ryan, M.: Representing Morals in Terms of Emotion. In: 8th AAAI Conference on Artificial Intelligence and Interactive Digital Entertainment, Palo Alto, California, pp. 69–74. AAAI Press (2012)

Metrics for Character Believability
in Interactive Narrative

Paulo Gomes[1], Ana Paiva[2], Carlos Martinho[2], and Arnav Jhala[1]

[1] UC Santa Cruz, Santa Cruz,
CA, 95064, USA
[2] Instituto Superior Técnico, Technical University of Lisbon,
2744-016 Porto Salvo, Portugal

Abstract. The concept of character believability is often used in interactive narrative research hypothesis. In this paper we define believability metrics using perceived believability dimensions and discuss how they can be accessed. The proposed dimensions are: behavior coherence, change with experience, awareness, behavior understandability, personality, visual impact, predictability, social and emotional expressiveness.

Keywords: believability, metrics, emotion.

1 Introduction

In the beginning of the 19th century, the english poet Samuel Taylor Coleridge coined the term *suspension of disbelief* [3]. The term referred to the mental state in which the reader of a poetic piece could regard a supernatural, or simply romantic, character as real, regardless of characteristics out of the ordinary. When explaining his motivation for *Lyrical Ballads* [4], Coleridge expresses his desire to write in "semblance of truth" and to spur the reader's imagination, clouding what would, at first glance, and without context, be regarded as unrealistic.

Since Coelridge's *Biographia Literaria*, the term has evolved: the concept of character was generalized to a fictional situation; and the term now encompasses any art form, and not specifically poetry. One such art form is Animation, that in the 1930's saw great technical, and aesthetic progress, in the hands of Walt Disney Studio artists. Thomas and Johnston would describe the animation principles learned by these artists in the seminal *The Illusion of Life: Disney Animation* [19]. In this book, they explain how animated characters can give the illusion of being alive, of having motivations, of thinking and acting accordingly. Later on, Lasseter identified the possibility of applying the lessons of traditional animation to this new area [9].

In the nineties, computer science researchers in the field of autonomous agents began to analyze how the artistic principles of animated characters could be used to design believable agents that gave "the illusion of life". Researchers from Carnagie Mellon who were part of the OZ project made a significant thrust in this direction [2][11][13]. Loyall dissected the definition of believable agent and proposed several requirements, many of them related to models of personality [11].

H. Koenitz et al. (Eds.): ICIDS 2013, LNCS 8230, pp. 223–228, 2013.

By personality he considered "all of the particular details - especially details of behavior, thought and emotion - that together define the individual" (p. 16). Ortony [16] proposed a definition for believable agents more centered around emotion. He considered that there should be consistency in the way agents evaluate events, and how this evaluation influences their emotional state. Agent believability was also analyzed in more specific contexts, such as pedagogical agents by Lester and Stone [10]. They defined believability as the identification, from the user or spectator, of an agent's goals, beliefs and personality.

These definitions of believability provide guidelines to AI designers on how to design systems that support believable characters. For instance, the interactive drama Façade [14] combines a structured narrative with simulated autonomous agents, and uses such guidelines to shape character behavior. Specific implementations of AI systems focus on different aspects of believability. This makes it difficult to evaluate the degree to which characters developed in different AI architectures and behavior models are believable.

This paper presents initial work in defining metrics for evaluating believable virtual characters in interactive narratives. Specifically, we are interested in analyzing how an audience unfamiliar with the abstract concept of believability can provide feedback on the believability of characters whose behavior is defined by a computational system. The idea is to tap into their interpretation of the narrative discourse generated. The ultimate goal is to create metrics to help researchers assess how a computational system is contributing to the final believability of characters in interactive narratives.

There have been efforts to measure different notions of believability: in relation to expectations [12], in the context of story generation [18], connected with trustworthiness [1], for opponents in a first person shooter [8], through empathy [17]. Nonetheless, these works to not evaluate a broad notion of believability considering consistency, emotions, personality, and other elements deemed important to believability [11][16][10]. .

In this article we will identify dimensions of believability an audience can report about, describe how to use them to access overall beliveability, discuss limitations of the methodology, and propose future work.

2 Dimensions of Believability

The ultimate goal of our metrics is to measure perceived character believability. However, directly asking an audience how believable a character is can be an ambiguous question. Unless, the audience is familiar with the notion of illusion of life, the answer will probably not reflect this concept. Hence, we propose a measure that uses several believability dimensions contributing to the overall perception of believability. In this way, participants are asked about more objective aspects of the agent. Here are the believability dimensions that we consider an audience can self-report about:

- **behavior coherence** : according to Ortony [16] coherence is a crucial element of believability. An audience will see the character's behavior, and not explicitly its internal state, so they can be asked about the coherence of the first.

- **change with experience** : the agent's change is an element referenced in [11]. In the context of interactive narrative, it can be related to Mckee's idea of story event, a significant change in a life value of a character [15]. These events are essential building blocks of a classical plot arch.

- **awareness** : agents should show they perceive the world around them. This dimension can be mapped to Lester and Stone's situated liveliness [10] as well as Loyall's reactive and responsive elements [11].

- **behavior understandability** : in Ortony's definition of believability [16], it is implicit that participants must be able to create a model of an agent's behavior motivations. Furthermore, Bates [2] points out that an agent's actions must express what it is thinking about and its emotional state. For situations in which the thought process is not explicitly shown this last sentence can be translated to: the agent's actions must express what the participant thinks the character is thinking about. But for this to happen, the spectator must be able to create a model of the character's thought process. Hence, the participant must understand the character's behavior.

- **personality** : the notion of personality is present in almost all believability definitions presented. Following Loyall's definition [11], participants should be able to identify the agent's behavior details that define it as an individual, that make it unique.

- **emotional expressiveness** : the extent to which the character expresses its emotions. The concept of emotion is mentioned by Loyall [11] and Ortony [16].

- **social** : participants should be able to identify social relationships between characters [11].

- **visual impact** : is the amount by which an agent draws our attention, and was proposed by Lester and Stone as an enhancer of believability [10].

- **predictability** : Lester and Stone also point out the importance of behavior patterns not being recognizable, specially in the context of long term interactions. Moreover, when considering variability, Ortony [16] warns for the harmful effect predictability can have on believability. However, Ortony also stated that complete lack of predictability may affect behavior coherence, and consequently believability. Thus, both extreme predictability and extreme unpredictability harm believability.

By having believability measured through factors, measurements can be more informative as design feedback. For instance, if a graphic agent scores low on awareness, authors may need to create more looking/staring animations, or provide better programmatic hooks for those animations.

3 Quantifying Believability

We want to describe how to assess an audience's perception of a character's believability through dimensions. Since believability is an internal construct to each individual we believe that the most adequate strategy would be to ask the audience to self report about their perception. Likert scales are commonly used in assessing individual subjective perceptions, thus we propose to use them by having one scale per dimension (except for emotional expressiveness that we will tackle separately). We now present templates for phrases that a participant would have to rate in which the $< X >$ field would be replaced by the name of the character being analyzed. The range boundary values would be labeled as "totally agreeing" and "totally disagreeing" with the statement. Here are the templates:

- awareness: $< X >$ perceives the world around him/her.
- behavior understandability: It is easy to understand what $< X >$ is thinking about.
- personality: $< X >$ has a personality.
- visual impact: $< X >$'s behavior draws my attention.
- predictability: $< X >$'s behavior is predictable.
- behavior coherence: $< X >$'s behavior is coherent.
- change with experience: $< X >$'s behavior changes according to experience.
- social: $< X >$ interacts socially with other characters.

For emotional expressiveness we would ask participants what emotions they believe the character was mainly expressing at specific situations. That could be assessed by having a multiple choice in which each option corresponded to a basic emotion such as anger or fear [5]. In this case a higher value would correspond to a higher frequency of correctly identified emotions. By correct we mean according to what the system was trying to express. These scales were used in previous work [7] with anecdotal evidence gathered that users understood the questions.

It is our belief that enhanced perception of the believability dimensions corresponds to a greater sense of believability, with the exception of predictability. The hypothesis that a character controlling system B promotes a higher sense of believability than a system A would be supported if all the following conditions are verified:

- No dimension (excluding predictability) is significantly higher (higher agreement) in A than B.
- System B does not have predictability values significantly closer to one of the rating extremes (totally agree or totally disagree) than A.
- The overall accuracy of character emotion identification is higher than chance ($100\%/(number of expressions)$).
- At least one dimension (excluding predictability) is higher in version B than version A, or version A has a predictability value significantly closer to one of the extremes than version B.

4 Conclusion

In this paper we have argued for systematic believability metrics that support research hypotheses related to interactive narrative systems. We defined the following believability dimensions: behavior coherence, change with experience, awareness, behavior understandability, personality, visual impact, predictability, social and emotional expressiveness. We described how to measure believability using phrase templates related to these dimensions. Finally, we presented a method for using these measures to support a belivability hypothesis.

A possible critique to our metrics is that the suggested dimensions have a significant degree of ambiguity to a rating audience. Nonetheless, it should still be less ambiguous than simply asking an audience to rate characters' believability. We believe that this work would serve as a strong basis for refining the measurements of believability for direct and systematic comparison of narrative systems.

As future work, we propose to validate the presented metrics. We would present participants in an experiment with non interactive animated clips of cartoons that are considered references in believability portrayal (e.g. old Disney animations, Pixar shorts). Then, ask them to rate these cartoons according to the above mentioned dimensions. Afterwards, verify if the ratings are according to what was expected, that is, dimensions were rated as high in general apart from predictability that should have medium scale values.

In our work we have focused on a sense of the term believability connected with *observed behaviors* and less on internal representation of agents' mental model. Nonetheless, the term is used with other senses. One sense is in terms of creating a believable *mental model* of agents that is coherent and consistent with the rules of the virtual environment with respect to the agent's beliefs, desires, and intentions. Another sense is in terms of *visual believability or realism*, especially regarding graphical representation and facial expressions, and in areas like robotics with physical believability of robotics rigs. Third is in terms of *believable interactions* that take in the context of communication protocols and languages (including verbal and non-verbal forms of communication) of agents make the overall interaction with human participants more natural. We suggest that researchers clearly specify what definition of believability they are using since each one entails different research goals.

Believability is an inspiring concept that has been around in the computer science context for a while. It is time to reclaim it as a measurable factor.

Acknowledgments. This work has been supported, in part, by the FP7 ICT project SIREN (project no: 258453). We would like to thank Michael Mateas for his comments on believability metrics as a design feedback tool.

References

1. Bartneck, C.: How convincing is mr. data's smile: Affective expressions of machines. User Modeling and User-Adapted Interaction 11(4), 279–295 (2001)
2. Bates, J.: The role of emotion in believable agents. Commun. ACM 37(7), 122–125 (1994), 176803
3. Coleridge, S.T.: Biographia Literaria: Biographical Sketches of my Literary Life & Opinions. Princeton University Press (1985)
4. Coleridge, S.T.: Lyrical Ballads. Penguin Classics (2007)
5. Ekman, P.: An argument for basic emotions. Cognition & Emotion 6(3-4), 169–200 (1992)
6. Frasca, G.: Video games of the oppressed (2006)
7. Gomes, P.F., Martinho, C., Paiva, A.: I've been here before! location and appraisal in memory retrieval. In: Proceedings of the 10th International Conference on Autonomous Agents and Multiagent Systems, Taipei, Taiwan, pp. 1039–1046. IFAAMAS (2011)
8. Gorman, B., Thurau, C., Bauckhage, C., Humphrys, M.: Believability testing and bayesian imitation in interactive computer games. In: Nolfi, S., Baldassarre, G., Calabretta, R., Hallam, J.C.T., Marocco, D., Meyer, J.-A., Miglino, O., Parisi, D. (eds.) SAB 2006. LNCS (LNAI), vol. 4095, pp. 655–666. Springer, Heidelberg (2006)
9. Lasseter, J.: Principles of traditional animation applied to 3d computer animation. SIGGRAPH Comput. Graph. 21(4), 35–44 (1987)
10. Lester, J.C., Stone, B.A.: Increasing believability in animated pedagogical agents. In: Proceedings of the First International Conference on Autonomous Agents, pp. 16–21. ACM (1997)
11. Bryan Loyall, A.: Believable Agents: Building Interactive Personalities. PhD thesis, Carnegie Mellon University (1997)
12. Magerko, B.: Measuring dramatic believability. In: Intelligent Narrative Technologies, pp. 79–82 (2007)
13. Mateas, M.: An oz-centric review of interactive drama and believable agents. In: Veloso, M.M., Wooldridge, M.J. (eds.) Artificial Intelligence Today. LNCS (LNAI), vol. 1600, pp. 297–328. Springer, Heidelberg (1999)
14. Mateas, M., Stern, A.: Façade: An experiment in building a fully-realized interactive drama. In: Game Developers Conference, Game Design Track, vol. 2, p. 82 (2003)
15. McKee, R.: Story: Substance, Structure, Style, and the Principles of Screenwriting. Harper Collins Publishers (October 1997)
16. Ortony, A.: On making believable emotional agents believable. In: Emotions in Humans and Artifacts. MIT Press (2003)
17. Paiva, A., Dias, J., Sobral, D., Aylett, R., Sobreperez, P., Woods, S., Zoll, C., Hall, L.: Caring for agents and agents that care: Building empathic relations with synthetic agents. In: Proceedings of the Third International Joint Conference on Autonomous Agents and Multiagent Systems, vol. 1, pp. 194–201. IEEE Computer Society (2004)
18. Riedl, M.O., Young, R.M.: An objective character believability evaluation procedure for multi-agent story generation systems. In: Panayiotopoulos, T., Gratch, J., Aylett, R.S., Ballin, D., Olivier, P., Rist, T. (eds.) IVA 2005. LNCS (LNAI), vol. 3661, pp. 278–291. Springer, Heidelberg (2005)
19. Thomas, F., Johnston, O.: Disney Animation: The Illusion of Life. Abbeville Press, New York (1981)

Fully-Automatic Interactive Story Design from Film Scripts

Larissa Munishkina, Jennifer Parrish, and Marilyn A. Walker

Natural Language and Dialogue Systems Lab
University of California Santa Cruz, Santa Cruz, CA 95064, USA
{mlarissa,jlparrish,maw}@soe.ucsc.edu

Abstract. Game design is an expensive and time-consuming process. In this paper we explore the potential of a fully-automatic game design system that uses the scripts from famous action films to generate interactive, text-based, RPGs. We automatically extracted key information such as dialogues, characters, settings, and events from the movie scripts. For level design, we applied a TF-IDF clustering algorithm to determine which scenes could be grouped together as levels. We test a pilot game based on *The Adventures of Indiana Jones*, in which the player is presented with a series of choices in the form of abstract responses as she guides Indiana Jones to complete his mission successfully. Evaluation of our scene clustering algorithm indicates a high correlation between automatic and gold-standard clusters, while our preliminary user evaluation shows that our approach is promising.

1 Introduction

We introduce a pilot system to reduce the heavy authoring burden inherent in game design and create a novel interactive storytelling experience. Automatic Game Designer (AGD), takes a script from a famous action-adventure movie, uses natural language processing (NLP) methods to automatically generate narrative events, and then builds an interactive, text-based game around the adventures of an iconic film character, such as Indiana Jones. Our approach builds on recent advances in NLP which enable automatic extraction of narrative schema from free text, including extracting event representations, predicting causal and temporal relations between events, and resolving co-reference between characters in a story [1–4]. However, we apply these methodologies to a new domain, game design, in order to create a different type of interactive story experience, one that is machine-authored and data-driven, while adhering to the guidelines of classic narratology and game design theory [5, 6]. This paper provides evidence that our approach to automatic game design is promising.

2 The Automatic Game Designer

System Overview. Our suite of programs, which we call the AUTOMATIC GAME DESIGNER (AGD), includes a document preprocessor, scene extractor, scene

H. Koenitz et al. (Eds.): ICIDS 2013, LNCS 8230, pp. 229–232, 2013.
© Springer International Publishing Switzerland 2013

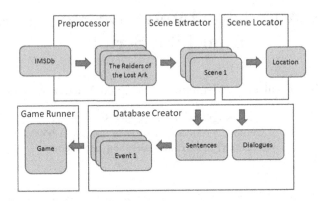

Fig. 1. General pipeline of the AUTOMATIC GAME DESIGNER

locator, database creator, and game runner. The components of our game designer correspond to the program pipeline shown in Fig. 1.

Our hypothesis is that movie scripts are a good basis for the design of interactive role-playing games because they offer rich, fully-realized personalities, who are inspirational to children and teenagers, and with whom movie lovers already have a strong connection. Moreover, movie scripts provide a useful foundation for generating game story plots, as they contain detailed information about characters, settings and actions, as well as complete dialogues. They are also written in a temporally-ordered sequence that can be easily adapted for a game story timeline. Also, movies scripts can be acquired from the Internet Movie Script Database (IMSDb[1]), a freely available online resource. To illustrate our method, we utilize the movie script *The Raiders of the Lost Ark* by George Lucas and Lawrence Kasdan, which we selected for the following reasons. First, the main hero, Indiana Jones, is a very popular movie character with people of all ages. Second, we thought that the action of the movie would make for an interesting game plot. Third, we felt that the adventure genre was most likely to provide a wide-range of scenarios that would be appealing to young players.

Scene Extraction and Clustering. The preprocessing step removes irrelevant information from the script (such as html tags, document description, and camera instructions). Then the scene extractor automatically divides the script into scenes by taking advantage of the existing text formatting. The scene locator module determines how scenes interrelate: its divides the game story into large, relatively-independent sections that correspond to different levels in the game (see Fig. 1). To find cohesiveness between scenes, we performed TF-IDF clustering using the NLP package in RapidMiner, a freely distributed data mining software package[2]. When we applied this clustering method to *The Raiders of the Lost Ark*, we found that many scenes can be grouped based on the geographic location where the events take place. We successfully identified four major sections

[1] http://www.imsdb.com/
[2] http://http://rapid-i.com//

of the story, corresponding to Peru, China, Egypt, and the Mediterranean island. These sections then became the levels of *The Adventures of Indiana Jones*.

Database Creation. The database creator takes the extracted scenes and further divides them into dialogues and event blocks that are sequentially processed into sentences, word tokens, dependency graphs, and coreferences using the Stanford CoreNLP Toolkit[3]. The Stanford CoreNLP dependency graphs provide rich information to construct deep representations of events from each sentence [7]. Nodes of the dependency graphs correspond to words that can be identified by POS tagging, whereas edges correspond to dependency relations such as subject (nsubj, xsubj, agent, nsubjpass), direct object (dobj), indirect object (iobj), etc[4]. We extracted events in the following form $predicate(\langle subject \rangle, \langle dobj \rangle, \langle iobj \rangle)$ from each clause in a sentence. The extracted events were used in the generation of abstract responses by the game runner. For example, the sentence *"Barranca yells at the fleeing Indians and pulls his pistol out"* is processed into two events *yells(Barranca, null, null)* and *pulls(Barranca, pistol, null)*. Dialogue blocks are also processed by the database creator, which extracts a speaker name, supplementary information about the speaker attitude or mood, and utterances. The extracted events, sentences, utterances, speakers, dialogue blocks, and event blocks are grouped according to scene and stored in a corresponding database file.

Game Interface. We designed a web-based interface for AGD so players can play anywhere, using any operating system or platform, without installing special software. At the beginning, players presented with the choice of playing the game as one of three famous movie characters: Indiana Jones, Harry Potter and Luke Skywalker. If the player selects Indiana Jones, the player is shown a map of important locations from the film: China, Egypt, Peru, the USA, and the Mediterranean island. Upon choosing a location, the player is brought to a new screen containing important background information about the character and the goals of the game. Pressing continue will bring her to the main interface, which is comprised of a text panel and three buttons, representing each of the three options for possible next actions. These options are presented in form of abstract response, such as talk to another character, look at something, examine some object or location, or perform some action. Once the player has selected one of the actions, it will be displayed in its full, unabbreviated form on the screen. For example, if the player selects talk to Marion, the full utterance will be written inside the text panel. Once the player has completed her ultimate mission, AGD displays an end state of game over.

AGD Evaluation. First, we evaluated the division of the movie script into sections based on geographic location by comparing to a gold standard of manually-identified scene sections (data not shown). There is a high correlation between the automatically-derived partitioning of the scenes and the actual scene sections, with t-value of 1.92 and p-value of 0.055 using Student t-test. For our

[3] http://nlp.stanford.edu/software/corenlp.shtml

[4] http://nlp.stanford.edu/software/stanford-dependencies.shtml

initial evaluation, we surveyed eight people from among the UCSC community. We asked them to play our game and provide feedback by rating the game, on a scale of 1 to 5, in response to the following three questions: "Was the game interesting?", "Was the story of the game cohesive?", and "Was the game coherent?" On average our playtesters provided positive feedback, with 3.5 ± 0.27 for interestingness, 4.4 ± 0.18 coherence, and 4.5 ± 0.19 cohesiveness.

3 Discussion and Future Work

We have implemented the game designer AGD, a fully-automatic system for designing interactive, text-based role-playing games from movie scripts. AGD extracts narrative schema from free text to regenerate stories, in a similar way to work by [2, 3], who also used deep-structures from existing text, such as predicates, arguments and their co-occurrence statistics, to create a knowledge-base for the succeeding automatic generation of phrases and sentences. However our work aims to create interactive stories, rather than generating new narratives. The novelty of our approach is that we take established ideas from the field of narrative intelligence research and apply them to game design methodology.

The initial evaluation of our game designer was done on playtesting of *The Adventures of Indiana Jones*, generated by AGD. Overall the response by the playtesters was positive; who found the game interesting and the story both coherent and cohesive, with an average rating of 3.5 for game interestingness, 4.4 for coherence and 4.5 for cohesiveness. In the future, we want to improve the game experience by implementing more sophisticated automatic modules for parsing, co-reference resolution, surface realization, and story and character development.

References

1. Chambers, N., Jurafsky, D.: Unsupervised learning of narrative event chains. In: Proceedings of ACL 2008. HLT, pp. 789–797 (2008)
2. McIntyre, N., Lapata, M.: Learning to tell tales: A data-driven approach to story generation. In: Proceedings of the 47th Annual Meeting of the ACL and the 4th IJCNLP of the AFNLP, pp. 217–225 (2009)
3. Li, B., Lee-Urban, S., Johnston, G., Riedl, M.O.: Story generation with crowd-sourced plot graphs. ACM Transactions on Interactive Intelligent Systems (TiiS) 2(3) (2012)
4. Manshadi, M., Swanson, R., Gordon, A.S.: Learning a probabilistic model of event sequences from internet weblog stories. In: Proceedings of the 21st FLAIRS Conference (2008)
5. Rollings, A., Morris, D.: Game Architecture and Design: A New Edition. New Riders Publishing (2004)
6. Bal, M.: Narratology: Introduction to the Theory of Narrative. University of Toronto Press (1999)
7. De Marneffe, M., MacCartney, B., Manning, C.: Generating typed dependency parses from phrase structure parses. In: Proceedings of LREC, vol. 6, pp. 449–454. Citeseer (2006)

Storytelling and the Use of Social Media
in Digital Art Installations

Clinton Jorge[1,*], Julian Hanna[1], Valentina Nisi[1], Nuno Nunes[1], Miguel Caldeira[1],
Giovanni Innela[2], and Amanda Marinho[1]

[1] Madeira-ITI, University of Madeira, Campus da Penteada 9020-105, Funchal, Portugal
{clinton.jorge,julian.hanna,miguel.caldeira}@m-iti.org,
{njn,valentina}@uma.pt
[2] Northumbria University. Newcastle upon Tyne NE1 8ST
Giovanni.innella@northumbria.ac.uk

Abstract. In recent times new story formats have appeared along with new media channels that allow more reach and target a broader pool of authors and audiences. This paper investigates the repurposing of a Solari Udine airport split-flap display as a new public channel/medium for storytelling. We explored the potential of this repurposed display through a high fidelity prototype positioned in a high density and flow area at the main entrance to a regional university. The content displayed consisted of stories by published authors as well as passersby. Stories could be sent to the display via Twitter, SMS and Facebook. We observed and reported the reactions of the invited authors as well as of the public. Through the analysis of the data collected with this study, we aim at advancing and supporting the design of interactive storytelling installations in public spaces.

Keywords: Digital art, public displays, storytelling installation, Twitter fiction.

1 Introduction

Today the proliferation of new media channels is presenting a definite challenge to narrative intended as art, and pushing narrative as pure content or experience. Nevertheless the majority of the public, or anyone who comes into contact with a channel open for narrative, remains reluctant to share experiences—as they are concerned about issues of privacy, craft, and technique.

Borrowing from narrative theory, the shifts from one narrative genre to another, from oral to written, can function for example, as a frame of reference for those times when a new technology advances or enters the world of narrative and storytelling. In times of transition, where new technologies are appropriated by the public, genres coexist, interact, and borrow from each other. New forms of storytelling are being created, fused, and reinvented at a tremendous pace. Recent examples include Twitter-, micro-, nano-, or flash-fiction; blogging and microblogging; new serial forms;

* Corresponding author.

H. Koenitz et al. (Eds.): ICIDS 2013, LNCS 8230, pp. 233–244, 2013.

cell phone novels; books as apps; multimedia books and books for tablet PCs; and the rise of new genres like Alt Lit. The sum effect is an ever-increasing array of new media, forms, and channels available for us to connect with other storytellers and audiences, to share, and to express ourselves in new and innovative ways.

While storytelling has been open to change, the acceleration and proliferation of new formats, genres, and communities, aided by the expansion of digital media, has been unprecedented in recent years [18]. Increasingly, today people can share their stories with larger and more remote audiences. The ubiquity of mobile portable devices and social networks allows users to share with the general public or to focus on a select audience of followers, friends, family, and so on. Social networks and blogs are at the heart of this dispersion of stories.

Twitter, SMS and Facebook seem to retain some of the oral characteristics of storytelling. They are ephemeral: they are merely passing utterances with no physical counterparts. They are digits which can be read, but they do not have any permanence beyond the moment that they are posted. Not because they actually disappear, but because others will quickly and inevitably replace them as the most recent post or update. Stories move rapidly today, the sheer number and constant flow can be hard to keep up with.

In our previous studies [cf. 9] we found that collaborative storytelling, especially when relying heavily on user-generated content, is a difficult task for users. We also found that the majority of passersby enjoyed a more passive role such as reading the stories rather than creating them. Evidence from studies of user-generated content patterns in online social networks such as blogs, bookmarking networks and picture sharing has found that 20 percent of users contribute 80 percent of the content. The "80-20" rule of user contribution in online social networks indicates that a small fraction of users generate most of the content in the network [6].

Furthermore, we argued previously how to leverage on ambiguity to engage a public audience [cf. 9]. The rich aesthetic and conceptual potential of ambiguity have long been exploited in the arts, and more recently in design [4]. By repurposing and detaching familiar public displays such as an airport split-flap display we were aiming to provoke curiosity and attract users to try and understand why this artifact (object/display) was decontextualized and what was its new purpose.

Before approaching the subject of the paper itself, we should clarify how the term "interactivity" is being interpreted and used by the authors in the context of the MStoryG installation. As Lister points out, interactivity as defined through large media studies allows for "a more powerful sense of user engagement in media texts, a more independent relation to sources of knowledge, individualized media use, and greater user choice". In addition, "being interactive signifies the user's ... ability to directly intervene in and change the images and texts that they access. So the audience for new media becomes a 'user'" [13]. The focus here is on the user's active and physical engagement with the text, rather than the power of being able to alter the plot, or participate in the story in some way.

In this paper we focus on a five-week, two-part deployment of MStoryG as a semi-public storytelling installation exploring theme-based storytelling on an airport split-flap display. MStoryG builds on the *campfire* model, where stories were shared around a

particular place or location, and where people would gather expecting stories to be shared, or to have a place to share their own stories. We investigate this new channel for storytelling by employing a high fidelity prototype of our physical split-flap airport display. We stress the tension between the authoritative and informative use of traditional airport displays and our attempt at a new "democratic" storytelling art installation. We present our methodology in exploring our concept and implications for making improvements to future iterations of public displays as storytelling installations.

2 Related Work

There is a growing interest in cultural, artistic and entertainment applications of interactive technologies in settings such as museums, galleries, and theaters [17]. Over the past few decades many artists and researchers have explored public displays. One example is the work performed by artist Candy Chang, who invites communities to voice their hopes and ideas on shared public canvasses. Her projects range from Post-it size public notes to huge community blackboards which entice passersby to fill in the blank space in the sentence: "Before I die I want to _____." [2][14]. These projects present an example of how artists can use "low-tech" solutions to create a space and time, but most of all a motive, for the audience to participate and to become authors themselves.

Another example of art using ambiguity to foster curiosity and engagement in its audience is the work of American artist Jenny Holzer, who is known for conveying thought-provoking, ambiguous messages through repurposed public displays. Holzer's works invites curiosity and presents challenges to authority through the manipulation of familiar public displays and their content. Her *Truisms* have been broadcast on several such displays, including the Spectacolor electronic signboard in Times Square (1982) and the Dallas Cowboys Stadium video board (2012). In the exhibition *Terminal 5* (2004), Holzer's messages appeared on an LED departures screen in the disused TWA Flight Center at New York's JFK[1].

In a previous study we presented work on repurposing an old airport split-flap display to explore ambiguity and curiosity as tools for overcoming interaction resistance [9]. Repurposed airport displays have been used in art installations in museums such as MoMA[2], and their split-flap modules have been used as individual exhibits[3]; other experiments have explored their particular characteristics, such as the sound they produce[4].

3 MStoryG

MStoryG is a digital art installation employing a donated Solari Udine airport split-flap display that is intended to be located at a high density and flow public space. The

[1] http://en.wikipedia.org/wiki/Terminal_5_(exhibition)
[2] http://www.marcodemutiis.com/flaps
[3] http://www.moma.org/explore/inside_out/2011/09/30/hacking-the-solari
[4] http://lab-au.com/#/projects/signaltonoise/

large (3.5m by 2m) display is familiar to those who have passed through the regional airport, or indeed to anyone who has encountered this type of display in an airport or train station.

The repurposed display is meant to function as a catalyst (on the *campfire* model) or object to tell stories around. MStoryG seeks to foster the act of storytelling and facilitate a more intimate connection between storytellers and their audiences, inviting curious passersby to become participants as readers or even as storytellers themselves.

Characteristics inherent to this type of display trigger in some people certain pre-conditioned responses. For example, the sound of the flaps rotating provides an audible cue to people that new or updated information is being presented.

4 Study

4.1 Background

In previous work performed with MStoryG we approached the issues of attracting passersby and provoking curiosity in order to motivate interaction, through exploiting the ambiguity of repurposing and recontextualizing an airport split-flap display into a storytelling digital art installation (using a high fidelity prototype). We found that passersby immediately identified the display as "the one from the airport" and were curious to understand its purpose at the new location (the regional science park hall).

We found, moreover, that an installation that relies heavily on user-generated content, especially collaborative storytelling (in this case using the game "exquisite corpse"), faces a significant obstacle: our interviewed users rated creating stories as a "high difficulty" activity, and the majority preferred only to consume the stories. We also discovered that given an open theme, people's stories tended to gravitate towards the theme of travel, at least until meta-references to actual events took over, as in work by Likarish, P. et al [12].

4.2 Installation

Our objectives in deploying this study started with choosing a mixed-use location (high traffic flow and waiting area) at the entrance to the main university building, and an emphasis on invited authors rather than spontaneous user-generated content. At the same time we still wanted to encourage and leave the display open to users, so we enabled contributions from passersby via Twitter and, in the second phase of the deployment, SMS and Facebook.

Location and Set-up. The MStoryG study consisted of a five-week, two-part deployment of the installation at the main entrance of a regional university. This location was chosen due to its characteristics of leisure space (a student café), waiting time (a perpetual queue for the cashier), and high flow of passersby (students and faculty going to and from classes).

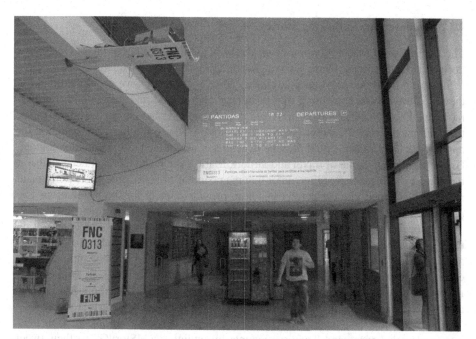

Fig. 1. Photograph of the main entrance to the university showing the projector (top left), the installation signage (bottom left) and the projection of MStoryG displaying a story

Due to its limited adaptability and the logistics involved in moving an 800kg airport display board, a high-fidelity software prototype of the display was created in Adobe Flash AS2.0. This prototype, a projection of the airport split-flap display, facilitated an easy set up and rapid conceptual explorations.

The installation employed a Sony 4500 ANSI lumens projector, which was suspended on an overhead platform in the main entrance and projected onto a white wall (see figure 1). Steps were taken to shade the projection wall without darkening the entranceway itself. The installation was powered by a Mac Mini located on top of the projector alongside two JBL desktop speakers which provided the split-flap animation sounds.

Unlike other researchers who have attempted to minimize the attention a display attracts while updating content [8] we took the opposite approach, seeking to capture the curious glances of passersby at the moment each new story appeared. In its original function and context, of course, the airport split-flap display was designed to attract attention to the updating of content, because air travelers needed to pay attention to flight information updates. Within the same projection frame, just below the airport board, a banner was projected with a simple call to action: *"Use Twitter to share a story with MStoryG."* Signage was created and distributed across the campus inviting people to participate by reading or sharing their own stories on the display located at the main entrance. Leaflets designed as airplane origami were circulated with a short introduction to the installation and its travel-related theme. A roll up was placed adjacent to the projection and was highly visible from the main entrance.

4.3 Interaction: Authoring Stories

The first phase of MStoryG ran for two weeks beginning 12 March. Phase One ended during the Easter break. Phase Two ran for three weeks starting 16 April.

Learning from our previous study (see end of section 4.1), we concluded that the theme of travel was something that passersby appreciated and understood. Furthermore, we found that most users preferred to just read or comment on the board, rather than submit their own content (story). In the light of these findings, we searched for appropriate authors who could provide us with a constant feed of high quality content. Given the chosen theme of travel and airport, Mark Yakich and Christopher Schaberg, the editors of Airplane Reading, an online magazine of travel-related short fiction and nonfiction, seemed like the perfect match to provide content for the installation. The pair are experienced in collecting and publishing very short stories through Twitter.

Our local audience, meanwhile, were provided with three forms of contributing their stories: initially through Twitter (phase one) and subsequently also through SMS and Facebook (phase two). By following this format of invited authors and passersby contribution, we expected to address an issue identified in our previous studies: that not everyone wants to be an author and that passersby often prefer a more passive role as observers and readers, only occasionally choosing to be active contributors.

Invited authors and local passersby could create and share stories through their own personal devices and Twitter accounts by adding "@MStoryG" to their tweet (thus mentioning the MStoryG user account). Contributions were filtered by facilitators in order to avoid any possible offense to the public or the university faculty. Two levels of tweets were developed: high rotation tweets, a "best of" collection of exemplary tweets from users that were displayed by default whenever there were no new contributions available, while single rotation tweets, which included all other vetted submissions. Single rotation tweets, once they were filtered for offensive material and broad adherence to the travel theme, were "favorited" on Twitter by the MStoryG account and placed in a queue to be displayed on the installation. We found that this made for a quick (if asynchronous) interaction, whereby a user's story could be shown within a minute if no other story was in the queue and the facilitator was able to favor the tweet rapidly.

Interaction through Facebook, meanwhile, required users to go to the MStoryG page and post a story. If the story was travel themed and shorter than 160 characters, a facilitator would select it to be added to the queue of stories to be shown at the installation by favoring the post through the MStoryG Facebook account.

Interaction through SMS was performed by passersby texting to a local mobile number that was running on a Samsung mobile phone (Android OS) with the SMSSync application. Messages were received on the phone and then forwarded to a web server through SMSSync, where a script would receive the message and tweeting it through the MStoryG Twitter account. If an SMS was longer than 140 characters, the script would break the SMS into two or more parts, appending a unique ID and 'tweeting' both parts. A facilitator then would favorite the SMS (a tweet from the MStoryG Twitter account) for display.

The installation would introduce a new story as often as every 2.5 minutes, reflecting the fast pace of foot traffic and the average time people would wait in the cashier queue. If no fresh content was added, "best of" stories would rotate every 5 minutes.

We decided against an on-site user interface in order to minimize social embarrassment and increase user interaction by other avenues [1]. We were concerned that an on-site interface could wrongly imply that interactions were synchronous, which would cause users to wait for their story to appear and possibly become frustrated.

4.4 Evaluation Protocol

Evaluating digital art installations using traditional HCI rules and models rather than through a more flexible and critical thought process can be ineffectual or even harmful. It has been shown that traditional models tell us very little about the relationship resulting from interaction with the installation [5][3]. For this deployment of MStoryG we relied on an analytical framework used in our previous studies, which is based on Mathew et al and Brignull and Rogers' work [14][1]. Mathew's analytical framework, like others' [15], uses the notion of engagement trajectories defined by phases, activities or thresholds to evaluate user engagement with public displays.

A particularity of MStoryG is that it did not offer any traditional adjacent interfaces such as touch screens or gesture input interactions, and thus the evaluation of direct interaction threshold had to be constrained to semi-structured interviews and questionnaires. Our evaluation protocol consisted of in-field observations and semi-structured interviews with passersby. For feedback from the invited authors, a (six question) questionnaire was sent out via email at the end of the experiment.

5 Results and Findings

The installation was set up and maintained in a way that would minimize the exposure of researchers and facilitators within the installation area and thus attempt to minimize any feelings of the installation being an experiment.

5.1 Phase One

During the first phase of MStoryG, eight (8) observation sessions of approximately one hour each were performed totaling nearly nine (9) hours. Here the researcher would evaluate the perception phase shadowing passersby and trying to overhear any relevant comments on the installation while monitoring the perception trajectory [1], i.e., the number of passersby that entered the peripheral awareness and focal awareness thresholds, and identifying any *honey pot effect*. Passersby were chosen at random to perform a semi-structured interview in order to further understand their reactions to the installation and engagement with the concept.

During Phase One, sixty (60) passersby were approached for a semi-structured interview. Groups were found easier to approach and more open to interviews than

individuals. Nine out of ten (90.6%) of the interviewees did not have an active Twitter account. The remaining ten percent (9.4%) had a Twitter account, though some were not actively using it.

Forty-six (46) tweets were directed especially at MStoryG, the majority of which were from our invited authors. Around eight (8) unique users (passersby) tweeted at least once. A small number of tweets from passersby were filtered; mainly "test" or "hello" messages. Two users deleted their tweets after their stories were shown on the installation while a third user deleted her two tweets after a week.

Figure 2 displays the most traversed footpaths through the entrance hall. The area that afforded the highest identification of focal awareness was the cashier queue, shown as the green striped area (FA) in figure 2. This provided the best viewing and the required waiting time provided the best conditions to observe the installation and read the stories. Here people would engage in conversations about the installation in general or about specific stories. Some people took on a "teacher" role and tried to explain the concept of the installation to others. No significant *honey pot effect* was observed. The highest interaction peaks were during lunchtime (13:00 to 14:00), most likely due to the increased number of passersby and the increased queuing time.

Initially, the first perception of most passersby was that the installation was a university-related communication. Users would first try to understand the purpose of the display without reading the roll up or posters, with only a small number actually reading the adjacent information. Some passersby tried to relate MStoryG to other public displays or advertisements located near the entrance.

The majority of feedback for not contributing was either about technical barriers (not having Twitter and preferring other social networks or SMS) or anxieties about creating a good story, something worth sharing. Some passersby complained about the difficulty of reading stories in English.

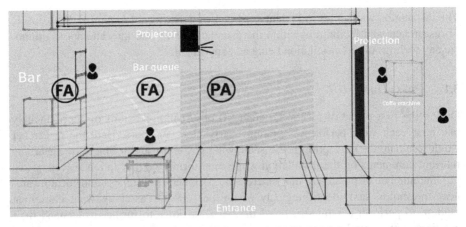

Fig. 2. Most traversed footpaths augmented with most identified peripheral awareness (PA) and focal awareness (FA) regions

5.2 Phase Two

The second phase was comprised of eight (8) observations totaling six (6) hours with the majority being in the morning when light conditions were optimal for the projection. Less emphasis was given to observations of activity thresholds and more to the interaction and engagement phases. Here our observer took a more active role in interviewing passersby in order to better understand their perception of the installation, interaction modalities and concept engagement.

Phase Two started after the Easter break and introduced some changes from Phase One. Facebook and SMS were integrated in an attempt to offer more familiar interaction modalities to facilitate user sharing. Vinyl signage was added to call more attention to the projection as well as to provide details of the Facebook account and SMS number.

During eight observations, 59 passersby were approached for a semi-structured interview. Passersby were seen to develop a more accurate understanding of the installation over time, but similar to [16] still a number of passersby did not fully comprehend the purpose of the installation.

None of the passersby interviewed in Phase Two had Twitter accounts. During this phase MStoryG received no tweets and no Facebook posts from passersby. Three individual SMS messages were received, all of them "test and hello" messages.

5.3 Feedback from Invited Authors

All four of our invited authors responded to the six-question email questionnaire. The questions asked how they felt about interacting and writing for the medium and context; what was the most rewarding aspect; what did they do with the photos we sent of their stories on MStoryG; what content did they think would suit the display; whether Twitter felt limiting; and what the ideal location for a future installation with the physical display might be.

Author one (A1) called the installation a "fascinating intersection between technology and humanities" and said he enjoyed having the MStoryG website (with the Flash prototype) running on his desktop so that he would hear the clicking of the board whenever a new story appeared. A1 described the interested reaction of his ten student interns and of his colleague, a literary theory expert, who said that the display had immense appeal. A1 was accustomed to writing Twitter fiction and called this format limit "liberating". He suggested that returning the (repurposed) airport display to its original context would create a stronger context for the stories being shared.

A2 described MStoryG as an "amazing, live, interactive forum for an original kind of writing, an imaginative hybrid that blends the informatics of global air travel with poetics, aphorisms, and epigrammatic insights". He characterized the linguistic economy demanded by the medium as "thrilling" and "thought provoking". A2 sent his photos of the installation to friends and family, who called MStoryG "a marvelous and bizarre experiment". A2 found MStoryG to be "a great third medium" to add to the mix of Twitter and storytelling.

A3 and A4 were less familiar with Twitter fiction. Nevertheless they both found the most rewarding aspect of their involvement to be the challenge of creating engaging 140-character stories for an unknown audience to read. A3 shared her photos on her writing blog and both shared photos of their stories displayed at the installation on their Facebook pages.

6 Discussion

Early on and from previous experiments we recognized that passersby would prefer reading on the board and enjoying the content displayed. As we discovered through our interviews, this was due not only to feelings of social embarrassment, but also to not knowing what to share, or how to write a short story, or what level of quality was expected, or indeed the purpose of the installation itself. We approached this by providing users with a familiar source of interaction (their own devices) and allowing them to choose either to share or simply observe. If they chose to share, they could do so on the spot or at another time and place. Although active contribution was a secondary concern, we hoped to increase user contribution by lowering feelings of social embarrassment caused by standing in front of the installation and typing a story that would be immediately visible. Instead we strengthened our findings from the previous study: creating content is difficult, especially on the spot or while on the move. We value this as an important reconfirmed finding regarding public display and user generated content.

Through our interviews and observations, we found a clear distinction in motivation and comfort levels between the different types of users of the installation, invited authors and casual passersby. While our authors were confident in their ability and excited by the challenges offered by the new medium, passersby found it difficult to create a meaningful story to share and most preferred not to try, content to remain instead as observers and readers.

MStoryG probably avoided the problem of interaction blindness due to not resembling a television screen [11]. On the other hand most passing users knew from previous experience that an airport display is an authoritative reference display that does not allow external user interaction and that provides important information. People make extremely rapid decisions about the value and relevance of large display content, and content that requires more than a few brief seconds to absorb is likely to be dismissed or ignored by passersby [7]. Even after several weeks of deployment some passersby still failed to notice the projection, which could have been due to poor light conditions at certain hours and to the installation being located above eye-level, thus diminishing the effectiveness of attracting glances [7].

A person who sees other people interact with an installation is influenced in their perception of the importance of a public display or installation in terms of personal gain and personal relevance [10]. Our attempt to counter social embarrassment by affording remote interaction led to passersby not being able to observe others interacting directly with the installation—i.e., no *honey pot effect*, the presence of others attracts attention and evokes initial curiosity [1].

6.1 Future Work

Our results motivate us to continue this line of investigating the potential of public displays for storytelling: very short stories (nano-fiction); and inviting a diverse range of users, including published authors, to contribute the main body of content while leaving the installation open to passersby and allowing them to express themselves and create stories. In future we plan to expand the role of users by providing them greater control over the airport display elements including character layout, lights, other informational flaps and how their story appears (animation). We are aiming for the final MStoryG installation deployment with the physical display in its original context, i.e. the regional airport, for an even stronger connection to travel-theme stories as well as the constant flow of first time passersby, but above all to exploit the power of the physical artifact, which carries its own aura and charm. Furthermore, we will persist in finding new ways to engage passersby in inventive and serendipitous ways. Due to the complex setup of Internet access at airports we should locate a kiosk near the physical installation for passersby to write a story, which would allow access for a broader audience than if we focused on Internet based connections to social networks or relied on receiving SMS from foreign numbers.

7 Conclusions

Facebook (and other social networks) functions as a virtual public display in the ethereal space of the Internet, and in this experiment we have networked social fiction through a physically embedded public display. American artist Jenny Holzer imitates and through the use of irony and ambiguity ultimately subverts the voice of authority that people expect from public displays. Holzer uses her own voice in the form of her mock slogans and aphorisms she calls "Truisms" to perform this act of subversion.

In deploying MStoryG we have also subverted the authoritative/authoritarian nature of the display, but by different means and for a different purpose. We invited four authors to contribute creative— as opposed to strictly practical or informative— content in the form of Twitter stories on the travel theme. At the same time, we also opened up the display to the audience, giving them a chance to experience their own Warholian "fifteen minutes of fame", or a chance to try out the "voice of authority".

We reconfirmed that passersby have a difficult time creating stories and prefer to read them. We concluded, therefore, that in feeding a storytelling installation it is best to rely on users who are confident in providing story content while still leaving open the possibility of user interaction and contribution to anyone who wishes to participate.

Acknowledgements. The authors would like to thank Mark Yakich and Christopher Schaberg (*Airplane Reading, New Orleans Review*) for their contributions and invaluable feedback.

References

1. Brignull, H., Rogers, Y.: Enticing people to interact with large public displays in public spaces. In: Proceedings of INTERACT (2003)
2. Chang, C.: Before I Die, http://candychang.com/before-i-die-in-nola/

3. England, D., et al.: Digital art. In: Proceedings of the 2012 ACM Annual Conference Extended Abstracts on Human Factors in Computing Systems Extended Abstracts - CHI EA 2012, p. 1213. ACM Press, New York (2012)

4. Gaver, W.W., et al.: Ambiguity as a resource for design. In: Proceedings of the Conference on Human Factors in Computing Systems - CHI 2003, p. 233. ACM Press, New York (2003)

5. Greenberg, S., Buxton, B.: Usability evaluation considered harmful (some of the time). In: Proceeding of the Twenty-Sixth Annual CHI Conference on Human Factors in Computing Systems - CHI 2008, p. 111. ACM Press, New York (2008)

6. Guo, L., et al.: Analyzing patterns of user content generation in online social networks. In: Proceedings of the 15th ACM SIGKDD International Conference on Knowledge Discovery and Data Mining - KDD 2009, p. 369. ACM Press, New York (2009)

7. Huang, E.M., Koster, A., Borchers, J.: Overcoming assumptions and uncovering practices: When does the public really look at public displays? In: Indulska, J., Patterson, D.J., Rodden, T., Ott, M. (eds.) Pervasive 2008. LNCS, vol. 5013, pp. 228–243. Springer, Heidelberg (2008)

8. Intille, S.S.: Change blind information display for ubiquitous computing environments. In: Borriello, G., Holmquist, L.E. (eds.) UbiComp 2002. LNCS, vol. 2498, pp. 91–106. Springer, Heidelberg (2002)

9. Jorge, C., et al.: Ambiguity in design. In: CHI 2013 Extended Abstracts on Human Factors in Computing Systems - CHI EA 2013, p. 541. ACM Press, New York (2013)

10. Klemmer, S.R., et al.: The designers' outpost. In: Proceedings of the 14th Annual ACM Symposium on User Interface Software and Technology - UIST 2001, p. 1. ACM Press, New York (2001)

11. Kukka, H., et al.: What Makes You Click: Exploring Visual Signals to Entice Interaction on Public Displays, pp. 1699–1708 (2013)

12. Likarish, P., Winet, J.: Exquisite Corpse 2.0. In: Proceedings of the Conference on Designing Interactive Systems - DIS 2012, p. 564. ACM Press, New York (2012)

13. Lister, M.: New Media: A Critical Introduction. Routledge, London (2003)

14. Mathew, A., et al.: Post-it note art. In: Proceedings of the 8th ACM Conference on Creativity and Cognition - C&C 2011, p. 61. ACM Press, New York (2011)

15. Müller, J., et al.: Requirements and design space for interactive public displays. In: Proceedings of the International Conference on Multimedia - MM 2010, p. 1285. ACM Press, New York (2010)

16. Munson, S.A., et al.: Thanks and tweets. In: Proceedings of the ACM 2011 Conference on Computer Supported Cooperative Work - CSCW 2011, p. 331. ACM Press, New York (2011)

17. Reeves, S., et al.: Designing the spectator experience. In: Proceedings of the SIGCHI Conference on Human Factors in Computing Systems - CHI 2005, p. 741. ACM Press, New York (2005)

18. Don't look for e-literature in novels, http://www.guardian.co.uk/books/booksblog/2012/sep/12/e-literature-novels

Faceless Patrons –
An Augmented Installation
Exploring 419-Fictional Narratives

Andreas Zingerle[1] and Linda Kronman[2]

[1] University of Art and Design, Linz, Austria
andreas.zingerle@ufg.ac.at
[2] Kairus.org - Art+Research, Linz, Austria
linda@kairus.org

Abstract. 'Faceless patrons' is an installation that documents stories used by Internet scammers in so called 'overpayment check scams'. Scammers use scripted stories to reach their victims, yet when correspondence continues story worlds start to evolve. We created a virtual character to interact with scammers who posed to be art buyers. The installation presents five of these interactive narratives in form of a series of photos each coupled with a forged check. By using smartphones or a tablet an augmented reality layer can be accessed to expose further story elements.

Keywords: Unsolicited electronic mail, scambaiting, Computer mediated communication.

1 Introduction

Scamming is a global phenomenon and victims can be found everywhere with no difference in gender, age or race. To persuade the victim into paying money upfront, the scammers create story worlds with 'get rich quickly' schemes that seem 'too good to be true'. The scammers draw on emotions like greed, empathy or love. The different narratives are situated in the grey area between reality and fiction [3]. Story worlds can get very detailed and involve several characters and are often related to real life. We wanted to take a closer look on these '419-fiction' cybercrime stories, '419' relating to the criminal code in Nigerian law that deals with fraud. These stories reflects the dystopian side of computer mediated communication where the Internet enables a world of false representations, abuse of trust, humiliation and desperation for opportunities. The 'Faceless patrons' installation has been described earlier in a poster paper [5], in this paper we therefore focus on the narratives that lead to the creation of the installation.

2 How the Scam Works

We want to take a closer look to the overpayment check scam, that is still largely used although digital payment methods are a common practice. In this type of

H. Koenitz et al. (Eds.): ICIDS 2013, LNCS 8230, pp. 245–248, 2013.

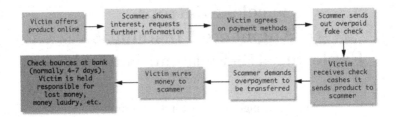

Fig. 1. Overpayment check scam lifecycle

scam a scammer shows interest in a product offered online by contacting the auctioneer. Once the deal is closed the scammer sends a forged check to the victim, often involving another victim as a 'money mule'. The mule acts as a 'transaction processor' who is duped to accept fake cheques or stolen money and forwards it to the scammer. The check is issued for far more money than agreed and the scammer convinces the victim to immediately cash the check and after deducting the costs of the product wire the rest of the money back. The scammers are using a loophole that the check transfer system affords. Normally wire transfers are done within a couple of minutes, whereas it can take up to several days for the bank to refuse to honor the check with the result that the victim loses money and additionally can be charged for money laundering [4].

3 Interactive Storytelling with the Scammer

In the following paragraphs we highlight some parts of the correspondence with the scammers that we see as interactive storytelling. The story takes the form of e-mail correspondence where two characters are involved; one art patron created by the scammers and our fictional artist 'Anna Masquer'. The scammers posed identity is often based on either identity theft or a confusing mix of several existing individuals, giving them the opportunity to remain faceless and anonymous. While we were aware of the fact that we are dealing with scammers, we use a fictional character and narration to investigate how the scammers react to various turns in the plot. Our character 'Anna Masquer' represents an average contemporary artist in her late 30s. Her story is backed up by a virtual identity presenting herself and her artwork on a Wordpress blog and a Flickr channel [1]. When a prospective customer gets in touch with her, she responses that the photo series 'Faceless' is currently presented in a gallery in Vienna, Austria. Anna acts surprised when she is contacted by an international patron, but sees an opportunity to sell her art. The scammers that pose as wealthy art buyers wants to pay by check and have the artwork series shipped to them. Anna wants to sell her photo series and accepts the check payment. In the beginning the correspondence is quite generic both parts expressing their interest in the deal. The crucial point for the scammer is to convince the artist why the payment can only be delivered in the form of a check-payment.

Freiermuth's rhetorical moves analysis reports that in 92.31% of scam-emails a background narrative is told to justify the claims being made [2]. In our example, a wealthy person interested in the arts wants to buy an artwork. Since he is busy with his professional job, he demands to pay by check. In an email sent to 'Anna Masquer', the patron 'Mac Nuel' states:
"I can only prepay the total amount of this gift product by cheque payment only. This is as a result of my deployment to the gulf of Mexico since we are presently engaged in a Deep-water project at our offshore location hence I am presently not in the UK and cannot make a bank transference from this location offshore".

The check is a physical evidence that can be tracked if the scammer is sending the letter from a different country than where his virtual character is situated, he needs to get creative to present a credible storyline. In the following snippet of an email, the patron 'Joshua Daniels' explains that an associate of him will actually do the payment. By introducing a new character only known as 'associate', the scammer disconnects the physical evidence from his virtually created profile.
"I am very glad to read from you, i am really interested and i stay in Scotland. I am okay with your asking price So i have an associate of me who is owning me the sum of 9000euro I will ask him to issue you a check".

When the victim believes the narrative and agrees to receive a check as our character Anna did, the offer gets more detailed. The art buyer 'Michael Silverberg' justifies an overpayment to cover the shipping costs and to compensate the sellers extra efforts:
"I'm sending you an overdraft which will include my shippers fees as well. [...] So, once you've received and cashed the check, deduct your funds and PLEASE help me send the remaining funds to him (shipper). I'll forward his contact details to you once you've received the payment".

Tensions between the characters start to emerge when the check arrives. The scammers character starts to put pressure on our victim to receive the advance payment before the check bounces and the plot is revealed. Our character Anna who is a victim in disguise aims to linger and keep the correspondence up as long as possible without transferring money back to the scammer. The situation looses its tension when the scammer realizes that the check cannot be cashed and to send another check or to provide a different payment method. In all times, the scammers stopped contacting us. Once the checks were received, we reported them to law enforcement. This was done through the scambaiter community, where a group specializes in reporting fraudulent bank account activities. For the scambaiters, a fake check is considered a 'trophy' [6], a physical representation of the scam attempt that can be used to document and inform ongoing criminal activities to bank officials, who monitor account transactions, freeze accounts and inform local law enforcement.

4 The Augmented Installation

The installation setup consists of five photo-frames hanging on a wall. Each frame connects to a correspondence with a scammer and holds a photograph and a fake check that was received as an advance payment for Anna Masquers' photos. By using a smartphone or a tablet the visitor can scan each photograph via a third party AR-Browser. Each physical photograph is then overlaid with an AR layer containing a video compilation of images. These images are the result of an online search in an attempt to confirm or invalidate the authenticity of the scammer's character and his online representations. This search result tries to give a face to the faceless scammer, yet fails while the posed art buyer can be anyone or no one of the persons found within the search. Additionally to the images the video contains a voiceover narrating parts of the email correspondence. Due to the similar scripts of the scam only snippets of each correspondence are presented in the artwork. This still enables the visitor to follow the whole narrative path of the 'overpayment check scam' scheme. The installation functions as a documentation of the scam scheme and represents part of the interactive storytelling process that we experienced with the scammers.

5 Conclusions and Future Work

'Faceless patrons' is an art project that uncovers story scripts that scammers use in 'overpayment check scams'. By accessing an augmented reality layer, people can listen to parts of the correspondence and see results of an online search that tries to give a face to the scammers' characters. Understanding the story structures of the scam scheme enables us to efficiently gather overpayment checks and report them to law enforcement. The artwork is part of an ongoing research on 419-fiction, testing various scambaiting methods to point out its info activist potential. In our future work we want to combine ethical scambaiting methods with interactive narration as media competence trainings.

References

1. Anna Masquer Portfolio, http://annamasquer.wordpress.com
2. Freiermuth, M.: 'This transaction is 100% risk-free!' Why do people fall prey to e-mail scams? In: International Conference on Language and Communication (LAN-COMM), pp. 222–230 (2011)
3. Hotz-Davies, I.: Internet fictions. Cambridge Scholars Publishing (2009)
4. Stabek, A., Watters, P., Layton, R.: The Seven Scam Types: Mapping the terrain of cybercrime. In: Cybercrime and Trustworthy Computing Workshop (CTC), pp. 41–51 (2010)
5. Zingerle, A., Kronman, L.: Faceless patrons - an augmented installation exploring 419-fictional narratives. ACM Cyberworlds (2013)
6. Zingerle, A., Kronman, L.: Humiliating entertainment or social activism? Analyzing scambaiting strategies against online advance fee fraud. ACM Cyberworlds (2013)

Minun Helsinkini/My Helsinki/Wa Magaaleydi Helsinki – Finnish Somali Youth Speak for Themselves in Their Document Film

Helena Oikarinen-Jabai

Aalto University, School of Art, Design and Architecture, Helsinki, Finland
helena.oikarinen-jabai@aalto.fi

Abstract. In my demonstration I will show a document film Minun Helsinkini/My Helsinki/Wa Magaaleydi Helsinki made by young men with Somali background. The film is one of the productions produced during my multidisciplinary research project A Finn, a Foreigner or a Transnational Hip-hopper? Participatory Art-Based Research on the Identification Negotiations and Belonging of the Second Generation Finnish Immigrant Youth in Helsinki, Finland. My research project deals with themes of cultural in-between spaces and issues of multiculturalism that I have also approached in my previous research. Methodologically I am interested in applying experimental postures and perspectives in the research context. I think that art based, narrative and performative methods can be used to advance understanding of the interplay between diverse contemporary social and aesthetic realities, and can also be seen as a way of building bridges between artistic and scientific approaches in academic contexts.

Keywords: art and media based research, performativity, visual approaches, video as a participatory tool, multidisciplinary, youth work.

1 Background

In this demonstration I concentrate on the workshops conducted with a group of Somali youth and photographer Sami Sallinen in Youth's Multicultural Living Room run by the Youth Centre of the City of Helsinki, and especially on the video document created during the workshops. We have also organized, together with a team of participating youngsters, several exhibitions and made a radio program and a book.

In this way the research participants have been part of a multi-level theory and methodology development of intervention approaches that community researchers across multiple fields embed in their studies [13, 16, 19, 22]. In this particular film Finnish Somali youth discuss their experiences in Finland and in Helsinki using different types of styles and approaches. Participating youth had photo and video cameras and they decided themselves what they wanted to shoot and present. In the film they for example interview each other and other youth, discussing on issues like racism, nation, ethnic identities, military service and youth cultures. They also speak about their childhood memories, relations to public spheres and their future horizons.

H. Koenitz et al. (Eds.): ICIDS 2013, LNCS 8230, pp. 249–252, 2013.

2 Methodology

Participatory action research includes the subjects of research as co-creators of the research. It encourages polyvocality and increase participation in producing knowledge as well as action. Visual, audio, audiovisual and literature productions created together with the participants provide sites for them to tell their narratives and facilitate sensuous knowledge and understanding of the density of social identifications [13]. Divya Tolia-Kelly [20, p. 132] claims that making perspectives substantial in visual forms entails a possibility for coming up with unexpected grammars and vocabularies that can be inexpressible in other contexts. I think that in the film – and other productions created with youth this becomes understandable.

In my research I find Avtar Brah's [3] analysis of diaspora spaces and Bill Ashcroft's [1] concepts of interpolation and horizon useful for my research. In the film becomes obvious that even if diaspora involves an aspect of separation and dislocation, diasporas are also the sites of new beginnings [3, p.193]. The multi-locationality across cultural geographical and psychic boundaries and possibilities are differently experienced and mediated within each generation and gender [3, p. 194].

I think that audio visual methods give the participants tools to be co-researchers. They become main actors of the research when they take part in the productions that emerge from the project. In our project these productions are created in a way that will interest the wider public, not only academics and authorities. This helps in creating discourses between "majority" and minorities [16].

The landscape created in the context of participatory art based research reveals many kinds of practices of differentiation. When embodied and expressed by visual and textual narratives, these discourses open the 'potential space' in-between objective and subjective reality experienced by the participant [15, 21]. This also lends support to considerations of citizenship from new perspectives [10].

Jon Prosser and Andrew Loxley [18] argue greater understanding of individual lives and group culture is possible through close reading of videos. Children and youth are able to access physical and mental territory not available to adults and, consequently, to act as fellow researchers. The images represented in the research functioning as a phenomenological centering of the participants lived experience.

Maggie O'Neill claims that participatory approaches are useful when dealing with transnational and diasporic experiences, because they involve praxis as purposeful knowledge, which tells us, in a relational and phenomenological sense, something about what it is to feel 'at home' and have 'a sense of belonging'. These approaches allow us to include creative methods in the study such as subjects producing artistic work or visual/poetic material [14, see also 16]. According to Laura Chernaik contemporary society should be analyzed through material semiotic practices, by performing and in practice. In this way we could examine and find connections between techno science, transnationalism, 'race', gender and sexuality [5, p. 91; cf. 7, p. 68]. Donna Haraway asks for new kinds of epistemological stand points and localized texts, so that we researches could detach ourselves from the beliefs and normative expectations that are deeply rooted in scientific thinking.

3 Results and Future Perspectives

It seems that the youngsters who participated in the project are at least as familiar with the locations on borders as with (their) potential homes in different countries and cultural spheres. The transnational spaces, to which they concretely belong through the kinship relations and the diasporic community, make it possible for them to share a kind of "horizontal citizenship" and an experience of home reaching over different continents [1, p. 86; 10]. They are used to negotiating in-between different cultures, languages and value systems. "One is like James Bond, playing a role in a cover story," one participant remarked about his placement in-between cultures. An outsider position gives a standpoint to examine the structures of Finnish society and its connections to global value mappings. [2, p. 55; 12, p. 112].

Brah [3, p. 193] talks about homing desire, which is not the same thing as desire for a 'homeland'. The young people who participated in making the document, created their own places and followed their desire 'to feel at home' as they produced their visual and audio-visual narratives. When they looked through the lens, they could make their own research and open up for themselves and for spectator spaces where it was possible to deal with difference in alternative ways as well as to build bridges across difference [20, p. 132].

The youth are aware about the fact that visibility does not necessarily mean re-representation [17, p. 6]. Anyhow the youth re-structured and re-represented familiar images connected to 'race' and ethnicity. They also performed personal experiences of self that opened new routes to in-between landscapes. For example, in his 'identity collection' one participant played with both the black male images – so unavoidable on the streets of Helsinki - and with his personal narratives.

Although the youth don't know the postcolonial academic vernacular they give smart descriptions of the phenomena also discussed in the theory. I agree with Minh-ha [9, p. 83)] that audio work can let the voice find its own way, powerful in its vulnerability and magical in its simplicity. Moreover, the electronic communications media has made it possible for sub-cultural groups to intervene in the contradictions generated by modernity, and to democratize everyday and political culture [4, p. 265].

In our project, to be able to present their productions in public spaces has been important for the participants. Their work and perspectives have been socially and culturally recognized [20, p. 134]. Practical projects conducted by people with immigrant backgrounds open 'dialogic spaces' that may help in creating a cultural imaginary and furthering an understanding of processes of belongings [13].

The youth with immigrant background are ground breakers who take part in deconstructing and restructuring the surrounding culture and existing ethnic relations. Because they feel at home in in-between spaces where locality and possibility merge, they have qualifications for being cultural mediators [1, p. 182–189; 11] As specialists in matters with specific phenomena and images which are not openly discussed and dealt with in Finnish society, these youngsters are able to recognize and transgress rigid conceptual borders and national images, and eventually transform such notions and attitudes into brand new ways of thinking.

References

1. Ashcroft, B.: Post-colonial Transformation. Routledge, London (2001)
2. Alitolppa-Niitamo, A.: The Icebreakers: Somali-Speaking Youth in Metropolitan Helsinki with a Focus on the Context of Formal Education D42/2004. Väestöliitto, Helsinki (2004)
3. Brah, A.: Cartographies of Diaspora, Contesting Identities. Routledge, London (1996)
4. Canclini, G.: Hybrid Cultures. Strategies for Entering and Leaving Modernity (Chiappari, C., Lopez, S. (eds.)). University of Minnesota Press, Minneapolis (1995)
5. Chernaik, L.: Transnationalism, Technoscience and Difference. In: Crang, M., Crang, P., et al. (eds.) Virtual Geographies: Bodies, Space and Relations, pp. 79–91. Routledge, London (1999)
6. Haraway, D.: Simians, Cyborgs and Women: The Reinvention of Nature. Routledge, New York (1991)
7. Haraway, D.: The Haraway Reader. Routledge, New York (2004)
8. Minh-ha, T.T.: Other Than Myself, My Other Self. In: Elsewhere, Within Here: Immigration, Refugeeism and the Boundary Event, pp. 27–42. Routledge, New York (2011)
9. Minh-ha, T.T.: Voice over I. In: Elsewhere, Within Here: Immigration, Refugeeism and the Boundary Event, pp. 77–94. Routledge, New York (2011)
10. Oikarinen-Jabai, H.: This is my home country or something in-between – Finnish-Somali youth sharing their experiences through performative narratives. Journal of Arts and Communities 3(2), 151–166 (2012)
11. Oikarinen-Jabai, H.: Minun Helsinkini – Maahanmuuttajataustaisten nuorten näkemyksiä kotikaupungistaan. Nuorisotutkimus 4, 63–67 (2010)
12. Oikarinen-Jabai, H.: Syrjän tiloja ja soraääniä: Performatiivista kirjoittamista Suomen ja Gambian välimaastoissa Taideteollinen korkeakoulu, Helsinki (2008)
13. O'Neill, M.: Participatory Methods and Critical Models: Arts, Migration and Diaspora. Crossings: Journal of Migration and Culture 2, 13–37 (2011)
14. O'Neill, M.: Making Connections: Ethno-mimesis, Migration and Diaspora. Psychoanalysis, Culture and Society 14, 289–302 (2009)
15. O'Neill, M.: Transnational Refugees: The Transformative Role of Art? Forum: Qualitative Social Research/Sozialforschung. Performative Social Science 9(2), Art. 59 (May 2008), http://durham.academia.edu/MaggieONeill/Papers/102390/Transn ational_Refugees_The_Transformative_Role_of_Art
16. Pain, R., Kindon, S., Kesby, M.: Participatory action research: making a difference to theory, practice and action. In: Kindon, S., Pain, R., Kesby, M. (eds.) Participatory Action Reseach Approaches and Methods: Connecting People, Participation and Place. Routledge Studies of Human Geography, pp. 26–32. Routledge, London (2007)
17. Phelan, P.: Unmarked: The Politics of Performance. Routledge, London (1993)
18. Prosser, J., Loxley, A.: ESRC National Centre for Research Methods Review Paper. Introducing Visual Methods. National Centre for Research Methods. NCRM/010 (2008)
19. Schensul, J., Trickett, E.: Introduction to Multi-Level Community Based Culturally Situated Interventions. American Journal of Community Psychology 43, 232–240 (2009)
20. Tolia-Kelly, D.P.: Participatory Art: Capturing Spatial Vocabularies in a Collaborative Visual Methodology with Melanie Carvalho and South-Asian women in London, UK. In: Kindon, S., Pain, R., Kesby, M. (eds.) Participatory Action Research Approaches and Methods: Connecting People, Participation and Place. Routledge Studies of Human Geography, pp. 132–140. Routledge, London (2007)
21. Turner, V.: Dramas, Fields and Metaphors. Symbolic Action in Human Society. Cornell University Press, New York (1974)
22. Wang, C., Morrel-Samuels, S., Hutchison, B., Bell, L., Pestronk, R.: Flint Photovoice: Community Building Among Youths, Adults, and Policymakers. American Journal of Public Health 94(6), 911–913 (2004)

Re: Dakar Arts Festival - Exploring Transmedia Storytelling Methods to Document an Internet Scam

Andreas Zingerle[1] and Linda Kronman[2]

[1] University of Art and Design, Linz, Austria
andreas.zingerle@ufg.ac.at
[2] Kairus.org - Art+Research, Linz, Austria
linda@kairus.org

Abstract. With the 'Re: Dakar Arts Festival' project we present an alternative way to raise awareness about online advance-fee fraud scams, by exploring the extent to which concepts of transmedia storytelling are adaptable in representing a scambait - the practice of scamming a scammer. By investigating practices of scammers we can question the trust that is put into online representations. Yet, what happens when transmedia concepts are adapted to documentation material and blended with fictional characters? With the help of an example, we illustrate how a documented scambait evolved into a transmedia story, unfolding over several media channels.

Keywords: Transmedia Storytelling, Online representations, 419 scam.

1 Introduction

Boosted by Internet technologies, scammers increasingly seek out to reach victims through fraudulent online representations and mass e-mails. We all receive proposals, either in our inbox or spam filter, that in fact are attempts to scam a victim. Most of us delete the spams and have a critical eye for offers seemingly 'too good to be true', yet scamming is a big industry that many victims fall for [2]. Scams come in various forms, some quite unbelievable, others smartly entwined in our daily practices. If we take a closer look into our spam filters, a number of scam stories reveal to be quite creative and intriguing story worlds. The 'Re: Dakar Arts Festival' project documents the practice of scammers, who announce an online open call for a fake art festival in Dakar, Senegal. We received the call for the first time in 2010 and a first version of the artwork was presented in 2011. At an early stage we recognized that the project as well as the scam would evolve over time. This poster paper summarizes some key aspects of the artwork and how it changed since its first version functioning as an addition to the paper that was published in connection with the launch of the artwork [5]. The festival is just a lead story for advance-fee fraud and victims are lured into wiring money for reservations, transportation costs, commissions or other

H. Koenitz et al. (Eds.): ICIDS 2013, LNCS 8230, pp. 253–256, 2013.

service charges without knowing that the festival does not exist. 'Re: Dakar Arts Festival' consists of two parts, an interactive installation and online in form of websites and on various social media channels.

2 Challenges and Design Choices

The main challenge of the project is to retell a documentation of a scam in an interesting way such that it invites various levels of involvement from the audience. The mix of real life and fictional elements in the story world also leads to interesting discussions on design ethics.

2.1 Interactive Installation

The suitcase consists of various elements: video trailer introducing the story, an interactive audio-timeline reproducing selected parts of the email correspondence, various printed documents taken out of the email correspondence with the scammers, including: invitations, money transfer forms, hotel and flight reservations, a map of Dakar with important locations combined with a fact sheet about Senegal and Heidis art postcards and Peters business cards that visitors can collect and use as entrance points to further investigate the story online.

In the case of 'Re: Dakar Arts Festival', when the story unfolds over the various channels in a non-linear fashion and with several possible entrance points, it is not possible to introduce elements chronologically, though each channel like a blog or each mode like the audio timeline in the suitcase can have a linear time perspective. Thus when designing the story, we emphasized on Jenkins' idea of 'Spreadability vs. Drillability' [3], meaning that viewers should be able to scan the story, decide if it is interesting for them, as well as drill or dig deeper into it when the story captures their imagination.

The story in the suitcase is open ended; it partly continues online and partly overlaps. The online stories take a more personal point of view by reflecting more on reactions and feelings that Heidi, Peter and Toni have in relation to the correspondence with the scammers instead of repeating it.

2.2 Online

The story unfolds online through a number of social media platforms. The canonic narrations that transmedia storytelling affords can be used to give insight into various perspectives of the same issue. The website dakarartsfestival.net facilitates the audience in the process of assembling the puzzle, by presenting the characters of the story and leading visitors to investigate their social media profiles. All the fragments of the online story assemble into the second main entrance point of the story. This takes place when a potential victim receives an email from the scammers and uses online search engines to find more about the festival. The presented search hits include the characters social media

profiles and the dakarartsfestival.net site, subsequently making the online search a main entrance point to the story.

Many artists who received the email invitation and searched online for the festival came across the websites. The responses were very different; some interested artists wrote an email to us and the scammers asking about the actual date of the opening reception, since there were divergent dates on our website and the ongoing open calls that the scammers were sending out. Others tried to warn our galerist 'Peter Irrthum' not to cooperate with the festival, since there exists a group on Facebook warning about the festival being an art scam. Several websites like embassies in Dakar or the Dak'art Biennale [1] published alert messages about the scam format linking to our website for further details, helping us to inform about the fake art festival and introduce the story to a broader audience.

2.3 Scam the Scammer Kit

The Scam the Scammer kit is an extension of the 'Re: Dakar Arts Festival' story for those in the audience willing to become actively involved. This continues the documentation of the the 'Dakar Arts Festival' scammers' practices. By introducing the ethical guidelines in the kit we want the users to question their motives and methods of scambaiting before entering scambaiting communities. The kit can be seen as a facilitative tool for a potential activist, who is working to raise awareness about cyber crimes. In the scope of the project the kit was conceptualized.

We continued to work on the kit and developed it further into a '419-fiction toolkit' and a series of workshops. The workshops give a theoretical and practical introduction to interactive narratives in 419-fictional environments where participants can take the first steps of creating their fictional characters and infiltrating a scammers story-world to observe and interrupt their workflow.

3 Further Developments

In 2011 the 'Re: Dakar Arts Festival' art project was created as a response to the circulating scam. Since then we had several opportunities to present our work in different setups and implement the feedback from the visitors. As a result of overlapping exhibitions at different festivals, we created a second version of the suitcase and accordingly made improvements in both versions. We added QR-tags to the map in the suitcase presenting video footage of various sites in Dakar, providing more background information about the city and its inhabitants. We created posters showing the 'anatomy diagram of the scam' giving an instant overview of the content that could be further explored in the installation. This extension of the installation works as a preamble transferring the visitor to the world of cybercrime. Over the time the scam method also evolved and it is still possible to find open calls for the fake art festival:

DAKAR International Festival of Visual Art (I.C.V ARTS) took place at the Daniel Sorano center. Dakar Visual art will happen all year round in Dakar

for four weeks every year from September 2013. I.C.V.ARTS DAKAR-2013, the International Festival of Visual Arts, under the aegis of the Ministry of Culture of the Republic of Senegal, is an international art event dedicated to visual arts and bringing together various events around, African artists and professionals of contemporary art from all continents. [...] For more information for your participation [...] write Mr. Sow at festival_arts@yahoo.fr.

In 2010 we observed a slightly different open call published by the scammers; the name was changed to 'DAKAR International Festival of Visual Art (I.C.V ARTS)'. An addition to the open call is the reference to the 'Daniel Sorano' center as an exhibition venue, this adds credibility to the storyline. The main contact person is 'Mr. Sow' instead of 'Mariama Sy'. After contacting him to get more informations about the festival, he replied and portrayed himself as a sculptor who lived for several years abroad and returned back to Senegal to help the development of the local art scene. He also referred to his website ousmane-sow.com. When contacting 'Ousmane Sow' over his website [4], he refuses to be involved in the organization of the festival. It became clear to us that he became a victim of identity theft and that the scammers use his name and credibility to lure other victims to fall for the scam.

4 Conclusions

While corresponding with the scammers we figured out that the online repre-sentations for our virtual characters highly increased their trustworthiness and therefore gave us more possibilities to investigate and document the scammers' practices. Concepts of transmedia storytelling were used to unfold multi layered stories providing a method to spread details of the story over various channels. Both entrance points - the installation and the story online - arose awareness about the scam and therefore the 'Re: Dakar Arts Festival' project meet its pur-pose of documenting a scam. Side by side the scam evolves as well showing the importance of documentation-oriented scambaiting. Our experience with this project also motivated us to further develop the 'scam the scammer kit' and test its potentials in a series of workshops.

References

1. Dak'art Biennale, http://www.biennaledakar.org/2012/spip.php?article29
2. IC3 Annual Report 2012 (2012),
 http://www.ic3.gov/media/annualreport/2012_IC3Report.pdf
3. Jenkins, H.: Keynote: Revenge of the Origami Unicorn: Five Key Principles of Trans-media Entertainment. MIT TechTV (2011), http://techtv.mit.edu/
4. Sow, O.: http://www.ousmanesow.com
5. Zingerle, A., Kronman, L.: Transmedia storytelling and online representations - Issues of trust on the Internet. In: International Conference on Cyberworlds, pp. 144–151 (2011)

Building Narrative Connections among Media Objects in Cultural Heritage Repositories

Antonio Lieto and Rossana Damiano

Dipartimento di Informatica, Università degli Studi di Torino
Torino, Italy
{lieto,rossana}@di.unito.it

Abstract. In this paper, we propose a semantic framework for narrative-based access to digital media repositories in the field of cultural heritage. Narrative relations are employed as paths the user can follow to explore a media repository, thus providing a powerful conceptual tool for the description and navigation of resources.

Keywords: narrative models, cultural heritage, semantic technologies.

1 Background and Motivations

When dealing with large and diverse online collections, users need more effective conceptual frameworks to abstract from the complexity of cultural resources. For example, concerning digital imagery, [1] claim that an abstraction layer is needed in the presentation of online archives, since a single investigation may involve different types of artefacts and different realms, such as history, art, archeology, etc. Narrative, in particular, is a powerful metaphor for the exploration of cultural heritage [6], exploited by different projects which range from online access to digital collections [2,4] to situated storytelling on mobile devices [5].

In the last decade, the use of ontologies (and narrative ontologies in particular) in online access to cultural heritage has been investigated by several projects, starting from the pioneering contribution given by the Culture Sampo project [4]. The Agora system [8] provides an event based navigation of cultural objects framing the narrative exploration into historically relevant episodes. In Europeana, it is possible, for example, to navigate among the artifacts representing a given action or displaying a certain character, across a large number or indexed objects; the system does not provide, however, a navigation within or among stories.

In this paper, we describe an application for exploring digital media repositories with the guidance of a set of "cultural archetypes", the Labyrinth system. Inspired by the research in iconology and narratology represented, respectively, by the work of Warburg [9] and Thompson [7], we use the term 'archetype' to refer to a conceptual core, set at the intersection of narrative motifs, iconological themes and classical mythology. For example, the archetype of the "labyrinth" can be employed to track the connection between a Greek vase representing

H. Koenitz et al. (Eds.): ICIDS 2013, LNCS 8230, pp. 257–260, 2013.
© Springer International Publishing Switzerland 2013

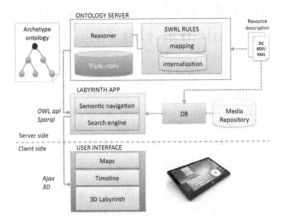

Fig. 1. The architecture of the system

Theseus and the playbill of a theatrical play inspired by the story of Ariadne, since both involve a character who plays some part in the classical myth. The system relies an OWL ontology, the Archtype Ontology, where each archetype is described by the set of its related stories, characters, locations and objects (a description can be found in [3]).

2 System Architecture

The Labyrinth system allows the user to explore a repository of media resources through the conceptual mediation of an "archetype" of narrative nature. The system encompasses four main modules (see Fig. 1):

- The Ontology Server maintains Archetype Ontology, maps the media resources onto the ontology (through a SWRL rule base), and provides the reasoning services to the web application.[1]
- The Media Repository is indexed by a relational database (a mySql DB).
- The Web application, written in Java, provides search and navigation by querying the Ontology Server through SPARQL language.
- The web site supports the interaction with the user through maps, timelines and 3D navigation.

When a new resource is added to the database, the information about it (i.e., its metadata) is integrated into the ontology as well. First, the *internalization* phase imports the metadata of the resource (creator, date, etc) into the ontology. Then, the *mapping* of the imported resource with the archetypes (and narrative features in particular) is performed on the internalized metadata. Both steps are achieved via rules encoded in SWRL format, in order to guarantee the portability of the system.

[1] Currently, the ontology server is provided by the Owlim RDF database management systems (www.ontotext.com/owlim), Standard Edition.

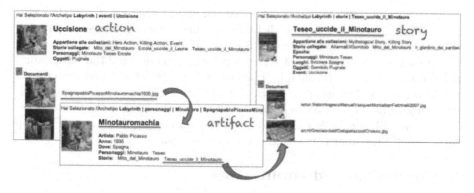

Fig. 2. A navigation path in the Labyrinth system (in Italian). The first step, "action" (top left) shows information about the "killing" action ("Uccisione"), the stories it belongs to, the characters who take part in it, the artworks depicting it; the second step, "artifact" (bottom), shows the information about an artwork, its creator, the characters it displays, the stories it refers to, etc.; the third step, "story" (top right), shows the information about a story ("Theseus kills the Minotaur", "Teseo uccide il Minotauro").

3 Narrative Navigation

After selecting an archetype, the system allows the user to choose one of its defining element (i.e., the stories, characters, events, locations, etc. related with the selected archetype) and filters the media resources in the repository according to their relation with chosen element. When the user selects one of the proposed resources, she/he starts navigating the repository resource by resource, following the relations between them.

As an example of the user-system interaction, let us assume that the user selects the "Labyrinth" archetype, and then chooses to explore the actions related with it. The system shows a set of action types, displaying, for each of them, the number of related artifacts. If the user chooses the "killing" action, the system will display the screenshot in Fig. 2 (top left, "action"), which includes the following information:

- the action categories it belongs to in the ontology: here, the "Hero action" and the "Killing action".
- the stories to which the action belongs, which include both single episodes ("Theseus kills the Minotaur") and larger stories ("Theseus and the Minotaur"). Notice that the latter information is not explicitly stated in the ontology, but has been added by reasoner as an effect of the inferences conducted on the *partOf* relations among stories.
- the characters and objects that play some role in the different occurrences of the action : "Theseus", "Minotaur", "Heracles" for the characters, and "dagger" for the objects.

In the bottom part of the page, the user can browse the artworks related with the "killing" action. If the user clicks on the first artwork (Picasso's painting "Minotauromachia", Fig. 2, bottom), the system displays the information about the artwork, including the characters it involves ("Theseus" and the "Minotaur") and the story it refers to (again, 'Theseus and the Minotaur" and the episode "Theseus kills the Minotaur" in particular). If user decides to continue the navigation from this artifact to one of its related stories (let assume the user chooses the episode "Theseus kills the Minotaur") the system displays (see Fig. 2, top right, "story") the information about the selected story.

4 Conclusions and Future Work

The system described in this paper relies on an ontology to let the user explore the relations among a set of media resources which share common narrative features, such as characters, actions, objects, locations.

A prototype of the systems was developed and tested on a pilot corpus of 24 resources of different type and format. The corpus was issued from a bibliographical search conducted by editorial professionals and included 8 visual artworks, 6 literary works, 2 movies and 2 musical works. A test on a larger corpus is planned as future work.

References

1. Chen, C.-C., Wactlar, H.D., Wang, J.Z., Kiernan, K.: Digital imagery for significant cultural and historical materials. International Journal on Digital Libraries 5(4), 275–286 (2005)
2. Collins, T., Mulholland, P., Zdrahal, Z.: Semantic browsing of digital collections. In: Gil, Y., Motta, E., Benjamins, V.R., Musen, M.A. (eds.) ISWC 2005. LNCS, vol. 3729, pp. 127–141. Springer, Heidelberg (2005)
3. Damiano, R., Lieto, A.: Ontological Representations of Narratives: a Case Study on Stories and Actions. In: 2013 Workshop on Computational Models of Narrative, Dagstuhl, Germany. OASIcs, vol. 32, pp. 76–93 (2013)
4. Hyvönen, E., et al.: Culturesampo: A national publication system of cultural heritage on the semantic web 2.0. In: Aroyo, L., et al. (eds.) ESWC 2009. LNCS, vol. 5554, pp. 851–856. Springer, Heidelberg (2009)
5. Lombardo, V., Damiano, R.: Storytelling on mobile devices for cultural heritage. New Review of Hypermedia and Multimedia 18(1-2), 11–35 (2012)
6. Mulholland, P., Collins, T.: Using digital narratives to support the collaborative learning and exploration of cultural heritage. In: Proceedings of the 13th International Workshop on Database and Expert Systems Applications 2002, pp. 527–531. IEEE (2002)
7. Thompson, S.: Myths and folktales. The Journal of American Folklore 68(270), 482–488 (1955)
8. van den Akker, C., van Erp, M., Aroyo, L., Segers, R., Van der Meij, L., Legene, S., Schreiber, G.: Understanding objects in online museum collections by means of narratives. In: Proc. of the Third Workshop on Computational Models of Narrative, CMN 2012 (2012)
9. Warburg, A.: Der Bilderatlas Mnemosyne, vol. 1. Akademie Verlag (2008)

StoryJam: Supporting Collective Storytelling with Game Mechanics

Yujie Zhu and Jichen Zhu

Digital Media
Drexel University, Philadelphia, PA 19104
{yujie.zhu,jichen}@drexel.edu

Abstract. Collective storytelling is a narrative form that has cultural, cognitive, and organizational applications. Built on existing research in group collaboration, this short paper examines how certain game mechanics can be used to encourage and structure collaboration in *StoryJam*, a multi-player online game for collective storytelling.

1 Introduction

It has long been observed that storytelling is an effective form of communication. When telling stories in a group, individual experiences can be shared and compared through multiple perspectives. In this paper, we focus on a particular form of this practice: collective storytelling, where multiple individuals participate in the creation of *a single*, usually coherent, story. A well-known early form of collective storytelling uses Haiku, a traditional Japanese poetry style. In a popular poetry activity called "Ranga," which can be dated to the 15th century, poets gather to create Haiku poems in turn as a group. Each poet's short stanza has to follow the metric and thematic requirements of the form and extends the content already created by other poets. In the end, the stanzas turn into a long linked poem. Some other salient examples of collective storytelling include improvisational theatre and table-top roleplaying games.

In addition to its applications for organizational community building (e.g., [1]), collective storytelling recently has received increasing amount of attention in the IDS community. For example, Magerko's research group has been studying the cognitive strategies used by improv actors for collective storytelling as the basis for new artificial intelligence (AI) algorithms [3]. Zhu et. al. studied collective storytelling techniques deployed by performers at Disney's interactive attractions such as *Turtle Talks* to better guide the players of interactive narrative through what they call "back-leading" [6].

In this short paper, we explore how to use game mechanics to facilitate and design collective storytelling experiences. Based on observations of recent work in digital forms of collective storytelling, a key challenge is to encourage collaboration on an equal footing and provide structure to the group experience. We believe game mechanics offer a promising means to do so in a play-based environment. We discuss how *StoryJam*, a multi-player online game for text-based collective storytelling, addresses these challenges.

H. Koenitz et al. (Eds.): ICIDS 2013, LNCS 8230, pp. 261–264, 2013.

2 Related Work

A ground-breaking experiment that pushed the limit of digital collective storytelling is *A Million Penguins Project* [4], combining the Internet and traditional collective storytelling. Launched by Penguin Books and De Montfort University, the project illustrates the potential of digital collective storytelling and its ability to mobilize a large number of participants. However, it also reveals the challenges involved. Only a small portion of the 1,500 registered users (less than 6%) edited the story more than once. Among them, 2 users made 25% of all edits. This highly concentrated contributions, however, did not save the final story from being incredibly fragmented; the creators of the project concluded that it was "the wrong way to try to answer the question of whether a community could write a novel." [4, p.21]. An important lessons here is that, in a completely open and unstructured environment, it is very difficult to foster equal collaboration, the basis of creating a community and a rewarding collective storytelling experience.

Designing for collaboration has been studied in other domains, such as corporations and classrooms activities. We use Johnson and Johnson's design guidelines for collaborative activities [2] below as our framework for designing *StoryJam*. **1. Positive Interdependence:** A good collaborative environment creates the sense that team members benefit from one another and an individual cannot succeed unless the whole team does. Some tasks need to be solvable only if participants act together. **2. Individual/Personal Accountability:** Clear statements of activities and individual responsibilities enhance participants' understanding of the group work. It requires mutual access to the group members' performance. Avoiding selfish decisions and misunderstandings, collaborative tasks require communication and negotiation in the activity. **3. Face-to-Face Promotive Interaction:** Studies of group work in real life suggest positive impact of face-to-face communication. In online environments, we believe that preserving limited form of direct interaction, such as chats, can still have positive impact on creating a collaborative environment. **4. Social Skills:** An effective co-working relationship needs to address four dimensions of collaboration design: efficient exchange of information between players; negotiation; leadership; and coordination. **5. Group Processing:** The group as a whole needs the ability to assess its members' performance. A prerequisite is group awareness. Participants must know what group they belong to, how to identify their partners, and what progress has been made by the group [5].

3 *StoryJam*

StoryJam (Fig. 1) is an online multiplayer game where the game mechanics are designed to encourage collaboration and structure collective storytelling. Each game session requires six players, in two competing teams. Within a fixed amount of time, the two teams collaborate on setting the constraints for the stories and compete on creating the stories collectively within the team.

The six players first enter the *Story Setup* stage. They are grouped into two competing teams of three players and StoryJam assigns a particular genre

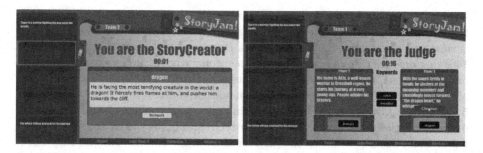

Fig. 1. Sub-story Creation from the StoryCreator's (Left) & the Judge's View (Right)

(e.g., Fantasy) for this session. Two random players, one from each team, create the beginning and the end of the overall story respectively. The rest of the players each contribute one keyword, which will give bonus points if used (details later). All six players can communicate and coordinate through an in-game chat window. The resulting beginning, end, and four keywords are the shared constraints of the game.

Next in the *Sub-Story Creation stage*, each team independently constructs the middle parts of the story in three rounds. Status updates of the major steps are broadcasted to the competing team. In each round, two members of a team are "StoryCreators" who write a sub-story in parallel and independently (Fig. 1, Left). The remaining player is the "Judge" who can see the progress of both StoryCreators and assign them keywords as she sees fit (Fig. 1, Right). Within the time limit for each round, the Judge chooses which of the two newly-created parts to continue. The player whose writing is chosen becomes the Judge for the next round. Once all five parts of the story are complete, the complete stories from both teams are *Assessed*. Currently, all six players vote for their favorite complete story. The votes, weighted by each player's stats such as how many times they have played StoryJam and how often their stories have won in the past, and the usage of keywords in each story are used to select the winner. In our next step, we plan to open the online voting to everyone who plays StoryJam.

We designed the game mechanics for StoryJam specifically to encourage collaboration and facilitate collective storytelling in a structured way. Below we focus on the design of StoryJam's formal elements. **1. Players:** Different roles are assigned to different players based on the *Positive Independence* guideline. At each stage, players need to work together in order to succeed. We believe that competition is not the antithesis to collaboration. In StoryJam, we use the competitive Player vs. Player (PvP) setup to create a strong sense of a team. Within each team, each StoryCreator competes with her teammate to create a better story part. **2. Objectives:** The objective is to construct a successful story collectively. We intentionally leave it to each group to interpret what "successful" means to them through *Group Processing*. **3. Procedurals & Rules:** See descriptions above. Notice the rule for selecting the Judge (i.e., the winning StoryCreator from the previous round) rewards players who perform well and therefore increases *Individual Accountability*. It also helps to create a shared

sense of ownership by not letting one player take the directing role (i.e., Judge) twice in a role. **4. Resources & Boundaries:** The main resource for the game is time and characters. Each round has a timer and a character limit (currently 140) that ensures the collective storytelling process moves along. We also use it to make sure that, unlike the A Million Penguins Project, the final story outcome of StoryJam is from relatively equal amount of contribution from all players. **5. Conflict:** Given the overall PvP setup, the main conflict of StoryJam is to outperform the other team. For the StoryCreators, they need to outwit their fellow StoryCreator in order to win over the Judge. For the Judges, they need to strategically pick the story part that is both interesting in its own right and fits the game constraint. **6. Outcome:** Although this is a "zero-sum" game, we see the stories collectively created as the main outcome of the game.

In our initial playtesting session, participants seemed to enjoy this collective storytelling game and they frequently used the chat function to share ideas and ask for opinions. This is a positive indication for collaboration. They successfully designed stories in teams in the Story Setup and Sub-Story Creation stages. The players reported that they felt engaged and motivated as the game switched their roles in the process. Based on these initial observations, we believe that the idea of using game mechanics to facilitate collective storytelling is feasible.

4 Conclusion

In this short paper, we presented our *StoryJam* project which uses game mechanics to facilitate collective storytelling. Built on guidelines of collaboration in other settings, we designed the game mechanics of StoryJam and conducted preliminary playtesting which showed positive results. In addition to collective storytelling projects, our design approach can also be generalized to other digital applications where collaboration and group decision-making are needed.

References

[1] Boyce, M.E.: Collective Centring and Collective Sense-making in the Stories and Storytelling of One Organization. Organization Studies 16(1), 107–137 (1995)

[2] Johnson, R.T., Johnson, D.W.: Cooperative learning: two heads learn better than one. Transforming Education 18, 34 (1988)

[3] Magerko, B., Manzoul, W., Riedl, M., Baumer, A., Fuller, D., Luther, K., Pearce, C.: An empirical study of cognition and theatrical improvisation. In: Proceedings of the Seventh ACM Conference on Creativity and Cognition, pp. 117–126 (2009)

[4] Mason, B., Thomas, S.: A million penguins research report. Tech. rep., Institute of Creative Technologies, De Montfort University (2008)

[5] Villalta, M., Gajardo, I., Nussbaum, M., Andreu, J., Echeverra, A., Plass, J.: Design guidelines for Classroom Multiplayer Presential Games (CMPG). Computers & Education 57(3), 2039–2053 (2011)

[6] Zhu, J., Ingraham, K., Moshell, J.M.: Back-leading through character status in interactive storytelling. In: Si, M., Thue, D., André, E., Lester, J., Tanenbaum, T.J., Zammitto, V. (eds.) ICIDS 2011. LNCS, vol. 7069, pp. 31–36. Springer, Heidelberg (2011)

2nd Workshop on Games and NLP (GAMNLP-13)

Noriko Tomuro[1], Yun-Gyung Cheong[2], and R. Michael Young[3]

[1]DePaul University, USA
tomuro@cs.depaul.edu
[2]IT University of Copenhagen, Denmark
yugc@itu.dk
[3]North Carolina State University, USA
young@csc.ncsu.edu

1 Overview

Natural language processing (NLP) investigates computational aspects of natural language which humans produce and understand. While applications of NLP range from information retrieval to machine translation, this workshop aims at promoting and exploring the possibilities for research and practical applications of NLP in games. With the advances in videogames in recent years, areas in which games and NLP can help each other have greatly expanded. For example, games could benefit from NLP's sophisticated human language technologies in designing and developing novel game experiences through natural and engaging dialogues, or studying games formally. On the other hand, NLP could benefit from games in obtaining language resources (e.g. construction of a thesaurus through a crowdsourcing game), or learning the linguistic characteristics of the game users (as compared to those of other domains). However, those two fields have been regarded distant, and there has not been much collaborative work which exploited the use of one in the other field.

To promote the cross-feeding between the two fields, the 1st workshop on games and NLP was organized and successfully held in 2012 (GAMNLP-12)[1], as a special session at the 8th International Conference on Natural Language Processing (JapTAL 2012)[2]. To continue to explore the possibilities further, the 2nd installment will be held at ICIDS 2013 (as a half-day workshop), aiming to attract researchers both from NLP and Game communities. The workshop will welcome the participation of both academics and industry practitioners interested in the use of NLP in games or vice versa.

2 Objectives and Potential Topics

Main objectives of the workshop are to explore the possibilities for research and practical applications involving NLP and Games. The workshop will provide a forum for researchers and practitioners to discuss ideas on how to promote the collaboration between the two fields.

[1] http://lang.cs.tut.ac.jp/japtal2012/special_sessions/
GAMNLP-12.html
[2] http://lang.cs.tut.ac.jp/japtal2012/

H. Koenitz et al. (Eds.): ICIDS 2013, LNCS 8230, pp. 265–266, 2013.
© Springer International Publishing Switzerland 2013

Potential topics of interest for the workshop include, but are not limited to:

- Text-based Interactive Narrative Systems
 - o Narrative Comprehension
 - o Narrative Generation
 - o Text realization
- Discourse planning and management in games
 - o Dialogue generation and management
 - o Question and Answering, Question Generation
- Information and content extraction, text mining
 - o Analysis of large-scale game-related corpora (e.g. game reviews, gameplay logs)
 - o Real-time sentiment analysis of player discourse/chat
 - o Recommender systems for gamers
 - o Real-time commentary for games
- Natural language interaction in games
 - o Speech recognition and synthesis in games and in-game chat systems
 - o Language-based real-time interaction with virtual characters
 - o Chatterbots and conversational agents
 - o Context-aware systems in virtual environment
- Automated construction of game ontologies
- Serious and educational games for learning languages
- Games for the purpose of constructing language resources (e.g. *Games With a Purpose*[3])

3 Workshop Format

The workshop will include paper and poster presentations and systems demonstration sessions. In particular, we expect to gather potential answers and ideas to the following questions through round-table discussion activities.

1. How could games benefit from better NLP?
2. What are the overarching problems in NLP - How could games help?

The workshop may also include a panel discussion on how to generate and analyze affective dialogues and narratives. This topic (affective narratives) is chosen actually to follow up the round-table discussion from the 1st workshop (GAMNLP-12) --- many people in the audience raised the issue as a significant element in achieving more 'natural' interfaces (in addition to languages). We plan to solicit a panel consisting of people who have worked on this problem and ask them to share their experiences.

[3] http://aclweb.org/aclwiki/index.php?title=Games_with_a_Purpose

Adapting Narrative Complexity to Games

Eddo Stern

Design Media Arts Department, University of California Los Angeles, Los Angeles,
CA, USA
eddostern@arts.ucla.edu

Abstract. This workshop explores methods and approaches that may be used to adapt complex short story narratives into the form of playable games. The challenge and value of the workshop lies in the nature of the stories selected, as they are drawn from a set of contemporary literature, which has traditionally been avoided as source material for games. For instance works of highly symbolic, poetic, allegorical, illogical or political plotlines where physical action plays only an ancillary role. For example stories by Paul Bowels, Jorge Luis Borges, Raymond Carver, George Saunders, and Kelly Link.

Keywords: Narrative, Adaptation, Games.

1 Introduction

This workshop is drawn from ideas generated over the past five years from my introductory course on game design taught at UCLA since 2008.

In this workshop participants will develop a playable multiplayer tabletop game prototype (pen and paper) adapted from a short story. I deliberately choose stories that are unusual in structure and fairly difficult to adapt into a game (not straight-forward action adventure stories or mysteries, science fiction, fantasy etc.). The challenge and value of the workshop lies in the nature of the stories we will be working from, as the stories are drawn from a cannon of contemporary literature that are rather psychological and nuanced.

I believe it is of significant importance for the future growth of gaming as a creative medium that attention is focused on the complexity and nuance of the narratives involved. One of the questions that I hope to work through in this workshop is seeing whether new gameplay mechanics can be developed from the intricacies of a narrative text. Rather than simply skinning what are known game mechanics with a narrative layer, we will try and discover and improvise new gameplay mechanics and dynamics that are derived from the nuances of a particular text. Additionally, we should strive for a game that can stand in for the story and be appreciated by players who have not read the original text (think movie adaptation - good ones arguably still work without having to read the book).

H. Koenitz et al. (Eds.): ICIDS 2013, LNCS 8230, pp. 267–268, 2013.
© Springer International Publishing Switzerland 2013

2 Workshop Outline

I will select a few short stories from which each participant picks one story to work with. Participants will prepare a preliminary game design document/proposal that will be developed into a simple playable board game.

The central experience of this workshop is to explore the complexities and contradictions that evolve when adapting a non traditional narrative into a game, and designing games that incorporate game mechanics and dynamics that keep the game narrative front and center. Following are some questions to ask when conceptualizing an adaptation: How many players will play?, What roles and goals will they have?, How will unexpected events be handled?, how will the game progress over time?, What choices or agency do the players have?, will players be competing against each other or collaborating?. Perhaps a narrator/game master is needed in the game to guide the players through and manage time and improvise around unexpected events?. Think about plot progression. and character identification? How does the game account for time moving forward and plot progression? How to work with surprise and suspense? How to create a replayable game experience?

I will show examples of some previous adapted games and discuss several approaches to game design and adaptation. Most of the examples I will discuss in the workshop were produced by undergraduate students at UCLA for my introductory game course titled "Game Design Workshop". Following are links to some example projects:

Trek to Tessalit. a board game By Leslie Calvert. 2009. Adapted from the short story *"The Delicate Prey"* by Paul Bowels.
Images: http://games.ucla.edu/game/trek-to-tessalit/.
Design Document: http://games.ucla.edu/wp-content/uploads/2010/10/trek-to-tessalit-PDF.pdf

That Damn Baby. a board game by Nate Smith. 2010. An adaptation of *Feathers* a short story by Raymond Carver.
Image: http://classes.design.ucla.edu/Spring10/157A/wp-content/uploads//nate-1024x719.jpg
Design Document http://classes.design.ucla.edu/Spring10/157A/wp-content/uploads//feathers_design_doc1.pdf

Figure 4. *Escape From Spider Head.* A board game by Andre Gerner, 2011. Adapted from the George Saunders short story of the same name.
Images: http://games.ucla.edu/game/escape-from-spiderhead/
Design Document: http://games.ucla.edu/wp-content/uploads/2011/07/spiderhead.pdf

Scatter. A board game by Bryan Wuest, 2010. An adaptation of *Stone Animals,* a short story by Kelly Link.
Images: http://games.ucla.edu/game/scatter/
Design Document: http://games.ucla.edu/wp-content/uploads/2010/10/Scatter-Final-Doc.pdf

Classic Games Workshop

Ahmet Nazif Sati

Istanbul, Turkey
ahmet@borderlineworlds.com

Abstract. Games have been facilitating personal and cultural growth for as long as human culture and society have endured, and for the majority of that time, games were developed on mediums other than computers. On the other hand, it is crucial to remember that scientific process is a matter of evolution from classical ideas into novelty. Even the spark of genius often stems from a deep pool of classical awareness. therefore classical game design methods should be experienced in order to become a strong game developer. In accordance with this view, this workshop aims to build a board game based on a work of classical literature.

Keywords: Board Game Design, Classical Game Design, Narrative Adaptation.

1 Introduction

We have been playing games for as long as human culture and society have endured. For the great part of that time, computers did not exist. That's why, our digital games borrow heavily upon classical games that have been perfected over many centuries. The closest approach to digital games from the vector of classical gaming is board games. Both share a game platform (screen or game board) upon which game actors (a player character or a game piece) move according to certain rules to overcome obstacles.

This workshop is based on the premise that, in order to become a good digital game designer, it is crucial to have an intimate understanding of classical board games and their *gestalt*.

On the other hand, digital games also provide us with a brand new storytelling medium to work with. Then, why not produce a classical game, which tells a classical story out of classical literature?

2 Description

2.1 Objectives

This workshop aims to design a game or a set of games using the work of classical literature as inspiration. The products of this workshop are going to be:

H. Koenitz et al. (Eds.): ICIDS 2013, LNCS 8230, pp. 269–271, 2013.
© Springer International Publishing Switzerland 2013

 a. A game design document
 b. A playable game prototype

Since time limitations and technical considerations apply, the prototype is going to be a simple board game with sketchy art. Primary focus will be on conversion of the story into a fun ludic experience, rather than producing a piece of visual art. Also, the game design document is expected to provide prospective plans to turn the board game into a working digital title by speculating on the following issues:

 a. Choice of digital platform (mobile devices, massive online gaming, social games, etc.)
 b. Development schedule
 c. Feasibility & Funding

2.2 Intended Audience

 a. Game Designers (freelance, professional, or aspiring)
 b. Literary and narrative theorists
 c. Artists

2.3 Method

The following method is going to be used in order to realize the workshop objectives:

1. The participants are going to be expected to select and deconstruct a classical work of literature into gameplay components.
2. The works to be selected for deconstruction will be public domain works that are generally well-known in literature, such as: *Wuthering Heights (Emily Brontë), Romeo & Juliet (William Shakespeare), 20.000 Leagues Under The Sea (Jules Verne), etc.*
3. Wikipedia plot summaries should be used as helpful tools for the deconstruction process.
4. The deconstructed works are going to be re-interpreted in game design language:
 a. Type of game (Roll and Move (*Candyland, Chutes and Ladders*), Simulation (*Monopoly, Life*), Strategy (*Chess, Go*), Wargames (*Diplomacy, Axis & Allies*), Party/Family (*Taboo, Cranium*), Resource Management (*Settlers of Catan, Puerto Rico*), Cooperative (*Knizia's Lord of the Rings, Shadows over Camelot*), Abstract (*Blokus, Ingenious*), Miniatures (*Heroscape, Memoir '44*), Collectible (*HeroClix, Magic: the Gathering*), Auction (*Medici, Modern Art*), Tile Laying/Modular game board (*Carcassonne, Zombies!!*)
 b. Player units or characters
 c. Game rules
 d. Story elements
 e. Fun factors

5. Proper sketchy art is going to be developed for the prototype, with an additional style sheet for further development (as part of the game design document) if time permits.
6. The playable prototype is going to be developed and produced in-situ using simple materials.
7. A game design document is going to be refined, which will also act as the gameplay booklet.

2.4 Timeline

This is a one full-day workshop. The whole process is expected to take approximately 8-9 hours. A sample timeplan is as follows:

20 mins.	Introductory Speech
20 mins.	Introduction of Participants
20 mins.	Selection of Classical Works From A Shortlist (List open to participant suggestions)
120 mins.	Private Group Session (Development & Sharing Of Ideas)
60 mins.	Lunch Break
150 mins.	Private Group Session (Development Of Prototype)
60 mins.	Wrap-up & production of the Game Design Document (by filling-in a template form)
90 mins.	Presentation Of Games & Playtesting
-	Postmortem (Resulting games could be demonstrated for playtesting on the remaining days of the event)

Edularp : Teaching, Learning and Engaging through Roleplay and Interactive Narratives

Bjoern F. Temte[1], Morgan Jarl[2], and Henrik Schoenau-Fog[1]

[1] Department of Architecture, Design and Media Technology, Section of Medialogy, Aalborg University Copenhagen, A.C.Meyers Vænge 15, 2450 Kbh SV, Denmark
btemte07@student.aau.dk, hsf@create.aau.dk
[2] University of Gothenburg, The Board of Teacher Education
Box 100, SE 405 30 Göteborg, Sweden

Abstract. This workshop will be offering the participants both a theoretical and practical introduction to Edularp, a form of interactive narrative roleplaying game that uses methods derived from Nordic-style live-action roleplaying games to heighten engagement and learning in education. The Edularp demos included in the workshop showcase concrete, real-world examples of applied Interactive Narratives, and the workshop relates Edularp and its methods to seminal works from the Interactive Digital Narrative community.

Keywords: Edularp, Roleplaying Game, Engagement, Interactive Narratives, Nordic Roleplaying Game Tradition, Teaching, Learning Assessment, LARP.

1 Introduction

One of the most concretely applied subtypes of Interactive Narratives, Educational Live Action Roleplay or "Edularp" has gained great popularity in the past few years since its inception in Scandinavia. The concept has now reached USA, Israel/Palestine, Belarus, Brazil and beyond. Utilising methods derived from the live action roleplaying game types unique to the Nordic region, the interactive narratives of Edularps are now being used to heighten both engagement and learning in education and commercial environments alike.

2 Edularp

Similar to a real world simulation, an Edularp offers the narrative to be experienced through a physical world, built or chosen for the particular pedagogic and artistic purpose. The participants co-create the story with the designers by improvisational drama similar to audience-free improvisation theatre. Through a common backstory - created and facilitated by the designer - it is possible to create a web of incentives for player to player interaction, based both on character motivations in the story and player motivation to succeed and "win" the game. This all can create very immersive, engaging experiences, capable of motivating students, and giving them the

H. Koenitz et al. (Eds.): ICIDS 2013, LNCS 8230, pp. 272–273, 2013.

opportunity to truly embody knowledge and try it out in a non-threatening environment.

2.1 Edularp Examples

- A historical reenactment of the Roman senate, where the players try to achieve their character's political goals, while learning about the formalia behind our modern day democratic parliamentarism, the math and physics of road and aqueduct building, and different barbarian peoples the military face through their conquests.
- A game of math set in a post-apocalypse where the participants get to rebuild a society, with a new political system of their design, calculate the food and agriculture needs for their aspiring civilisation and learn to build houses.
- A game where the players portray a crisis situation, and try out the company's security and crisis management systems. Dealing with people in chock, taking on the role of others in the organisation and understanding other perspectives.
- A Harry Potter game about the basic elements of chemistry, using different elements to cast different spells, all played in English (for non-native english speakers). The plots revolve around a competition between the different houses and the spells will be invaluable to solve the tasks to win, so you have to learn them.

3 Workshop

Co-organized by one of the world's leading experts on Edularp, this half-day workshop will present concrete examples of how interactive narratives can be utilized for teaching, education and learning. Researchers and practitioners within the field of Interactive Digital Narratives will discover new techniques and approaches to constructing and enhancing an interactive narrative experience. The methods used, directly relate to many of the challenges and solutions encountered in other media, and these approaches will shed lights on new ways of thinking about interactive learning.

Furthermore, current predominant principles and research results from the Edularp community, professionals and academics will be presented and related to the field of Interactive Digital Narratives. These results include suggestions about how to assess learning outcomes and impact of Edularps as well as how to improve educational roleplay experiences through theories about engagement.

The workshop will feature several Edularp demos, in order to provide workshop attendees with their own first-hand experience, which will function as the foundation for a subsequent general discussion of the merits and relevance of Edularp in relation to Interactive Digital Narratives.

Interactive Digital Storytelling: Practice, Impact and Aesthetics

Noam Knoller[1], Henrik Schoenau-Fog[2], and Udi Ben-Arie[3]

[1] Interface Studies Group, Amsterdam School for Cultural Analysis and the Department of Media Studies, University of Amsterdam
knoller@uva.nl
[2] Purposive Games and Interactive Storytelling Group, Department of Architecture, Design and Media Technology, Section of Medialogy, Aalborg University, Copenhagen
hsf@create.aau.dk
[3] Department of Film & Television, Faculty of the Arts, Tel-Aviv University
udiben@post.tau.ac.il

1 Introduction

ICIDS has always been an interdisciplinary conference, open to scientists, scholars, artists and other makers from many different fields. However, over the years the balance between the various types of submissions has been unstable. Artists and other makers, who often operate outside the academic world, have seldom found ICIDS to be a relevant venue in which to present their work, receive critical feedback, find inspiration, and establish new contacts with fellow practitioners and with the ICIDS community of scientists, engineers, scholars, and educators. Nevertheless, in recent years we can discern more accomplished projects and applications that tell stories interactively on digital platforms, in fields such as documentary, advertising, indie (and mainstream) games, therapy or education. Most of those, however, have made little to no use of the knowledge generated by the ICIDS community.

As projects, applications and tools for the creation of Interactive Digital Storytelling begin to mature, the time is ripe to discuss how various makers practice their craft of creating experiences, how the works impact their audiences and how the aesthetics and content of these works can be theorized, appreciated and critiqued as cultural artefacts. We believe such discussions, as well as such contacts between the current community and makers are crucial for all those interested in the further development of IDS/IDN as a medium and art form.

This workshop, therefore, aims to establish a significant venue at future ICIDS conferences for the presentation and discussion of Interactive Digital Storytelling works that will reflect the concerns and perspectives of makers and audiences. The envisaged venue will allow artists and other practitioners to present novel and inspiring interactive digital works, provide an opportunity for mutual enrichment on questions of form and aesthetics, content, and the cultural and societal impact of current and future interactive storytelling applications. By being part of ICIDS, this venue can build bridges by offering a structural interdisciplinary meeting point.

H. Koenitz et al. (Eds.): ICIDS 2013, LNCS 8230, pp. 274–275, 2013.

2 Format

The workshop will consist of two discussions: (1) Projects, (2) Venue.

2.1 Projects

We will initiate the workshop by discussing some concrete projects. Participants who have projects they would like to share as inspiration during the workshop are welcome to prepare a video and/or a 10x20 second per slide mini-"Pecha-Kucha"-style presentation of their work. Those participants are requested to register their intent to present before October 23rd, 2013, by sending an email to icids2013workshop@interfacestudies.org, including the project's name, a brief description and a URL (if applicable).

2.2 Venue

We will continue with a moderated discussion of the envisaged venue, based on a list of questions, for which participants will be asked to provide the answers before October 23rd, 2013 via the online form available on http://www.interfacestudies.org/icids2013.

Some of the questions included are:

- Which current and future trends in IDS/IDN works should we highlight and encourage?
- How can IDS/IDN attract more authors, artists and practitioners? How can we encourage them to engage with the field?
- What format should the venue have that would best tease out questions of cultural and social impact? Should we establish a competition? What sort of competition, or what alternative format to a competition would you support?
- What are the logistical considerations involved and what resources could be made available to realise this vision?

The final format of the workshop will be fine-tuned based on the amount of submissions for each part.

Interactive Story Creation with Smartphone Video

Lorene Shyba

School of Creative and Performing Arts,
University of Calgary, Alberta, Canada
lorene.shyba@gmail.com

Abstract. The aim of this full-day introductory workshop is to showcase and make use of new digital tools for game creation; primarily smartphone and tablet video cameras. The expected outcome of this session is the collaborative creation of an interactive serious game story that incorporates elements of role-playing and adventure. The theme and characters of the gameplay will be determined by the participants at the workshop but will deal with a current social or political issue, enabling conference attendees to contribute ideas and even solutions for serious global issue. The take-away for game developers is a new tool to tap into the smartphone camera's ubiquity and portability to document real life conflicts and to use this footage, or dramatizations, to construct storyboards or even fully fledged interactive movies and games.

Keywords: Smartphone video, Mobile phone video, Serious Games, Storyboard, Social Issues.

1 Description

In this full-day practical session, participants will explore new tools for interactive story generation through the use of smartphone or tablet video cameras and simple computer editing and delivery methods. The workshop aims to bridge the fields of theatre and filmmaking, politics, and social issues to tap into the immense potential of interactive narrative for use in serious games.

In the morning session, participants will work in pairs or groups to create characters and dramatize scenes of social or political significance; either a current or a historical event. Simple scripts will be written/improvised and performed for the camera.

In the afternoon, participants will decide on one story theme to take into an interactive format using a combination of simple video editing and interactive game software. Once the piece is completed, an in-session critique will follow with slight adjustments made by the group. If requested, the final piece can be presented at an ICIDS conference event such as a luncheon or at the concluding party event.

The theme and characters of the gameplay will be determined by the participants at the workshop but will ideally connect with a current or historical social issue, enabling the work of conference attendees to contribute alternative solutions for a serious global issue. The take-away for game developers is a new tool to tap into the smartphone camera's ubiquity and portability to document real life conflicts and to

H. Koenitz et al. (Eds.): ICIDS 2013, LNCS 8230, pp. 276–278, 2013.

use this footage, in combination with dramatizations, to construct storyboards or even fully fledged interactive movies and games. This workshop is expected to both generate ideas and provide practical skills that will provide participants with ways to envision promising directions for their future research and practices.

The primary inspiration for the workshop was the favourable response from international participants at Lorene Shyba's 2011 ICIDS Workshop, "Making Interactive Stories Meaningful: Story and Character Development through Theatre Games." The proposed ICIDS Workshop is a direct followup to the spirit and themes of the 2011 sessions insofar as it is once again practice-based and an exploration of new tools for creating interactive narrative. Additional inspiration for the workshop material comes from Augusto Boal, Brazilian theatre visionary and developer of Forum Theatre. "A dynamic place of interactivity. An environment where spectators becomes 'spect-actors.' A forum for direct action and social change." Although these are descriptions of Boal's potent political theatre, they might also apply to serious videogames where social impact is a component of the experience.

2 Equipment

It is preferred that participants use their own smartphones or tablets for this workshop, however, it is not mandatory as they will work in teams and can be matched with participants who own this necessary equipment. Technology can be Apple iphones/ipads or cellphones (mobile phones) that use mini SD cards and shoot to Final Cut Pro X compatible formats such as .avi or .mov. The necessary video editing and presentation software will be provided by presenter, Lorene Shyba.

3 Preliminary Work

In advance of the workshop, participants are requested to:
- Pay attention to current event news coverage, especially of political and social issues, and bring newspaper clippings or detailed field notes.
- Read the online *Popular Mechanics* online guide to shooting video with a smartphone, in the Resources section below.

4 Resources

Boal, Augusto: *The Aesthetics of the Oppressed.* Tr. Adrian Jackson. London: Routledge (2006).

---: *Legislative theatre: Using Performance to Make Politics.* Tr. Adrian Jackson. London: Routledge (1998).

---: *Theatre of the Oppressed.* Tr. Adrian Jackson. Routledge: London (1979).

Johnstone, Keith: *Impro: Improvisation and the Theatre*. New York: Routledge (1981).

Levelle, Tony: *Digital Video Secrets: What the Pros Know*. Michael Weise (Publisher) (2008).

McKee, Robert. *Story: Substance, Structure, Style, and the Principles of Screenwriting*. New York, NY: HarperCollins (1997).

McLuhan, Marshall. *Understanding Media: The Extensions of Man*. Cambridge, MIT. ([1964]1994).

Popular Mechanics, "How to Shoot Great Video With Your Smartphone." Dec. 2011. http://www.popularmechanics.com/technology/how-to/tips/how-to-shoot-great-video-with-your-smartphone

ICIDS 2013 Workshop:
Revisiting the Spam Folder –
Using 419-Fiction for Interactive Storytelling

Andreas Zingerle[1] and Linda Kronman[2]

[1] University of Art and Design, Linz, Austria
andreas.zingerle@ufg.ac.at
[2] Kairus.org - Art+Research, Linz, Austria
linda@kairus.org

Abstract. This workshop will be offering the participants both a theoretical and practical introduction to interactive narratives created by scammers and scambaiters in '419-fictional environments'. We seek to understand different sides of online fraud and through creative storytelling reflect on issues like online privacy, virtual representation and trust within networks. We also draw parallels to other practices and cultures like: gaming, transmedia storytelling and creative activism. Through a '419-fiction toolkit' participants take the first steps of creating their fictional characters and infiltrating a scammers storyworld to observe and interrupt their workflow. By reflecting on scambait experiences we enter a discussion around the topic of interactive narration connecting the theme to the participants' and their general work in this field.

Keywords: Unsolicited electronic mail, Transmedia storytelling, Computer mediated communication.

1 Introduction

With the term '419-fictional environments' we refer to computer mediated story worlds where advance-fee fraud is used as a confidence trick to lure the victim into paying a fee in advance, with the future hopes of getting a larger amount of money in return. The origin of advance-fee fraud dates back to the 16th century and is known as the Spanish prisoner [1], Internet and new communication systems have rapidly increased the opportunities for the scammers to reach victims. At the same time they have helped the scammers to hide their personalities and their working practices. Scammers can work with standard office computers on a global level, tricking their victims by impersonating: fundraising Charity NGOs, State Lottery institutions, Conference/Art Festival organizers or as romance seeking lovers on Dating websites. These types of cybercrime are often called 419-scams, 419 referring to the Nigerian Criminal Code dealing with cheating and fraud[1].

[1] History of 419 Scam - Scam Mails, Advance Fee Fraud, Scammers, Scam Victims
http://www.nigerianspam.com/history-419-scam.htm

H. Koenitz et al. (Eds.): ICIDS 2013, LNCS 8230, pp. 279–280, 2013.
© Springer International Publishing Switzerland 2013

The workshop will give participants valuable first hand insights how to raise awareness about online advance-fee fraud scams that deal with issues of trust betwixt and between real and virtual. We will do this by providing the participants a '419-fiction toolkit' [3] that helps us to explore the practice's of scambaiters, persons who reply to scam emails, being fully aware that the emails are written by scammers. Scambaiters turn the tables and lure the scammers into incredible story-plots, always giving them the feeling that they will get a lot of money. The workshop provides a base to discuss if components of scambaiting culture can be used in terms of community service in form of creative activism [2]. We also welcome discussion around the game like interaction that takes place between the scammer and the scambaiter. How storyworlds are built, how characters are designed and dialog exchanged to build trust between the actors.

2 Intended Audience

The intended audience of this workshop would be students, artists, writers, narrative designers, and other people involved in the creation of IDS on a practical level or those with an interest in that direction. Attendees should be willing to actively participate in the discussions and the practical exercises which require: to bring an own laptop, decent internet connection, some improvisational role-playing skills, internet savviness and an active imagination.

References

1. Brunton, F.: Spam: a shadow history of the Internet. MIT Press (2013)
2. Tuovinen, L., et al.: Baits and beatings: Vigilante justice in virtual communities. In: Proceedings of CEPE 2007. The 7th International Conference of Computer Ethics: Philosophical Enquiry, pp. 397–405 (2007)
3. Zingerle, A., Kronman, L.: 419-fiction - anti-fraud activism, http://419fiction.kairus.org/

The Importance of Storytelling on Online Activism for Creating Change

Uygar Özesmi, Serdar Paktin, and Zennube Ezgi Kaya

Change.org Türkiye, Istanbul, Turkey
info_turkiye@change.org

Abstract. The core of this workshop is to inspire participants to think of social change as a process of collective storytelling. In this workshop, participants will come together to produce an online campaign to create real social change in a collaborative hands-on approach.

Keywords: Change.org, online activism, internet petitions, social media, collective storytelling, digital communication networks.

1 Introduction

Online activism is on the rise together with the internet technologies and the possibilities that emerge in collective mind. In the last 10 years, we have observed the escalation of activism on the internet terrain. It is more and more visible in each social movement all around the world.

Online activism's rise also brought up diverse methods and approaches to activism. Some of these methods can be enumareted as, 1) hacktivism 2) social media bombing 3) online petitions 4) crowdfunding/crowdsourcing 5) online boycotts. Each of these methods are utilized by themselves in various situations and in other situations some or all of them are used to achieve the end goal.

In this context, online activism highly relies on the immense potential of interactive narrative and storytelling. Change.org [1], the world's biggest online petition platform, is empowering people everywhere to create the change that they want to see. Change.org is an online platform that provides tools for people that makes the opportunity to voice their personal stories to create social change. From that one personal story, supporters sign his/her petition and add their comments, their own stories to it and start creating a network of stories that lead to social change.

We can call this a "journey of social change from individual to community". This is a collective experience of building a movement around a cause by contributing their personal stories via digital channels and creating a network of stories to create a framework of social change that comes directly from the people. In this experience, the most crucial thing is, signing the online petition, in which the essential story is embedded. In addition, each person who shares their own story, shares their vision of it on social media, and each news article and/or comment from institutions fills into the cobweb. Consequently, this movement ends up in a grand network of stories, which ends happily for all by creating the desired change as a result.

H. Koenitz et al. (Eds.): ICIDS 2013, LNCS 8230, pp. 281–282, 2013.

A recent study by Georgetown University and Ogilvy Worldwide Public Relations Agency [2], shows that people who are connected to a cause via digital channels are four times more likely to volunteer their time and/or donate for that cause than people who are connected via traditional channels. We can say that, the continuity of relationship and a growing sense of attachment keeps the person's motivation alive. Therefore, this network of stories must be planned to be more engaging, inviting and calling for action.

Online activism campaigns are becoming more and more strategically planned stories that are embedded into time and space via digital technologies. Within this context, the individual person and his/her story and the way of annexing that story to the network of stories that are targeting that social change. This workshop is designed and planned to give participants a hands-on opportunity of collectively creating an online campaign and the strategic approach around it.

References

1. Change.org, http://change.org
2. Ogilvy Public Relations Worldwide & The Center for Social Impact Communication at Georgetown University (November 2011), http://csic.georgetown.edu/research/215767.html

The Possibilities of Implementing Productive Interactivity in Emergent Narratives

Sebastian Hurup Bevensee and Henrik Schoenau-Fog

Department of Architecture, Design and Media Technology,
Section of Medialogy, Aalborg University, Copenhagen,
A.C. Meyers Vænge 15, 2450 Copenhagen, Denmark
sbeven09@student.aau.dk, hsf@create.aau.dk

Abstract. This workshop offers the audience the opportunity to participate in a short and intense discussion on the possibilities of implementing productive interactivity in emergent narratives. The conceptual idea is to let one user be productive through different means of interactivity which affect the perceived story of the next user in an interactive digital environment. This approach could contribute to solving a possible diversity-lacking authoring problem when designing emergent narratives.

Keywords: Emergent narrative, productive interactivity, game design, the narrative paradox.

1 Introduction

The intention of the workshop is to introduce participants to the basic theory and the thought-provoking concept of productive interactivity [1] in emergent narratives –a game concept where players mutually affect each other's narrative experience through user-generated content by 'leaving a mark' in the world, which is then passed on to the next user. Furthermore, it aims to provide an insight into general creative perspectives addressing the potential authoring issue in emergent narratives. The concept of emergent narratives in the interactive storytelling domain has been defined by both Aylett and Louchart [3] as well as Jenkins [2], which can be respectively defined as emergence from intelligent agents and from the environment of the world.

Clarifying the concept should lead to a short yet intense discussion with small problem-solving exercises for the audience to complete on the practical and theoretical possibilities, issues, and realization of the concept. The intended audience for the workshop will include creative and more practical-minded persons who can apply fresh inputs into the design of the concept and enjoy discussions on a potential new research area within emergent storytelling.

Being on a conceptual level, the idea raises an array of interactive storytelling issues when regarding the implementation and realization of the concept. For example, the productive actions the user performs might break the immersion or steal the attention of the user's narrative-related goals. As a result, for instance, this could transform

H. Koenitz et al. (Eds.): ICIDS 2013, LNCS 8230, pp. 283–284, 2013.

productive actions into motivating game elements and incorporate them in the main narrative. A relevant issue is also how to make sure the experience will be dramatic enough for a large number of participants to affect each other. Last but not least, how can the experience be measured in order to evaluate the experience?

The concept is currently being implemented in Cryengine 3 SDK as a story world which will be presented at the beginning of the workshop, but there are still unsolved issues such as motivating the user to be productive and designing an intelligent drama system which can control events, character behaviour, locations, and objects. As such, based on the conceptual idea, the main issues that will be encouraged to be discussed during the workshop can be presented in the following questions:

- The author problem—who will want to "leave a mark" and thus potentially break the immersion and narrative engagement?
- How to transform productive interaction into a motivating game element?
- Drama management (How could a potential drama manager function keep the player interested?)
- How does one implement AI and drama management?
- How can it be evaluated (game usability, interactive narrative user experience, immersion, flow, engagement etc.)?

After the workshop the participants should be inspired to use creative authoring techniques and apply them to emergent storytelling design in interactive environments, and hopefully the discussion will result in some new and inspiring ideas within the field.

The organizers will be Sebastian Hurup Bevensee and Henrik Schoenau-Fog. Sebastian is currently a Master's student at Aalborg University Copenhagen, and his specialities are in game design, user experience design, and Cryengine 3 game development. He participated in ICIDS 2012, contributing with the experimental interactive computer game 'Aporia: Uncover the Mystery'—an experience designed for environmental storytelling in an open world. Henrik is an Assistant Professor at the Section of Medialogy at the Department of Architecture, Design and Media Technology at Aalborg University, Copenhagen. He is currently conducting research into areas of user and player experiences as well as purposive games and interactive storytelling.

References

1. Ryan, M.-L.: Narrative as Virtual Reality. The Johns Hopkins University Press (2001)
2. Jenkins, H.: Game Design as Narrative Architecture. In: Wardrip-Fruin, N., Harrigan, P. (eds.) First Person: New Media as Story, Performance, and Game, pp. 118–130. MIT Press, Cambridge (2004)
3. Louchart, S., Swartjes, I., Kriegel, M., Aylett, R.: Purposeful Authoring for Emergent Narrative. In: Spierling, U., Szilas, N. (eds.) ICIDS 2008. LNCS, vol. 5334, pp. 273–284. Springer, Heidelberg (2008)

Towards Mapping the Evolving Space
of Interactive Digital Narrative

Hartmut Koenitz[1], Mads Haahr[2], Gabriele Ferri[3], Tonguc Ibrahim Sezen[4],
and Digdem Sezen[5]

[1] University of Georgia, Department of Telecommunications, 120 Hooper Street
Athens, Georgia 30602-3018, USA
hkoenitz@uga.edu
[2] School of Computer Science and Statistics, Trinity College, Dublin 2, Ireland
Mads.Haahr@cs.tcd.ie
[3] Indiana University, School of Informatics and Computing, 919 E Tenth St, Bloomington,
Indiana, USA
gabferri@indiana.edu
[4] Istanbul Bilgi University, Faculty of Communications, santralIstanbul, Kazim Karabekir Cad.
No: 2/13, 34060 Eyup – Istanbul, Turkey
tonguc.sezen@bilgi.edu.tr
[5] Istanbul University, Faculty of Communications, Kaptani Derya Ibrahim Pasa Sk. 34452
Beyazit - Istanbul, Turkey
dsezen@istanbul.edu.tr

Abstract. This workshop explores future research directions towards a better categorization and comparison of IDN works, with the objective of a more adequate understanding of this evolving field. In such a multidisciplinary area, an effort is necessary to establish a shared space across different analytical perspectives and practical approaches. As a complement to a position paper presented at ICIDS 2013, the authors wish to demonstrate, discuss and improve multidimensional spatial mappings considering well-known IDN examples as well as novel cases from the periphery of the field.

Keywords: Interactive Digital Storytelling Theory and Practice, Interactive Digital Narrative, Categorization, Mapping, Narratology, Digital Media.

1 Overview

Academics have long started from the assumption that Interactive Digital Narrative (IDN) is somehow different from non-digital, non-interactive narrative. As to the exact extent and nature of the difference, the debate shows no sign of concluding. IDN has been viewed through a variety of theoretical lenses, from post-classical narratology [1] and neo-Aristotelian Poetics [2, 3] to African oral traditions [4, 5], French post-structuralism [6], or transmediality [7], to new media-specific views [8]. Regardless of the specific approach, the continuously evolving field of IDN challenges many definitions. Indeed, the rapid changes enabled by new technology create a dichotomic situation empowering creators and challenging theoreticians at the same time. In this regard we have argued for an interdisciplinary approach [9].

H. Koenitz et al. (Eds.): ICIDS 2013, LNCS 8230, pp. 285–286, 2013.
© Springer International Publishing Switzerland 2013

The discussion at ICIDS 2013 will resume from the preliminary conclusions of the workshops that took place at ICIDS 2012 and ICIDS 2011. In the 2013 workshop, related to a position paper on the same subject [10], a research initiative towards novel methods for categorization will be detailed with special attention to spatial and comparative mappings. Furthermore, the pressing question of works to include in a canon as a basis for a classification will be addressed. In addition, we will continue to engage the question of a shared vocabulary as a necessary component for a widely accepted categorization.

2 Workshop Format

We will introduce a range of possible mappings, including vectors representing opposing value pairs, 3-dimensional plot diagrams and table of weighted categories. Revised models will be tested with the help of workshop participants against a corpus of representative IDN pieces. At the same time, attendees will be asked to propose artifacts for a shared canon. The general objective of this workshop is to present, evaluate and discuss an ongoing research effort towards better schematizations in this field. Participants will engage in short analyses, theoretical discussions and evaluations that will help in shaping research in the field of IDN. The results will be shared on the *Games & Narrative* research blog (http://gamesandnarrative.net).

References

1. Ryan, M.-L.: Avatars of Story. University of Minnesota Press, Minneapolis (2006)
2. Laurel, B.: Computers as Theatre. Addison-Wesley, Reading (1991)
3. Mateas, M.: A preliminary poetics for interactive drama and games. In: Wardrip-Fruin, N., Harrigan, P. (eds.) First Person: New Media as Story, Performance, and Game. MIT Press, Cambridge (2004)
4. Jennings, P.: Narrative Structures for New Media. Leonardo Journal for Art and Science 29(5), 345–350 (1996)
5. Harrell, F.: GRIOT's Tales of Haints and Seraphs: A Computational Narrative Generation System. In: Wardrip-Fruin, N.P., Harrigan, P. (eds.) Second Person. MIT Press, Cambridge (2007)
6. Montfort, N.: Twisty Little Passages: An approach to interactive fiction. The MIT Press, Cambridge (2003)
7. Jenkins, H.: Convergence culture: Where old and new media collide. NYU Press, New York (2006)
8. Murray, J.H.: Inventing the medium: Principles of interaction design as a cultural practice. The MIT Press, Cambridge (2011)
9. Koenitz, H., Haahr, M., Ferri, G., Sezen, T.I.: First Steps Towards a Unified Theory for Interactive Digital Narrative. In: Pan, Z., Cheok, A.D., Müller, W., Iurgel, I., Petta, P., Urban, B. (eds.) Transactions on Edutainment X. LNCS, vol. 7775, pp. 20–35. Springer, Heidelberg (2013)
10. Koenitz, H., Haahr, M., Ferri, G., Sezen, T.I., Sezen, D.: Mapping the Evolving Space of Interactive Digital Narrative - From Artifacts to Categorizations. In: Koenitz, H., Sezen, T.I., Ferri, G., Haahr, M., Sezen, D., Çatak, G. (eds.) ICIDS 2013. LNCS, vol. 8230, pp. 55–60. Springer, Heidelberg (2013)

Author Index

Printed in the United States
by Baker & Taylor Publisher Services